*Benjamin Morris's* Hattiesburg, Mississippi *needed and reliable reference. This superb book* is a well-written and thoroughly documented *addition to historical materials about the city's past. Morris brought a scholar's objectivity to his writing as he balanced Hattiesburg's impressive progress with reminders that not everything in the city's history is laudable. Readers will appreciate his comprehensive coverage of Hattiesburg's past, including the latest archaeology on the city's prehistory. Morris deserves congratulations and appreciation for this up-to-date document of which citizens of Hattiesburg can be exceedingly proud.*
　　　　*—Aubrey K. Lucas, President Emeritus, University of Southern Mississippi*

*Don't think for a moment that* Hattiesburg *is another windy exercise in boosterism. It's local history of the best kind: thorough, balanced and wonderfully evocative of how a lumber village grew up to be a hub city. Morris even makes the ennui of basic training on an army base come back to life for anyone who has ever experienced it.*
　　　　*—Lawrence N. Powell, author of* Accidental City: Improvising New Orleans

Hattiesburg, Mississippi: A History of the Hub City *gives the reader a glimpse into the lives of individuals who made a difference, people who valued community above personal gain, and it is filled with anecdotes and sentiments. It honestly explores the multifaceted dimensions of diversity and breathes new life into some of the expressions and idioms that have faded away from memory. It is storytelling that uncovers the invisible artifacts of this geographic area of Mississippi, and it reveals the fortitude of leaders whose sense of place and placemaking go beyond the call of duty.*
　　　　*—Diane Williams, Mississippi Arts Commission, author of* Mississippi Folk and the Tales They Tell

*Urban history lives! Benjamin Morris's* Hattiesburg, Mississippi: A History of the Hub City *is a beautifully written and deeply researched story of how a sense of place develops through the vagaries of human experience that transform environments by creating community and culture. As a native Mississippian, Morris has deep ties to his subject, but they never interfere with his judicious and even-handed rendering of Hattiesburg's history.*
　　　　*—Bruce Boyd Raeburn, author of* New Orleans Style and the Writing of American Jazz History

*This welcome volume fills a long-neglected gap in the historiography of Mississippi in general and of Hattiesburg and the Piney Woods in particular. Thoroughly researched and well written, it is the first study that traces the area's story from prehistory, through the founding and early expansion of the Hub City, to its growth and development in the modern era. It should be of interest to historians and general readers alike.*
　　　　*—Chester M. Morgan, Professor of History and University Historian, University of Southern Mississippi*

# HATTIESBURG
## ★ MISSISSIPPI ★

### *A History of the Hub City*

BENJAMIN MORRIS

THE
History
PRESS

Published by The History Press
Charleston, SC 29403
www.historypress.net

*Front cover*: Main Street, Hattiesburg, Mississippi, early 1900s. *Forrest Lamar Cooper Postcard Collection, courtesy of the Mississippi Department of Archives and History.* April 8, 1968, Hattiesburg, Mississippi march in memory of Dr. Martin Luther King Jr., four days after his death. *Moncrief Photograph Collection, courtesy of the Mississippi Department of Archives & History.*
*Back cover*: The Slogan Sign of Hattiesburg atop the Ross Building downtown, date unknown. *Forrest Lamar Cooper Postcard Collection, courtesy of the Mississippi Department of Archives and History.*

First published 2014

Manufactured in the United States

ISBN 978.1.62619.200.3

Library of Congress Control Number: 2014951892

*Hope*
*Then, to belong to your place by your own knowledge*
*Of what it is that no other place is, and by*
*Your caring for it as you care for no other place, this*
*Place that you belong to, though it is not yours,*
*For it was from the beginning and will be to the end.*
*—Wendell Berry*

*In memoriam: Toxey M. and Dorothy C. Morris*

*To the people of Hattiesburg*

# CONTENTS

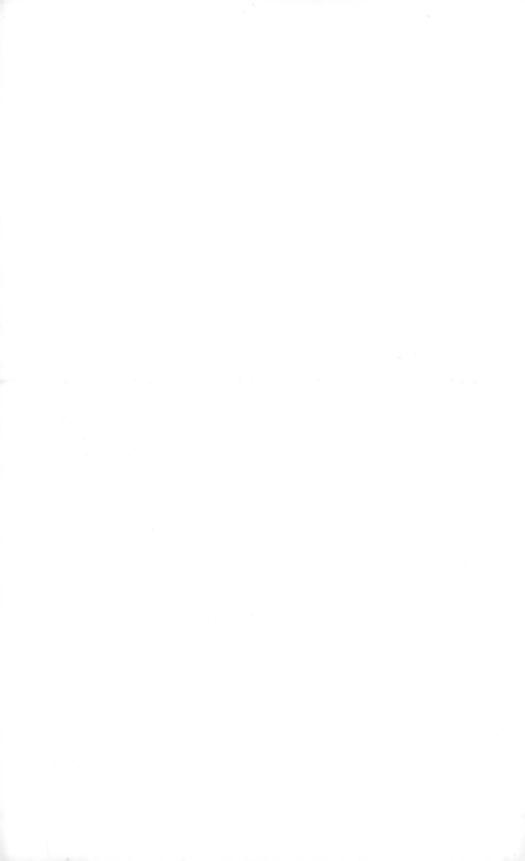

# INTRODUCTION

Those woods were lovely, dark and deep. I still remember them: up a slight hill from our house, past the point where the asphalt ended and the gravel gave way to dirt, dirt that would well up in spring rains into puddles of slick clay and catch the wheels of our bikes in the muck. We weren't supposed to go too far into these woods—our house was one of the first in the neighborhood in those days, the land in that area still largely uncut, second-growth timber—so of course we went in as far as we could, young boys off in search of adventure. The trees formed a foreign architecture, a grand labyrinth whose every turn promised new and untold secrets, hidden treasures to discover, the cool of their shade offering instant relief from the heat whose dust kicked up into our eyes, our ears, our lungs. As young boys less concerned with the threat of spiders or snakes than the thought of coming home late for dinner, my brother, our friends and I drank deeply of those woods, whose pines, gums and oaks seemed to extend forever. Just like our youth.

Anyone growing up in Mississippi knows what it means to have a childhood spent outside—fishing, hunting, swimming, even just playing around—and the story of this childhood, of coming home dirty and torn after hours of exploring Gordon's Creek, will doubtless echo that of many who grew up in the area. For a great many years, indeed for the vast majority of its history, Hattiesburg offered many such benefits to those who grew up and lived here: good schools, ample opportunity for work and play, tight-knit communities where everybody knew everybody (including when supper

was served) and a proximity to the natural world that stimulated a healthy combination of curiosity, wonder, appreciation and pleasure.

The same, I like to think, would have been true for the young men and women of the late nineteenth century, the brave and resourceful families who arrived here in the 1880s and 1890s to put down roots, build a community and create a better life for themselves and their children. Their dreams—of opportunity, of prosperity, leveraged by determination and hard work—cannot be so different from our own, and though the city's forests might have been trimmed and its rivers largely tamed, and the number of those families might have grown over the years, the distance between our visions almost certainly remains too small to see. At its heart, this history of the city is, in many ways, a chronicle of those visions, a simple accounting on paper of those dreams.

More than anything else, this history is two things: a story and a synthesis. For the former, I have sought to focus on the narrative aspects of the city's origins and growth, to illuminate the lives and trajectories of Hattiesburg's individuals and institutions more than to offer a strictly statistical or encyclopedic account. Departing from previous works that largely offer pictorial accounts of the city's past, I have sought to tell the story of Hattiesburg's birth, growth and development through the years, from its prehistory to the present day. In covering this ground, certain parts of that story have come to light that have either not been included in previous accounts or that took place after their publication, and it is my hope in telling this story that a fuller portrait of the city's history can emerge.

As for the latter: before elaborating on what those specific contributions are, it is important to clarify what I mean by synthesis. Simply put, this story is not my own. Rather, it is more faithfully a story by, about and for the citizens of Hattiesburg whose lives and deeds are the raw material out of which this story is spun, material whose many different threads are woven together to create one tapestry. In writing this history, I have sought first and foremost to serve as the conduit for those stories; where possible, I have aimed to render the events and the opinions of those caught at the crossroads of history in their own words, even while enlisting the assistance of the previous historians who have worked on the topic as well, referencing not just extant works but also those that are in progress and will be published in years to come. This history is just what the title says it is: it is *a* history of Hattiesburg, not *the* history. And while I have sought to be as comprehensive as possible, balancing breadth with depth, it is nevertheless true that no one volume can examine every moment in time with the perfect proportion of perspective or the ideal level of detail that it deserves.

One remedy to this malady is its bibliography. Far from its humble origins in Otis Robertson's beloved 1898 pamphlet, Hattiesburg history has become a subject of great interest in recent years, and this volume never could have existed without the work of its forebears. To peer into the past, any historian stands on the shoulders of those who came before them, and I have stood on the shoulders of giants. Superb works by Kenneth McCarty, Gilbert Hoffman, Reagan Grimsley, Andrew English, Chester Morgan, Donna Duck Wheeler, Mark Olderr and Brooke and Colter Cruthirds have all informed this volume in innumerable ways, and rather than duplicate their efforts or plow over old ground, I have sought to complement them by taking their accounts on board and weaving their insights into this one. Indeed, in many cases it has been better to yield the discussion to their expertise; where possible, for instance, I have sought not to reproduce images available in their works but rather to use unpublished or new images to add to the city's extant base of knowledge. Any reader interested in pursuing Hattiesburg history further is urged to consult these works for the wealth of information they offer, and it is this writer's hope that, in time, that list will continue to grow.

To wit: as noted above, as part of that complementary process, this volume has had the opportunity to address a number of topics that previous histories have not had the time, space or chance to include. These include a discussion of the prehistory of the Piney Woods and the archaeology of the area that would become Hattiesburg; an account of previously unexamined judicial and criminal records of the pioneer town in the 1890s; recognition of the city's earliest (if short-lived) institution of higher learning, McLendon Business College; an exploration of African American life under Jim Crow in the first part of the twentieth century; a clearer portrait of life on base at Camp Shelby during World War II; and a discussion of governmental reform in the 1980s that led to the creation of the modern political structure we know today. To add these topics to the city's print historiography has been an enormous privilege, and I am grateful for the opportunity to have done so.

For every topic that is new or expanded, however, as many if not more still await inquiry, and this investigation has highlighted rich ground for future historians to explore. Much remains to be learned. A few topics bear mentioning: among them include the careers of individual mayors, and their influences on the city's direction and growth; an exploration of the city's banking and finance sector, whose origins in the late 1800s conditioned the city's early development and which saw profound upheaval in the 1970s and 1980s; consideration of the role of the Forrest County Board of Supervisors in the city's growth; and a complete charting of the landscape of public

education in Hattiesburg, a topic here addressed only intermittently (largely for reasons of space). All of these topics are part of Hattiesburg's story and deserve fuller treatment. Warranted as well is the study of specific years and eras, such as the year 1893, which saw the potent combination of a national economic panic combined with explosive local growth in the city's timber industry and a pivotal, devastating fire in the early downtown. So, too, the story of how Hattiesburg retooled to serve the war effort during World War II; while individual instances of this story are known, such as the Hercules powder plant producing ammunition or the arrival of the Victory Cola Bottling Company, much still remains anecdotal or unexplored. Finally, it has not been possible to explore Hattiesburg's relation to, and occasional rivalry with, other nearby cities such as Laurel, Columbia, Gulfport and Meridian, a story that awaits its full recounting.

Undoubtedly, the depth of the municipal collections in public and academic libraries will aid in these explorations; with the recent deposition of the Tatum Family Business Records in the McCain Library and Archives at the University of Southern Mississippi, a collection spanning 749 boxes and 443 cubic feet, future researchers will have no shortage of opportunities. This writer is convinced that it is high time for a volume that explores the history of the civil rights movement in Hattiesburg in depth and properly considers each actor and event; while previous histories such as Mark Olderr's and Anthony Harris's have broken that ground, no one volume explores the Hub City's experience in this defining period in American history in the fullness that it deserves. With the events of Freedom Summer in 1964 still well within living memory, many of its veterans still resident and a wealth of primary documents preserved in public and private archives, such a contribution to the city's historiography would be beyond price. Hopefully such opportunities will not be lost.

IF, IN WRITING THIS WORK, I have been indebted to previous researchers, I have been especially indebted to those individuals and institutions who gave selflessly of their time and attention in the year of this pursuit. At the outset, I am grateful to Diane Williams of the Mississippi Arts Commission for first alerting me to the opportunity and for her close and careful reading of the manuscript. My thanks to John Appleyard of Pensacola, Florida, for an early and influential conversation about the practice of writing history, as well as to Professors Max Grivno, Louis Kyriakoudes, Frances Karnes and Chester Morgan of the University of Southern Mississippi for their graciousness in sharing their knowledge of local, state and national history with me. As a

student in Hattiesburg years ago, I had the great fortune to study history under the late Blanchard R. Hinton and, more informally, the late Milton Wheeler of William Carey University; their passion for the subject was inexhaustible, and it is one of my deep regrets that neither one of them lived to see this book. It is undeniably poorer for their loss.

I am grateful to Wayne Easterling for many helpful conversations over this past year, and to the family of Vernon Dahmer for the generous use of photographs in their private collection. My thanks also to Deloris Washington, Betty Sugg, Bill and Mary Wicht, Diane Shepherd, Steve and Kellar McAlister, Chris and Mary Margaret Harper, Jonathan Lambert, Dacia Viejo-Rose, Joe Smith, Bradon Smith, Lauren Lastrapes, Jeremy Walton, Brent Tranchina, Rafael Delgadillo, Sara Hudson, Beryl McCormick, Felix Lewis, Sanford Hinderlie and Helma Kaldewey for their friendship, warmth and hospitality in so many ways. I am grateful as well to Ray Cannata, Shane Gibson and Ben Cunningham of New Orleans for reasons that they well know.

At the city's many institutions, I have a host of individuals to thank. I am indebted to the staff of the Library of Hattiesburg, Petal and Forrest County; Pamela Pridgen first directed me to the resources in the Hattiesburg Vertical File, and Donna Davis, Sean Farrell, Jessica Herr, Nick Parker, Jennifer Baxter and the reference department staff went above and beyond the call of duty in opening the library's many doors for me. At USM, I owe a special debt of thanks to the staff of the McCain Library and Archives: Cindy Lawler, Jennifer Brannock, Stephen Haller, Andrew Rhodes, Elizabeth LaBeaud and Leah Rials all showed inestimable hospitality and warmth as their reading room became a home away from home. Without the talented and generous staff of these two institutions, this book would not exist. My thanks also to Drs. Cheryl Jenkins and Sherita L. Johnson of the Center for Black Studies at USM for organizing a stimulating conference on Freedom Summer in June 2014, at which I obtained much valuable material. My thanks to Ursula Jones and Laurie Crowson of the Hattiesburg Area Historical Society, to Raoul and Althea Jerome, to Matt and Anna Bush and to Thomas Carter Fowlkes, great nephew of Hattie Lott Hardy. Finally, I am grateful to Dr. Aubrey Lucas for his encouragement, and to Dr. Kenneth McCarty for the permission to include previously unpublished photographs from his collection at USM.

Elsewhere in Hattiesburg, I am grateful to Ruth Cook and Ken Sewell of Molpus Timberlands for their hospitality at the old Bonhomie timber mill; area residents are encouraged to visit the site, now restored, for an

engaging window into the city's past. Chad Daniels and Christy Calhoun at the Mississippi Armed Forces Museum at Camp Shelby opened the museum to me, providing invaluable expertise in base and military history; similarly, Barbara Hamilton and Reese Powell kindly granted me access to material at William Carey University. Mike Lee at the Mississippi Forestry Commission and Robert Reams and Keith Coursey at the De Soto National Forest Branch of the United States Forest Service generously shared their knowledge and resources; their generosity is evident in the first two chapters of this book. In Jackson, Jeff Giambrone and Jim Pitts at the Mississippi Department of Archives and History helped me find original records and previously inaccessible sources, and I am grateful for their skilled navigation of the waters of the state's past.

In New Orleans, I am especially indebted to the staff and researchers of Tulane University. Not only did my colleagues extend an unprecedented level of flexibility as I worked on this book, but I am grateful for their kind support and understanding when deadlines loomed. In particular, I would like to thank Yvette Jones, Luann Dozier, Linda Peal, Matt Roberts, Pamela Palmer, Mary Sparacello and Makenzie Kozojet. I am especially indebted to the benefactors of the New Orleans Center for the Gulf South at Tulane, which generously offered me a research fellowship in 2013 to begin the research for this book. My thanks to Joel Dinerstein and Lawrence Powell, as well as to Bruce Boyd Raeburn and Randy Sparks for early and insightful conversations that improved this book immeasurably.

Before concluding this introduction, three special sets of thanks are in order. First, I am grateful to all my interviewees, formal and informal, who so graciously gave of their own personal histories to aid in the writing of this collective story. While space forbids thanking each one individually—they are listed in the bibliography—this book would be much the poorer without their insights, opinions and deep knowledge, and my only regret is that I could not include the fruits of these interviews in full. Thankfully, the Center for Oral History at USM has long pursued this kind of work; doing this research has illuminated the continued need for engagement with those who lived through these eras and who shaped them, and it has been a singular honor to hear and include the stories of many of the city's elders, including the late former mayor Bobby Chain.

Second, no one individual has influenced or improved this manuscript more than my editor at The History Press, Christen Thompson. Her wisdom, patience and skill at guiding manuscripts such as this one from conception to completion is beyond compare, and without her experienced hand on the

tiller, this boat never would have made it to shore. Throughout this process she has offered suggestions both to the story and to its telling with the eye of an artist and the hand of a surgeon; a writer could not ask for a finer editor with whom to work. Long may her glass be full.

Last, the greatest share of my gratitude goes to my family, who have supported and inspired me throughout this process in more ways than I can possibly recount and who provided encouragement, research assistance, personal knowledge, warmth and humor, and the occasional vodka tonic when the going got tough. To Toxey and Virginia Morris, Robert Morris and Sabree Hill, Ashton and Alexander Hill, John Alan and Ann Morris, John Wilson and Stephanie Morris, Suzanne and Shareen Hill, Dave and Millicent Smith, Freddie and Mary Joe Wicke and Laura Blackwell go my deepest thanks, as well as a shared sigh of relief that, for the first time in over a year, we can talk about something else at the dinner table.

As a native of Hattiesburg, the honor of writing this history has been deeply humbling. Our ancestors were not just early settlers of Mississippi, but some of the founding residents of Morriston (now Petal) in Perry County; as noted at the end of Chapter 2, if the sources consulted here are accurate, one of our direct ancestors, Francis Marion Morris, seems to have been responsible for the naming of Forrest County. But I think most of my grandparents, Toxey Montice Morris, a shoe salesman and small business owner, and Dorothy Cinkowski Morris, a nurse at the South Mississippi Infirmary first hired by W.W. Crawford himself. Residents who lived in Hattiesburg from the 1940s to the 1970s may well recall buying their shoes at Toxey's Shoe Store at 105 East Pine (and, later, 511 Main Street)—like food, water and shelter, it is a fact of life that people need shoes. Born in the early 1900s, my grandparents lived through nearly the whole of this history, and I only wish they were still with us to read this account and to have improved it with their own contributions. For them, this history would have been personal, just as it was for my grandfather when he threw the only punch that any of us ever learned about: at two Klansmen who were harassing his store. It is to them, as much to the people of Hattiesburg, that this book is dedicated.

To conclude. What happens in Mississippi anywhere happens in Mississippi everywhere, and speaking as a native, the pride that we take in our state must necessarily be matched by a full reckoning of the weight that its past bears. No history of triumph can be written without an account of struggle; no tale of victory can be savored without the taste of loss. My hope in writing this history has been that the story of Hattiesburg—with all

its hills and valleys, in all its sorrows and joys—will become better known throughout the Magnolia State, that its young men and women will have a better idea of where their own dark and deep woods come from and that knowledge of its contributions to Mississippi's history (indeed, to our country's history) may be brought on par with that of Jackson, Vicksburg, Oxford or any other town or community therein. Historians of every stripe and era concur that the culture and history of the Piney Woods are almost universally overlooked by researchers; this volume aims, as did Noel Polk's collection of thirty years ago, to redress that imbalance where possible. That said, I am delighted to take issue with Polk's claim (doubtlessly issued tongue-in-cheek) that "nothing has ever really happened here"; as with so many now, though, I only wish that he were still here, too, to sit on the porch and jaw about it a little.

One caveat, chiefly technical. For local sources, such as personal recollections or primary documents of city fathers, the vagaries of spelling and grammar have usually been corrected for readability. Where an author's original style flavors the text, however, I have left it alone. Furthermore, in certain instances, particularly at the denser phases of the city's history (its founding years, or periods of great upheaval such as World War II), different sources offer different dates for the same events, whether the construction of buildings or the arrival of troops. Most of these discrepancies are minor, no more than a year or two, and in some cases, mere months or days. In telling this story—which is primarily built on a chronological scaffolding—I have sought to use the most reliable sources available. Future researchers might well uncover more accurate dates; in the absence of Borges's coveted map, the historical record will be grateful for their kind correction. Any errors are, of course, my own.

*Benjamin Morris*
August 2014

# 1

# HATTIESBURG BEFORE HATTIESBURG, PREHISTORY-1880

## *The Prehistory of Southeast Mississippi*

Long, long before Hattiesburg, before the creation of Forrest County or the state of Mississippi; long before the United States or the presence of European colonists on the land; long before the very idea of sovereign nation-states ruled by distant monarchs and whose borders were primarily imagined, not fixed like a cliff or visible like a river; long before even the invention of paper and ink on which a people could write down their stories for future generations to remember and hold dear, guarding against the twin worms of death and forgetting; long before any of these features of the modern world we so unthinkingly enjoy, people lived on this land, made use of it as we do and left a record, however partial and mysterious, for us to examine and trace. Situated as this city is in a relative absence of major prehistoric sites compared to so many other areas of the state—Winterville, Jaketown, the Natchez Grand Village or the ancestral Choctaw birthplace of Nanih Waiya—it is easy for modern residents to forget that, for many millennia prior to our arrival, these lands and these woods were inhabited. Yet the land is full of the imprint of their activities and has its own quiet stories to tell.

Before embarking on the story of Hattiesburg itself, it is worth considering the story of Hattiesburg before there was Hattiesburg, a story that is surprisingly seldom told. Part of the reason for this general lack of awareness

of the prehistoric record of the Piney Woods is the fact that prehistorians themselves have, until very recently, barely considered it. The first professional archaeologists in Mississippi, Calvin S. Brown and C.B. Moore, did not even include the southeastern part of the state in their surveys in the early 1900s, concentrating instead on the more celebrated areas of the Mississippi River Valley, the coastal plains and the settlements along the Tombigbee River and hills. As archaeologist Robert Reams puts it,

> *Although the "Piney Woods" is a vast area covering more than 30 million acres over parts of nine states, the "Piney Woods" generally remain archeologically unknown. The reasons for this include the lack of attention by archeologists, the lack of open ground, the quick generative capacity of the vegetation (especially the understory), and the erodibility of the upland soils in the forests.*[1]

Add to these factors the highly acid nature of the soils due to the density of these pines, acidity that consumes the artifacts, bones and human remains that would have otherwise remained in a more tolerant environment, and the volume of material that archaeologists would expect or attempt to find diminishes even further. Following early neglect of the area, this trend of disinterest only continued for the majority of the twentieth century, with some archaeologists writing off the area as largely unoccupied altogether.[2] Knowledge of prehistory in the region can be said to take shape in the 1970s and 1980s, when archaeologists began to conduct studies and develop methods to characterize more fully the ways of life of these past peoples. With the increased attention to this area, the emergence of new technologies such as carbon dating and scientific excavation and a deeper understanding of prehistory along the Gulf Coast and southeastern United States generally, a clearer portrait of the past has begun to emerge.

From the time of the earliest settlement in the area to the point of European contact, a span of about thirteen to fourteen thousand years, archaeologists have outlined a series of five major phases of prehistoric peoples. The peoples of each phase had their own distinctive culture and style of settlement in the landscape, groups identified today by the tools, pottery, ornamentation, earthworks and other kinds of material culture they produced, whose collective remains preserved in the ground still allow us to form impressions of how these societies rose, fell, moved, transformed and interacted with other groups of peoples in the area. Given the distance of the past—few fields appreciate the weight of the imbalance between what

is known and what is not more than archaeology—these phases are taken as ranges, by nature overlapping, and will remain ranges only until more research is done. As archaeologist Edwin Jackson has observed,

> *Beyond basic chronology and some preliminary and quite broad inferences regarding settlement organization, present evidence remains insufficient to be very confident about any general statements regarding the basic cultural features of the prehistoric societies that occupied south Mississippi. Continued research is needed to build adequate models of prehistoric human adaptations that incorporate the range of site function variability, demography, the character of settlement systems, subsistence strategies, or the nature of social organization.*[3]

Nevertheless, characterizations of these phases are serviceable enough. The first phase began with the arrival of migrants from across the Bering Land Bridge in present-day Alaska, descending southward and settling (among many other places) in the Mississippi River Valley. This Paleoindian phase, from 11,500 BC to around 8000 BC, ends with the cooling of the global climate and the corresponding decline of the sea level to atmospheric conditions more like those of today and signals the beginning of the Archaic phase of prehistory, which lasted from approximately 8000 BC to 2000 BC. This second phase, which enjoyed a brief warming period known as the Hypsithermal, was characterized by the dominance of mobile, foraging

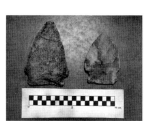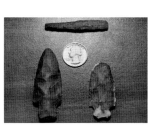

*Left to right*: (1) Two Crains, Middle Archaic period, present-day Stone and Perry Counties. (2) Three bifaces, all Late Archaic, present-day Forrest County. (3) Biface cache, probably Late Archaic/Early Woodland period, present-day Perry County. *Courtesy of Robert Reams, United States Forest Service, De Soto National Forest.*

hunter-gatherer cultures, who would rarely stay in one place for long but would instead extract resources for food and tools from a given landscape, primarily from its flora and fauna, before moving on to their next destination. In the surviving assemblages in the ground, their tools are made from a wider variety of types of stone, suggesting more mobility across the region.

These two phases would have shared cultural and technological affinities across the broader region more so than later phases, which began to see sharper subdivisions among peoples. In southeastern Mississippi and the Gulf of Mexico region—although the notions of cardinal directions or cartographic place-names would only arrive much later—the third phase marks the beginning of more finely grained distinctions between cultures. The Gulf Formational phase, from approximately 2000 BC to 200 AD, sees the emergence of specific, identifiable cultures and societies, as evidenced not just by the introduction of unique pottery (ceramic technology) to the region for the first time but also by the differing styles of that pottery, signaling different methods and techniques of producing it and therefore bodies of knowledge and lifeways. Edwin Jackson writes, "In Mississippi and Alabama, fiber tempered Wheeler series pottery is the earliest pottery now recognized, making its appearance between 1500 and 1100 BC. Its appearance coincides with the beginning of the middle Gulf Formational."[4]

Following the Gulf Formational phase is the fourth phase, which many archaeologists consider to be the peak expression of prehistoric peoples in the Gulf South, the Woodland phase, which lasted from approximately 200 BC to 1000 AD. According to contemporary archaeologists, in the modern-day Hattiesburg area, the majority of known and recorded prehistoric sites date to the Middle Woodland period.[5] Granted, terms such as "peak" must be taken with caution—without care, they can suggest that one group of prehistoric peoples was existentially or morally superior in some way to another, scarcely an assessment that can be offered—but archaeologists do concur that in the Piney Woods region, the material record does suggest that the cultures of the Middle Woodland period were more highly developed and more active presences in the landscape than their predecessors. The increased number of mounds from the period and the presence of pottery and artifacts from surrounding cultures—known groups such as the Porter, Miller and Marksville cultures from the present-day Mobile, north Mississippi and riverine and coastal Mississippi areas, respectively—indicate that residents of this area enjoyed greatly increased contact with peoples across the region and traded not just for useful implements but also for exotic artifacts such as burial items or grave goods. As archaeologist Matthew Freeman puts it,

"the Mississippi Pine Hills position at the center of a triangle formed by the Miller, Porter, and Marksville mound cultures heightens the possibility that aspects of cultural complexity in the region flowed through the environs of Deathly Silent [a Middle Woodland–era mound in east-central Forrest County] by movement of people and/or exchange of ideas."[6] Indeed, in one recent survey of this area, Forrest County was one of the only counties in an eight-county region that showed evidence of intermingling of all of those three cultures at the same time, based on the sherds of pottery that were found.[7]

Prior to reaching the fifth and final phase of prehistoric peoples, the Mississippian phase, it is worth describing in slightly more detail how these peoples used the Piney Woods, as knowledge of these practices is considerably more advanced than it was a generation ago.[8] While archaeologists had once thought that the overwhelming majority of sites were small lithic scatters—buried assemblages of worked stone artifacts in varying stages of completion, from raw stone to partially worked knives and arrowheads and axes to finished tools, often surrounded by the stone flakes produced in their construction that signal temporary workshops—it is now known that this is not the case. Thanks to modern laws of preservation and documentation, a much wider variety of sites has now been found, and the notion of the Piney Woods solely as a place of transient, mobile peoples is now being challenged.

Part of this revised conception comes from a more nuanced understanding of the idea of what a prehistoric site is. As archaeologist Robert Reams has argued,

> *Different site types with functionally and formally different contents are all part of the overall organization of the cultural system of a region. Some sites represent a resource compromise, while other sites such as special use camps may be dependent on a single resource…Sites do not just represent the direct use of an area but can also reflect unsuccessful attempts at settlements, temporary visits of an area, passage through the area from one to another, or religious activities (e.g. shrines).*[9]

In an age before modern conveniences and luxuries, places were only permanent so long as they were useful: when they outlived their use, they would have been necessarily abandoned. While it is well established that the Pine Hills of present-day Hattiesburg and Forrest County were not used for fixed settlement in the way that alluvial floodplains and coastal deltas elsewhere in the state were—this area has no large mound villages

of the kind seen elsewhere, for example—one view put forth for the types of sites that are found suggests a more provisional, use-contingent pattern. Edwin Jackson has suggested that site distribution may conform to what he calls a basecamp and satellite outpost model, in which people founded semipermanent settlements in lush, easily navigable areas such as river floodplains and then ventured into the forested uplands for hunting, stone gathering for tools and contact with other tribes. These basecamps would have lasted a season, while the outposts would have been highly temporary, some lasting as little as a few days before the materials and resources were gathered and the expedition continued.[10]

Archaeological assessments such as these revolve around the balance of the presence and absence of evidence, wherein the presence of certain kinds of evidence in the material record and the landscape is weighed against the absence of expected evidence based on other excavations and results in a given area. Both are required to paint a portrait of aboriginal life, no matter how cautious. What *is* found in the area, apart from the large proportion of lithic scatters, are pottery production centers, small informal ovens and hearths built directly into the ground, isolated mounds of modest size (though, unlike other mounds in Mississippi, containing neither burials nor purposefully deposited artifacts) and quarries for local stone where early peoples would obtain the raw materials needed to fashion their hunting and foraging tools. In the immediate Hattiesburg area, a gravel pit at Beaumont seems to have been an especially important source of local stone.[11] Tellingly *not* found are large-scale residential settlements, major burial or ceremonial mounds or mound complexes of the kind found closer to the Mississippi River, large midden sites (trash pits) that would suggest prolonged occupation in a given area or substantive evidence for sustained agricultural or horticultural development over time.[12]

From the archaeological record, then, the Piney Woods appear to be a region used by prehistoric peoples more for periodic hunting and foraging and resource gathering than for long-term, permanent habitation, but the notion, once popular, that the area was uninhabited in any meaningful way is now known to be anything but the case. They manufactured stone tools such as knives, axes, scrapers and arrowheads (with the arrival of the bow, a late development in this area), heating the local Citronelle gravels over small fires to create cleaner, sharper breaks that would lead to deadlier blades.[13] They availed themselves of the rich abundance of produce and game in the forests and streams of the area, hunting in the homogenous pine forests and gathering in the more fruitful and nutritive mixed hardwood forests, where

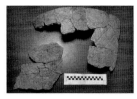 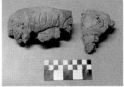 

*Left to right*: (1) Marksville Incised pot, Middle Woodland period, present-day Perry County. (2) Marksville Incised bowl, Middle Woodland period, present-day Perry County. (3) Barton Incised pot, Late Mississippian period, present-day Forrest County. *Courtesy of Robert Reams, United States Forest Service, De Soto National Forest.*

large stores of edible plants, roots, fruits and berries could be found.[14] In their homes, typically marked off by rings of posts whose holes we still read like inverse Braille letters in the land, they used domestic implements such as pottery and crude earth ovens and ornamented themselves with beads, shells and precious stones that they often obtained by trade. And when they gathered together for ceremonies or rituals such as burials or sacrifices, they did so in supplication to deities most commonly resembling serpents or birds, or other natural features, deities they then inscribed on their plates, bowls and other precious *objets d'art*.[15]

Interestingly, after the Woodland period, when this kind of activity was at its peak, it appears that communities in the Piney Woods began to abandon the upland woods in large numbers, moving instead to the more agriculturally amenable alluvial floodplains and coastal deltas such as the Pascagoula River basin, where they began to grow staple crops such as maize. In this fifth and final phase of prehistory, the Mississippian phase (1000–1700 AD), the number of sites in the modern-day Hattiesburg era drops considerably, down from about 40 percent representation in known sites to about 10 percent.[16] Archaeologists concur that, ironically, despite being closer in time to the historic era of European contact and written records, our understanding of the Mississippian phase is in some ways more limited than that of others. The irony stems from the fact that, as Robert Reams has argued, our understanding of Mississippian cultures generally is so highly developed, given the number, density and quality of sites elsewhere in the state and the Mississippi River Valley. "Although the Mississippian period is probably the most well understood of the Southeastern culture history sequence," he writes, "in southeastern Mississippi little is known about the period except on the Gulf Coast."[17] Edwin Jackson echoes this point:

*While significant population concentrations are well documented along major river valleys, Mississippian occupation of the Leaf River and Chickasawhay drainages and adjacent uplands appears to have been limited to small farmsteads or temporary camps. No large Mississippian sites or sites with mounds have been reported…Sites appear to be transitory or special purpose camps, with single or only a small number of vessels represented in shell tempered samples. Sites in the Pine Hills are all in close proximity to "fairly large streams with wide terraces"…[which] could reflect agricultural use of the broad bottoms or else simply the use of larger drainages as transportation corridors.[18]*

Unfortunately, then, with comparatively fewer sites and artifacts in this area, there is less material from which to draw conclusions or even inferences. At the time of European contact in the early 1600s, the only surviving group of Mississippian-era Native Americans in the Piney Woods area were the Natchez, who, despite extensive contact and trade with the French along the Mississippi River, were destroyed after a violent series of conflicts in the early 1700s at Fort Rosalie, now modern-day Natchez.[19] The remnants of this tribe were either scattered or absorbed into the more dominant Choctaw and Chickasaw populations in the north and central parts of the state. With respect to southeastern Mississippi and the area that would become Perry and Forrest Counties and eventually Hattiesburg, prehistory had come to an end. As archaeologists John Blitz and C. Baxter Mann put it, by the mid-eighteenth century, this part of the state was "largely devoid of resident native inhabitants, serving primarily as a foraging territory for interior Choctaw groups."[20]

Today, Native American heritage in the greater Hattiesburg area lives on in its numerous place names, which are derived primarily from Choctaw words for natural features or descriptions. According to ethnolinguist Keith Baca, the name for Bogue Homa lake and creek in nearby Jones County comes from the Choctaw words *bok* (creek) and *homma* (red). The Tallahala Creek, passing within a few miles of Hattiesburg near Petal, draws its name from the Choctaw words *tvli* (rocks) and likely *hieli* (the plural form for the verb to stand), which translates to "standing rocks," or on another interpretation, "smooth rocks." And the beloved Okatoma Creek just north of Hattiesburg, a popular destination for summertime canoeists and kayakers, comes from the Choctaw word *oka* (water) and either the words *tomi* (to shine) or *oktohbi* (foggy), both apt descriptions of this beautiful waterway.[21]

Even with the discoveries of the past generation of research, our knowledge of the prehistoric Hattiesburg area is by no means complete. Far

from it. Prehistoric sites are now known to be far greater in number than early assessments first surmised: as of this writing in 2014, United States Forest Service archaeologists have recorded approximately 4,300 sites on over 383,000 acres on federal lands in the De Soto National Forest and surrounding area, and those are just the known sites. Sites are discovered with each new clearing and development on public and private land alike, yielding an even greater understanding of the age before written records, when the stories that we now learn of the past were first preserved in bone, wood, clay, earth and stone, and the voices around communal fires were once overheard only by the winds.

# Mississippi: From Colony to State

After the arrival of European colonists, the area that would become Mississippi and, ultimately, Hattiesburg remained in a constant state of flux. In the era in which European interests and conflicts on the continent were often played out on colonial shores, scarcely a decade went by in the 1700s during which the land in this area did not see a differently colored flag. Part of the reason for this was the early valuation of the strategic natural resources and landscape that was attractive to any imperially ambitious power seeking a foothold in the New World: despite the oppressive conditions of heat, humidity and disease, the Gulf South region afforded a wide variety of navigable seaways, natural harbors and inlets ideally suited to an age of naval exploration, wide rivers that promised untold commercial bounty, and on land, rich stores of timber and livestock that would sustain a colonial economy. As early as 1699, Jean de Sauvole, second in command to Pierre le Moyne, Sieur d'Iberville (leader of the expedition that founded the French colonies in the area), noted the usefulness and the "prodigious size" of the trees of the Gulf Coast region while stationed at the fledgling fort in Ocean Springs. The westward-looking greed of the colonial powers thus comes as little, if any, surprise.[22]

That hunger for resources and power would ensure that in nearly every major conflict of that era, some portion of the Gulf South would change hands. The list of conflicts, treaties, disputes and cessions reads almost like a doubles tennis match that lasted for the better part of a century: though the French had held on to the area as the first major colonial power and had brokered the early encounters with the Native American tribes of the region,

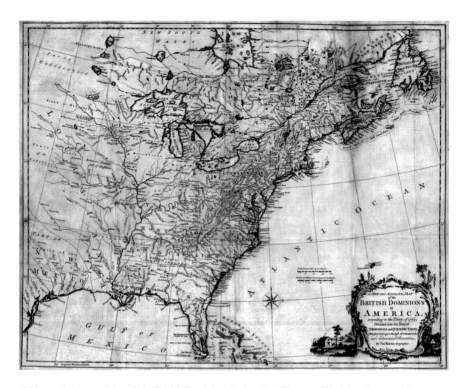

*A New and Accurate Map of the British Dominions in America.* Thomas Kitchin, circa 1763. Historical Map Collection, Reference# MA/86.0006(c). *Courtesy of the Mississippi Department of Archives and History.*

their influence came to an end after the Seven Years' War of 1754–63 (a global conflict misleadingly called the French and Indian War in the United States, misleading in that within the North American theater, the French and Indians were allies against the British). After a string of early victories, the French suffered decisive defeats by the British, including the fall of Montreal and Canada, which would complete the British expulsion of French Acadiens to Louisiana and lead to the birth of the Acadian, or Cajun, culture. In the first treaty to follow this war, the 1762 Treaty of Fontainebleau, Louis XV of France gave his holdings in Louisiana to Charles III of Spain in gratitude for their alliance—a period that would prove pivotal in New Orleans history, wherein Spanish architects rebuilt its famous French Quarter after devastating fires into what we know it as today.[23] The following year, in the 1763 Treaty of Paris, France ceded the rest of its colonial American territory to the victorious British, making Great Britain the dominant colonial power on the North American continent, with a nervous Spain watching its every

move. In the future Mississippi area, the British used their gains in this treaty to create the province of British West Florida through the acquisition of land from the 32°28' line of latitude south to the Gulf of Mexico.

British settlers moved into the area, primarily to the regional settlements along the coast such as Pensacola and Mobile (whose name they changed from the French Fort Condé to Fort Charlotte), until a decade later when the American Revolution broke out in 1776. While the Gulf South theater was nowhere near as central to that war as was the Atlantic seaboard—at this time, most southern territories were still Native American controlled and unorganized by colonial powers—the region did see significant action. Midway through the war, joining forces with its old rival, France, Spain entered the conflict against the British, hoping to curtail their dominion and further establish its own foothold in the region at the same time. Swiftly the Spanish pressed the attack and captured important British garrisons in Baton Rouge and Natchez in 1779, Mobile in 1780 and Pensacola in 1781, leading ultimately to the cession of British West and East Florida to Spain in the 1783 Treaty of Paris that ended the war. At the close of that long and bloody conflict, the Americans had gained their independence from Britain but had also acquired (or re-acquired) a new, victorious neighbor in their backyard.

The area that would become Mississippi was still not formally fixed. The northern boundary of Spanish West Florida had been left unresolved after the war, and in a twist of history, a considerable portion of this area enjoyed a brief stint as part of the colony of Georgia, as part of the land grant of its original charter. Recognizing the tension this would create, federal commissioners now under President George Washington pressured Georgia governor George Mathews to dissolve the claim. After a generous settlement, dissolved it was, but the area would remain in dispute until the 1795 Treaty of San Lorenzo (also called the Treaty of Madrid, or Pinckney's Treaty), in which the United States negotiated for all the Spanish lands east of the Mississippi River between the thirty-first parallel and the extant boundary of 32°28'. Spain, suffering tremendous economic difficulties at home, including a massive war debt and little viable plan for continued settlement in the area, was only happy to unshelve its burdensome holdings, as well as to stave off any further Anglo-American pacts after Jay's Treaty the previous year that might threaten their other colonies. Three years later, in 1798, the federal government organized the Mississippi Territory out of land obtained from that treaty, a territory that comprised most of modern-day Mississippi and Alabama, with Winthrop

Sargent as its first governor.[24] Colonially, the ball had been played in all four corners of the court, in both singles and doubles play: Mississippi had been French, Spanish, British and Spanish again—and now, finally, it was American. And American it would stay.

But not without continued contention. Prior to statehood in 1817, a further two decades of conflict and change would ensue. The first change was regional, with the Louisiana Purchase of 1803: when the United States bought the remaining colonial holdings of France west of the Mississippi River, doubling the size of the country, the major factor catalyzing the newly formed territory's growth was the permanent opening of trade with New Orleans. That the river and the port controlling its mouth were now firmly in American hands did more—as the historian Lawrence Powell, among others, has noted—to drive demographic and economic growth in the Gulf South than almost any other event of that era. Arguably, it would become the defining factor of the next century, up to, during and even after the Civil War: for the first Mississippians who clustered along the river (primarily in Natchez) and the coast, New Orleans ensured trade, markets and labor for the crops, goods and products that were now being produced all along the region.

Unresolved, however, were matters with the Native Americans, who lived in those areas still unbroached by white settlement, and a series of treaties in the early 1800s led to the rapidly accelerated removal of native peoples from inland Mississippi counties and the opening up of land for white settlers. When not accompanied by outright bribery or coercion, frequently at the end of a bottle of whiskey to which the natives had little to no tolerance, these treaties were often signed at the point of a barrel. Especially after the disastrous Creek War in Alabama, in which then-colonel Andrew Jackson's defeat of the Creek tribes established a grim precedent for any others who would forcibly resist American presence, treaty after treaty cemented the young American government's desire for viable economic investment in land, agriculture (namely cotton) and taxation in its southwestern territories.[25]

Of the major treaties, the Treaty of Mount Dexter (1805), signed with the Choctaw, was the first, after which followed the Treaties of Doak's Stand (1820), Dancing Rabbit Creek (1830, the largest land cession by a Native American tribe in history) and Pontotoc Creek (1832), all of which together led to the removal of the communities that had called these lands home for thousands of years, the creation of the reservation system and the relocation of almost the entire Choctaw and Chickasaw nations to territories farther west such as Arkansas and Oklahoma. By the

1840s, this process of relocation was largely complete. Of this process, historian James Barnett has observed that:

> *The removal of the Mississippi tribes accomplished the crucial objective envisioned by the Thomas Jefferson administration some thirty years earlier. Without the use of military force, a combined Indian population of almost 20,000 had surrendered their homeland and voluntarily left the state. Despite the absence of gunfire, the United States did not win its victory without bloodshed, for hundreds perished from smallpox, exposure, starvation, and dysentery.*[26]

Even amid that process, conflict continued in forms both minor and major. Following the revolt and skirmish over the short-lived Republic of West Florida in 1810 and the annexation of coastal counties to the Mississippi Territory in 1812, the British returned to American shores that same year seeking to reclaim their lost colonies; when the dust finally

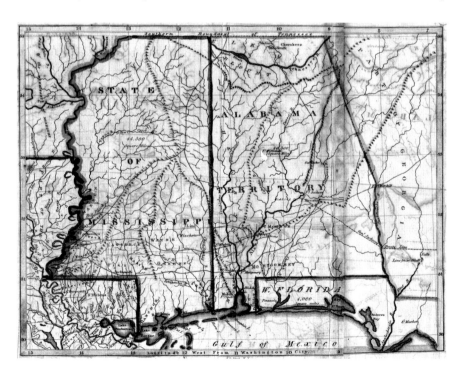

*State of Mississippi and Alabama Territory* (circa 1817). William Darby, (New York: J.D. Stout). Historical Map Collection, Reference# MA/94.0012(a). *Courtesy of the Mississippi Department of Archives and History.*

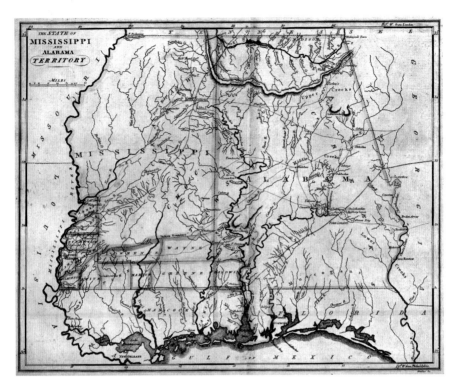

*The State of Mississippi and Alabama Territory*, 1818. Matthew Carey. Historical Map Collection, Reference# 87.0007(b). *Courtesy of the Mississippi Department of Archives and History.*

*Opposite: Louisiana and Mississippi*, 1820. Henry Schenck Tanner. Historical Map Collection, Reference# 87.0006(c), *Courtesy of the Mississippi Department of Archives and History.*

settled in 1815 with the Americans' second victory and the retention of their national sovereignty, it was clear that the new territories of the young republic would not remain mere territories much longer. In early 1817, President James Monroe authorized the creation of a constitution for the people of the territory, and after a convention that summer, the articles were drawn up. To resolve a dispute over its boundaries, Congress drew a line dividing the territory vertically in half, and the area west of the line became Mississippi.[27] Its capital was Natchez (soon to move to Jackson in 1822); its interior was unsettled; its economy was agricultural and slave-driven; and the magnetic pull of economic opportunity on those coming from the north and east was nigh irresistible. But as of December 10, 1817, Mississippi was a state.

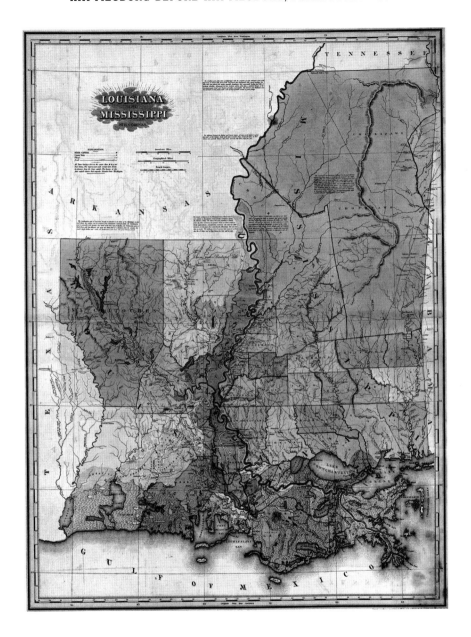

## Settling the Area: Statehood to the Civil War

Though Hattiesburg would still not come into existence for another seventy years—its founder would not even be born until 1837—it is worth touching on what life in this area of the state was like during those years, to set the

stage for what life would be like when the city was finally founded and to illuminate how it grew out of the ashes of the Civil War and Reconstruction, the dominant political force that shaped all of Mississippi (and the South) in the postwar period. After 1817, the years between statehood and the Civil War were characterized predominantly by pioneer living: clearing land, farming, raising livestock and building rudimentary houses and communities in the midst of a still-expansive wilderness. As writer Mark Olderr characterizes it,

> *In the area that would become Hattiesburg, there was not much economic activity going on in the 1830's or 1840's. Clearing land for agriculture and eking out a living through farming supplemented by hunting and fishing was a typical lifestyle for those residents hardy enough to make it there. Lumberjacks of the day used primitive tools and transportation to get the lumber to market. It was simple brawn against an ocean of leviathan-sized trees.*[28]

Yet early explorers had begun to brave that ocean, and the subdivision of land in southeast Mississippi reflected their forays and the need for better organization and mapping of the terrain. Pressured by local agents to recognize the increasing number of land claims in the area, federal authorities relocated the land office from its former location at Fort St. Stephen's north of Mobile, Alabama (a holdover from the days in which the two states comprised a single territory), to a location much closer to the emerging claims—a relocation that would serve to spur the growth of the county over the next decades. As historian Andrew English explains,

> *On May 18, 1819, the U.S. land office was officially established at a remote site on the Leaf River. On February 3, 1820, Perry County* [named for Commodore Oliver Hazzard Perry, naval commander in the War of 1812] *was created out of the lands that had formerly constituted Greene County, Mississippi. The seat of government for Perry County was conveniently located near the new U.S. land office and the village of Augusta emerged as the government center for the isolated Piney Woods. The proximity of the government land office served as a catalyst that drew in more pioneers seeking lands and journeymen seeking to establish their trades in and around the new county.*[29]

The first settlement in what is now Forrest County was the homestead of Malcolm McCallum, who moved to the area with his family to raise livestock and farm the land. Like McCallum, many of these pioneers eventually gave

their names to local communities—such as Glendale, Eaton and Monroe—
that have long since been absorbed into larger towns and cities in the area.[30]
At the time, however, Lowry and McCardle's history of Mississippi notes that
the earliest settlers barely numbered in the dozens and that their settlement
followed the plan of the major rivers in the area. They write:

> *There were many difficulties to contend with in the early settlement of the county,
> and boys in their teens cheerfully assumed their share of pioneer hardships.
> Reuben Hartfield, a boy of fourteen years of age, rode an Indian pony from
> Perry county [sic] via St. Stephens to the Chattahoochie river in Georgia, alone
> and without a guide, following Indian trails, and when necessary, swimming
> rivers and creeks. Alexander McKenzie moved his household goods from North
> Carolina to Perry county, in a hogshead made of oak, with an iron axle and
> drawn by one horse. Robert Chaney established the first cattle ranch in the
> county on a creek that now bears his name.[31]*

Land and livestock husbandry were principal indicators of wealth. Lowry
and McCardle note that Perry County, with its county seat of Augusta, was
"especially adapted to the raising of sheep and cattle. Not less than one hundred
citizens own each over one hundred head of sheep, besides cattle in proportion.
Ten or more persons, own each, not less than five hundred head, and two or
three persons own each over one thousand head of sheep. Two or three persons
in the county own each over five hundred head of cattle."[32] To echo the point,
historian Grady McWhiney notes that federal census data

> *confirm the observations of contemporaries that herding was the basic
> activity throughout the Piney Woods. In 1840 no fewer than twenty-five of
> the thirty-two counties of southern Mississippi (those south of the thirty-
> third parallel) contained more than four times as many beef cattle and hogs
> as people. Greene and Perry counties had thirteen times as many cows and
> pigs as people; Jones and Smith counties nearly eleven times as many. In
> 1850, although more people had moved into the Piney Woods, twenty-three
> of the thirty-two counties of southern Mississippi still contained more than
> four times as many beef cattle and hogs as people.[33]*

For modern readers who are accustomed to the idea that Mississippi is and
has always been part of the American South, it is critical to remember that
in its earliest days, the notion of the South had not yet been fully formed.
Rather, Mississippi and Alabama were known by the earliest settlers as the

"Old Southwest," with all of the contingencies of life that to the modern ear the "Old West" evokes.[34] Certainly, these small homesteads and trading posts had begun to settle the area, as evidenced by institutions such as Providence Baptist Church near Eatonville (several miles northwest of William Hardy's chosen site, discussed in Chapter 2).[35] The church dates to 1818, only a year after statehood, and was originally a log cabin with a simple pitched roof that was home to eight members who moved there from Georgia. But in the main, with the exception of the coastal and riverine counties, the interior of Mississippi was largely untamed. One traveler to Perry County in 1838 observed:

> *The population...is small in proportion to the square miles; when this part of the county was brought in to market it was settled with astonishing rapidity, and in a very short time became very populous; a few years, however, served to convince its inhabitants of the uncertainty of their prospects; and the extraordinary inundation of the lands, together with the opening of a new purchase...from the Choctaw nation of Indians, caused the tide of immigration to flow as rapidly from the county as it had previously done towards it.*[36]

The suggestion that the population was "small in proportion to the square miles" was made vividly clear by another visitor traveling through Perry County a few years later. In a moving description of a journey through southeast Mississippi in the summer of 1841, Colonel John F.H. Claiborne, an editor at the *Natchez Free Trader and Gazette*, wrote a celebrated account of his voyage through the thick, unpopulated forests of the pine belt. Having crossed the Leaf River on his way toward the fledgling settlement of Ellisville in present-day Jones County, he wrote:

> *This county is thinly settled and adapted chiefly to grazing. It is intersected by large creeks that afford fine water power, more than two-thirds of the land yet belongs to the government and will not be entered for years to come at present prices. Much of it is covered exclusively with the long leaf pine; not broken, but rolling like the waves in the middle of the great ocean. The grass grows three feet high and hill and valley are studded all over with flowers of every hue...The unbroken forests abound with game. The red deer troop along by dozens; for miles the wild turkeys run before you in the road; and the sharp whizzing of the startled partridge is constantly on the ear. But for this panorama of life, the solitude of a ride through this region would be painful. The houses on the road stand from ten to twenty miles apart; the cheering mile posts and the gossiping traveler are seldom*

*met with; the armless pines look gaunt and spectral and fall sadly on the soul. At night-fall, when the flowers have faded away, no fireflies gem the road; you hear no tinkling bell; the robber owl flaps by lazily on the wing; fantastic shadows, like trooping apparitions, chase each other into settled gloom; and instead of the "watch dog's cheerful cry" the "wolf's long howl" comes up from the adjoining reed-brakes and is echoed back by the strolling companion on the neighboring hills.*[37]

When settlers were not facing drought, floods, blights, illness and infectious disease, they had other fears to contend with—one another. Easily the most famous account from early Perry County is of James Copeland, a brigand, murderer and career criminal who, since the early 1840s, had terrorized much of southeast Mississippi and the Gulf Coast with his "clan." While truly authoritative accounts of his exploits are impossible to come by, the manuscript that survives of his "confession"—a celebrated, if at times fanciful and overwritten, document ostensibly taken down by the sheriff present at his execution in Augusta—is enlightening for what it reveals of life in the 1840s and 1850s in south Mississippi. Towns such as Augusta, Biloxi or Mobile were commercial centers and trading posts for settler communities and the remaining Native Americans alike, but outside of those areas, hardscrabble subsistence living by families and small communities was met by a rudimentary legal and criminal justice system: settlers were frequently forced to defend themselves from frequent attacks, animal and human, on their land.

Copeland, who had finally been arrested in 1849 in Mobile after a decade spent in theft, arson, impersonation and murder, was eventually captured by Mississippi authorities in 1853. Imprisoned for the next four years in Augusta and Jackson, in 1857, he was finally sentenced to hang by a Perry County jury (on which settler Malcolm McCallum, interestingly, served). After his death, which was allegedly attended by thousands, a story quickly arose that his remains were secretly exhumed and put on display. As historian John D.W. Guice observes,

*The Copeland mystique persisted with astounding vitality in the piney woods and coastal counties. The Perry County file includes a gory account of the disinterment of Copeland's corpse and the alleged assembly of his bones into a skeleton subsequently displayed at a drugstore...Depending on which version of the myth one encounters, the skeletal remains were displayed in Hattiesburg, Moss Point, or other Mississippi towns.*[38]

A tantalizing, if historically unhelpful, note in the sheriff's account itself, dated 1909, suggests that:

> *To bear out the statement of the author where he says the body of Copeland*
> *disappeared from the grave a day or two after burial, Mr. Dan McInnis,*

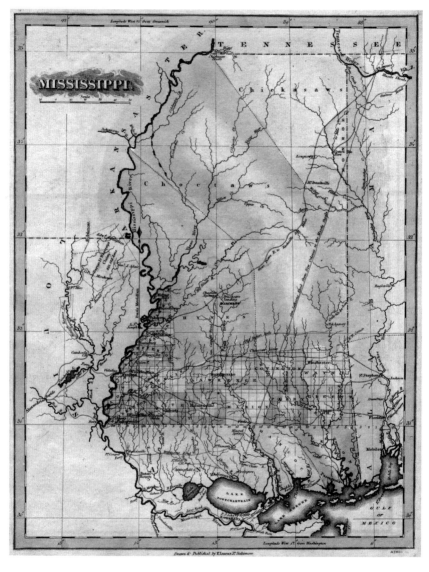

*Mississippi* (circa 1823). Lucas Fielding. Historical Map Collection, Reference# MA/92.0062(a). *Courtesy of the Mississippi Department of Archives and History.*

*of Hattiesburg, Miss., stated to the writer not long ago that he and the now lamented Dr. A.M. Dozier, also of Hattiesburg, in later years, got in possession of Copeland's skeleton and kept it on exhibition at their drug store for some time, hundreds of people flocking to see it, and during the time it was in their possession a party from Alabama came to Hattiesburg and offered him $500 in cash for it, but the same was refused; however, some time after this, the skeleton disappeared, and has never since been seen.*[39]

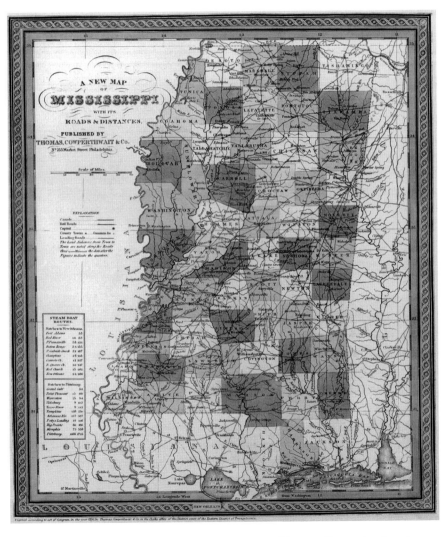

*A New Map of Mississippi with Its Roads and Distances*, 1850. Thomas, Cowperthwait and Co. (Philadelphia). Historical Map Collection, Reference# MA/88.0005(a). *Courtesy of the Mississippi Department of Archives and History.*

Even in times of relative peace, however, progress was slow, and settlement, commerce and transport typically followed the waterways of the Pascagoula River drainage basin, which in the Perry County area largely followed the Leaf River, which begins in Scott County and flows due south before making a southeastward turn. At this turn, the tributaries that drain into the Leaf like tines on a fork include the Bouie River, Tallahala Creek, the Bogue Homo and Thompson Creek, all of which eventually drain into the upper Pascagoula River, which ends in the Gulf of Mexico. Even despite the famous "Flush Times" in Mississippi of the 1830s forward, driven largely by high cotton prices and the slave economy, population growth in the southeastern part of the state lagged far behind other regions. Historian Nollie Hickman notes that the increase "for Perry [County] from 1820–1860 was 569 people; for Greene, 787; and for Wayne, 368."[40] Historian James Fickle explains the challenges: "Farming [in the Piney Woods counties] was risky and hazardous, and on the hills large-scale cultivation was impossible. Large numbers of farmers looking for better land moved northward following the removal of Native Americans from middle and north Mississippi."[41]

Even if one takes these numbers as a minimum, given the prevalence of itinerant travelers, backwoods individualists and those individuals who avoided or never appeared on a census roll, the figures are still remarkable: in the period between statehood and the Civil War, the area that would give rise to Hattiesburg only grew by a rate of about fourteen people per year, or just over one new inhabitant per month for four full decades. In retrospect, compared to other counties in coastal and riverine areas, and certainly to its later growth, it seems remarkable that the area was settled at all.

## The Civil War and Reconstruction

But settled it was, and during those intervening years, the story of pioneer families moving to the area was as much a story of state and nation building as it was the story of individual farmers, frequently of Scottish and Irish descent, seeking to establish their fortunes. And throughout the state, those twin projects often hinged on the system of slavery that, up to that point, had made the South in general, and Mississippi in particular, simultaneously wealthy off the backs of those enslaved individuals and the locus for tensions that, like a pot on a hot stove, were bound sooner or later to boil over.

Tensions had been running high for a generation. That same forty-year period between statehood and the outbreak of the Civil War reads like a litany of one event after another that threatened to imperil, if not sunder, the union that had been formed just a few precious decades earlier: the Missouri Compromise, in 1820; the nullification crisis in South Carolina, in 1832; the *Amistad*, in 1840; the Fugitive Slave Act and the Compromise of 1850 in the same year, the latter of which staving off the specter of secession if only for a time; the Kansas-Nebraska Act of 1854, giving the country its first taste of violent, protracted civil conflict; and the *Dred Scott* Supreme Court decision in 1857, a horror to abolitionist hopes and the partial impetus for John Brown's raid on Harpers Ferry in 1859—an act of insurrection that put the entire landowning South on guard and led to the formation of Southern militias, proto-Confederate troops, expecting similar incursions from radicals from the North.

Finally, as if these mounting incidents were not enough to quell fears of open rebellion, in 1860, a candidate who was not even on the ballot in most Southern states, Mississippi included, was elected president. Abraham Lincoln's election was anathema to the ruling class of white landowners in the South who refused to allow a president they had never elected to dictate their way of life from afar and only served to cement their resolve to defend their individual states' rights and the institution of slavery those rights theretofore protected. South Carolina, picking at an old scab from thirty years earlier, was the first to secede; after a turbulent, breakneck convention in Jackson following Lincoln's election, on January 9, 1861, Mississippi followed suit.

Contrary to widespread belief, the decision was not universally popular across the state. Historian Chester Morgan has noted that resistance to the Confederacy ranged from the northeastern hills to the coast; as Timothy B. Smith has recently shown, it was not even universally popular among those legislators making the decision.[42] Prior to secession, many Mississippians had hoped for compromise or delay, but to no avail: the most ardent secessionists knew that the chances of a successful confederacy hinged on the swift assent to the project by as many other states as possible. In state, pockets of dissent existed from the Delta to the coast, across economic and racial lines, and would remain throughout the war. In the Piney Woods, where the populations of slave owners and slaves alike were lower than the surrounding regions (indeed, nowhere near the levels of political epicenters such as Jackson and Natchez), historian Victoria Bynum has shown that Jones, Covington and Perry Counties fell well below state average.[43] The yeoman farmers and

settlers of the area, tied far more to field crops, orchards and livestock than they ever were to King Cotton—which was less conducive to the area than to the fertile soils of the old river counties or northeastern prairie—were by no means guaranteed to rally wholesale behind the cause. Rather, they were more interested in personal and familial survival first, and societal and state welfare only after that had been secured. Such a view illustrates the complexity not just of southeast Mississippi but of much of the rural South: the desire to defend one's land and holdings did not necessarily equate to the desire to uphold the institution of slavery or to advance the notion of secession, two separate ideas in any case.

On average, however, the Confederate cause was more popular than not, especially once war did break out and in the first years of the conflict, when morale, troops, supplies and victories still ran high. War did not come quickly to Mississippi, but when it came, it came and stayed and made itself a home. As historians Andrew English and Robert McSwain Jr. have observed, the counties of south Mississippi produced a number of regiments in the first two years of the war, with Perry County alone yielding around five companies of approximately eighty men each. These regiments were quickly mustered into larger battalions of infantry and cavalry and served both as state guards and as part of the armies of the western front under Generals John Pemberton and Albert Sydney Johnston. The majority of these regiments would see continual action until the end of the war, fighting in dozens of battles from minor skirmishes to grand sieges and conflagrations in Tennessee and Georgia.

On a national level, once the major campaigns were underway, Mississippi quickly became a focus for two main reasons: control of the Mississippi River, not only a border but also a highway for troops and supplies traveling north and south, and the state's extensive railroads, which served the same purpose traveling east and west. The first major encounter on state soil came immediately after the Battle of Shiloh in Tennessee in April 1862, when Union generals Ulysses S. Grant and Don Carlos Buell defeated and pursued Confederate general P.G.T. Beauregard to the critical rail crossing at Corinth, Mississippi, the junction of the Mobile and Ohio (north–south) and the Memphis and Charleston (east–west) lines. After abandoning Corinth without a fight—the battle there would not take place until October of that year—Confederate forces pulled back into the interior of the state, leaving the northern part of Mississippi firmly in Union control.

The next phase of conflict saw Grant's daring plan to take Vicksburg, the seemingly impregnable fortress over the Mississippi River and the city that

Confederate president Jefferson Davis famously called "the lynchpin that holds the whole of the Confederacy together." After his first unsuccessful attempt in late 1862 to take the city overland from the northeast, with General William Tecumseh Sherman's advance repulsed by Confederate forces, Grant then crossed the Mississippi River north of Vicksburg and cut a road over one hundred miles through Madison Parish, Louisiana, to reappear south of the city and its fortifications. He then re-crossed the river and crawled back up into the Mississippi interior. After first taking the state capitol at Jackson (and sending the state government, then under J.J. Pettus, into exile in Meridian), Grant then laid the infamous siege of Vicksburg. At the same time, Colonel Benjamin Grierson would draw Confederate forces away from Grant's main army by conducting a raid south across the heart of Mississippi, leaving a trail of destruction, pillage and demoralization from the northwest corner of the state down to Baton Rouge.

Vicksburg fell on July 4, 1863, the day after Robert E. Lee's devastating defeat at Gettysburg, Pennsylvania. Though Mississippians, and Confederates generally, did not yet know it, that week would serve as the turning point in a war that, until then, had seemed to go the Rebels' way. But it was nowhere near the end yet: for residents across the state, the Piney Woods included, the war would continue in novel and surprising ways. Apart from federal troops manning the naval blockade along the coast, the closest major force of troops to traverse the present-day Hattiesburg area was Grierson's column, which passed within seventy-five miles of the site both at Garlandville to the north and again at Brookhaven to the west before swerving southwest again toward Louisiana. But several lesser-known incidents also took place in Perry County that would expose local residents firsthand to the hardships of war. Again, they involved the railroads, those life-giving arteries of troops and supplies. As historian Andrew English and official accounts of the war observe, on two separate incidents, Union commanders sent forces through the Piney Woods toward Alabama in order to cut the lines of the Mobile and Ohio Railroad.[44]

The first took place during the siege of Vicksburg in June 1863, when all available troops in the surrounding area had been called north to help defend the city. As English records, a small company of cavalrymen from the 5th Illinois rode east from Rodney, Mississippi, toward the railroad line, pushing through the dense stands of trees until a band of Confederate forces, who had been tracking them along the way, ambushed them just outside of Ellisville in Jones County. Troops under First Lieutenant W.M. Wilson of the 43rd Tennessee Cavalry surprised and overwhelmed the Union detachment

and captured the whole company, leaving four dead and five wounded and taking their captive prisoners to Jackson.

The second incident came late the next year, long after the fall of Vicksburg and Gettysburg, when Union troops under Brigadier General John Davidson attempted the same basic mission—to disrupt the supply line of the Mobile and Ohio Railroad and thereby prevent any reinforcements to Confederate troops waging a defensive action against General Sherman's devastating march through Georgia to the sea. Davidson's column of five thousand troops marched east into the Piney Woods from Louisiana, skirmishing with local Confederate companies and raiding the nearby towns in the present-day Hattiesburg area—Columbia, Monticello and Enon—before finally arriving in the county seat of Augusta on December 7–8, 1864. As historian Robert McSwain records,

> *When the Union Army arrived at the Leaf River, they could not cross it as the ferry had been sunk. The army fired warning shots into the town of Augusta. The men called out, "If any woman is brave enough to come out with a white flag, we will cease firing." Mrs. Rebecca Lewis, wife of John Lewis, fastened a bed sheet to her broom and waved it, and the firing ceased. The army set up headquarters at the Carter-McSwain place on December 8, 1864. The next morning, on December 9th, the Union troops pulled out of Augusta only after killing off the livestock and stealing the townspeople's valuables.*[45]

With their prize in sight, a Union cavalry detachment under Lieutenant Colonel Asa Gurney sped ahead of the main column to try to cut the line at Leakesville, Mississippi, but was again stopped in its advance by Confederate forces in the area. Rejoining Davidson's main column, which had left Augusta the morning after it arrived for the southeastern part of the county, the reconsolidated Union battalion pressed on southward down the banks of the Pascagoula River to the Gulf of Mexico, where they were retrieved by Admiral David Farragut. The railroad line was preserved, but in a matter of mere months, it would hardly matter: in April 1865, Robert E. Lee would surrender the Army of Northern Virginia at Appomattox Courthouse and conclude the fading hopes of the Confederate States of America.

The war was not confined to campaigns or skirmishes, however. More so perhaps than any other war in American history, the Civil War was fought in the hearts and minds of those individuals and families its torrent caught up, and it led to heated, often deadly, altercations far behind the action of

the front lines. Alongside those battles just described, another kind of war was taking place deep in the Confederate states, a war of allegiances whose combatants faced the keen edges of hunger and homesickness just as much as that of the bayonet. By the middle of the war, desertion had become a major problem for Rebel armies, particularly in Mississippi, where crops lay fallow and families distraught, and where, despite early Confederate conquests at places such as Fredericksburg, Chancellorsville and Bull Run, the string of Union victories from 1863 onward demoralized the Rebel troops. Regular calls from wartime governors J.J. Pettus and Charles Clark for fresh conscripts, combined with furloughs that were far too short for most soldiers' liking, further exerted a drain on manpower and willpower, and by late 1863, the state government was sending regular detachments of guards to round up deserters and return them to active duty.

The situation was exacerbated by growing local sentiment toward and collaboration with the Union from the river to the coast, especially as the war drew on and federal forces leveraged increasing control over goods, currency, transportation and arms. In the Piney Woods, never the hotbed of pure secessionist sentiment as popular notions imagine, multiple outfits of pro-Union (or merely anti-Confederate) marauders launched raids on homesteads and livestock, some using deadly force.[46] By far the most famous were the ragtag band of Confederate deserters and Union sympathizers led by Captain Newton Knight, whose alleged "Free State of Jones" in Jones County has for nearly 150 years inspired fable, legend, embellishment, adulation and vilification in equal measure. The story of the brilliant, daring, Robin Hood-esque figure of Knight leading his local insurrection against the ideology and forces of his home state—a rebellion within a rebellion, as it were—continues to capture the attention of those seeking to understand the complexity of the war in the South, and even today inspires historical investigation, novelistic treatments and even feature films dramatizing the events.[47]

Regardless of how much of the Free State story is true—in this case, history might never separate the wheat of truth from the chaff of rumor, hearsay, opinion and lie—what *is* true for all residents of southeastern Mississippi in those years are the tales of deprivation and struggle for survival. Free, slave, male, female, adult and child alike felt the losses of war, the pangs of hunger and, increasingly, the cold fear of a lawless society. According to historian Timothy B. Smith, G.W. Bradley, the sheriff of Perry County, once wrote to wartime governor Pettus that to attempt to collect taxes from his constituents would be a life-threatening activity, so destitute and desperate were the people. These conditions, exacerbated both by crop failures in 1864

and the punitive measure, reviled even by loyal Confederates, of the tax-in-kind system (whereby officials could seize food, goods and livestock as payment for taxes owed to the state or Confederate government) led to a dire economic situation across the entire region. This situation was what soldiers whose regiments had surrendered or been captured found on their return home, regiments such as the 27th Mississippi Infantry, Kennedy's Guards, after its seven-hundred-mile walk home from where it had been paroled in Greensboro, North Carolina. With the combined defeat of the Confederate armies and the devastation of the Southern landscape and economy, the recovery after the war would be years in the making.

Despite the peace imposed by Union forces, the period of Reconstruction that ensued was anything but peaceful. While modern historians continue to explore the many facets of the period between 1865 and 1876—when Rutherford B. Hayes defeated Samuel J. Tilden in the electoral college for the presidency, ending a period of Northern interest in and support for Southern states—it is indisputable that the era was marked by continued hardship, repression and injustice across the South. In Mississippi, the last state to formally reenter the Union in 1870, the land itself had been ravaged by war and required extensive care to return it to health and profitability. As historian Patt Roberson records,

> *Agriculture, especially the old standby cotton, was counted upon for postwar economic recovery. But several natural disasters and a poor market caused farmers to diversify into cattle and grain. Though conditions began to improve, still many farms and plantations were lost for nonpayment of taxes. Mississippi historian Richard Aubrey McLemore stated, "By 1870 the state alone held more than two million acres of tax-delinquent lands."*[48]

Nor were changes in government necessarily changes in power, law and order. Not only did former Confederate states immediately try to countervene the newly ratified Thirteenth Amendment and its political implications by forming reactionary, repressive Black Codes (with Mississippi's 1865 version immediately vetoed by Northern-appointed lawmakers), but ex-Confederate soldiers, resentful of what they viewed as the occupation government and its policies toward blacks and black education—namely, the founding of Freedmen's Bureaus and black schools—formed into roving, organized bands that frequently outwitted, outrode and outgunned law enforcement in many rural counties.[49] And that was when they were not coercing, or even constituting, that local law enforcement.[50]

Keeping blacks and poor whites servile to the land and its owners, the system of sharecropping soon emerged, a system that defined class relations in the years after the Civil War and came to be known as "slavery by other means." As the region began to rebuild itself economically and politically, part of this widespread return to farming and agriculture stemmed from the disbursement of formerly Confederate lands to open auction and sale. With the combination of the boom of the age of rail and the ready availability of cheap land (as cheap as ten cents an acre in postwar Perry County),[51] communities began to develop in previously spare areas of the state—namely, the Piney Woods and the wilds of the southeastern counties. As historian Bradley Bond has put it,

> Between the early 1870s and the late 1880s, legislation favorable to railroad companies allowed rail line builders tax breaks, access to state convict labor, and cheap or free land. Government efforts to attract railroad investors paid off: in 1870, 990 miles of railroad lines crisscrossed the state; in 1890, the total number of miles reached 2,397, and in 1910, 4,342 miles of track traversed Mississippi...In the Piney Woods and the Delta, large-scale timber cutters and sawmill operators made fortunes from the forests of the region. Between 1880 and 1900, the value of products manufactured in Mississippi increased by 150 percent, and investors poured 350 percent more money into Mississippi manufacturing facilities in 1900 than they had in 1880.[52]

As more people moved to the area, filling in an otherwise thinly painted spot on Mississippi's canvas, a new chapter of the region's history was about to be written. In the last quarter of the nineteenth century, the small hamlets and trading posts in the interior of the Piney Woods would grow to accommodate those who saw opportunity in the forests and who, as much as they nursed the wounds of the recent past, could not resist looking to the future. Out of this vision, a new town would soon be born.

## 2
# BIRTH OF A CITY, 1880-1910

## *William Harris Hardy: 1837–1917*

To appreciate fully the prospects of those early settlers, it is important to portray the landscape that they faced. For the most part, the land between the central counties of the state and the coast—where Mississippi City was one of the earliest rail settlements, and Biloxi, Ocean Springs and the other small towns hugged the waterways and natural harbors—was, for all intents and purposes, still wilderness. Cities and towns, even medium-sized settlements, were few and far between and were usually situated as or near the seats of the main central southern and coastal counties. Otherwise, the land was still heavily forested, creating both challenges and opportunities in transportation for those across the region.

This is not to say that the land was unappreciated—far from it. Valuation of the land had been taking place for years, since 1820, when Congress had set the price of land at $1.25 per acre, a figure that would waver at various points but eventually stabilize as the de facto standard for much of the nineteenth century.[53] Speculation was, understandably, rife, with interests from inside and outside the state buying land on the cheap and then selling it at a premium later on, sometimes years later. But the main problem was getting access to it—the roads were few, crude and entirely subject to inclement conditions—and then getting the lumber back out. That would require labor of the raw, backbreaking sort: to clear the brush, fell the trees, cut them to size, haul them off, level the ground and maintain the roads when rain, floods, tree falls or any other mishap

Carte-de-visite of William H. Hardy (circa 1870s–80s). *From the Hardy (William H. and Sallie J.) Papers, McCain Library and Archives, University of Southern Mississippi.*

Hattie Lott Hardy (date unknown). *From the Hardy (William H. and Hattie L.) Papers, McCain Library and Archives, University of Southern Mississippi.*

caused them to wash out or become blocked. And that labor, of course, would cost one thing: something that shrewd, educated merchant and upper-class—and almost entirely white—families had.

Enter Hardy. William Harris Hardy was born on February 12, 1837, in Todds Hill in Lowndes County, western Alabama, to a farmer's family of seven. He moved to eastern Mississippi in May 1855 to recover his health with extended family while on sick leave from his studies at Cumberland University in Tennessee. After a series of chance encounters led him to take a job as a schoolteacher in Enterprise in Smith County, he eventually co-founded Sylvarena Academy, became a lawyer, married and began to raise a family. As the winds of war blew through the South, he joined the military and rose in ranks to become a captain in the 16th Mississippi Regiment in the Confederate army, in command of the eighty-man Company H, nicknamed the "Defenders." His command included, as was not uncommon in that war, his own family: his brother Thomas Judson Hardy, his brother-in-law Henry W. Evans and his cousin Snowden Hardy.

Hardy's war was on and off. Mobilized to Virginia in August 1861 after the First Battle of Manassas, his regiment took part in conflicts such as Kelly's Ford, the Second Battle of Manassas, the siege of Harpers Ferry and Antietam,

after which point a chronic intestinal illness (usually described as a severe gastric ulcer) forced him into a brief convalescence in Gordonsville, Virginia. Throughout the war, beginning with his training at Camp Clark in Corinth, Mississippi, he wrote numerous letters home to his first wife, Sallie Ann Johnson Hardy, detailing his movements and his engagements.[54] After his recovery, he rejoined the Confederate forces as an aide-de-camp under General James Argyle Smith in the Army of Tennessee, with whom he remained until the end of the war, fighting in numerous engagements, including against Sherman during his campaign in Georgia. In June 1865, two months after Lee's surrender at Appomattox, Hardy returned home to his family in Mississippi. According to historian Claude Fike, "When the war ended it took a month for Hardy to travel from North Carolina to Mississippi. His horse was lame, and he had to walk much of the way."[55]

The years following his return were no less eventful. After returning to Raleigh in Smith County, Hardy resettled in Paulding in Jasper County, where he resumed and grew his legal practice. Several years later, in 1872, Sallie died unexpectedly of a virulent strain of malaria. Heartbroken, Hardy moved to Meridian to make a fresh start, and on a visit to Mobile in 1873, he met Hattie Lott, whom he began to court and whom he married the following year. "I was impressed by her modest demeanor," he writes in his memoir about their meeting,

> *Her beautiful figure, and her fair complexion…My wife was a blonde of the most beautiful type, lovable and a devoted member of the Baptist Church. She was twenty four years of age at the time of our marriage* [Hardy was twelve years her senior]*; and I must add, that she possessed all the qualities needed to make the very best possible stepmother to my little children…All of them became absolutely devoted to her and she was as deeply attached to them as if they had been her own.*[56]

They returned to Meridian; it was during this time, from 1875 onward, that Hardy began to turn his attention southward—in particular, to New Orleans and the Gulf Coast.

Personally humble, compassionate and gracious as biographical accounts make him out to be, there was also an ambitious streak within Hardy, not atypical of the industrious merchant class of whites in the postbellum era. For many, the prospect of so much unclaimed land between Jackson, Meridian and the coast was irresistible, representing—to those who could assess its value, leverage the appropriate backing and pursue its development—untold

profits. Hardy had known this for years; as early as 1868, he published an article in the *Meridian Mercury* arguing for development of a railroad to serve that corridor and later served as the general counsel for that rail corporation. As noted in the last chapter, railroad fever was high. In a letter from May 1880, he wrote to Hattie in Mobile, reporting that

> *I look for Mr Asa Carter up tomorrow to get his instructions preparatory to entering upon the work of securing Right of Way for our RR. We give him $100 per month. Wolffe* [a business partner] *is now in New Orleans and I am waiting to hear from him with anxiety. A good deal of excitement prevails here over the prospects of our Road, and I have applications every day for positions and for internships &c, and every man I meet now is "glad to see" me.*[57]

It was on one of his many reconnaissance trips along the line that Hardy came across the site of his future town, at the junction of the Leaf and Bouie Rivers. At the time, the site was already a small hamlet named Gordonville, after one of the earliest settlers in the area. Prior to Gordonville, it had been called Twin Forks, after an old Choctaw name marking the confluence of the rivers; Otis Robertson, an early Hattiesburg resident and its first historian, describes Gordon's Station as having "a depot, one or two stores, a railroad switch, a few dwellings and a lot of gallberry bushes and mosquitoes."[58] By and large, however, the area was still uncut, lush and wild. As Hardy recalls,

> *I had reached the banks of a beautiful piney woods stream, narrow but rather deep in places. This was during July or perhaps August, 1880. I had driven quite a way that hot day when I arrived about noon at this stream. The crystal clear water running over a white sandy bottom was a refreshing sight. Within a hundred yards of this stream, near the crest of a little hill, there were two hickory trees and a large oak which afforded a very fine shade. The ground was covered with pine straw as there were many long leaf pine trees around. There I stopped to rest for a couple of hours.*[59]

Assessing the topography of the area, he made a swift calculation:

> *I traced with my pencil a line on the map from a point on the Gulf Coast opposite the entrance between two islands which form the southern boundary of Ship Island Harbor to the approximate place where I was then sitting under the trees and from there on northward. I reached the conclusion that*

*a road would be built some day from the sea coast to the interior and when that came about, a competent engineer would [select] the route I had indicated in pencil on my map. I then and there determined to locate a station here because this was the place where the line from the Gulf Coast would cross the New Orleans and Northeastern. I also decided to name the place Hattiesburg for my wife, Hattie. So when the New Orleans & Northeastern Railroad was finished I had a depot located there and a station house erected and the place was named Hattiesburg. I entered a part of the adjoining land from the U.S. Government and in 1883 laid out the present city of Hattiesburg.*[60]

Eventually, those lines would grow to incorporate the Gulf and Ship Island Railroad, the other major urban planning project that Hardy devised. That connection took somewhat longer to get off the ground, in part due to more political and financial wrangling—not to mention a major setback in 1888, the murder in a duel of Wirt Adams, then-president of the railroad, whom Hardy was forced to succeed[61]—but to link Jackson with the coast was always a part of his vision. Interestingly, not all of that original vision survived. Hardy had dreamed of "a great

Federal land grant to William Hardy for Hattiesburg, Mississippi, 1882. *Hattiesburg Historical Photographs Collection, McCain Library and Archives, University of Southern Mississippi. Courtesy of Kenneth G. McCarty Jr.*

trunk line running centrally through the state to the Tennessee line where it would connect with another line from Chicago, furnishing the shortest line from Chicago to the Gulf." But today, after leaving Jackson, the line instead runs through the Mississippi Delta to Tennessee.[62]

Unfortunately, details of Hardy's earliest days founding the community are now lost: out of his voluminous lifelong correspondence, only seven letters survive from the immediate period surrounding the founding of the town (1878–88), during which some mention of the new settlement would be reasonably expected. Hattiesburg is not mentioned in any of these letters, only the railroad project itself. If Hardy did write letters about his experiences or opinions of the project, which is almost certain, they are either now lost or preserved only in a private archive. But ground was broken in March 1883 after years of financial negotiation, and in October of that year, the New Orleans and Northeastern Railroad ran for the first time from New Orleans to Meridian across a newly completed bridge across Lake Pontchartrain (dubbed "Hardy's Moonshine Bridge" by skeptics). The first of its kind, the bridge was a technical and logistical achievement. Hardy himself rode on the first car, traveling at a breathtaking forty miles per hour.

Hattiesburg was officially incorporated in March 1884, but tragically, Hattie Lott Hardy would never get to see her namesake. Her death in May 1895 was sudden and unexpected, like the death of Hardy's first wife, Sallie Ann Johnson. Given that her illness lasted only a few days prior to her passing—Hardy's memoir suggests a neurologic pathology, possibly a cerebral hemorrhage, but it is unclear what actually happened—it came as a shock to the entire family. After her funeral at her church in Meridian, Hattie was interred with the Lotts in her hometown of Mobile, where her father and other family still lived.

At the news, letters and telegrams of condolence poured in from across the South, even from as far as Hardy's business partners in London. Admired for her musical talents (in particular the sweetness of her voice), her gracious disposition and her devoted service to her church and to her community, Hattie seems to have been beloved by everyone she met. To suggest how deeply these feelings ran, a letter from Jennie L. Gary, writing from Siding, Mississippi, offers some insight:

> *She was one whom every right-thinking woman* [considered] *an honor to know and whose close acquaintance was so well worth cultivating. She always seemed to exhale elegance and refinement as unconsciously as a flower does perfume. One thinking of her not long in the Club* [the

Fortnightly Club, a literary and social gathering in Meridian] said *"She cannot enter the room without claiming the respect of every woman there." She was so perfect a lady.*[63]

Hardy was devastated by the loss and, for years afterward, wrote poetry expressing his grief, such as the 1896 elegy "Oh, Come to Me, Dear":

*Oh, come to me dear, once again,*
*And let me hear thy gentle voice*
*Breathing forth its soft refrain,*
*In heavenly sweetness, rich and choice.*

*Oh, come if but for a moment,*
*And staunch this bleeding heart;*
*Come, thou Angel in mercy sent,*
*and bid this night of gloom depart.*

*Come, oh come, if only in dream,*
*In vision, in song, oh come,*
*And bring to my soul one gleam,*
*Of thy dear self in the heavenly home.*[64]

Again, as after the loss of his first wife, the sorrow was too much to bear. Too heartsick to remain in Meridian, Hardy moved to Hattiesburg in 1899, where he would live for the next ten years before finally settling on the Gulf Coast until his own death in 1917. Whether it was easier for him to live in the city of her namesake rather than the city of their shared home, history is not forthcoming. But one thing was clear: in 1895, Hattiesburg had just celebrated its ten-year anniversary, and business was booming. No longer just a railroad depot in the middle of the Piney Woods, Hattiesburg had become a bustling town of several thousand people and a burgeoning regional hub for the harvesting, processing, sale and distribution of the area's prime natural resource. For the first two decades of its existence, the town would be devoted solely to one industry: longleaf pine (*Pinus palustris*, also called yellow pine or southern pine)—of which there were hundreds of thousands, if not millions, of specimens available.

# The Lumbermen

In its virgin state, the expanse of the southern longleaf pine forest was so great that researchers estimate the total size of the belt between eastern Texas and southern Virginia at up to 90–94 million acres,[65] with contemporary foresters prone to joke that a squirrel could travel from the Mississippi River to the Atlantic Ocean without the tip of its tail ever touching the ground. As forest historians note, early human impact had been minimal, leaving these forests remarkably well developed:

> *The effects of settlement on longleaf pine forests were initially minor, with harvesting limited to areas near early towns and villages where log structures were constructed…Later, lumber was cut from longleaf pine logs using hand-powered pit saws, which yielded only a few rough boards per day. By the 1700s, water-powered sawmills became common, but log transportation was inefficient and still largely confined to rivers…with logging conducted on 5- to 6-km-wide strips along rivers, where logs could be dragged by oxen or horses and floated to the mill. This so limited harvesting that, by the end of the Revolutionary War, most longleaf pine forests remained intact.[66]*

In Mississippi, the longleaf pine belt extended northward from the coast—characterized as much by pine savannahs as it was true forests—up the river basins into the central counties. In the area around Hattiesburg, the Leaf and Bouie Rivers, whose riverbanks were formed primarily of Ocklocknee clay, yielded a more diverse forest ecosystem of mixed hardwoods, but a few miles from the water, longleaf began to dominate. The trees grew best on poor, sandy soils to which they had adapted millennia ago, soils such as Ruston sandy loam, Susquehanna silt loam, Norfolk loam and Orangeburg sandy loam, whose high drainage allowed water to flow through them like a sieve. The land itself consisted primarily of rolling uplands and hills never more than a few hundred feet high, whose ridges were frequently carved through by drains and creek beds, all easily navigable by four legs or two.

The life of any plant is determined by a balance of a handful of basic elements: soil, water, sunlight and, in the case of a forest, fire. On its way to maturity, a longleaf pine tree would need a consistent mixture of all of these but, paradoxically, most of all, fire. As they grow, longleaf pines require frequent, low-level fires to sweep through the undergrowth, clearing away their competitors for sun, water and nutrients and opening

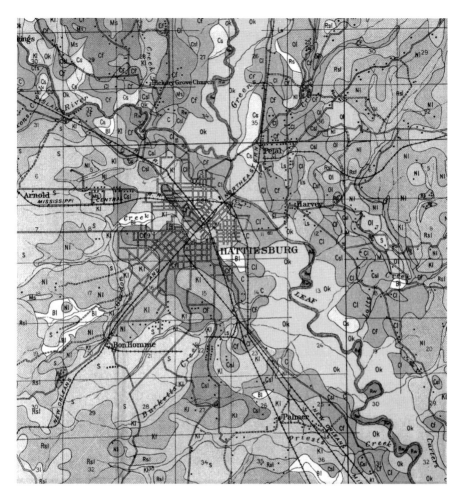

1911 Soil Survey of Forrest County, Mississippi, United States Geological Service. *Courtesy of United States Forest Service, Wiggins, Mississippi.*

up pathways for light. In fact, they encourage it: even as seedlings, longleaf pines will drop their needles to the ground to create additional leaf litter and therefore fuel for the flames, all the while insulating their precious seed pods at the crest of the tree in a protective cocoon of needles. After establishing themselves and fending off additional challenges such as invasive pine beetles, brown-spot disease, hungry hogs greedy for their roots or fast-growing brakes of cane starving them of light, over time these pines would achieve dominance over their less-adapted rivals, growing to diameters of twelve to fourteen inches and heights of seventy-five to eighty feet after sixty years.

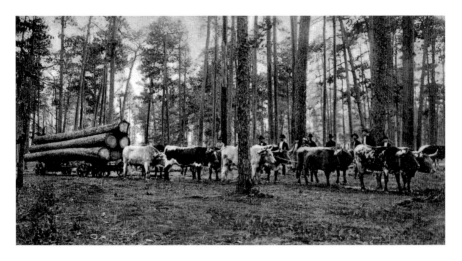

8 Wheel Wagon, made by Hattiesburg 8 Wheel Wagon Co., Hattiesburg, Mississippi. *Forrest Lamar Cooper Postcard Collection, courtesy of the Mississippi Department of Archives and History.*

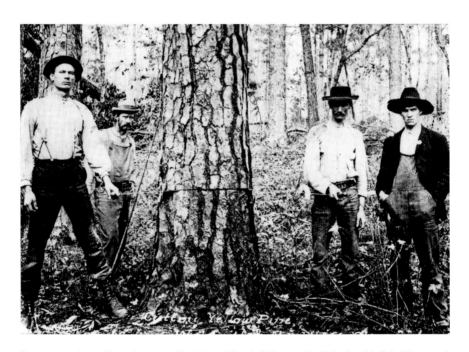

Loggers cutting yellow pine tree. *Hattiesburg Historical Photographs Collection, McCain Library and Archives, University of Southern Mississippi. Courtesy of Kenneth G. McCarty Jr.*

But these were just the average trees, still extant today both as protected forest and cash crop alike. In a forest like the early lumbermen found, specimens could easily be two centuries old or older, with a diameter of well over three feet and looming larger than one hundred feet tall. A mature longleaf pine stand, having enjoyed regular baths of fire from below, and regular haircuts from storm events above, would actually resemble open parkland carpeted by low-growing wiregrass more than a thick, dark canopy that neither light nor wind could penetrate. While transitional zones in these rolling uplands were common along topological gradients where water and soil differences governed species composition, pure stands were nevertheless everywhere, creating a stark, beautiful, haunting landscape of giants.

Such a landscape attracted interests from all over.[67] Coming in off the railroad from New Orleans and Meridian (and, later, Gulfport and Jackson), these lumbermen would have passed through long stretches of the forests they were coming to cut and would have seen more than one shade of green through the train windows. As Mike Lee, forestry commissioner for the southeastern district of the state, aptly explained, "If you could get into an upland pine site with a yoke of oxen, you can bet somebody was going to turn that into money."[68] Recalling the size of the town at the time, it is important to remember that the edge of the piney woods was never more than a few miles away in those earliest days, and that the signature of the city's future surrounded its residents—even, despite the extent of modern expansion, as it still does today. When they went in, they went in on foot, hooves and wheels to their company tracts, in wagon teams outfitted with horses, oxen and all the tools needed to fell the trees. Entering a tract, their eyes scanned the trees for the most prized specimens: the straightest and truest trees, those not afflicted by pine beetles or rot, everywhere noting the older individuals girdled in darkened flame shadows from fires up to six feet tall. Surrounding each one with axes and double-handled saw blades the very length of the men who held them (coated, in some cases, with kerosene to ease the cut), they proceeded to carve away at the tree line bit by bit.

In the early days, the only sounds from the interior would be of the men shouting, the snap and crash of the falling trees, the lowing of the oxen and the creak of the wagon axles as the logs, cut and sectioned on site, were hauled up onto their beds, followed by the crack of the whip driving the beasts on. At its densest, forward visibility in the pure stands could be less than one hundred feet. In more open patches, with a viewshed of several hundred yards, the vista would still be largely uniform, with the bodies

of the trees taking up the majority of the forward perspective and the sky only loosely filtering down. Visually, it was a pure palette: mile after mile of ridge, swale, plain and hill were covered with the same earthen colors of orange-brown and gray bark, russet leaf litter and shrub brush on the ground, thin green canopy and understory and a distant azure sky streaked and smeared with clouds. Deep inside, any game in the area having long fled from the oncoming sounds, the only motion would have been the upper canopy swaying gently in the breeze, which rarely reached the forest floor. As they cut, however, the wind would have rushed into the empty spaces below, bringing a refreshing cool upon their brow in the summer months, or a bracing chill in the winter. When they would reach a clearing, a small meadow filled with brush or native grass, the trees in the distance would stand out against the forest behind them like ancient scratches on a cave wall. During their breaks from labor, apart from the snorts and grunts of the work animals, the crinkle of sandwich paper and the conversation of the men, the forest would be almost totally silent.

Time and technology would change these early forays, as would the thirst for capital. Crews swarmed over the area like locusts, with new, more efficient methods of harvesting to speed the clearing of the trees. Developments in saw technology and technique meant the trees fell faster than before, and developments in transport—first in wagons, with primitive log carts being replaced by the locally made eight-wheeled Lindsey wagons, far more durable and better in muddy conditions—meant the logs were brought back to the mills for processing at ever-increasing rates. As historian Nollie Hickman records, in the earliest days of harvesting, freshly cut logs, branded and penned by their owners like cattle on the way to slaughter, would be floated downstream on the nearby waterways, with young men driving the charge and racing alongside and atop them to prevent their jamming or sinking in an exhilarating, extended run lasting dozens or even hundreds of miles.[69]

From early on, the naval stores industry producing turpentine, tung oil and pitch accompanied the lumbermen and brought additional profit; as Hickman notes, the labor force in this sector was composed primarily of African American workers and their families who lived in separate camps, often deep in the woods.[70] The truly exponential development took place, however, with the shift from log transport from overwater to overland and the arrival of rail into the pinelands. Historian William Sturkey notes that "[trains] did more than just render steamboats obsolete. They created completely new avenues of economic activity in places like Hattiesburg by opening all parts of the Mississippi Longleaf Pine Belt for harvest. Railroads

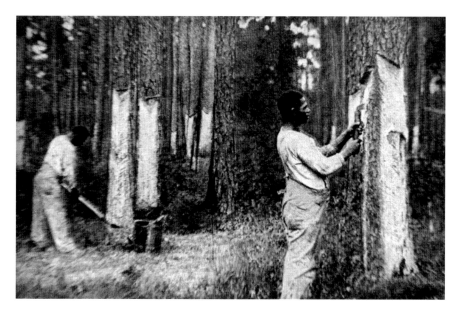

Dipping and scraping pine trees for turpentine. *Hattiesburg Historical Photographs Collection, McCain Library and Archives, University of Southern Mississippi. Courtesy of Kenneth G. McCarty Jr.*

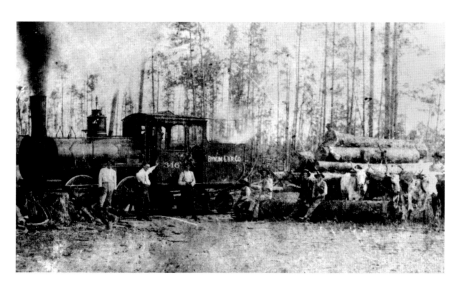

Bynum Lumber Company locomotive with oxen team. *Hattiesburg Historical Photographs Collection, McCain Library and Archives, University of Southern Mississippi. Courtesy of Kenneth G. McCarty Jr.*

replaced rivers as the veins in the heart of the Deep South, pumping timber from the interior to almost everywhere in America."[71] Indeed, railroad lines from mills to company tracts (often built from wood harvested from the trees themselves) invaded the stands like hungry worms nosing into new, fresh patches of dirt and fostered the settlement of company towns across the region. At their terminus points in the woods, steam-powered skidders hauled logs to railcars far more quickly than men and beasts ever had but destroyed all the saplings in their path and crushed any attempts at natural regrowth. Productive as these technologies may have been, the clearing of the forest and the departure of the crews left behind countless "dummy lines" of abandoned track, their ghostly imprimaturs like scar tissue on the body of the land.[72]

With a seemingly inexhaustible crop ahead of them, these mills—owned by lumber magnates such as J.J. Newman, W.S.F. Tatum and D.W. McInnis, to name but the largest—chewed through the timber like mice through cheese, with their output reaching remarkable figures even by modern standards. In an oft-cited figure, Hickman records that by 1893, "there were fifty-nine sawmills with a daily output of 1,000,000 board feet in the Hattiesburg vicinity," and that by the end of the century, the total combined output of all the mills on the New Orleans and Northeastern Railroad had reached 300 million board feet.[73] If, at the height of the forest, a squirrel could leap from tree to tree from river to coast, writer Alec Clayton has suggested that in the glory days of the mills, "legend has it you could throw a baseball from sawmill to sawmill all the way [from Hattiesburg] to the gulf."[74] Continually developing new methods in transporting, processing and drying timber and bolstered by the advent of electric lighting, which extended the workday past sunset, these mills rarely, if ever, ceased—except when they burned, which they were prone to do.[75]

One recollection by an early Hattiesburg resident characterizes their activity nicely. Thomas Dearman, born in 1900 (and whose grandfather had served as chief alderman of the city until his death in 1904), recalled as an adult the workings of the McInnis Mill in his youth:

> *It was located along the Southern R.R.* [a later name for the New Orleans and Northeastern] *tracks towards the river. The first you saw coming from Hattiesburg just over the railroad right of way was a big bonfire. It was quite a distance from the mill and was fed with pieces and bark from the trees that they wanted to get rid of. Any scrap that was not used was taken out to the fire on a long conveyor. Just beyond the conveyor*

*was the mill-pond where the logs were floating waiting to be cut up. It was not exactly a pond but more like a lake. A long trestle ran out over the mill-pond for several car-lengths. The log cars were shoved out there, the chains released and they would roll into the water. There was another conveyor that went up into the mill and it was fed with logs by a fellow at the bottom. The logs went on a carriage that went back and forth with 3 or 4 men riding it. It was quite interesting to watch that sawyer slice those logs up into planks. Those planks were sawed up into smaller pieces and put on a large cart and put into a steam dry-kiln. Right there close was the steam boilers and I think there was six of them. The fuel used was sawdust from the plainer [planer] mill and the big saw that cut the logs up. Three shovels of dry sawdust to one of green. Next was the plainer mill and that's the one I knew best. It was a noisy place and lumber I saw it plain mostly was tongue and groove. There was always a piece cut off after it came out of the plainer machine. I had a two wheel wheel-barrow and I would take what we needed home to feed the cookstove. There was a long leather conveyor that went out to the loading dock where they loaded the railroad boxcars. The millpond or lake had small shacks around one side where the colored workers lived. The mill owned a big store or commissary where the workers bought their groceries. Seldom would you see one of those workers in Petal. In fact there was nothing for them to come in for. A general store, a post office and a blacksmith shop was Petal (period).*[76]

The problem was, the mills were too successful. Its thirst insatiable, the unchecked expansion of the industry took its corresponding toll on the forests, especially before the notion of sustainable forestry—much less the very word "sustainable"—and state and federal laws to support it would emerge. (W.S.F. Tatum famously forbade the use of skidders on company land, recognizing their destructiveness to young growth, but he stood largely alone in his policy.) The result of this overharvesting was the simultaneous death both of the old-growth stands themselves and of many of the towns that sprang up along the rail lines. In the Forrest and Perry County areas, towns like Purvis, Sumrall, Lumberton and Poplarville survived intact, while other towns like Morriston, Glendale and Richburg were swallowed up by Hattiesburg as it grew. But as historian James Fickle notes, a vast number—Red Top, Wilco, Nortac, Pytonah—now survive only as names on obsolete maps, their mills long fallen silent, their dummy lines and buildings long taken back up for parts or reclaimed by the earth.[77] According to historian John Napier,

> *There was irony in the fact that the very Piney Woods in which our rude settler had sought sanctuary from the outside world would betray him. Those magnificent, tall, cathedral-like virgin yellow-pine forests, through which soft winds soughed in an otherwise silent world, would be a magnet to that outside world, its maw insatiable for more and yet more timber to help build the ships, railroads, and cities of the new Industrial Age. Timber companies, which had first desolated New England, and then the Great Lakes, would soon descend upon the primeval southern forests, and would render them a naked, howling wasteland in an all-too-short half-century.*[78]

Unfortunately, no virgin stands of old-growth longleaf exist in the area today—not even in Mississippi as a whole, and only a handful in the Gulf South.[79] According to state foresters, individual specimens of the age of the original giant pines can be found, but the closest true stands of pure old-growth longleaf are found outside the state, such as the Wade Tract Preserve in Thomasville, Georgia. Even so, in portions of mature new-growth such as are found in the De Soto National Forest, a few hundred acres can still feel limitless. Driving along the interior roads of De Soto today, it is the easiest thing in the world to see how the lumbermen thought it would never end. This would be true not just of those who had already arrived and established themselves, like Tatum and Newman, to build their empires but also of those who were still arriving off the train every month, seeking their fortunes in the fields of standing gold. As one outside observer would remark in a much-celebrated passage in 1905,

> [Hattiesburg] *being located about the middle of the Gulf and Ship Island and with its ninety mills, the terminus of the Mississippi Central with about twenty-six mills, and about midway between New Orleans and Meridian on the Northeastern and the line of Mobile, Jackson, and Kansas City, with possibly thirty mills, it is easy to see that the future of Hattiesburg is assured.*[80]

## "No Room for Loafers": Hattiesburg Takes Shape

Assured it was. Back in town, new industries were emerging at a remarkable rate, both to serve the lumbermen and their mills and to take advantage of increased traffic through the area—traffic that, just a few years earlier,

would have been unimaginable. Goodspeed's 1891 history of Mississippi, which describes Hattiesburg as "the only important town in Perry county," records the city as having a population of 1,172 in 1890; by 1900, it would reach 4,175, a nearly fourfold increase.[81] Settlers were arriving at the depot on a near-daily basis, drawn by the prospect of limitless opportunity fueled by the mills—many from within Mississippi, but a considerable proportion (including, notably, Tatum, Newman and Newman's business partner, Fenwick Peck) from out of state and up north as well.

Glimpses of the day-to-day history of the town in its very first years after its founding are limited: unfortunately, until the 1890s, contemporary accounts from newspapers, observers and official records are intermittent. We do know that city government was quickly established, with mayors elected to terms of one year (terms would be extended to two years in 1893, and four in 1913) and aided in their duties by a board of five aldermen—all white, of course, given the political power structure of the time. Historian Patt Foster Roberson notes that in the first recorded meeting of the inaugural mayor—Oliver Hazzard Perry Jones, a former justice of the peace and chancery and circuit clerk of Perry County—and the aldermen in January 1885, it was agreed that the town ordinances were to be published in the *Hattiesburg Herald*, the town's first newspaper and frequent outlet for the Perry County Board of Supervisors.[82] Apparently, certain pressing matters needed to be discussed at this meeting: these ordinances concerned, among other things, "the discharging of firearms, indecent exposure and drunkenness, authorizing the marshal to summon help and ordering that privy filth be taken out of town or buried two feet deep."[83]

Of the layout of the town and the other daily activities that consumed the townspeople, the portrait of nascent Hattiesburg remains only a sketch, but a sketch that is likeness enough. One of the best descriptions comes from Justice T.J. Pittman, one of the town's earliest settlers:

> *I came to Hattiesburg on January 5, 1884, arriving in the late afternoon on the New Orleans and Northeast Railroad from Meridian. On getting off the train, I asked a Negro, Old Bill Pickens, where the hotel was. I don't know why I wanted to know as I had no money. He told me up town and pointed in the direction I would have to go. After a good long tramp, my wife, the children and I came to what is the corner of Front and Mobile Streets. A small frame building had just been erected; in fact, it was not finished, but Eaton and Collins were opening up a general mercantile store therein. Up the path was Drs. Gillis and Dearman's "Doctor Shop." Adjoining*

*that was O'Flinn's barroom where he dished out the "how-come you-so" to the thirsty wayfarer and was doing a land-office business. Next to that was Ed Anderson, who competed with Joe in distribution of the "oh-so joyful." The only hotel was an unfinished, two story building, managed by a Mrs. Couch. In the early spring, the hotel was bought by William Johnson and his son, W.A. Johnson, who finished it and operated it for several years. In the fall of 1884, Dr. John Bertrand opened up a drug store. His stock of goods consisted of a few bottles of quinine, Jamaica ginger, some pills and possibly caromel and a good quantity—not quality—of "booze."*[84]

That pioneer layout would not last long; a disastrous fire in 1893 would consume twenty-six buildings, primarily wood frame, and lead to the creation of an ordinance that required new construction to be made of inflammable material such as brick—a costly decision at the time, but one that ultimately preserved much of the downtown area for posterity.[85] Another early contemporary account is preserved in an 1894 copy of the *Hattiesburg Democrat*, an eight-page broadsheet newspaper that was published since 1885 and billed itself as "the oldest paper on the New Orleans and Northeastern Railroad." The editor and proprietor was Mary Oliphant, who, at the time of writing, was recovering from a serious bout of "la grippe," of which she made no small mention in her pages.[86] Only three of the eight pages of the *Democrat* were devoted to Hattiesburg itself—the majority of its reportage consisted of national and international wire dispatches; sermons; advertisements; poetry, stories and anecdotes on both serious and trivial subjects; and official notices from land, patent and legal offices.

The local news described in this issue included railroad timetables and advertisements, society news (including an extensive account of the recent New Year's Ball, featuring many of the town's prominent families, future mayors and business leaders), commercial bulletins, ecclesiastical directories and bread-and-butter notices of marriages, funerals, newborns and traveling dentists. Of special concern on this date was the notice of a stray pony found by one John West of Perry County, "a poney horse about ten years old of yellow roan color, branded 'K' on his left jaw with black mane and tail," a loss that to the modern mind may seem trivial, but in 1894 could have signaled economic peril for its owner.[87] That, and an apparent price war over candy between two merchants, both of which wooed *Democrat* readers with multiple insistent ads. One simply proclaimed, "CANDY! CANDY!! Candy!!! at Eaton & Collins," whereas its competitor took a more verbose approach: "S.O. Harris has received a new lot of

candy, the choicest that has ever been brought to Hattiesburg, and he is selling it the cheapest. Chocolate-creams, caramels, and dozens of other varieties. Call at his stand on Front Street."[88]

The geographic roots of early Hattiesburg settlers are reflected in the *Democrat*'s advertisers, which included both the *New Orleans Picayune* and the *New Orleans Times-Democrat* (both of which eventually merged with others to become the present-day *Times-Picayune* of New Orleans), reflecting the reading interests not just of Hattiesburg citizens who had commercial interests there but also the growing market for people traveling up and down Hardy's rail line. What Oliphant does not seem to have entertained, however, is criticism of her distinctive editorial tone, as evidenced by a tantalizing riposte to a rival newspaper in eastern Mississippi. Responding to the editor of the *Newton County Progress*, Oliphant offers the spirited rebuttal of an early suffragette:

> *Brother Seitzler of the* Newton County Progress *accuses us of being a little "sassy" and seems to think that on account of our being only a woman, we have no right whatever to be so. That is a privilege to be enjoyed exclusively by the opposite, or we should have said superior sex, it seems; and while it is very becoming and appropriate for the editor of the* Progress, *who is not the feminine gender, third person singular number, to blow off as much "chin music" as he pleases and poke fun at his exchanges, it is distinctly out of place for the editress of the* Democrat *to do so, and all on account of a little accident for which the Lord and not she is responsible. And as for the exchanges—Brother Seitzler can rest assured that the* Progress *is not one of the condemned three, as it is never stale, and we have no reason to doubt that all of its lies are original.*[89]

Modern readers are undoubtedly the poorer for lack of more of Oliphant's opinions: regrettably, the issue of January 4, 1894, is the sole surviving copy of the *Democrat*, nor have many of the other early Hattiesburg newspapers survived either. Historian Patt Roberson has tallied the forty-two newspapers published in Hattiesburg's first century, from 1885 to 1985, and found that thirteen of those, the majority from the first two decades of the city's history, have no known extant issues. The loss to our understanding of the city's early growth is incalculable.

Thankfully, other sources do exist. Another early snapshot of Hattiesburg comes from Virgil Otis Robertson, whose 1898 pamphlet *Facts about Hattiesburg*—originally sold for twenty-five cents—contains a wealth of information from the time.[90] Proudly, Robertson offers an inventory of

what the young town had: fifty-one stores, nine factories, thirteen miles of railroad, three electric light plants, eight churches, a bar association and a truck growers' association, an opera house, seven physicians, four drugstores, two newspapers, "a few vacant lots for sale" and, lest there be any doubt over who was welcome in town, "no room for loafers."[91] What Robertson does not explicitly list in this inventory, however, are the other industries that by this point had sprouted up. Advertised in his volume are jewelers, travel agents, furnishing houses, milliners and clothiers, hardware houses and metalsmiths, machinists, pharmacists, dentists, grocers and bakers, realtors and land agents, banks, hotels, restaurants, notaries and justices of the peace, as well as multiple different liverymen and stablemen, general store merchants, attorneys and solicitors, including William Hardy's own office. Add to these the brick makers, finishers and turpentine distillers that supported the mill industries; the boot and shoemakers; and the "tonsorial artists" also advertising in the *Democrat* (the latter promising "polite attention, keen razors, [and] hot towels"[92]), and a portrait of life in the early town quickly begins to emerge. Hats, health, hardware and horses seemed to be the main focus of the early Hattiesburgers, an industrious lot from their beginnings.

Remarkably, all of this activity was concentrated within a narrow geographic space of just a few square miles. At the time, as Justice Pittman described, downtown was miniscule by contemporary standards, and most of the businesses that emerge from this snapshot were located on three main streets: Pine, Front and Main, all of which were walking distance from the railroad depot. Pine and Front ran north and south, parallel to the tracks and to each other; Main cut across them all, winding westward to match the path of the Bouie River a few miles away. Even today, the other original street names in the downtown area reflect both its compact size and its order, such as Railroad Street, which sat roughly parallel to and within yards of its namesake, and Buschman Street and Newman Street, both running along the tracks and leading to their respective mills. Eventually, Pine Street would grow to the size at which it was subdivided into East Pine (downtown) and West Pine (outskirts, primarily residential), but at the time, it was home to merchants, dry goods salesmen, light manufacturers and hardware houses. The city's first cemetery, Oaklawn, was established in 1887 west of downtown on what would later become Hardy Street.[93]

Residential areas for whites grew to the east of downtown, across the railroad tracks along Bay Street and to the south and west along streets numbered First, Second and Third. North of downtown along Mobile Street, past the railroad tracks and an area of light industrial activity, lay the

early African American neighborhood. Around town, transport was by foot or by horse and buggy, with motorized trolley cars arriving later, in 1907. Inventive as local residents were, horses were not the only form of transport: in at least two separate photographs from the era, we see young children driving buggies drawn by harnessed goats, which seem perfectly well suited to the task (and happy to be paid in mouthfuls of fresh grass).[94] A weather station was founded in 1890 just two-tenths of a mile from the first post office,[95] the city's first financial institution, the Bank of Commerce, opened in 1895, and communication took place by telegraph, post and word of mouth until August 1896, when early local entrepreneur Thomas Ferguson wrote the mayor and board of aldermen, saying,

> *Your petitioner Thos. M Ferguson would respectfully show unto your Honors that he and associates are desirous of erecting operating and maintaining a telephone exchange in the City of Hattiesburg Miss for the public use, therefore they pray that your Honors will grant them the right to set post and bring their wire, to operate and maintain the same along any street or alley in said city of Hattiesburg that they may here-after desire to use.*[96]

While details of its installation are scarce, its end result was not: two years later, Otis Robertson would heap praise upon Ferguson and his remarkable new system, marveling, "To be enabled to ring a bell, say 'Hello!' and commence talking to a man in Meridian, eighty miles away, is one of the wonders of the nineteenth century. That is what is done in Hattiesburg daily."[97]

Early life in Hattiesburg was not just centered on work; within the first few years of the city's founding, social and religious institutions quickly emerged. For men, chapter societies such as the Freemasons and the Oddfellows took shape by the mid-1880s, with the Knights of Pythias and the Elks to follow shortly thereafter. For women, ladies' aid and local literary societies served for recreation and camaraderie.[98] Houses of worship, at first mainline Protestant denominations, arrived immediately. The First Presbyterian Church, originally founded in 1882 at McDonald's Mill (a local sawmill a few miles from downtown), relocated to the center of town in 1883 and erected its first building on Main Street.[99] Main Street Methodist and First Baptist Churches were founded in 1883 and 1884, respectively, followed by Sacred Heart Catholic Church in 1890; all of these denominations erected iconic local buildings that are now part of the architectural heritage of the city. Other congregations would arrive more slowly—while individual Jewish settlers such as Brookhaven millman Maurice Dreyfus moved into

the area shortly after incorporation, a full-sized Jewish congregation did not emerge until around the turn of the century, meeting in the Oddfellows Building prior to the construction of its first temple.[100] Of other traditions of worship in early Hattiesburg, there is no record; as Robertson declared in his history, "The town is strictly a Christian town, five-eighths of the people being members of one or the other of the eight churches that are to be found in its limits."[101]

But for all the houses of worship, early Hattiesburg was still a rough-and-tumble place, where in their off-hours, townsfolk took their pleasures as strong as they took their preaching. When not at work in the forests, mills or downtown stores, residents found their way into wide varieties of entertainment, and as many histories gleefully record, "the story of Hattiesburg, had it been taken from the cases in the Mayor's Court Docket, was one of 'wild, wild women and wild horses.'"[102] The Sullivan-Kilrain bare-knuckle boxing fight of 1889—the last of its kind in the country, organized in secret, lasting for an astonishing seventy-five rounds and becoming one of the most famous events in all of Hattiesburg's history—is perhaps the best-known instance of extracurricular activity.[103] When things got out of

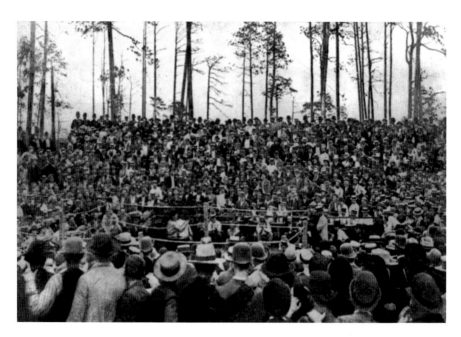

Sullivan-Kilrain bare-knuckled boxing match, 1889. *Hattiesburg Historical Photographs Collection, McCain Library and Archives, University of Southern Mississippi. Courtesy of Kenneth G. McCarty Jr.*

hand, however, the law was there to step in: new research into previously unexamined sources, the surviving criminal affidavits from the late 1890s, suggests that, much to the chagrin of city fathers, local recreation seems not to have changed from their first mayoral meeting in 1885.

In the documents preserved at USM,[104] far and away the vast majority of offenses were for profanity. Usually cited as "swearing or cursing in a public place in the presence of two or more hearers or witnesses," with startlingly crude examples recorded, these offenses are followed immediately by second-place finishers of gambling (with dice or cards, and often with property at stake) and the unlawful sale of what would have most likely engendered these and other crimes: "vinous, spiritous, and intoxicating liquors." Curiously, no charges for public drunkenness from the period survive, despite how many must have been issued and despite the traditional interpretation of spirit handling by Protestants, explored in depth by the historian Grady McWhiney.[105] A close third were offenses of assault and battery and disturbing the peace—which frequently also involved profanity, according to the affidavits, but which in one instance whose details are regrettably unrecorded for posterity also involved "the explosion of

Arrest affidavit, Bob Moore, August 24, 1898. *From the Hattiesburg Municipal Records, McCain Library and Archives, University of Southern Mississippi.*

Gunpowder." Equally prevalent were crimes on and around the railroad, such as freeloading, carhopping and loitering around the depot—crimes that, given Hattiesburg's raison d'être, come as little to no surprise.

Fewer crimes recorded, at least within this period, were incidents such as discharging firearms within the city's small and highly audible limits, carrying concealed weapons such as knives or pistols, tax evasion from municipal authorities and theft—including, memorably, the theft by one Caley Williams in 1899 of a box of oysters from one Hugh Graham worth all of ten cents. Other offenses included depositing garbage without burying it, beating a living horse (animal cruelty) and, in what must be one of the city's first issued speeding tickets, the charge against one Bob Moore on August 24, 1898, who "did unlawfully drive a horse at a reckless gait and against the peace and dignity of the State of Mississippi." Limited though this picture may be, one thing is clear: fast, violent, drunken and, above all, profane, early Hattiesburg was no place for sissies.

While many of these activities would be expected in any small southern town—or in any town, for that matter, small or southern—it is remarkable that profanity stands out so prominently at the top of the list of our surviving records. Standards of the era differ from those of today, of course, but early Hattiesburg seems to have been highly concerned with decorum, at least in public. As a burgeoning timber town, city fathers may have been eager to present the face of gentility to those visitors and prospective settlers deciding whether this was the place to seek their fortunes. Even so, among the other issues to be resolved by the end of the 1890s were the continued construction of city facilities—such as city hall in 1898, which suffered labor disputes when workers went unpaid for days or weeks at a time[106]—and perhaps most importantly, the physical infrastructure of the town in its streets. The crime noted above of a resident failing to bury his or her garbage was one of many such concerns that had plagued the city in the years before sewerage, drainage or paved streets, and had for years.

As early as 1891–92, city attorney George Hartfield had written to then-Mayor J.M. Williamson about the condition of the city's streets and sidewalks, widely recognized as poor. Until that time, the state legislature had decreed the cost of constructing and maintaining sidewalks to be borne by the owner of the property, a process that Hartfield called "cumbrous and slow." The city being charged with making improvements to its streets, he noted that, by law, "the notice to make these sidewalk improvements must be served by the street commissioner, under Section 3012 [of the Mississippi State Code of 1892]—our city has never elected

# QUARANTINE REGULATIONS.

––––––––•❖•❖•❖•❖•❖•––––––––

At a meeting of the Board of Health of Hattiesburg, Miss., held in the office of Dr. Donald, Sept. 13th, 1897, the following proceedings were had, towit:

On motion T. J. Mixon was elected President, T. J. George, Vice-President, W. W. Massengale, Secretary.

On motion it was ordered that ALL TRAINS pass through the Corporate Limits at the rate of 15 miles per hour and that no mails be received or distributed.

On motion it was ordered that the President be instructed to employ 16 guards, 8 for day and 8 for night service, to guard the public highways leading into the city and also 2 additional police for the city, one for night and one for day service, the day man required to do sanitary service. The salaries of the guards being stipulated at $1.00 per day for day service $1.25 for night service, the salaries of the 2 extra police to be left to the discretion of the President.

On motion it was further ordered that all places of business within the corporate limits of Hattiesburg be promptly closed at 5:30 o'clock p.m., drug stores excepted; that all public gatherings, religious, political or otherwise, are strictly prohibited and that all persons are prohibited from being on the streets of the town after 9 o'clock p.m.

On motion the sanitary officer was instructed to report promptly to the authorities, any citizen who refuses to comply with his orders with reference to cleaning premises.

W. W. MASSENGALE,                                    T. J. MIXON,
            Secretary.                                              President.

Yellow fever quarantine regulations, 1897. *From the Hattiesburg Municipal Records, McCain Library and Archives, University of Southern Mississippi.*

a street commissioner—therefore the legal notice has not been given, and cannot be given, and the ordinance cannot be enforced."[107] Hartfield went on to provide advice on where to find a law regarding that office, hopefully so that the mayor could implement it and therefore provide Hattiesburg, barely eight years old, with what improvements it needed to keep pants and petticoats free from mud and filth.

The problem was more than cosmetic: in town as in the woods, rain and floods led to muddy, impassable streets, as well as standing pools of water that bred bacteria, mosquitos and disease. The city had suffered from outbreaks before—the first yellow fever outbreak was in 1888, and smallpox arrived two years later along with the infamous Pest House for the infected[108]—but the late 1890s would see larger outbreaks sweep through town. Documents from the time indicate that in September 1897, Mayor T.J. Mixon called a special meeting of the board of aldermen "for the purpose of requiring all landlords tenants leaseholders etc to immediately have a thorough cleansing of said premises of all privies sewers cesspools or other places that might form a possible source of infection." The town was put on quarantine: all trains were instructed to pass through at fifteen miles per hour without stopping, mail service was suspended, public highways were staffed with guard patrols, all businesses (except drugstores) were ordered to close at 5:30 p.m., any public gatherings of any nature were prohibited and a nine o'clock curfew was put in place.[109]

How long the yellow fever lasted is not recorded; the following year, however, smallpox arrived, resulting in a similar situation. A letter dated September 28, 1898, again from Mayor Mixon, calls for a special meeting of the board of aldermen, toward "passing an ordinance requiring all persons to be vaccinated who live in an infected locality."[110] Guards were hired to man detention camps and were paid around $1.50 per day; according to receipts issued by A.C. Duckworth, the city jailor, at least some of the infected seem to have been housed in the city jail.[111] With most vaccinations or major medical supplies almost certainly arriving from outside of town, internal improvements would have to come first. Apparently, by the end of the decade, sanitation issues had become so pressing that in December 1899, Mayor Evans Hall made them the subject of his annual report to the aldermen, noting not just the transportation and access issues involved in improving the city's physical infrastructure but the health issues as well, which had the potential to drive prospective residents away. At the end of a letter detailing the failings of the present system and making recommendations for improvements, he wrote:

*Gentlemen: I feel it is my duty to say something about a sewerage system for the city. It is supposed that we will now reach near 6000 inhabitants, and the outlook is bright for more in the near future. Our business lawyer is making every effort within their power to induce manufacturers of various kinds, and before we could induce capital with people to come, it is highly important that we insure a reasonable possibility for health. And to do this, it occurs to me that the only thing to do is to issue bonds and put in a complete sewerage system and thereby relieve all fears of people from coming within our limits. I recommend that you take this subject under consideration until the January meeting of your board and if you will then concur with me in this scheme, I feel satisfied that it is the right thing to do. Respectfully, E Hall, Mayor.*[112]

Hall's concerns over fearful incomers were unfounded. Over the next few years, the streets were paved, and despite its growing pains by the end of that decade—the turn of the century—Hattiesburg became far more than a muddy, filth-ridden cesspool. From Robertson's history alone, we see that in its first full decade, from 1884 to 1894, Hattiesburg had enjoyed a series of firsts: its first newspaper, the *Hattiesburg Herald*; its first schoolhouse, a log cabin with one teacher who apparently served as superintendent, principal and teacher of both the high school and grammar school;[113] and even its first murder, of one Mrs. Dolly Williamson in 1891, the wife of Mayor J.M. Williamson who was found slain in her room—as Robertson put it, with the murderer still at large seven years later, "It was one of the saddest and most mysterious incidents connected with the history of Hattiesburg."[114] It was proud of its electric lights (which had arrived late, the city still lit by oil lamps by night watchmen making the rounds as late as 1897),[115] its exemplary water pressure from the Hattiesburg Water Works (first privatized but eventually purchased by the city in the late 1890s), its first ice factory, its mechanized compress for tailoring and even its steam laundry, saving customers the expense of shipping clothes to Birmingham for laundering. By the end of the decade, it would also have its first graduates from Hattiesburg High School, in a graduating class of three—Robertson himself included.[116]

For growing pains do, after all, mean growth. In 1899, Governor A.J. McLaurin declared Hattiesburg no longer a town but a full-fledged city. But its story had only just begun: as historian Kenneth McCarty observes,

*Hattiesburg grew slowly in the first decade of her existence. In 1890, her population stood at 1,172. But in the next two decades Hattiesburg*

*experienced unparalleled growth which transformed her from a village into Mississippi's fourth largest city. By 1900 her population had reached 4175. More importantly, Hattiesburg now sat at the hub of four railroads in the midst of vast stands of virgin long leaf yellow pine. Ideally situated, Hattiesburg became in the first decade of the twentieth century the major production and distribution center for the yellow pine industry.*[117]

# From Town to City: Hattiesburg to 1910

Why did Hattiesburg survive—and thrive—when so many other towns in the area did not? Much of the answer lies in McCarty's quiet plural of the word "railroad" in the passage above: the fact that Hattiesburg, founded on one railroad, grew steadily to serve as the locus for three more. With the history of timber and rail inextricable, the years from 1900 to 1910, commonly held as the peak of the timber industry in the region, were characterized not just by the growth of the town but also by the expansion of the railroad network, linking Hattiesburg with New Orleans, Meridian and each of their surrounding cities as well.

Remarkably, this vision had been foreseen, even before Hardy—indeed, even while Hardy was still a toddler in Lowndes County, Alabama. In another famous passage from his 1841 travels through the Piney Woods, J.F.H. Claiborne took into account the same considerations of geography and economics that Hardy would four decades later. Having praised the pine forests of Jones, Perry and the surrounding counties for their quality of timber—"Finer, straighter, loftier trees the world does not produce," he lauded—Claiborne's observation took on a prophetic dimension. "The time must arrive," he wrote,

*when this vast forest will become a source of value. The smoke of the steam mill will rise from a thousand hills. Rafts and lumber boats will sweep down the Pearl, the Leaf and Chickasawhay, and a railroad will transport millions of feet to the city of Mississippi to be shipped in vessels, built there of our own oak, to the West Indies, Texas and South America, countries that furnish the best lumber market in the world, and to which we are so much more accessible than the hardy mariners of New England, that now monopolize the trade. A railroad to the gulf could be constructed at little expense. For one hundred miles or more the country slopes down to*

*the sea shore. Not a hill would have to be cut through. There are no rocks to excavate; the foundation or substratum is dry and solid, and the heart of yellow pine and white oak growing on the whole line would furnish the best of materials.*

He continued, arguing for a total re-envisioning of this area of the state:

*Look at the immense aggregate of wealth the people of North Carolina annually* coin out of their pine woods *by the manufacture and sale of tar, pitch and turpentine, to say nothing of lumber. Yet we, with a pine forest more extensive, with a sea coast far less dangerous, with the means of subsistence cheaper and more abundant, and health much superior,* ship none of these great staples of commerce, *and our counties where these rich materials abound and where they might be manufactured to an almost unlimited extent, are all thinly settled.* The opinion that East Mississippi is poor and barren, and therefore destitute of resources, is erroneous, *and one object of these hasty sketches is to point out that error.*[118]

It is impossible to say whether Hardy knew of Claiborne's writing. Hardy takes sole credit for his idea in his memoir, but as his first public foray into railroad development started in 1868 with his article in the *Meridian Mercury*, about thirty years after Claiborne published his accounts, it is possible that such reading material had migrated from the western to the eastern part of the state, where Hardy lived at the time. Nevertheless, what is remarkable is how closely their visions were matched, and indeed surpassed, by the end of their shared century.

To be fair, Claiborne was wrong—quite wrong—in thinking that a railroad to the Gulf of Mexico "could be constructed at little expense," as Hardy found out to his grief. If the spirit was willing, the cash was weak: Hardy's first attempt at constructing the Gulf and Ship Island Railroad failed in the 1880s due to skittish investors. After laying only twenty miles of track northward from Gulfport, he was forced to suspend company operations until a Pennsylvania businessman, Joseph T. Jones, came in and reorganized the company in the 1890s, a reorganization that had to contend further with the fallout from the Panic of 1893.[119] But overall, it was clear that with such a rich crop of timber awaiting harvest and export, Hattiesburg would have to grow its connections to other cities.

The year 1897 sparked the major phase of that growth. That year the G&SI Railroad was completed from Gulfport to Hattiesburg (partly via the

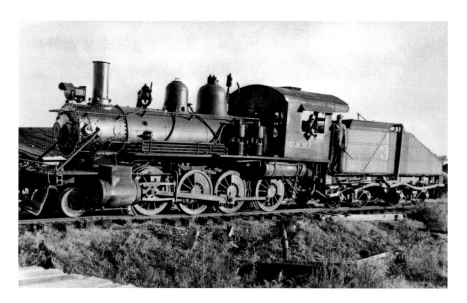

Gulf and Ship Island locomotive and tender (undated). *Hattiesburg Historical Photographs Collection, McCain Library and Archives, University of Southern Mississippi. Courtesy of Kenneth G. McCarty Jr.*

use of convict labor),[120] and the J.J. Newman Lumber Company laid the first tracks on the Pearl and Leaf Rivers Railroad westward from Hattiesburg to the towns of Columbia and Monticello.[121] After this followed the completion of the G&SI from Hattiesburg to Jackson in 1900, then Hattiesburg to Mobile on the Mobile-Jackson-Kansas City railroad in 1902, later bought by Tatum and renamed the Bonhomie and Hattiesburg Southern. In 1905, the Pearl and Leaf Rivers Railroad was bought and rebranded the Mississippi Central Railroad, and three years after that, with the completion of its westernmost link from Brookhaven to Natchez by the Natchez and Eastern Railway in 1908, an unbroken connection from Hattiesburg to Natchez was complete. By 1910, the year the Southern Railway Company rail depot opened, Hattiesburg was now linked by rail with all six of its nearest major cities—New Orleans, Meridian, Gulfport, Jackson, Mobile and Natchez—and all of their export markets in addition.

Back in town, however, this unbridled growth stimulated the continued development of city businesses and infrastructure, with many more of the town's basic services expanding as Hattiesburg rose to become the state's fourth-largest city. Chief among them was healthcare, an industry that grew at remarkable speed and many of whose contemporary pillars were established that decade. Physicians had practiced medicine in Hattiesburg since the days

of its founding, dating back to Drs. Gillis and Dearman's "Doctor Shop" on the hill downtown. Throughout the late 1880s and 1890s, they would be joined by waves of other physicians in private practice, including one of the city's founding fathers of medicine, Dr. Theophilus Erskine Ross, a graduate of the College of Physicians and Surgeons in Baltimore who opened his practice in the Dozier drugstore in 1892.[122]

But it was not until after the turn of the century that modern clinical facilities began to take shape. In 1900, Ross opened the Ross Sanatorium, an extension of his practice. In a partnership with two other physicians in 1901, Dr. Walter Wesley Crawford opened the South Mississippi Infirmary on Plum Street. In a spirit of healthy competition that continues to define medical practice in Hattiesburg even today, over the next decade, these physicians grew and expanded their practices to become major regional clinical centers. In 1903, the Ross Sanatorium entered into an agreement with the Gulf and Ship Island Railroad Company to serve its employees, and the clinic became known as the Gulf and Ship Island Railroad Employees Hospital. At the same time, the South Mississippi Infirmary was planning expansion into majestic new facilities that finally opened on Walnut Street in 1905, after burning down twice the year before. Not to be outdone, in 1906, the Gulf and Ship Island Railroad Employees Hospital founded its training school for nurses and, after a change of ownership, became the Hattiesburg Hospital in 1908 (later to become the King's Daughter's Hospital in 1918, Methodist Hospital in 1921 and, finally, Wesley Medical Center in 1997).

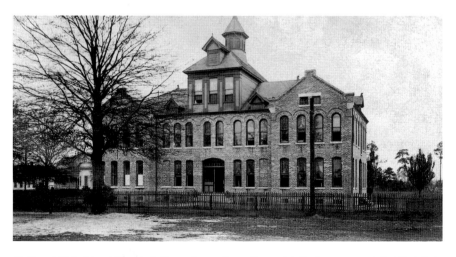

Gulf and Ship Island Hospital. *Forrest Lamar Cooper Postcard Collection, courtesy of the Mississippi Department of Archives and History.*

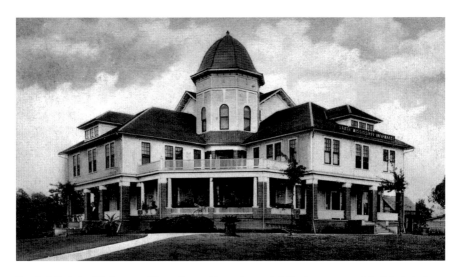

South Mississippi Infirmary. *Forrest Lamar Cooper Postcard Collection, courtesy of the Mississippi Department of Archives and History.*

Outside of physicians in private practice who would nevertheless use their facilities, the infirmary and the hospital would serve as the foundations of medical care in Hattiesburg for the next half century, until the 1950s and 1960s, when major new institutions would emerge. In that same pivotal decade, however, other basic services in public safety were also established: in 1903, the city formally established the Hattiesburg Police Department to replace the marshal system—who were, according to police department historians, "first taken off their feet when two horses were purchased in 1906"—and in 1904, the first paid fire department was founded under A.F. Potter to replace the volunteers.[123] With Potter at the helm, the first fire truck was a pair of beautiful Kentucky horses named Dexter and Duke drawing a hand-powered pump on a wagon, a system that remained in place until 1914, when the department bought its first motorized pumper.[124]

In the private sector, with timber continuing to fuel the growth of local businesses, individual proprietors quickly outgrew their humble, trading post origins of the 1880s. The year 1901 was another signal one, with the arrival of three major lumber concerns: the United Lumber Company under Fenwick Peck, J.J. Newman's ambitious former business partner; Rich Lumber and Manufacturing Company under millman and later mayor C.W. Rich; and Brookhaven Lumber Company under Maurice Dreyfus, mentioned above. Historian James Fickle has noted that in 1902, "the seventy-four-mile section [of the G&SI Railroad] from Hattiesburg to Gulfport averaged one sawmill

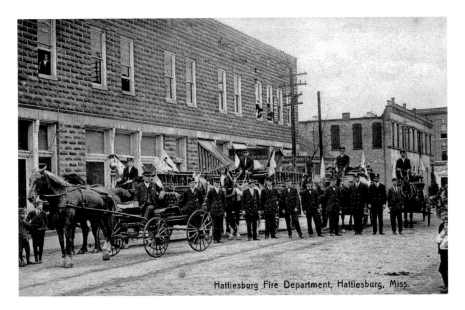

Hattiesburg Fire Department. *Forrest Lamar Cooper Postcard Collection, courtesy of the Mississippi Department of Archives and History.*

and one turpentine distillery every three miles," with approximately one-tenth of all yellow pine lumber produced in the South carried on that road by 1907.[125] Interestingly, Hattiesburg historian Kenneth McCarty observed that in 1902, with the founding of the Meridian Fertilizer Factory, the first primary industry in Hattiesburg not directly connected with the mills had arrived—suggesting that the city had taken a full two decades from its founding to diversify its economy.[126]

Lumber-related industries continued to develop—such as the Watkins Mechanic and Foundry Company, established in 1903 to service freight and logging cars—but diversify Hattiesburg did. Early industries such as the Hattiesburg Bottling Works bottled seltzers, tonics and early sodas, and in 1904, the Merchant's Company Grocers opened its doors, a major corporation whose parent company is still in operation today.[127] Many of these businesses, however, were small to medium-sized family-owned businesses such as Ben Shemper and Sons, an economic structure that would remain true of Hattiesburg for most of the twentieth century, until the 1970s and 1980s, when the wave of national chains and retail outlets would sweep the small towns of America.[128] Larger concerns such as the Kress Department Store, the Carter and Ross Buildings and the G&SI-serving Hotel Hattiesburg transformed the streetscape of downtown by

erecting iconic new buildings. With the founding of the Commercial Club of Hattiesburg (later the Chamber of Commerce) in 1906 to encourage economic development, an organization headed by city fathers including Hardy, continued prosperity seemed imminent.

Despite the city's rapid growth, however, this could not be farther from the truth. Thanks to the entrenched, virulent Reconstruction-era attitudes of the day, the 1890 Constitution of Mississippi and the 1896 Supreme Court decision of *Plessy v. Ferguson* that established the principle of "separate but equal," prosperity, nor even the opportunity to pursue it, was by no means shared equally by all citizens. The lives of African American residents of Hattiesburg had been legally curtailed compared to those of whites, leading almost to the creation of a separate city whose geographic borders partially overlapped with white Hattiesburg's but whose political, cultural, religious and economic borders were starkly defined.

Of these political structures, the Constitution of 1890 was by far the most damaging. A response to the return of the Republican Party to the White House in 1889, the constitution was assembled by a specially elected convention of white Democrats—many of whom were Confederate veterans and white supremacists—as an attempt to delimit the power of African American voters in the new era of the Fourteenth and Fifteenth Amendments. In order to establish legal methods of disenfranchisement of the uneducated, poor and primarily minority voters, this constitution required all voters to take a literacy test (of nonsensical difficulty), pass an understanding clause (a loophole for illiterate whites, and whose answers were subject largely to the examiner's satisfaction) and pay a poll tax of two dollars for two years in advance of any election in which the voter sought to participate, often a prohibitive fee. Unsurprisingly, voter turnout dropped across the state, with the drop among black voters far exceeding that of poor or rural whites.[129]

Political disparities were matched by economic disparities: across the South, sharecropping had continued well after the Civil War and would continue to do so in predominantly agricultural areas. The Piney Woods of south Mississippi were no exception. According to Nollie Hickman, in those ancillary industries surrounding lumber harvesting such as the naval stores industries, the lowest-paying jobs were frequently held by blacks, with living and working conditions that had changed little since the previous generation. Even in town, early photographs of the era reflect the ruling power structures of the day: the photograph of the founding meeting of the Commercial Club in the Hotel Hattiesburg depicts the town's white elites

being served by African American waiters, a visual motif that exists in a number of other photographs of businesses of the time.[130]

These disparities can also be seen in how opportunities were created, such as in public education, an area that perhaps most visibly defined the principle of segregation and that was observed as early as Robertson's 1898 history. The new public school for white students was a building of 21,268 square feet, which featured sixteen rooms, a library, playrooms for both boys and girls, a main hall that sat up to eight hundred people and the latest innovations in central heating, electricity, sanitation and lighting—not to mention automatic entrance into the state university system for graduates. Comparatively, the school for blacks in town was, in a word, nonexistent. As Robertson observed, "A school operated on the same principle as that of the whites is maintained for the colored people. They as yet have no building of their own, but a move is now on foot by which they will be furnished one in a short time. At present the school is taught in the Baptist church and is fairly well attended."[131] This schoolhouse would eventually be built: archival records at USM include building invoices for its construction in the late 1890s, a facility that, under the leadership and tutelage of educator W.H. Jones Sr., would grow from a one-room schoolhouse to the historic Eureka School in 1921, the first brick-built black school in Mississippi and one of the main schools for the African American community in Hattiesburg for the better part of the city's history.[132]

Unfortunately, print accounts of life in the black community have not survived to the extent that those of the white community have. Historian Flora Ann Caldwell McGhee has documented that of the three black newspapers (all weeklies) known to be published in Hattiesburg's early days—the *Herald*, published from 1898 to 1922; the *Hattiesburg Weekly Times*, also founded in 1898 and published at least through 1907; and the *Beacon Light*, published from 1913 to 1915—not a single issue of any of the three survives.[133] Unsurprisingly, other accounts record that discrimination was alive and well: early town leaders, steeped in the attitudes of the day, saw little reason for ideas about race to change. Gatherings of Confederate veterans were frequent, as a 1910 issue of the *Hattiesburg News* records, crowing that the dedication of the new Confederate monument at the courthouse was the "greatest event in Hattiesburg history."[134] While Hattiesburg did not suffer early White Camellia or Ku Klux Klan violence to the same extent as other southern cities, white supremacists did exert their influence. Historian William Sturkey has recorded the history of lynchings in the Hattiesburg area in chilling detail, with the first documented instance occurring in 1890

and later murders covered in national venues such as the *New York Times*.[135] To give but one example, W.H. Seitzler—Mary Oliphant's old adversary, and founder of the *Hattiesburg Daily Progress*, the newspaper that would become the *Hattiesburg American*—was known for his racist commentary, noting in one instance in a discussion of school funds for the black community, that "nothing has a greater tendency to elevate the Negro than a grass rope."[136]

This is not to say that all whites held these views, or that African American life was composed solely of hardship: in early Hattiesburg, blacks owned their own businesses, worshipped together in vibrant congregations—including the historic Shady Grove Baptist Church, which dates to 1864[137]—and created strong family and community linkages that continue to the present day. Ed Howell, for instance, was the highly respected owner of the People's Bank on Mobile Street and owned a prosperous small business serving the black community until his shocking assassination in 1907.[138] Nevertheless, these shared challenges did lead to the formation of a tight-knit community proud of its heritage, one that, over the course of the twentieth century, with the transformation of racial ideologies and attitudes in the civil rights era, would assert its voice in Hattiesburg's civic life in profound and remarkable ways.

Amid its growth, Hattiesburg faced other challenges in those years, such as natural disasters including hurricanes (including a major storm on September 27, 1906, which caused over $300,000 worth of damage in Hattiesburg alone and destroyed about 10 percent of the state's yellow pine[139]), floods and tornadoes against which residents had little defense and zero warning. In 1905, the Leaf River flooded, inundating the downtown residential districts and forcing residents to navigate by bark, boat and canoe, and in 1908, a massive tornado struck Purvis, the small lumber town a few miles south of Hattiesburg on the New Orleans and Northeastern Railroad.[140] On April 24, a twister—by some accounts as large as two miles wide—swept through the center of town, leaving 83 people dead, 340 wounded and 1,935 people impoverished and destroying the built environment almost completely. The tornado broke records not just in the state but also in the country for its lethality. As one account observes,

> *The depot of the New Orleans and North Eastern R.R. went down early. It was thrown across the track, while the cars standing in front were carried off the right of way. Then the large brick stores on a little hill opposite the depot were struck…A separate funnel seemed to have covered the town on the side where the Court House is located. This funnel seemingly followed the main portion of the tornado, and played with buildings as tho they were*

*put up of paper. The scenes of destruction were terrible. The big new Court House was in the center of town. Every piece of glass in it was blown out. The most of the roof was wrecked. The beautiful big "Town Clock" to a degree withstood the storm. The dial was perforated by flying timber in a number of places, the clock stopped at 2:13 o'clock, by this you could tell what time the cyclone struck the little city.*[141]

Given the limitations of transport and communication of the day—with the telegraph wires down, a horse and messenger had to be dispatched to Hattiesburg for help—the response was swift. That same afternoon, trainloads of doctors, supplies and relief workers (including Dr. W.W. Crawford) left for Purvis, led by United States Army major C.A. Devol from the nation's capital, a veteran of the 1905 earthquake in San Francisco. Devol's report to his superiors describes the organized relief efforts in detail, but in one example of the interlinked nature of these railroad towns, the New Orleans and Northeastern Railroad Company donated free passage for all relief material in the aftermath of the disaster, and Hattiesburg leaders such as W.S.F. Tatum and D.B. Henley immediately responded by serving as fundraisers and philanthropists to rebuild the devastated community. Tatum donated all the lumber for the rebuilding of a destroyed church, and Henley, the photographer to whom Hattiesburg owes so many of its early photographs, produced photographs of the disaster whose sale supported the relief fund.[142] Such community spirit would be found time and time again in Hattiesburg's history, including after another devastating tornado a century later, in 2013.

# 1910: A Pivotal Year

The turn of the century had seen remarkable transformations in the growing city, transformations that could not escape comment by locals. One writer in the *Hattiesburg Daily Progress* floridly observed in 1900 that

*Hitherto the city's career has been in the domain of doubt and uncertainty; but it is no longer beset by these clogs, all doubt and uncertainty have been dispelled as to her future. She is no longer the timid virgin of tender years, afraid to go forward, and determined not to turn back; but she sees the Beacon Light ahead to guide her footsteps and buoyant face, she is bounding*

*forward in the race of progress, determined never to stop until at least the goal is reached and she shall become the beautiful crowned queen of the pine woods and the first city of the state.*[143]

Such energy and enthusiasm was infectious, and not just due to the arrival of the Great Wallace Shows' traveling circus in 1904 and its Whirling Molassos, Marvelous Nevaros and Clever Deliemeads in the "World's Most Perfect Series of Arenic Displays."[144] Such spectacles were symptom, rather than cause, of the excitement. As Gaines S. Dobbins, the editor of another of Hattiesburg's earliest newspapers, the *Saturday Evening Eye,* famously wrote in 1905,

*From a village of barely 600 inhabitants twenty-two years ago to a city of 14,500 at the present; from a property valuation of about $30,000 in 1885 to nearly $8 million in 1905—twenty years since; from a dense pine forest, much of which twenty-five years ago had never been seen or traversed by man, to one of the wealthiest, most populous and prosperous sections of the state; in a word, springing from a wilderness to a metropolis within the phenomenally short time of less than thirty years—such is the record of Hattiesburg, typical of the New Era of the New South.*[145]

Echoing the point, W.O. Thomas would gush three years later that "Southward the star of empire takes its way, and Aladdin has rubbed his lamp on Hattiesburg. No city throughout the entire country, not even excepting the marvelous West, may show a more rapid ratio of growth than can Hattiesburg…[Of] the spirit of its citizenship, the human dynamo, pulsating with life and energy, nothing is herein set down, for that must be personally felt to be appreciated."[146] Of all of Hattiesburg's first years, however, those around 1910 emerge as those in which the present-day city took shape, with the majority of its layout, industry and major institutions established. Geographically, the town remained modest: to the north and east, the Leaf and Bouie Rivers still provided the main town boundaries (across the Leaf, the town of Petal would receive its first post office in 1904 but would not be officially incorporated until the 1970s[147]). To the west, even though in 1902 lumberman John Kamper had donated forty acres to the United Daughters of the Confederacy for a park that would bear his name, this area was still far outside of town.[148] To the south, Thomas Dearman, cited above, recounted that in 1908 "Hattiesburg only went to Sixth Avenue," beyond which "it was all open field where cattle were grazing

as the [State] of Mississippi was a free grazing State."[149] Nevertheless, despite this modesty, Hattiesburg's economic and political fortunes were still ascendant for two main reasons.[150]

First, its economic base was assured, with the majority of its mills still operating at full speed, and the downturns of the 1920s and 1930s still years away. Its population now stood at 11,773, almost three times what it had been just a decade earlier. Historian Nollie Hickman records that by 1910, the peak of the lumber industry in Mississippi and with millions of dollars and board feet flowing through the area each year—the same year that the Southern Railway Company opened its new, celebrated rail depot downtown—Hattiesburg was positioned to become far more than just a railway stop on any of its lines.[151] Known as a center both for production and distribution and home to "thirty important wholesale concerns," by 1911, Hattiesburg's role as the hub at the center of a wheel of many spokes was established, and to affirm this role, a public election would be held to replace its old nickname of the Magic City for a new one the following year.[152] To give but one indication of the newly christened Hub City's central position in the industry, WPA historians record that during these years, "market quotations for yellow pine were based on Hattiesburg prices."[153]

Second, Hattiesburg had emerged as the dominant town of southeast Mississippi, outpacing its rivals in the area such as Laurel, Gulfport and Meridian. In recognition of this fact, in 1906, the state legislature authorized the creation of a new county to be carved out of the western portion and

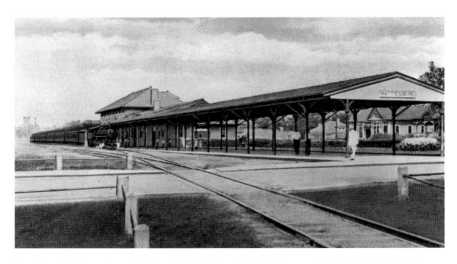

Southern Railway Depot (undated). *Hattiesburg Historical Photographs Collection, McCain Library and Archives, University of Southern Mississippi. Courtesy of Kenneth G. McCarty Jr.*

second judicial district of Perry County, of which Hattiesburg would serve as the county seat. As well known as the fact is that the new county's namesake would be Colonel Nathan Bedford Forrest, Confederate war hero and prominent early leader of the Ku Klux Klan, less well known is the fact that the original name put forth for this new county was indeed Hardy County, after the city's founder. This measure had come up not long earlier, when Hardy was serving as a state senator in the 1890s. Proving that power rarely forgets a slight, Governor A.J. McLaurin rejected the original measure on the grounds that Hardy had once opposed his choice of plans for a new state capitol building. As Hardy recalls in his memoir,

> *While I was a member of the Senate, a bill was introduced creating a new county with Hattiesburg as the County Seat. This bill named the new county "Hardy County" in my honor. The bill passed the Senate without a dissenting vote. I did not vote of course as I purposely absented myself from the chamber when the vote was taken. It passed the House with only four objecting votes and was sent to the Governor for approval. The Governor felt and expressed very keen resentment against me for causing the defeat of his plans for the new Capitol, though he must have known that I acted only on my best judgment after a thorough study of both plans. He had a chance here to strike back and he did so by vetoing the bill upon some trumped up constitutional ground. That was the end of Hardy County.*[154]

Hardy's legacy would instead fall to a street leading westward out of town, with Hardy Street today a central thoroughfare and, in many ways, a street that, fittingly, runs the length of the city. The year he died (a decade later in 1917), Hattiesburg would be home to nearly thirteen thousand people—no small legacy, either, for a farmer's son from rural western Alabama.[155] Even so, after a referendum in 1907, Forrest County was created on January 6, 1908: a new courthouse was erected, a board of supervisors was elected that same year and a new chapter in the city's history began. The road to that point had scarcely been smooth—the Hattiesburg Area Historical Society has noted that by the time Forrest County was created, the area that would become known as Hattiesburg had been part of five total counties: "This long, lean county was a part of Perry County, which was a part of Greene County, which was a part of Wayne County, which was a part of Washington County in the original Mississippi Territory. A small portion of the southern end of the county was a part of the West Florida Republic for a short while."[156] To that list, of course, add one rebellious and defeated

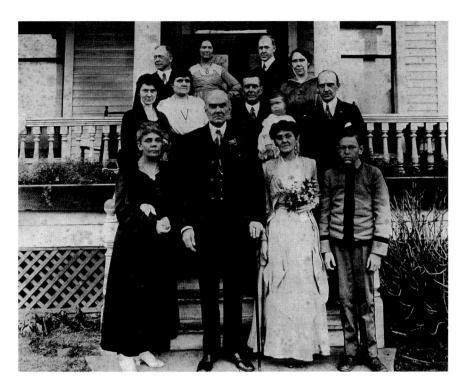

William Harris Hardy, eightieth birthday celebration, Gulfport, Mississippi. *From the Hardy (William H. and Sallie J.) Papers, McCain Library and Archives, University of Southern Mississippi.*

nation, three colonial empires and untold centuries of native settlement and cultivation. But from this point in 1910 on, just as much as downtown had already been transformed from its humble origins, major new institutions in higher education and the armed forces were soon to arrive in Hattiesburg, institutions that would transform the city permanently.

## 3

# THE HUB CITY MATURES, 1910-40

## *A Walking Tour of Hattiesburg*

To walk around Hattiesburg in those days—or to ride a horse, hopefully at legal speed—was to see, as newspaper editor Dobbins had exulted, a city in the very prime of its youth. With industry booming, the city was growing both upward, in its downtown commercial district, and outward, to its residential neighborhoods. The years between 1910 and 1940 would see profound changes in the local, state and national landscape: two global wars, national prohibition and the Great Depression would all leave their marks on the area, as would the transformation of its industry and economy. Moreover, the institutions that would come to define Hattiesburg in the twentieth century—the University of Southern Mississippi, William Carey University and Camp Shelby—would make their entry early, all in the 1910s.

As Hattiesburg was emblematic in those years of a thriving regional capital, it is worth a retrospective tour of what the city, now past its adolescence and entering its young adulthood, would have looked like. As historian Louis Kyriakoudes has suggested, few southern cities of the era still retain their original urban fabric and layout to this degree, giving Hattiesburg residents a ready source of pride.[157] Despite the losses it has suffered over the years, the city still enjoys a considerable degree of architectural integrity in many of its early neighborhoods, yielding views of the historic downtown area and neighborhoods that still resemble those taken by the men and women who first built them.

We begin, then, downtown and move clockwise through each of the surrounding neighborhoods. Downtown enjoys both architectural unity and diversity, one of its strengths as a historic district. While the majority of the city's flagship institutions—such as the new city hall (finished 1923), the Forrest County Courthouse (1905), the Masonic Temple (1920) and the Old Federal Building (1910)—were built in Neoclassical style, ideal for a young, proud democracy, commercial enterprises adopted more metropolitan, forward-looking motifs. The Ross (1907) and Carter (1910) Buildings exhibited the Commercial style, with elegant window and corner decorations featuring Prairie School elements that set them apart from their neighbors. As the period drew on, Art Deco entered in the Forrest Hotel (1929), the Saenger Theater (1929) and the Kress Building (1940) and found its fullest expression in the main post office (1933–34), a WPA project that added monumental weight to the downtown governmental and business district. While some iconic buildings of the era—such as the Hotel Hattiesburg (1906) and the YMCA building (1915), both Neoclassical—are now lost, architectural historians generally agree that downtown retains a large measure of its early character. As Jody Cook writes, "The city's center is defined by its combination of cohesive setting, local institutions, and range of architectural styles, conveying a distinctively urban sense of time and place within a rural state containing few similar urban environments."[158]

Spiraling out of downtown like numbers on a sundial were the city's residential neighborhoods, all of which were formed out of cutover timber land, with streets, houses and sidewalks gradually replacing the dense stands that had once completely surrounded the small town. As the city cut its way into the forest, the trees ironically fueled their own demise, reappearing as houses for residents whose livelihoods were often tied to the timber industry—a vicious cycle. In general, residents built according to the topography, materials, means and styles that were available to them, with those styles ranging widely from the humble folk vernacular for those who worked in the mills all the way up to imposing Colonial and Classical Revival mansions for those who owned them. Outside the city limits, small communities such as the company town at Bonhomie owned by W.S.F. Tatum enjoyed houses, churches and stores all their own.

Within the city limits, the earliest of these neighborhoods was the Newman-Buschman neighborhood, a stone's throw across the railroad tracks from downtown. City historians have observed that "when Hattiesburg was incorporated in 1884, the city limits were set as distances from the depot: the river on the east and a mile in all other directions. The

first structures of the young town sprang up around the depot, so that the Newman-Buschman District, an elongated area stretching along the New Orleans and Northeastern Railroad track at the southeast edge of downtown, was among the first areas settled."[159] Originally built to serve the Buschman and Newman mills, this small sliver of land bordering Gordon's Creek featured company offices, workers' dwellings and privately operated utilities. While the neighborhood has suffered some losses over the years, several structures in the Queen Anne, Neoclassical and Folk Victorian styles still survive, giving a sense of the intimacy and proximity of work and home life at the time.[160]

Immediately adjacent, across Gordon's Creek to the south, was the neighborhood now known as the Hattiesburg Historic Neighborhood District but that in its day was simply known as the neighborhood where the majority of the city's upper classes lived, including many of its founding fathers. This neighborhood, spread out on either side of Bay Street, is arguably

> *the Hub City's most architecturally significant residential neighborhood, and the oldest neighborhood in the city retaining its integrity. This district documents the growth and prosperity of southeast Mississippi's principal urban center from its beginning in the early 1880s until 1930 and*

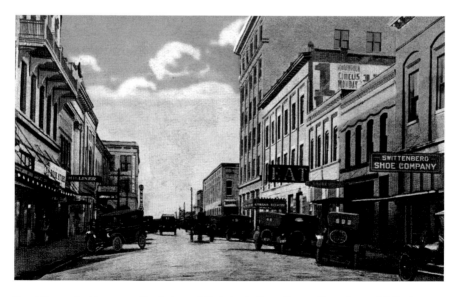

Front Street, looking west, Hattiesburg, Mississippi. *Forrest Lamar Cooper Postcard Collection, courtesy of the Mississippi Department of Archives and History.*

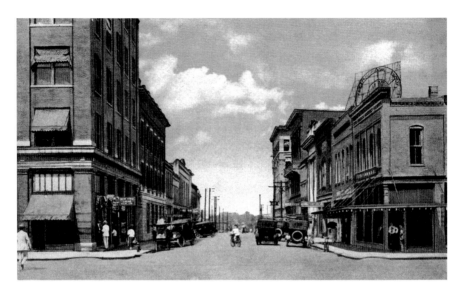

Front Street from Main, Hattiesburg, Mississippi. *Forrest Lamar Cooper Postcard Collection, courtesy of the Mississippi Department of Archives and History.*

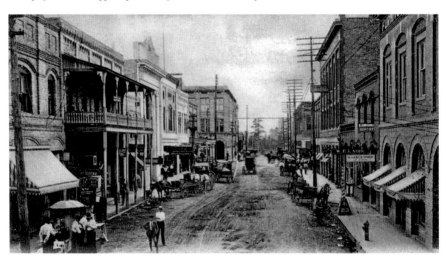

Front Street looking south from Palace Restaurant, Hattiesburg, Mississippi. *Forrest Lamar Cooper Postcard Collection, courtesy of the Mississippi Department of Archives and History.*

*parallels the development of the central business district. The district's dual significance is derived from its variety of house types and range of architectural styles and through association with its many historically prominent residents. Within southeast Mississippi, this is the outstanding*

*residential district representing the 1880–1930 era, in both its size and diversity of architectural styles.*[161]

Taking advantage of the low, flat land and open lots, these styles paid particular respect to local conditions of topography and weather. "The prevailing climate of Hattiesburg established only one universal restriction," city historians write, "the necessity of generous ventilation, satisfied by central hallways, large and numerous doors and windows, high ceilings, and extensive porches, all features common to southern architecture. The omnipresent threat of flooding—as well as demands of cooling—dictated pier and beam construction."[162] Residents built predominantly in the Victorian, Queen Anne, Neoclassical and Colonial Revival styles; early residents included Dr. T.E. Ross (of the Ross Sanatorium), J.P. Carter (of the Carter Building), George Komp (of Komp Machine Works), W.M. Conner (businessman and early mayor), Dr. W.W. Crawford (of the South Mississippi Infirmary) and the family of two later governors, Paul B. Johnson Sr. and Jr. Furthermore containing the city's oldest continuous house of worship, Bay Street Presbyterian Church (1907), this area has enjoyed minimal loss over the years, and a drive through the neighborhood today still evokes the pattern of life of over a century ago.

West of downtown arose a neighborhood between the railroad tracks to the southeast and Hardy Street to the north, growing westward into an expanding triangle carved up into a grid. This neighborhood, the Oaks, was characterized by its wide avenues of oak trees lining the broad streets (many of which date to their founding) and by its mixture, more prevalent as time went on, of upper- and middle-class housing. Architectural historians have noted two facts of interest about this neighborhood: first, its irregular phases of growth, with growth slow until the introduction of streetcars after 1907. After the streetcar lines arrived, traveling down Hardy and West Pine, however, "each decade until 1930, growth doubled in the district."[163] If the earliest and largest homes, closest to downtown, were built on multiple-lot tracts, the later homes picked up on a fad that was traveling the country: the kit home craze of prefabricated, do-it-yourself structures of the 1920s seems to have reached Hattiesburg just as the Oaks was expanding to the west, leading to an abundance of Craftsman-style bungalows built for the growing middle class and still present today. One historian explains:

*The nationally prevalent Craftsman style was very popular in Hattiesburg for several reasons. First, as a product of the "New South," Hattiesburg*

*lacked an architectural heritage from which to borrow. Second, as the hub of the "Piney Woods" of south Mississippi, there was an abundance of material to build these bungalows. Third, Hattiesburg was home to two plants which mass produced Craftsman bungalows and their components—the Michigan-based Aladdin Company, and the Iowa-based Gordon Van Tine Company.[164]*

Interestingly, the Oaks is also home to one of Hattiesburg's enduring myths: the origins of the names of Corinne, Adeline and Mamie Streets. Popular legend still holds that these streets were named after Hardy's three daughters, just as the town itself was named after his wife. Unfortunately for peddlers of this legend, however, of all of Hardy's twelve children from his three wives, none of his children, male or female, bore any of those three names. Rather, as writer Carolyn Thornton explains, "More likely Mamie was named for John Kamper's daughter and Adeline named after his [Kamper's] sister. Kamper, who donated land for the city's Kamper Park, was a lumberman, banker, and real estate man, and the original plat of the Oaks District bore his name."[165]

North of Hardy Street and northwest of downtown was the North Main Street neighborhood, now the North Main Street Historic District, which grew in rough agreement with the curve of the Leaf River. While this neighborhood has suffered considerable loss to its architectural integrity since its founding, it is known for such distinctive structures as the McLeod House, the most iconic Queen Anne Victorian structure in the city, and the old Hattiesburg High School, a 1921 Jacobethan building designed by the renowned Hattiesburg architect, Robert E. Lee. As one account explains,

*The Old Hattiesburg High School is architecturally significant in Hattiesburg's history because it is the largest and most sophisticated example of the Jacobethan Style in the city. It is the only known design in the style by Lee, Forrest County's foremost architect of the early 20th century. He also designed Hattiesburg City Hall, 1923, Masonic Temple, 1920, and I.O.O.F. Lodge No. 27, 1907. He was responsible for the designs of the 1907 Ross Building in the Chicago Commercial Style and a 1927 Mission Style school at Brooklyn.[166]*

Elsewhere in the neighborhood, the styles vary, including Colonial Revival, Craftsman and Queen Anne, as well as folk cottages and bungalows. Now seen as exemplary for its representation of how the city grew from a

railroad town to a regional center, architectural historians laud North Main as an "identifiable and cohesive district with an aesthetic sense of this past period of growth through elements which maintain their integrity. These elements represent a continuity of design style, type, period, and method of construction of architecture stemming from a shared cultural background and availability of materials. The period of significance for the district is from 1896 through 1942."[167] Put another way, its status as one of Hattiesburg's most normal neighborhoods has, ironically, made it unique.

Of course, in the Jim Crow South, neighborhoods were largely racially segregated, with the majority of the neighborhoods listed above inhabited predominantly by whites. While workplaces such as mills, offices and service-industry facilities would see a degree of everyday racial interaction, the residential sphere saw comparatively less with the exception of black domestic labor at white homes. For African Americans, who had settled in areas such as Palmer's Crossing and the Kelly Settlement outside of town, the primary neighborhood in town was Mobile Street, falling within a large, open expanse of the Leaf River floodplain due north of downtown. Architecturally, the major styles of residences included Colonial Revival, Queen Anne and folk cottages and bungalows:

> Along Mobile Street the one and two-story, row-style business structures are interspersed with residences, presenting a streetscape of alternating houses and business structures, some of which have been lost to demolition. On Mobile and throughout the district, structures are set close together with narrow setbacks from the street. The development of residences surrounding the Mobile business district was most dense west and south of the business section. Development on the north and east dwindled to fewer and fewer homes, giving way in the old days to cotton, pea, and potato patches, and areas of overgrowth where timber had been clear cut.[168]

While this neighborhood comes most visibly into focus in the context of the civil rights movement in Hattiesburg, it is important to note how central Mobile Street was to African American life in the early part of the city's history. Not only was it home to black-owned shops, banks, restaurants, hotels, churches and schools, but it was also home to the city's African American medical community, including its first doctor (Dr. C.E. Smith) and pharmacist (E.H. Smith). Mobile Street was, according to many residents who grew up there, a self-contained city, not just a source of livelihood but the place to see and be seen and a vibrant, lively community. Despite the fact

that segregation meant that public services and facilities were slower to arrive there than elsewhere—Charles Brown, one native of the neighborhood, recalls using outhouses instead of modern plumbing as a young boy as late as the 1940s[169]—Mobile Street was still very much beloved among the members of its community.

Taken together, by the 1910s, these six neighborhoods comprised the bulk of historic Hattiesburg, with only minor outlying exceptions such as company towns or small timber communities like Bonhomie, Richburg or Glendale—towns that would eventually be subsumed into Hattiesburg as years went by. As the Hub City grew, its civic infrastructure consolidated as well: in 1910, the city adopted the mayor-commission form of government that would last until 1985, and in 1917, the *Hattiesburg American* (formerly the *Hattiesburg Progress* and the *Hattiesburg News*) emerged out of the plurality of early news outlets to become the dominant news organization. The name change came from accusations that Howard S. Williams, editor of the *News*, harbored pro-German sentiments during World War I—which Williams promptly calmed by giving his paper a more patriotic masthead.[170]

Further changes were afoot as the city's physical character began to transform. As noted above, in 1907, a streetcar system operated by the

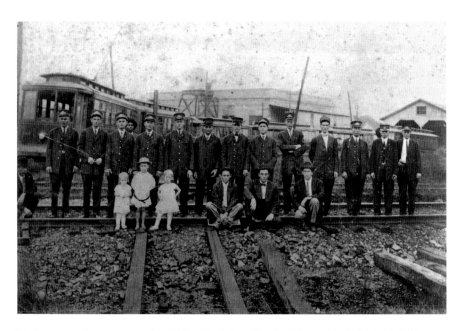

Trolley car and passengers, circa 1920. *Hattiesburg Historical Photographs Collection, McCain Library and Archives, University of Southern Mississippi. Courtesy of Kenneth G. McCarty Jr.*

Hattiesburg Traction Company began to radiate outward from downtown, traveling down major thoroughfares such as Hardy Street, West Pine Street and Bay Street. By 1913, it would reach Mississippi Woman's College, prior to which a horse and buggy had ferried students to and from town, and the year after that, a line would be built to Mississippi Normal College a few miles to the west.[171] The early 1920s would see the streets paved first with concrete (1922) and then with asphalt (1924), a motorized bus fleet would replace the streetcar system (1925) and tickets would henceforth be issued not to drivers of speeding horses but to drivers of horseless carriages.[172] J.O. Barron would found his famous Motor Company in 1919, and among other authorities and residents who traded in their reins for steering wheels in those years was the Hattiesburg Fire Department, which had motorized its engines early, in 1915. While ultimately allowing the department to respond more swiftly to outbreaks that continued to plague the city, the move was not without cost: an accident in 1921 took the lives of two firemen, including the department's first chief, A.F. Potter. Tragically, his son, also a fireman, had been driving the truck.[173]

These modernizations came none too soon, for alongside the growth of the city's industry and population that decade would come the next two significant sectors in its makeup, both in the same decade: higher education and armed forces. Hattiesburg would never be the same.

## *Higher Education Breaks Ground*

The story of Hattiesburg's history is inseparable from the stories of its two flagship educational institutions, the University of Southern Mississippi (neé the Mississippi Normal College) and William Carey University (neé the Mississippi Woman's College). But even though both institutions were formally established in 1910, the story of higher education actually dates back years earlier. The story begins properly in 1892, when educator W.I. Thames founded the Pearl River Boarding School in nearby Poplarville, a stop on the New Orleans rail line about forty miles from Hattiesburg. According to university historians, Thames's school survived until 1905, when a fire destroyed it completely. Undaunted, the determined teacher gained funding from a group of businessmen from New Orleans to establish a regional college in south Mississippi, the first institution of higher education in the Piney Woods.[174] As the largest city in the region and a clear locus of growth, Hattiesburg was the obvious choice, and so in November 1906, Thames

opened the South Mississippi College a few miles south of downtown, which promised the following lavish amenities: "accommodations for 300 students, with steam heat, electrical lights, sanitary toilets, hot and cold shower baths, and artesian water provided."[175] Nor were the educational facilities spared any expense. As historian Donna Duck Wheeler records,

> *The faculty of the college numbered 16, and the college had impressive facilities. The main building of the campus contained 12 recitation rooms to accommodate 500 students, music rooms, a library with several thousand selected works, an auditorium that would seat over 1,000, classrooms, and offices for the administration and faculty of the college. The girls' dormitory had rooms for over 100 women, and the boys' dormitory housed 200 men. The dining hall would accommodate 320 students.[176]*

Situated in an open field of barely tended scrub brush and wiregrass, the coeducational college would quickly develop a reputation for excellent academics and social life, with an emphasis on art, music, history and home economics, including a much-beloved band. Former students, however, recalled other aspects of campus life. As one recounted in 1956,

> *It* [South Mississippi College] *was nothing but a forest of cut-over pine land covered with stumps. We had a football team and a baseball team. We never had more than 11 men on the football team and substitution was unheard of then. We had demerits for rule-breakers and the penalty was digging stumps. For any offense, the student would be assigned an ax and shovel to dig up a stump. Mr. Thames was a strict disciplinarian.[177]*

The school operated until February 1910, when a catastrophic fire destroyed the main administration building. Thames's daughter later recalled that the band was practicing the night of the fire, and that it consumed nearly all of their instruments.[178] With the physical and symbolic heart of the campus destroyed—Thames's second loss of such a kind in five years—South Mississippi College was forced to close, and given the crippling cost of rebuilding and the rumors of the establishment of a new college across town, that closure would become permanent.[179] The immediate future

*Opposite, bottom*: Donation of property and funds to establish Mississippi Woman's College. *From left*: R.W. Dunn, W.S.F. Tatum, W.E. Holcomb (undated, circa 1910–11). *Copied from* Hattiesburg American *newspaper, origins of photograph unknown.*

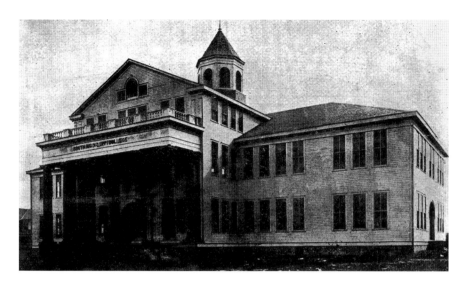

South Mississippi College. *Forrest Lamar Cooper Postcard Collection, courtesy of the Mississippi Department of Archives and History.*

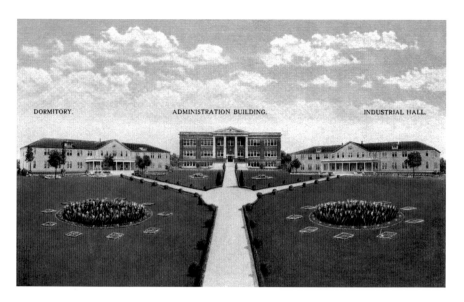

DORMITORY.    ADMINISTRATION BUILDING.    INDUSTRIAL HALL.

Mississippi Woman's College. *Forrest Lamar Cooper Postcard Collection, courtesy of the Mississippi Department of Archives and History.*

for the site seemed grim, but the need for higher education had become more than a passing issue, and the following year, lumber magnate and Methodist parishioner W.S.F. Tatum bought the abandoned property—ten acres of land and the two surviving residence halls—and, after his own denomination declined his initial offer, famously donated the land and the buildings to the Mississippi Baptist Convention to establish a new school for women (no longer a coeducational institution) under the Baptists' academic and spiritual tutelage. The Baptists formed a board of trustees composed of numerous city fathers (including Dr. T.E. Ross, who was named chair of the board), hired a founding president (W.W. Rivers) and, in November 1911, reopened the institution's doors under a new name.

In its first three years, Mississippi Woman's College enjoyed dedicated faculty, eager students and close quarters. Wheeler notes that Dockery Hall, one of the two surviving buildings,

> *housed the president's family, the faculty, a dining hall, a kitchen, a laundry room, and a makeshift auditorium. O'Briant Hall was the administration building, academic building, and housed the Industrial Home, which was run on the cooperative plan with the girls doing all the work, cooking, dishwashing, and scrubbing.*[180]

With the completion of the streetcar line to downtown, however, and the construction of the majestic new Tatum Court building in 1914—an echo of the lost SMC administration building that had preceded it, featuring an enormous auditorium, a library, classrooms and academic departments, piano practice rooms, a gym and even a swimming pool in its basement—the college began to take off.

Growth over the next decade was steady, with the college serving an ever-increasing enrollment of students from kindergarten age to baccalaureate, and the academic programs already beginning to show the strengths in the fine and performing arts that would characterize the institution over many of its subsequent decades. But fire had not yet consumed its final meal on Tuscan Avenue, and in March 1919, O'Briant Hall was completely consumed. As the *Hattiesburg American* recorded at the time,

> *O'Briant Hall of the Mississippi Woman's College was completely destroyed by fire here shortly before noon today. The loss, including the personal effects of the students and teachers in the dormitory, is estimated by Dr. J.L. Johnson, president of the institution, at about $35,000. The building, erected at a cost of $30,000, is covered by $5,000 insurance. It was a frame structure. Sparks falling from the smokestack of the engine room onto the roof of the building caused the blaze, according to the college authorities.*[181]

Thankfully, no lives were lost in the blaze, but the loss of one of the college's only three buildings (and only two dormitories) did lead to unavoidable problems: namely, housing. Students were quickly relocated, sometimes to surprising places. As one former student, Dorothy Ware, later recalled, "We had cots all over…we even slept on the roof some. We thought it was a great adventure. It was the biggest excitement we ever had!"[182] Moving quickly to respond to the disaster, the administration rallied both the college and the town communities to build two new dormitories—Ross Hall and Johnson Hall in 1919, built this time out of fireproof brick—and continued to pursue its mission of training young women over the following years. Their efforts would be rewarded: not only would a new infirmary for students, Mary Ross Hospital, open in 1922, but following the elimination of the precollege curriculum and a renewed focus strictly on higher education in the early 1920s, the Woman's College would receive accreditation in 1926 from the regional governing academic body, the Southern Association of Colleges and Schools, a major step forward for the institution.

Its fortunes would change significantly during the Great Depression—as would the fortunes of nearly every individual and institution in town—and it would even endure a brief period of closure during World War II, but the first two decades of its existence served both the college and the city well. The sights of uniformed young women in black robes and caps stopping off the streetcars and buses downtown for a combination of window shopping, sightseeing and people-watching were both common and, as historian and longtime Carey professor Milton Wheeler records, welcome. An editorial in the *Hattiesburg American* from 1929 observes:

> *Modern college students come in for a great deal of criticism. Some of it seems justified. There is no gainsaying the fact that many regard college as a very nice winter resort and pay more attention to sports and social life than to books and social service. There are schools in this country which turn out pampered pets trained only to live the life of social parasites. Mississippi Woman's College is founded along different lines. And it is quite evident that the institution is succeeding remarkably well in instilling its ideals in the minds and hearts of its graduates.*[183]

To return across town: like the Woman's College, the groundwork for the Mississippi Normal College had been laid in 1906, when the first of three successive bills in the Mississippi legislature to establish a state institution for the training of teachers was first proposed. (The campaign for such a college had begun in 1877 with the formation of a State Teachers Association, but legislation did not advance until after the turn of the century.[184]) As historian Chester Morgan records, following early defeats in 1906 and 1908, the third time was the charm: under the intense lobbying of state representative Marshall McCullough, a passionate advocate for education, lawmakers finally signed the bill on March 30, 1910.[185] After a brief competition between cities around the state for the site—Jackson and Laurel also put forth proposals—Hattiesburg was chosen and the planning process begun.

From the beginnings of the Woman's College and the Normal College, their histories have been intertwined. Interestingly, in the few months between the selection of Hattiesburg for the state teacher's college and the breaking of ground for its campus, the city's history could have taken a very different turn from what we know of it today. After legislation to establish the college had passed, W.S.F. Tatum, ever the shrewd businessman, quickly offered the site of the destroyed South Mississippi College on Tuscan Avenue to the new trustees, in competition with a proposal by other city fathers

such as Dr. T.E. Ross, A.A. Montague and H.A. Camp for a site on Hardy Street.[186] Ultimately, the Ross proposal won out over the Tatum proposal by the narrow vote of five to four, but it is fascinating to consider at such a key moment how different the future growth of Hattiesburg would have been had the decision gone the other way. Not only would there have been just one institution of higher education in the first half of the twentieth century as opposed to two to complement one another and spur each other on, but the development of the town as a whole would have skewed more to the south, toward Gulfport, rather than to the west, toward Columbia (as detailed in Chapter 6). Land to the west would have remained undeveloped for far longer, and minus one university, the city's population would have been curbed as well.

Counterfactuals aside, however, construction of Mississippi Normal College began in 1911 under the design of architect R.H. Hunt, who envisioned a largely Colonial, Neoclassical campus in a pleasantly symmetrical, landscaped setting. Not every aspect of Hunt's design was fully realized—some buildings were never built, and others, namely the iconic Administration Building, were modified before their construction—but his original vision survived largely intact. Recognizing the benefits of this influx of human and economic capital, the city government extended its utilities and infrastructure to the new campus, and the first five buildings—College Hall, Hattiesburg Hall, Forrest County Hall, the Industrial Cottage and the President's Home—arose. After the board of trustees hired educator Joseph A. Cook to serve as the first full-time president of the institution and assembled a cadre of professors and instructors to teach the new teachers, the Normal College opened its doors in September 1912, remarkably the same exact month as its sister institution across town.[187]

Like that sister institution, its beginnings were humble. Not only did the buildings appear out of nowhere like mountains on a plain, but in its first years, the campus was as rural as the students it initially served. As historian Chester Morgan observes,

*Officials scheduled opening ceremonies for September 18, 1912, and when the faculty, students, and visitors arrived, what they found was hardly R.H. Hunt's vision of a carefully landscaped neo-Jeffersonian "academical village." Those early students remembered their years in Hattiesburg as "the Stump Age," and with good reason. The campus had only recently been carved from a vast cut over pine forest, untouched by human hands, as [early faculty member] Orville Brim noted, "except to make it more*

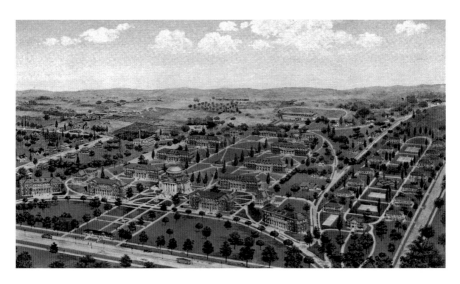

Mississippi Normal College, Hattiesburg Mississippi, showing proposed future development. *Forrest Lamar Cooper Postcard Collection, Courtesy of the Mississippi Department of Archives and History.*

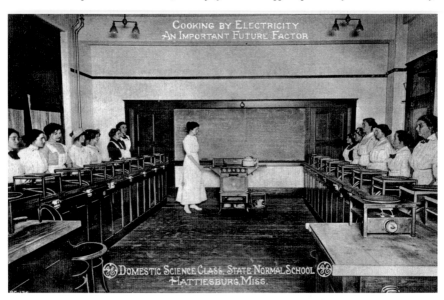

Mississippi Normal College classroom: "Cooking by Electricity: An Important Future Factor." *From the McCain Library and Archives, University of Southern Mississippi.*

*unattractive." The stump-scarred ugliness stretched as far as the eye could see in every direction except east, where the town lay some two and a half miles distant. Rising from this raw terrain, stark and incongruous, stood the*

*five handsome red-brick buildings, accompanied now by several functional wooden structures in various stages of completion, which were designed, according to Ed Polk Douglas, in what "could only be called 'lumber camp vernacular.'" They included a dining hall, a combination post office and college store, a powerhouse, and several dwellings. Excessive rainfall during the year had delayed construction, and evidence of the contractor's continuing presence lay scattered about: piles of dirt and debris, materials and equipment, a half-unloaded boxcar near the front of Forrest County Hall, and the builder's shack to one side, with several workers digging in an open trench to complete the water and heating systems.*[188]

Due to the need, and the shoestring budget that the institution maintained—it would not receive fiscal support from the state legislature until 1914—students quickly became heavily invested in the life of the college. When they were not in the classroom or studying, they served as farmhands, custodians, cooks and laborers in what is now called a work-study scholarship program but which then was simply keeping the doors open. Even so, school spirit and the sheer excitement of building a new institution kept morale high, with the early formation of an athletics association (1912), with its first (and ill-fated) teams nicknamed the Normalites, a post office and inaugural yearbook (1914), landscaping and beautification (1916–17), a campus newspaper and dedicated laundry building (1918) and, in 1920, a brass band, the precursor to the nationally celebrated symphony orchestra of today.[189] Student organizations grew like kudzu, to the point that within a few years after the school opened its doors, the list of available societies outpaced any one student's ability to take part in them all. As Morgan notes, "There were…in the early years county clubs, a college quartet, tennis club, debate team, women's glee club, storytellers league, Shakespeare club, and an honor council. By 1925 a school orchestra, commercial club, modern language club, dramatic club, American Legion chapter, and Masonic and Eastern Star orders had been added."[190]

Academics, true to the mission of the school, focused on training teachers to venture forth into the rural, poor areas of the state. Unlike the modern-day landscape of high school students populating college classes, many of the early teachers at the Normal College were mature students who sought either new careers or consolidation of their teaching practice. Their curriculum, a combination of remedial content in the liberal arts and sciences and teaching methods and strategy, led to certificates and diplomas for its graduands. One of the cornerstones of the campus was the Demonstration School

(originally the Observation and Practice School), a full-fledged K-12 school housed on-site at which teachers obtained immediate practical experience. Prior to its closure in 1962, the Demonstration School, as writer Bill Sutley notes, produced not only hundreds of trained teachers over its fifty-year history but thousands of proud "Demons" as well, including "at least two former Hattiesburg mayors, a one-time lieutenant governor, and others who achieved success in law, medicine, and other fields."[191] Writer Sharon Wertz summarizes the overall curriculum:

> *MNC was not set up as a degree granting institution. Students were given entrance tests to determine what courses they needed to study to prepare them to teach in the state's rural schools. Most took such courses as pedagogy (education methods), public school music, English, science, math, geography, art, domestic science (home economics) and physical education—courses which would help them directly in their teaching responsibilities. Depending on the number of courses taken, most students attended for from one to two years, working towards either a certificate, which was good for ten years' certification, or a diploma, which gave lifetime certification.*[192]

Again, like the Woman's College, the 1920s saw an emphasis on the standardization and professionalization of the school, with the awarding of its first bachelor's degree in 1922 and the changing of its name to the State Teachers College in 1924. With those advances in hand, over the course of the following decade, administrators fought to achieve regional and national accreditation from the Southern Association of Colleges and Schools and the American Association of Teachers Colleges, a process that, due to political conflicts and delays in the statehouse, would not reach fruition until 1929. If the institution's identity as Mississippi Normal College was largely tied to its leadership under president Joe Cook, its next incarnation was marked by the tenures first of Claude Bennett, who steered a wave of new construction including the auditorium and the iconic Administration Building, and, following Bennett's dismissal due to politics in the statehouse, J.B. George, who shepherded the college through further expansion in the 1930s. This era saw the construction of university landmarks such as the Hub, the Sunken Garden (now McLemore Hall) and Lake Byron on the corner of Hardy Street and Highway 49—not to mention Faulkner Field, which ushered in a period of mid-century prowess in athletics as well as academics.[193] Though challenges in this era would continue to arise—the Depression would slash campus budgets and enrollment lists, and the school would fend off two

separate legislative attempts to close it in the mid-1930s—by the end of its third decade, with another name change (this time to Mississippi Southern College) and with over thirty-six thousand teachers trained, its future as a major regional educational institution was assured.[194]

As is clear, notable parallels dot the accounts of both the Woman's College and the Normal College: sites several miles outside of town, strict academic and training regimens, active social and cultural lives, close-knit campus communities, a strong sense of group identity and spirit and a strident sense of purpose. The same characteristics would define the third major institution that dates to this period.

## The Founding of Camp Shelby: Hattiesburg's First War

In the years prior to that institution's creation, however, the city had been undergoing a subtle transformation. As noted earlier, with the bulk of the local timber cut, the 1910s had seen Hattiesburg quietly reach the peak of its lumber boom and begin a gradual, but inevitable, slope back down from its record profitability. The boom would not end immediately—historians Nollie Hickman and W.T. Schmidt both record that the Great War in Europe, which had broken out in 1914 after the assassination of the Austrian archduke Franz Ferdinand, had offered a brief lift in demand to the lumber market. Hickman notes that in response to foreign markets purchasing the bulk of their softwoods from the United States, "old sailing vessels were brought back into use to transport lumber overseas from ports on the Gulf of Mexico," and Schmidt offers an even more asserted, if slightly inflated, assessment: "As the war in Europe ground relentlessly on into 1917, the demands for pine lumber, turpentine, and other forest products sustained the economy of the area, secured the future of the city, and finally permitted the city's confident citizenry to look beyond the lumber business for other profitable enterprise."[195]

Given the strength of domestic pacifism and isolationism at the outset of the war, notions of American involvement were the exception rather than the rule. While students at the Normal College dodged droves of hogs and cattle on their way to class, while builders at the Woman's College put the finishing touches on Tatum Court and while one Dan Hall was pulling the largest catfish then recorded out of the Leaf River—a monster of a mudcat that "weighed

86 pounds, and measured 7½ inches between the eyes"[196]—newspapers and wireless transceivers trumpeted that the conflict between the European imperial powers would, and should, remain firmly on their soil.

All that ended, however, after the German sinking of the RMS *Lusitania* in 1915 (killing 128 Americans), the Zimmerman telegram from Germany to Mexico in early 1917 (a secret German communiqué promising the return of southwestern states to Mexico were it to fight against the United States) and a rise in attacks on Atlantic shipping. With support now behind President Woodrow Wilson, America's entry into the conflict on April 6, 1917, necessitated the founding of bases around the country to train its young men, recently drafted by the new Selective Service Act, into battle-ready soldiers. As has been so often the case in Hattiesburg's history, an insightful individual saw an opportunity. Dr. W.W. Crawford, founder of the South Mississippi Infirmary, had a personal connection to army chief of staff General Leonard Wood through a former colleague and seized his chance. W.T. Schmidt tells the story:

> *Realizing that Hattiesburg might capitalize on this personal relationship, Dr. Crawford immediately entrained for a Washington meeting with General Wood, leaving behind attorney T.C. Hanna, E.L. Robbins, and Judge N.C. Hill to prepare a prospectus designed to influence the selection committee. Following up on his cordial visit with General Wood, on April 17, Dr. Crawford submitted his committee's proposal to the War Department. After a preliminary inspection made by the army staff on May 27, the press announced, that following a personal inspection of various sites in the South, General Wood would make the final decision. Recalling those immortal words uttered by Mississippi's own Nathan Bedford Forrest, Dr. Crawford decided to "get there fastest." He promptly dispatched at the gallop of Dr. McHenry [his former colleague] and Judge Hill, who intercepted Gen. Wood in Atlanta, and persuaded him to come to Hattiesburg with a favorable decision.*[197]

The general visited the city on July 2 and announced his decision on July 12. Schmidt concludes: "Although Dr. McHenry's friendship with General Wood was probably decisive, the Commercial Committee's proposal was obviously enhanced by a generous offer made by the J.J. Newman Company and Captain J.P. Carter, who offered the use of their lands without charge to the government. The committee believed that the healthy climate, an abundance of good water, and the availability of rail services also helped their cause."[198]

Named after Isaac Shelby, veteran of both the Revolutionary War and the War of 1812 and the first governor of Kentucky, Camp Shelby's first incarnation would not last long. The base would only be operational from the autumn of 1917, when the first unit arrived—the 152nd Ambulance Corps, pulled by teams of horses, followed by its first fighting division, the 38th Infantry—until six months after Armistice Day, when the army closed the camp in April 1919.[199] But those eighteen months were enough to establish not just a fighting force of "doughboys" but a camp life and impact on the city that would not easily be forgotten. The most commonly cited figures note that the camp was constructed by 4,500 civilian workers at a cost of $3.3 million, billeting 36,000 troops at the peak of operations and featuring 1,206 buildings, not counting the tents in which the troops were housed.[200]

Tents indeed. Photographs of the time show the famous tent cities of the nascent camp, with six-man huts stretching as far as the eye can see, in

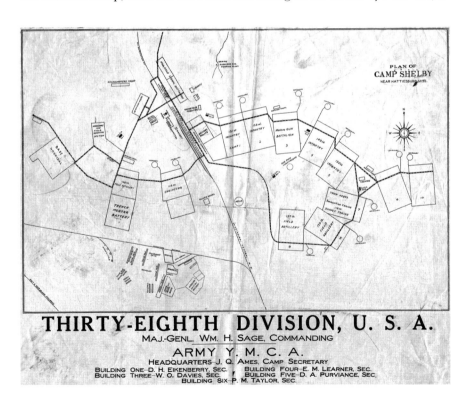

Plan of Camp Shelby, circa 1918. *From the Camp Shelby History Collection, McCain Library and Archives, University of Southern Mississippi.*

152nd Ambulance Corps, November 1917. *Hattiesburg Historical Photographs Collection, McCain Library and Archives, University of Southern Mississippi. Courtesy of Kenneth G. McCarty Jr.*

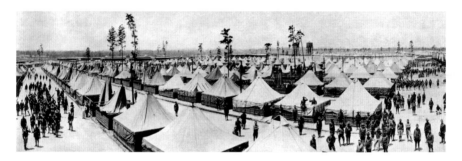

Tent City, *Bird's Eye View of Camp Shelby, 1917–1919. From the McCain Library and Archives, University of Southern Mississippi.*

recognition of the base's primary role as an army mobilization and training camp. Further recognition would come from unlikely places: in April 1918, shortly after the soldiers arrived, a tornado would strike the 38th Division, yielding its famous nickname of the Cyclone Division. Like the two colleges also connected to city life primarily by rail, the camp would grow into a separate, full-fledged settlement. With the wolf of scarcity ever at the door, however, a major issue was keeping the soldiers healthy even before they went overseas to fight, particularly from infectious disease. Discussing the Spanish flu epidemic of 1918, historian John Barry has outlined the extent of the challenge:

> *In the six months from September 1917 to March 1918, before the influenza epidemic struck, pneumonia struck down 30,784 soldiers on American soil. It killed 5741 of them. Nearly all these pneumonia cases*

*developed as complications of measles. At Camp Shelby, 46.5 percent of all deaths—all deaths from all diseases, all car wrecks, all work accidents, all training mishaps combined—were a result of pneumonia following measles.*[201]

While some historians suggest that camp life and city life did not greatly overlap, other sources tell a different story. The influx of increased economic activity in town during what writer Clarice Wansley calls the "meatless, wheatless, and heatless days," in which the war effort consumed all available and spare resources, resulted in contact between civilians and soldiers that led to plenty of collusion and, at times, collision. The troops' appetites for popular entertainment led to an explosion of music, film, sports, vaudeville acts, religious revivals, traveling exhibitions and general displays of southern hospitality to the soldiers, including town women's associations hosting them in their homes for holiday meals, a tradition that continues to this day.[202] The role of these organizations should not be underestimated; at the time, they served a critical need for soldiers and soldiers' families. As one observer recalled, writing for the *Hattiesburg American* on the city's fiftieth anniversary, the war effort by the city's women reached far and wide:

*For nearly three years then the story of Hattiesburg's club life, church societies, fraternal organizations, in fact, any organization of women, could be told in two simple words: "War Work." They "mothered" wards at the great Base Hospital, where they sponsored a weekly Flower Day, visited the wards taking goodies to the sick boys, wrote letters for them and showed them any other courtesies when the opportunities presented themselves. Each Y.M.C.A., the Knights of Columbus buildings, the Jewish Welfare Board hut and also the Episcopal hut were "mothered" by some church organization. Here programs were presented by some club or society in co-operation with the War Camp Community Service…when local talent and all visiting talent available appeared on the stage of the huts, assisting the boys in passing away many a lonesome hour. They also gave programs for the convalescing soldiers at the Base Hospital. Part of the time was spent in knitting for them, sewing and making bandages, helping with patriotic drives, acting in many capacities at Camp Shelby, consoling the homesick ones, those who were ill, making the strangers visiting their boys at Camp Shelby feel at home. Within the city they worked at the principal centers of activity, the Red Cross Soldiers' Club and the Red Cross Work Shop. At the former was located the headquarters for the War Camp Community Service*

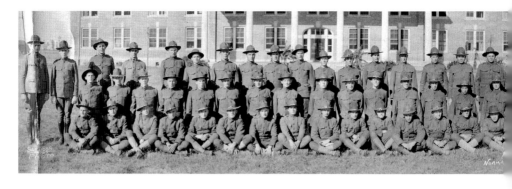

Student Army Training Corps, Mississippi Normal College. *From the Dr. B.B. Hilbun Collection, McCain Library and Archives, University of Southern Mississippi.*

*and here weekly entertainments were given free and at the Saturday night entertainments refreshments were served by some club or organization.*[203]

In general, despite the shared sacrifice and hardship of the time, it is clear that the Hub City was largely warm to the masses of troops, and the troops gave back to the Hub City in return. The Hattiesburg Fire Department records one instance in October 1917 in which "there was a disastrous fire on the corner of Newman and Plum Streets which threatened the block up to River Avenue. Soldiers from Camp Shelby rendered valuable assistance in this fire."[204] One issue did, for some odd reason—perhaps in some way due to this largess of hospitality—recur in a way that city residents had not expected. With the arrival of thousands of strong, eligible young men came also the arrival of enterprising dance hall operators and their scandalous "dime-a-dance" girls, which Wansley notes led to severe consternation among municipal and military authorities alike. While neither dance hall owners nor dancers were technically conducting any illegal business, the violation of moral law was enough. A public outcry in December 1917 ensued and led to an official intervention to reestablish "order." Eventually, the dance hall owners were run out of Hattiesburg to neighboring Sumrall, where Camp Shelby officials promised to post military police outside the venues to prevent any soldiers from becoming subject to "temptation." Pressed for comment, the mayor of Sumrall remarked:

*We will not tolerate any form of amusement here that the law does not countenance. If the law allows such dance halls, I cannot stop them from operating, but they will be well-policed and no disorders will be tolerated. We*

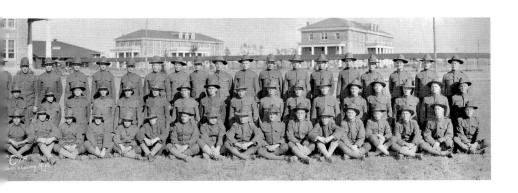

*will watch the women and men connected with the dance halls and cooperate with the military authorities in protecting soldiers from evil influences should they develop. I understand…that the women who were here last week left town. Whether others contemplate coming here, I do not know.*[205]

Unsurprisingly, those "evil influences" also reached the Normal College, where president Joseph Cook had to prohibit dating between students and soldiers and hire watchmen for the campus grounds, but ultimately, despite whatever dalliances they may have pursued on their home soil, the hearts of both city and camp alike remained oriented toward their common purpose overseas. Soldiers, arms, materiel and, above all, the will to win continued to flow east across the Atlantic Ocean, and with the Allies launching their "Hundred Days" counteroffensive in August 1918, the German line gradually began to collapse. Three months of the Allied advance, and the Kaiser would be forced to abdicate, and on the eleventh hour of the eleventh month of the eleventh year, a general ceasefire would go into effect. But for isolated skirmishes along the line, the war was over.

In Hattiesburg, a massive crowd poured into downtown at the news, and joyful celebrants welcomed the end of Wilson's "war to end all wars." Democracy had won out over imperialism, and while freedom would not yet carry the full weight of the word for all residents of the young southern city—Jim Crow was still firmly in effect and would remain so for another fifty years—among all parties and in every lane and quarter of town, there was still every reason to rejoice. As veterans began to return home—including the 390 students and 12 faculty from the Normal College, 6 of whom never returned, and where a memorial would be built in 1921[206]—army officers set about the dissolution of the camp. Little did they suspect, as the work orders for demolition and salvage came through that jubilant summer of 1919, just how quickly they would return.

# *Between the Wars: Hattiesburg in the 1920s and 1930s*

For the time being, however, relief and celebration reigned as the nation began its long-desired "return to normalcy." Following the turmoil and hardship of war, a new chapter in American history was beginning, marked by what historian Chester Morgan terms "postwar frivolity" in the emergence of new styles of fashion, music and design, but also by profound political and technological changes in the period after Progressivism.[207] After decades of campaigning, women's suffrage arrived in 1920, the world began to become accustomed to the sight not just of automobiles but of manned flight (which had arrived at Camp Shelby during the war[208]) and telephone service and electricity began to extend past urban areas in the age of rural electrification. While it was still the era of the five-cent Coca-Cola, the ice cream parlor and the drugstore malt, it was also the era of Bolshevism, Futurism and Modernism, an age of strange and difficult poetry, an age of swift and remarkable change.

In larger cities around the country, the Jazz Age had brought with it flappers, the Charleston, political machines like Tammany Hall and gangsters such as Al Capone, but south Mississippi seems to have passed much of that excitement by. For in many ways, Hattiesburg, despite its status as the state's fourth-largest city as of 1920, was still adjusting to the modern era and was reluctant to abandon its conservative, Protestant roots.[209] Not only had Mississippi signed its own statewide prohibition law in 1907, predating the Eighteenth Amendment by twelve years—the Great Mistake that would shortly be followed by the Great Depression—but it was also the last state to repeal it, only doing so in 1966.[210] But the question remains: as this new era unfolded, when locals in town—students and soldiers, millmen and merchants—went out after work, where did they go, and what did they do? Even as the timber industry waned and the floods of lumber money slowed to streams and trickles, 1920s Hattiesburg still enjoyed myriad options for entertainment.

One writer for the *Hattiesburg American* notes the explosion of social clubs and organizations in those years, many of which had a particular character: "That Hattiesburg," she wrote in 1932, "with its 21 literary clubs, one music, which sponsors junior clubs, and two home and garden clubs, is a cultural city no one can doubt. Reading from the records Hattiesburgians have always been lovers of literature and art and have always found time to enter whole-heartedly into things that tend to improve the cultural life of their

home town."[211] These clubs featured luncheons, literary and educational programming, music and discussion, but many included overt efforts toward civic improvement and charitable relief as well, particularly toward the city's poor. With names ranging from the prosaic (Wednesday, Thursday, Fortnightly) and the purposeful (Culture, Study, Mentor) to the mythic (Orpheus, Eucaria, Philoharmonia) and the all-inclusive (A.L.O.E., or A Little Of Everything), these organizations not only speak to the city's early interest in the arts but also offer insight into the activities of town women at a time when businessmen, millworkers and the male elite frequently dominate the historical record.[212] Even after suffrage, it would still be years before feminism or the women's liberation movement would reach this area, hence gender divisions tended to persist. As noted in the last chapter, the men's clubs—the Freemasons, the Elks, the Oddfellows and the like—had mostly been established at the founding of the town, with the exception of the Rotary Club, founded in 1919.

These years also gave birth to one of the city's annual traditions, the Krewe of Zeus. An offshoot of the traditions of Carnival found along the Gulf Coast, Hattiesburg's own Mardi Gras celebration was founded in 1924, when, according to one account, the Mystic Krewe of Zeus, spearheaded by one Joe McMahon, held its first Carnival ball in a tea house just outside the city limits. According to Krewe archives, McMahon was directly inspired by what he had seen in New Orleans and Mobile and urged a similar event for the Hub City, garnering support from the upper echelons of society. It worked: "Early Krewe celebrations were modest by today's standards. In the early 1930s, gatherings of the Krewe of Zeus took the form of dinners and business meetings. It was not until 1938 that the practice of staging an annual dinner dance began. As the years have gone by, coronations of King Zeus and his queen have become increasingly more elaborate and a growing calendar of parties and other social events have been added to the annual celebration."[213] In recent years, in further homage to its roots in the Crescent City, the celebration now features a parade down Hardy Street.

For residents not a part of high society, those years had other options for entertainment once the day's work was done. Downtown, with its restaurants, drugstore soda fountains (the Prohibition equivalent of the bar), hotel parlors and cafés, remained the hub of activity in the Hub City, encouraging the pleasures of a shopping trip to stroll the streets, inspect the latest arrivals of merchandise and see and be seen. Chief among them, as hinted at by the demands of the soldiers during the war, was movies: 1920s Hattiesburg enjoyed a striking film culture for its day, striking not

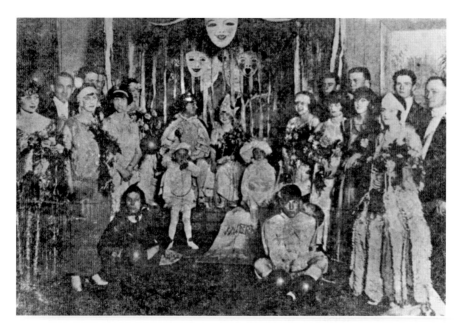

Krewe of Zeus inaugural Carnival ball (undated). *Hattiesburg Historical Photographs Collection, McCain Library and Archives, University of Southern Mississippi. Courtesy of Kenneth G. McCarty Jr.*

Halloween dance at the Forrest Club in Hattiesburg, 1913. *Hattiesburg Historical Photographs Collection, McCain Library and Archives, University of Southern Mississippi. Courtesy of Kenneth G. McCarty Jr.*

just for the number of movie parlors for its modest size but for their density in the downtown area as well. Compared to the Hattiesburg of today, with its lone corporate megaplex at the intersection of Hardy Street and Interstate 59, the contrast could not be more stark. Among the plethora of early establishments were the Royal, the Pick, the Lomo, the Ritz, the Rebel, the Buck, the Star, the Gem and the Strand, which Clarice Wansley notes featured over one thousand seats, quite possibly the largest filmhouse in the city's history.[214] The Almo served African Americans in the Mobile Street community, and the city's flagship, the Saenger Theater—the sole survivor of them all—would open barely a month after the stock market crash of 1929.

Film played a surprisingly personal role in city life in those years. Among such early film stars as Buster Keaton and Charlie Chaplin, who delighted audiences around the country with their antics, Hattiesburgers could watch their very own Dorothy Dell on screen in films such as *Wharf Angel* (1934) and the Shirley Temple film *Little Miss Marker* (1934). Dell, born Dorothy Dell Goff in Hattiesburg in 1915, had moved to New Orleans when she was thirteen to pursue a career as an entertainer, eventually winning the title not just of Miss New Orleans, but Miss America and Miss Universe in Galveston, Texas, in 1930 and enjoying a brief stint in one of Broadway impresario Florenz Ziegfried's last follies. Tragically, however, her career was cut short by a fatal car crash in 1934, just after finishing her third film (*Shoot the Works*), and for weeks that summer, the *Hattiesburg American* carried news and stories about her passing.[215]

The film industry had another, more lasting impact, however, through its influence on Hattiesburg's growing architectural fabric. As architectural historians Gene and Linda Ford observe, the Parkhaven Historic District west of downtown features a concentration of homes in the Spanish Eclectic style. The style, featuring terracotta tile roofs, arched colonnades and light stucco exteriors, had originated in architectural expositions of the 1910s but reached full prominence with the influence of film directors in the 1920s such as King Victor and Cecil B. DeMille, who commissioned lavish Hollywood homes in the style. With the stories and lifestyles of the emerging movie industry quickly capturing audiences' hearts, local developers could not resist. The Fords noted:

> *The Spanish Eclectic Style emanated from California via motion pictures, magazine articles and an awakened interest in Colonial architecture. This eclectic style thrived in the prosperous twenties and migrated to Hattiesburg*

*in the early 1920s. Beginning in 1922 M.M. Simmons developed the Parkhaven subdivision located west of the central business district and south of Hardy Street on South Twenty-Second and South Twenty-First Avenues. Parkhaven was "planned to be a suburban development of model homes." The style of the homes was fanciful and many examples in the subdivision exuded prosperity. A Spanish Eclectic gateway was built to introduce the neighborhood with its tri-portal of stucco clad and globe lights that lit the entrance into this extraordinary subdivision.*[216]

Music also played an important role. Historian Andrew English has chronicled Hattiesburg's early blues history in depth, and George Watson notes in his history of Hattiesburg that WFOR, the longest continuously operating radio station in Mississippi, had its origins in town, recording that "it went on the air in 1924 as a 10-watt station. Cleve Taylor, a Hattiesburg businessman and amateur radio technician, built the first transmitter and operated it from his book store on East Front Street under the call letters WDBT. The station used other call letters, WRBJ and WPFJ until 1935 when Mr. Wright changed the identification to WFOR."[217] Elsewhere downtown, music was performed in drugstores, hotel parlors and outdoor venues on special occasions; during World War I, Clarice Wansley recorded an amusing advertisement by the Rawls and Carter drugstore on Front and Main Streets: "The famous Bynum Jazz Band of Memphis, Tennessee, will entertain our patrons with all the latest musical selections. If you want to hear some real music, drop in this afternoon from 2:00 to 8:00."[218]

Those "latest" selections would, of course, have come in the earliest years of jazz; a few years later, Hattiesburg would earn a special place of recognition as one of the earliest locations where a new musical style would emerge. In 1936, brothers "Blind" Roosevelt Graves and Uaroy Graves met with pianist Cooney Vaughan to record as the Mississippi Jook Band, recording four songs for the American Record Company. As Andrew English notes, "One of those songs, 'Skippy Whippy,' is perhaps the best example of a prototype style of music that would later be recognized as Rock and Roll. The oft-quoted 1976 edition of *The Rolling Stone Illustrated History of Rock and Roll* heralds the Graves brothers' contribution to this session as: 'Fully formed Rock and Roll guitar riffs and a stomping Rock and Roll beat.'"[219] Though the Hotel Hattiesburg, where they recorded, unfortunately no longer exists, a nearby marker now signifies their place in history.

When locals were not inside, taking in clubs, societies, music or movies, they were outside, with the native Mississippian's love of the outdoors

drawing them to the parks, rivers, forests and playing fields of the area. Tent meetings (termed "sawdust revivals") featuring visiting evangelists were common, and air shows drew audiences from across the city and beyond, inspiring young residents such as Jesse Leroy Brown, who would go on become the first African American naval aviator in history.[220] The Leaf and Bouie remained prime spots for fishing, and Kamper Park, where in their earliest seasons the Normalites played, lay halfway between the Normal School and downtown, students and locals alike making the long trek for games.[221] But as historian W.T. Schmidt notes, if other sports were princes, in the age of Mickey Mantle and Babe Ruth, baseball was king. "Between 1920 and 1940," he writes, "athletic activities, more than any other endeavor, occupied the attention of young and old. Baseball was the pre-eminent sport and would remain so until after World War II, when stadium lighting made it possible to play football in the cool of the evening."[222] Historian Kenneth McCarty has unearthed a number of photographs of local teams of the era, including one of the Mississippi Central Railroad company team featuring Smokie Harrington, after whom the city's premier youth baseball field would later be named.[223]

Clubs, societies, films, music, sports—while, during Jim Crow, it is important to remember that these activities were still segregated, and with no end in sight to that system, it is nevertheless true that these ways of life constituted what life was like in Hattiesburg for much of the first half of the century for blacks and whites alike. Appreciation for the arts and culture, a lively social scene, a resourcefulness of time and materials and a healthy love for the natural world and the outdoors were all integral parts of the local makeup of both races and remain so today. In the second half of the interwar years, however, those characteristics—particularly resourcefulness—would help guide area residents through the Great Depression, a crisis that began with the stock market crash in October 1929.

Historian Bradley Bond has noted that the general prosperity of the 1920s caused by the growth of manufacturing and consumer products did not, contrary to popular belief, reach every area of the country. "Although Mississippians were aware of the nationwide 1920s boom and some benefitted from it," he writes, "the vast majority of Mississippians, particularly farmers, never fully tasted the economic bonanza of the decade. By the early 1930s, however, the depression had become so deep that even the agricultural economy of Mississippi keenly felt the strain. Finished products were in short supply, and the price paid for Mississippi's chief product—cotton—hovered at the 5 cent level, down by more than

Forrest Hotel under construction (Saenger Theater under construction at right), 1928. *From the Tatum Family Business Records. McCain Library and Archives, University of Southern Mississippi.*

50 percent from its previous peak in the twentieth century."[224] Echoing the point, Schmidt notes that the opening of the Forrest Hotel in downtown Hattiesburg in 1929, intended to lure out-of-town businessmen to the area, was inauspiciously timed:

> *Ironically, the dedication of the new hotel marked not the beginning of a new era of prosperity. Instead, it signaled the arrival of the worst depression*

*this nation has ever endured. As the economic life of the city slowed, there seemed to be no effective remedies to treat the malaise. More and more of Hattiesburg's people joined the ranks of the unemployed, once-prosperous businesses failed, and gradually a blanket of apathy and stagnation settled over the city and its people. State and federal relief programs minimally sustained the least fortunate of her citizens, and the city as a whole profited from a variety of New Deal programs. But, in general, life was pretty grim. Although efforts to quantify human misery are not often effective, one can gain some appreciation of conditions by noting that in 1934 the per-capita income tax paid by Mississippians was twenty-four cents.*[225]

Grim indeed. In the absence of ready cash, residents were forced to rely on savings, subsistence agriculture and whatever work would come their way. Bright spots amid the gloom were the arrival of the city's first municipal airport in 1930 and its Golden Jubilee in 1932, celebrating Hattiesburg's first fifty years since its founding, but few such rays could dispel the overhanging clouds. Economizing and bartering, older ways of life well familiar to locals, became survival mechanisms, as evidenced by David McRaney's account of how the *Hattiesburg American* coped with the shortages: "During the Depression, the newspaper printed and paid employees with in-house currency. The notes were redeemable around town at local merchants who in turn used the money to buy advertising. Subscriptions were sold through barter of goods like syrup and live chickens, which were in turn used to buy newsprint."[226] Other residents seem to have resorted to more nefarious means, such as insurance fraud: the chief of the fire department later recalled that "the national depression in 1930 caused a lot of unemployment and there were no replacements in the fire department until May 1, 1933. There were a great many residential fires through 1930, 1931, 1932, 1933 and 1934 and in many cases there was a strong suspicion of arson."[227]

As Schmidt notes, the worst aspects of the Depression were mitigated by free recreation—the Hattiesburg Public Library opened its doors on North Main Street in 1930, with Parmelee Chevis as its first librarian—and the New Deal programs of the Roosevelt administration that resulted both in a slate of construction projects under the WPA and forestry initiatives under the Civilian Conservation Corps. From the WPA emerged such buildings as the United States Post Office (1934), the Hattiesburg Homesteads to house industrial workers (1935) and the Camp Shelby Administration Building (1936), as well as a suite of projects at the State Teachers College, including the Sunken Garden and Lake Byron.[228] Its sister institution was

less fortunate—as noted above, faced with financial pressure and declining enrollment, Mississippi Woman's College would close from 1940 to 1946, housing officers at Camp Shelby during that time.[229]

Farther out of town, in the pine forests surrounding the city, Conservation Corps members across the region set about replenishing the depleted trees. One former employee, Elvin Spence, recalled, "We were going to reforest the state of Mississippi...There was very little timber left, only spots here and yonder. Hatten and Batson [Timber Co.] had cut most everything from south of Pearl River County to above Hattiesburg."[230] Their efforts—undergirded by new research into sustainable forestry that had arisen after the founding of the Mississippi Forestry Commission in 1926[231]—were largely successful. As journalist Carolyn Masters records,

> *The pine seeds planted by Spence and the CCC thrived in the climate of South Mississippi. From November 23, 1936, to February 6, 1937, the [Ashe] nursery, officially named for William Willard Ashe, a turn-of-the-century forester, shipped out 20,550,000 slash, longleaf and loblolly seedlings to be replanted in cut-over forests purchased by the federal government in Mississippi, Florida and Alabama. As yearly shipments continued, the historic forested quality of the Pine Belt returned and produced a renewable supply of timber for sales by the U.S. Forest Service. Sixty years later, the total number of pine and hardwood seedlings raised at the nursery for replanting stands at over one and one-quarter billion.*[232]

That renewal could not come soon enough. As noted above, the single issue underlying and driving Hattiesburg's transformation between the wars was the depletion of the resource that had built it, and no amount of precision replanting, seedling capture, controlled burning or selective harvesting would cure it. The forests of the area had been ransacked, not to regrow for decades, and already by the early 1920s, lumber companies in the region had retooled to find new means of making use of the raw products that clear-cutting had left behind. The first to do so was longtime employer Hercules, first organized as the California Powder Works, which relocated to Hattiesburg in 1922 to manufacture rosins, terpenes and other secondary products from cut-over pine stumps.[233] Following suit were the Dixie Pine Company, operated by former millman Maurice Dreyfus, and the Gulf States Creosoting Company, both of which pursued similar markets.[234]

If there was a silver lining to the period, it was that companies such as these were able to hold the worst of the Depression at bay, joined by larger

W.S.F. Tatum (right) and two unidentified men in pine forest, 1923. *From the Tatum Family Business Records. McCain Library and Archives, University of Southern Mississippi.*

concerns such as the Reliance Manufacturing Company, the Vickers Truck Farm and Willmut Gas, which employed hundreds of people. But an era had ended: in the same years as the last surviving Civil War veteran in the area passed away, unable to cope with the loss of their primary product, the mills that had first built the city forty years earlier began to close.[235] In 1935, the Newman Lumber Company—whose offices had burned in 1924, leaving

Toxey Montice Morris (left), Butler's Shoe Store, Hattiesburg, Mississippi, circa 1930s. *From author's family collection.*

only its historic steel vault—closed its doors, the years of producing over one million board feet per day a distant memory. And shortly thereafter, even magnate W.S.F. Tatum, facing reality, closed his mill and company town at Bonhomie in 1938.[236]

Raw materials notwithstanding, part of this transitional period may be attributable to the changing labor market of that decade—as historian Bradley Bond notes, the late 1930s had also seen the passage of the first federal minimum wage bill, which led to conflict between workers and company owners, the Tatums included.[237] But even despite this new economic infrastructure, ultimately providing more opportunity and fairness for the state's workers, neither labor organizers nor mill owners could do anything to hurry the trees along. The Mississippi legislature, to encourage conservation among private landowners, would abolish a despised tax on standing timber in 1940, but the benefits of reforesting would still be years away.[238] Hattiesburg would have to find another means to survive the end of that decade, a means that would arrive not from within the city limits, but from without.

Roads, bridges and buildings as well, one of the legacies the WPA left behind was a series of guides to the history, culture and attractions of each

American state. Written by legions of federally employed writers, artists and historians (whose ranks famously included Eudora Welty and James Agee), these guides offer a window into long-departed aspects of life that might otherwise elude modern notice. In the guide to Mississippi, the authors observe Hattiesburg's origins as a timber town and its shift into a post-timber economy and note that Hattiesburg "is a town whose heart is in the noisy factory district from which rise the pungent odors of turpentine and cut pine."[239]

True as their words once were, where once the winds carried those odors across town, those winds were shifting in the years those guides appeared, shifting in ways that their authors had yet to fully appreciate. Instead of the pungent tang of turpentine and pine oil, new winds were soon to arrive. With global fascism on the rise in the 1930s, and imperialist Japan and Nazi Germany on the march throughout Asia and Europe, the winds that would shortly blow through the Hub City were none other than the winds of war.

## 4

# THE WAR YEARS, 1940-50

## *War Returns to Hattiesburg*

The storm those winds would herald had been brewing for some time, and all through the years of the Depression, American eyes had been watching events unfold around the world with increasing concern. The 1930s saw a swiftly accelerating series of events that, by the end of the decade, would plunge nearly every major nation on earth back into war, in a way that was unthinkable just a generation earlier. After all, in the years between World War I and World War II, the former conflict was known only as the "Great War" or the "World War," since no party left standing could dream of its sequel. As army historians would observe in 1941, "at that period, the cessation of hostilities in the last World War had left the majority of our people with a desire to completely return to civilian life, with a feeling that preparedness in large proportions was not again to be known for a long time."[240]

That knowledge would return with one imperialist step after another. In 1931–32, the Japanese army, in defiance of its government, would invade the Chinese province of Manchuria in one of the bloodiest campaigns in either nation's history, while at home, American voters would place their faith in Franklin Delano Roosevelt and the New Deal he promised for the nation's workers and families. In 1934, the year after a young Austrian radical and failed art school candidate became chancellor of the German Reich and immediately began to dismantle the fragile democracy of the Weimar era, the state of Mississippi moved to purchase the dormant base

of Camp Shelby for a National Guard facility.[241] In 1936, the same year that Adolf Hitler remilitarized the Rhineland between Germany and France, directly challenging the terms of the Treaty of Versailles, and General Francisco Franco launched his rebellion against the democratically elected government of Spain, the WPA built the central administration building on that newly acquired base in advance of Guardsmen to come.

As the decade drew on, the winds began to pick up speed. In 1937, the same year that Japan invaded the rest of China, capturing major cities across the north and east of the country, the United States completed a major federal study on military readiness, concluding that years of neglect had left its army in a debilitated state, incapable of defending its overseas territories. In 1938, the year that Hitler seized Austria under the claim of Anschluss and then the Sudetenland in Czechoslovakia under the terms of the disastrous Munich Conference, and the same year that Nazi party members launched the Kristallnacht attacks on German Jews, the United States Army launched its Protective Mobilization Plan to conduct large-scale troop movements and training exercises. These movements included the army's "invasion" of southeast Mississippi and Louisiana, in which approximately forty thousand soldiers converged on the De Soto National Forest, with the tiny town of Wiggins serving as a deployment site and Camp Shelby as the base of operations. At the same time, the Camp Shelby Co-Operative Association, a joint partnership between town leaders in Hattiesburg and camp officers, arose to serve and support the base: war had returned to the Hub City, even if the United States was still technically neutral.

The final years of the decade, however, would see any pretense to neutrality swiftly dissolve. In 1939, the year that Hitler signed pacts of nonaggression with the USSR and alliance with Italy, prior to its invasion of Poland under the new military strategy known as blitzkrieg, the United States passed the Neutrality Act at Roosevelt's urging, lifting a long-standing arms embargo and allowing nations such as Great Britain and France to purchase munitions on a "cash-and-carry" basis. In 1940, the year that Hitler would occupy Denmark and overwhelm France, with German panzers rolling down the Champs-Élysées before the eyes of stunned Parisians, and the year that Japan would begin its conquest of the peninsula of Indochina, the United States Congress would pass the Selective Service Act to create the first peacetime draft in the country's history. The measure came in September of that year, the same month that the RAF held off the worst of the bombing of London by the German Luftwaffe, and the same month that officials announced that the federal government had acquired Camp Shelby from the state and would

shortly reopen it for troop training and mobilization. With the passage of the Lend-Lease Act to aid the Allies to follow only six months later, the time for pretending was ending.

The effects on the Hattiesburg area would be profound. As historian Chester Morgan observes,

> *The tremors* [of the war] *would shake even Mississippi, where they produced changes that, though quite modest when compared to dislocations elsewhere, were significant enough, both for the state and for its expanding teachers college. The southward drift of Mississippi's population had begun well before 1940, but World War II helped turn it into a flood. Workers poured into South Mississippi for jobs created by large military installations at Camp Shelby and Keesler Field in Biloxi and the huge shipbuilding complex in Pascagoula. Money poured in, too, shifting the state's economic center of gravity southward as well.*[242]

"Poured into," according to the account of historian W.T. Schmidt, is a polite way to describe it. As he notes,

> *The first call for 5,000 construction workers appeared in the* Hattiesburg American *on September 14, 1940. It advertised the following wage scales: journeymen carpenters, $1.00 per hour; brick-layers, $1.25 per hour; common laborers; 40¢ per hour. The work schedule consisted of ten-hour shifts, seven days a week…Two days after the call was made, an estimated 10,000 applicants, "who arrived by cars, trucks, bicycles, and anything else that would roll," inundated Hattiesburg and Camp Shelby. One shoeless Negro applicant from Prentiss walked thirty miles on rag-bound feet in order to stand in line at the employee office, where he waited for the issuance of his social security card. On the third day, 6,000 men "laid siege" to the employment office, moved from Hattiesburg to Camp Shelby in order to clear the stampede from the streets of the city. Hundreds of men slept on the ground under pine boughs and ate at soft-drink stands, which sprouted like mushrooms wherever men clustered around campfires. Within a week, the Gulf and Ship Island Railroad initiated a shuttle service of 1,000-man work-trains, and the majority of the men moved into Hattiesburg. A few remained in the woods because they could not pay the inflated rents demanded by city landlords.*[243]

The announcement of the federalization of Camp Shelby did not mean that it was immediately ready and open for business, however. Far from it. As

longtime railway employee Charles Harrington recalls, army officials in the nation's capital, far from the site of their newly purchased facility, had not realized that the idea they had of the base did not exactly resemble what it looked like on the ground, with one key feature missing: rail. Harrington writes:

> *Recalling that his railroad, the Mississippi Central, had handled a great deal of traffic to and from the camp during World War I, L.E. Faulkner, vice president and general manager of the MC, made a trip to Washington to confer with Army officials about serving the camp during World War II. The Army assured Mr. Faulkner that Camp Shelby was indeed to be reopened as an active training camp—that it was in a good training location, and the fact that it was served by two railroads (the Illinois Central with its Jackson to Gulfport line to the west of the camp site and the Mississippi Central) was excellent from a national defense standpoint. The officials even had maps showing how two Army divisions would be stationed at the camp simultaneously, one on each side of the MC tracks. There was a problem here, however, of which the Army seemed unaware. The Mississippi Central's track from Hattiesburg to Camp Shelby had been taken up nearly twenty years before, since it served no useful purpose after the end of World War I and the closing of the camp. When Mr. Faulkner told the Army officials that the line would have to be rebuilt, they were aghast. The line was still shown on all their maps and they naturally assumed that it was still in place.*[244]

But rebuilt it was, after Faulkner secured the financing, and within three weeks of the federal order, rail traffic reappeared on the line. By October, troops from the 37th Infantry Division—the "Buckeye" Division from Ohio—began to arrive, and not a moment too soon.[245] For within a year, the conflict overseas would escalate even further than it already had: Hitler would renege on his treaty with Stalin and invade the Soviet Union in June 1941, Roosevelt and Churchill would meet for the first time in Newfoundland and establish the Atlantic Charter later that summer and, after the Japanese attack on Pearl Harbor on "a day that would live in infamy" on December 7, 1941—the same day that the new chapel at Camp Shelby was dedicated—the United States would finally enter the war.

# Life on Base

Given the size, diversity and scale of the base, it is difficult to generalize about the experiences of soldiers in the years from 1940 to 1946, between its opening and closing. Indeed, such a claim is borne out by the sheer dimensions of manpower, land and operations that Shelby represented: with 84,058 troops billeted at the camp's peak in 1944, over 750,000 troops passing through its gates overall (for any reason, from induction to separation) and traversing 83,561 square miles at its greatest expanse, Camp Shelby enjoyed the status of two prestigious silver medals during the war—it was the second-largest army base in the country, second only to Fort Benning in Georgia, and it was the second-largest city in Mississippi, second only to the state capital, Jackson. Even if there was no such thing as a standard experience shared by every soldier, some commonalities do emerge, commonalities that illuminate daily life on the base as it prepared to send thousands of young Americans off to war.[246]

A soldier's story would start with induction. For volunteers or draftees not already arriving with a unit—many of whom came from the Gulf South and other states neighboring Mississippi—induction would entail a series of examinations and preliminary assessments conducted by camp officials. Selected troops were sent to the base reception center, where they would be held for medical examination or other reasons before being assigned to their unit. Photographs from the time show the men filling out their forms at crowded tables under canvas tents, overseen by crisp, attentive staff sergeants, eager to slot the men into place. While the army was the main recipient of these new troops, recruiters from other branches of the military did maintain a presence to enlist any men whose skills or inclination led them toward the navy or the marines (at the time, the air force was still a part of the army, from which it would only separate in 1947). By and large, however, most of the men joined the ground forces, with their assignments sending them either into infantry, artillery, engineering or medical detachments. With the exception of specialized units such as the celebrated tank destroyers, heavy armor would not arrive on base until years later (in the mid-1950s, when the 198th Armored Division arrived in Mississippi), but officers did retain a small number of tanks to train infantry to maneuver alongside and engage with them in combat scenarios. Otherwise, men who were deemed unfit to fight were assigned other roles on the base, such as in the kitchens, on the grounds crews or in the auxiliary offices.

After assignment to their units, soldiers would be directed to their company to meet their squadmates and get their bearings, and it was here—

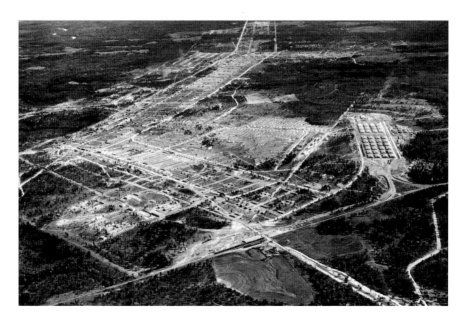

Aerial view of Camp Shelby, 1941. *United States Signal Corps, courtesy of Mississippi Armed Forces Museum.*

in one of the endless rows of tent cities, whose individual companies, generally occupying two rows abreast, were organized around their central "streets"—that they would call home for the duration of their stay on base. Though later replaced by larger, safer hutments (less prone to fires), the six-man tents were identical and ubiquitous: as one description of the time observed, "This squad tent is a soldier's home and palace. It is 16 by 16 feet, partly walled, canvas covered, wire screened, and stove heated, with an iron cot for a couch and healthy buddies as tent mates."[247] Hot in the summer, cold in the winter and only loosely protected from the elements, exactly how many soldiers called these makeshift dwellings home will never be known, but each one who did undoubtedly remembered them with great fondness and appreciation as they bivouacked in the mud, snow and muck of the battlefields across the world. Capping these rows of tents were white wooden buildings that served as company headquarters, situated just along the main roads of the base. The recollections of one young soldier in the 37th Division who arrived on base just as it opened offer a vivid portrait of the scene. William Chaney recalled:

*The famed 37th Buckeye Division of the U.S. Ohio National Guard was federalized on October 15, 1940, and assumed its place in the ranks of*

*The Army of the United States. The advance elements of 1400 men detrained at McLaurin, Mississippi, on Sunday, October 20, and marched into Camp Shelby. They were assigned to what was later known as "The Old Area," then in an early state of renovation. Squad tents with wooden floors were aligned along the grass-covered company streets. Drinking water was at a premium. It had to be drawn from lister bags at the end of the company streets. Company messhalls were single boxed construction with dirt floors covered with sawdust. Chow was cooked on World War I wood burning field ranges that had no bottoms. They were placed on a wooden box on a mud foundation. There was only one gang shower to the brigade and one well stocked P-X, housed in a primitive building. Basic training commenced on arrival and liberty wasn't given until basic was completed. After basic came extended order drill, the rifle range and night problems. In late November or early December the Buckeyes moved into their new quarters in the new area that consisted of permanent type messhalls with GI tables and coal ranges, company showers with plenty of water for all purposes, squad tents pitched over wooden frames with floors and sidewalls with screens, and equipped with Sibley stoves that burned either coal or wood. The regimental headquarters, P-X, and regimental recreation center were housed in framed permanent type buildings as were the brigade and divisional headquarters. Later, company day rooms and divisional and a non-divisional service clubs were added, as well as post theaters that supplied the needs of the troops. New equipment was arriving daily.*[248]

The geography of the base, later to become the army standard plan for a camp, was organized along an east–west axis with the camp's three main arteries—Highway 24 (later First Avenue), Second Avenue and Fourth Avenue, a stretch about five miles long—crosscut every few hundred feet like notches on a belt by sixty-six streets separating the individual companies. Highway 24, along which one entered the base from Highway 49 to Hattiesburg, was home to a variety of offices and unit headquarters, as well as clusters of guest houses, dental clinics, post offices, service clubs and filling stations spaced out approximately every mile. Prominent was the base hospital, halfway down the main drag between Thirty-second and Thirty-seventh Streets and featuring paved streets, modern electricity and drainage, covered walks and halls between all buildings and over two thousand beds. Running parallel to the highway were Second and Fourth Avenues, bounding the north and south ends of the rows of company tents, and containing contractors, post exchanges, fire stations, water tanks and tent theaters with capacity for

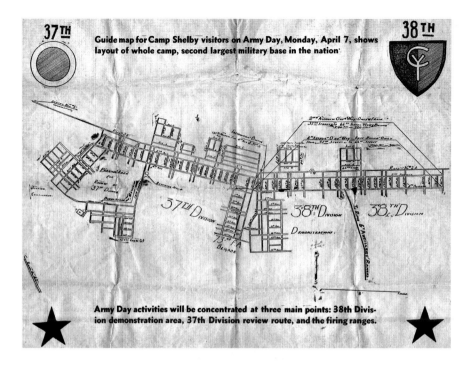

Guide map for Camp Shelby visitors, Army Day. *From the Camp Shelby History Collection, McCain Library and Archives, University of Southern Mississippi.*

*Opposite*: Camp Shelby *Reveille*, Vol. 1., No. 1, January 15, 1941. *Newspaper Collection, McCain Library and Archives, University of Southern Mississippi.*

thousands of men and showing movies typically every night. At the far western end of this corridor, just past the base entrance, were the main administrative buildings: camp headquarters, induction, reception and classification facilities, the quartermaster's and finance offices, the radio station and *Reveille* office and auxiliary offices for the WACs, the chaplain and the judge advocate. Support facilities were situated primarily to the south and north of the main residential and administrative quarters: to the south, infrastructure such as warehouses for storage and equipment, laundry, and offices for energy, transportation, and ordnance supply, and to the north, incineration, the power station, and sewage and wastewater treatment.

At its beginnings, the base was originally divided into the 37th and 38th Infantry Divisions—the former occupying the western sector and the latter, the first division to arrive at Shelby back in World War I, occupying the eastern—but as base historian Chad Daniels notes, with the expansion of the war, new buildings quickly arose to accommodate the additional thousands of

# The REVEILLE

VOL. I, No. 1.     CAMP SHELBY, MISSISSIPPI, JANUARY 15, 1941.     Official Camp Shelby Publication

# 37th Girds For Inspection

## Reveille Makes Its Bow

### New Paper Will Represent the 37th and 38th Divisions

With this issue the "Camp Shelby Reveille" makes its debut.

Weeks in the making, the new paper gets off to a start more auspicious than even its most enthusiastic backers believed possible. Its size, twelve pages, is precisely four more than originally were intended. In its content, the support given it by contributors, and the reception accorded it by advertisers, there is every reason for satisfaction.

The new Reveille has its work cut out for it. It will represent not only the 37th Division, but the 38th as well, plus all the smaller units that arrive soon from several northern states and the camp componentes. From its initial run of 10,000 copies the Reveille will soon hit a mark of nearly 50,000. This figure will put it in a major position among weekly papers.

**Easy To Read**

The appearance of the new paper is the result of an effort to produce an easy-to-read, clean-looking printing job, in keeping with the half-newspaper, half-magazine character of the publication. Columns piles have been omitted with this in mind. The selection of type faces is made with an eye to avoid of the blurred and a too "newspapery" look. The Reveille will streamline itself in the tempo of the times. It will be flexible in its make-up as well as flexible in its content.

The Reveille has sought a high journalistic goal. There is not the least doubt in the minds of its publishers that it has reached and will attain that goal. Already it is apparent that it has a rich field of talent from which to draw its material. The 37th Division has unusual degree of ability represented in its personnel. From material submitted from the men of the division it is plain that there will be no dearth of first-class copy for its columns. The response from the division's artists and cartoonists has proved that a superabundance, rather than a lack, of drawings will be the constant situation.

The Reveille will not cater to any segment of reader interest. Its editors realize that any group as large and varied as the population of Camp Shelby will represent every variety of taste, interest, and opinion. Within the limits of good journalism it will seek to satisfy all group. Its columns will endeavor to cover a range as wide as that represented by the rollicking "Korny Kook" of the comic strip and the serious matter presented in articles such as the one soon to appear on German industrial mobilization.

**Bid For Support**

For any publication to achieve its goal, the ultimate responsibility rests with its readers and those about whom it is written. If The Reveille is to reflect the 37th Division (and later on the 38th) it must receive more than passive readership support from the Camp Shelby personnel. The Reveille does not want to become the work of its staff, nor does it intend to. To be a living paper it must partly be the work of its readers.

For this reason the columns of the Reveille are wide-open to every officer and man at Camp Shelby. Stories, articles, feature material, cartoon and editorials all are acceptable from the camp. The staff of The Reville hopes to perform its editorial functions for a paper

(Continued on Page Six)

## 37th's Commanding General

**MAJOR GENERAL R. S. BEIGHTLER, Sr.**

## A Salute To The Chief By The Reveille Staff

The Camp Shelby Reveille is proud to dedicate its first issue to Major General Robert S. Beightler.

The dedication signifies more than a gesture toward the man who commands the division the paper serves. It represents the gratitude of public relations men to a man who has proved his interest and understanding of the work they have to do.

The past few years have shown that public relations are an important aspect of military operations. The army has recognized the importance of keeping the folks at home constantly informed of the doings of men in the service through the medium of newspapers, radio and service publications. General Beightler has won the allegiance of public relations men through his appreciation of this need.

The Camp Shelby Reveille, while basically a paper for the men at Camp Shelby, will have a significant part in maintaining the relations of the camp with the "outside" (Continued on Page Six)

### Sergeant Completes 21 Years Service

**By SGT. JOSEPH BONFIGLIO**
**145th Infantry**

CAMP SHELBY, Miss., Jan. 15.—Twenty-one years in the national guard and 10 of those years a master sergeant—that is the record of Personnel Sergeant Major Gilbert W. Lindsley of Cleveland, with the 145th infantry regiment.

Any man in the 37th division might well be proud of such a record, for since 1918, in August, when he joined the 74th infantry, New (Continued on Page Six)

### Old-Time Reveille Writer At Shelby

Capt. Charles M. Conaway, 145th Infantry Regimental Adjutant is one of the few men left in the service who in the pre-A.E.F. days served on the staff of the 37th Division "Sheridan Reveille."

Captain Conaway—a trifle more hefty about the midriffs now than he was 22 years ago, was a private first class with the 136th Machine Gun battalion in those days, but in addition to his regular duties, was the 74th Brigade reporter for (Continued on Page Two)

## Soldiers Face Rigid 2-Day Test

### General Brees and General Hodges Will View Training Demonstrations

A full-dress review of the 37th Division in which inspecting First Corps officers will witness the demolition of a temporary bridge and special firing exercises on the rifle and artillery ranges, will be held Friday and Saturday at Camp Shelby.

Lt. Gen. H. J. Brees, commanding general of the Third Army, Maj. Gen Campbell B. Hodges and Fifth Corps staff members, in reviewing the division's first three months of training and instruction progress, will be assisted by officers of the local camp. The inspection will extend down into the smallest unit of the division, according to Maj. Gen. Robert S. Beightler, and will be carried on in semi-impromptu fashion. Any organization may be called upon during the two days' exercises to perform some feature of their training in camp without benefit of prior notice.

**Engineers First**

First to come under the eye of the inspectors at 7:30 a. m. Friday will be the 112th Engineers Regiment who will assemble in their regular training area, equipped to perform any one or more of a dozen exercises. Maj. D. R. Ross, 145th Inf., is the inspecting office in charge.

In addition to standard exercises such as pitching tents, infantry drill, demonstration of organized equipment, use of scout and patrol duty, and attack and assault formations by various squads, the engineers will be called upon to erect a road block to obstruct light tanks, to execute the demolition of a log bridge, construct one, and two-line craters, by similar means, and for the medical detachment, the setting up of a first aid station.

**Infantry Next**

Taking the field one hour and forty-five minutes later will be one of the four infantry regiments. This regiment will have arranged its cadres within their regular training area at 7:45 a. m., individuals to be supplied with full field arms and equipment, including machine guns, and mortars, instruments of the heavy weapons companies, and communications outfits.

Extended order drill will be conducted there before Inspecting Officer Col. J. A. Blount, of the 147th Infantry Regiment, and will include "approach march," "development," "target designation," and "fire orders." Other battalions of the heavy weapons companies will be called upon to furnish platoons and squads to demonstrate their knowledge of technique and tactics with the 60-mm mortar, the calibre .30 machine guns, and the 81-mm mortar.

The message and radio service will be established from three battalion command posts to the division signal officer, Lt. Col. R. C. Bohannon, located as a point to be designated by him just prior to the exercises. The training communication er will finally order certain first aid stations established at his direction, and the commander of the enlisted men to be prepared to perform interior guard duty, defense exercises against chemical warfare and air and mechanized attacks; to demonstrate articles of military courtesy, discipline and law, first aid, and care of clothing and equipment.

**Pots Must Shine**

Mess sergeants and kitchen police are being advised that their turn may come at any time during the inspection period and that they should be dressed in their best bib and tucker, pots glimmering. A second regiment, similarly equipped, will be given opportunity (Continued on Page Two)

troops pouring in. By the end of 1943, he writes, "Camp Shelby expanded to accommodate two full divisions (around 34,000 troops) and built additional quarters and training areas for another 50,000 soldiers. In all, troop capacity was set at nearly 85,000, but the population at Camp Shelby regularly exceeded 100,000 when civilian workers and soldiers assigned to operate the camp were included."[249] Training grounds for all combat units sprawled out over thousands of acres to the south and east, straight into the heart of the Piney Woods. In the main areas of the base, young, second-growth pines dotted the landscape, providing sparse cover from the south Mississippi sun; out in the field, some areas remained clear-cut from logging operations, useful for large troop movements, but others were still heavily forested with both pine and mixed hardwoods, dense terrain that the troops would meet again deep in the European interior and in the jungles of the Pacific Islands.

Again, given the uniqueness of each soldier's experience, and the specific orders given to every company, brigade and division in the army during those years, it is difficult to generalize as to the nature of daily life at the camp beyond noting that most work days (days not on furlough or sick leave) were composed of a mixture of duty training, equipment and unit maintenance, review and inspection, movements or maneuvers and what every soldier awaits at the end of the day, chow in the mess hall and a little R and R before hitting the bunk. Shelby's size meant that it saw an extraordinary level of troop turnaround, some soldiers staying as little as a day while awaiting orders or reassignment, and others staying the whole six years and never once seeing a day of combat. Depending on orders from the War Office, the length of training cycles, the reorganization of divisions or brigades or the need to replace depleted units overseas with fresh troops, a soldier's life was never fully his to control.[250]

As though any soldier expected it to be. A soldier's life revolves around orders, either giving or receiving, of which there was never any shortage under a wartime footing. The brass primarily handled matters of personnel, intelligence, operational plans and training, supply and logistics, police and judicial affairs, ordnance, finance, medicine and chaplaincy. For the troops, however, the verbs of Camp Shelby were inexhaustible, and even as the conflict overseas escalated after America's entry into the war, they reflected the idiosyncratic blend of furious, concentrated activity and sudden, artful leisure that typifies military life. Photographs of major divisions at the time show soldiers engaged in a variety of tasks, tasks that provide a basic snapshot of camp life.[251] Out in the field, soldiers are shown taking positions, holding positions, advancing on positions and abandoning positions; aiming

weapons, firing weapons and reloading weapons; loading artillery, sighting artillery and firing artillery; digging trenches, holing up in trenches (some leftover from 1917) and camouflaging trenches; surveying maps and studying terrain; discussing battle plans; staking pup tents, striking pup tents; rolling packs, unrolling packs; spooling wire, unspooling wire; operating radios, calibrating armaments; laying dynamite, detonating dynamite; setting up machine guns, throwing grenades and arming mines; putting on gas masks; building bridges, crossing bridges and dismantling bridges; launching boats, rowing boats and towing boats (the Leaf River being used for amphibious training); driving convoys, riding in convoys and, once back on base, dissembling lines of convoys back into men.

Once back on base, however, the verbs only multiplied. Here the men are shown standing at attention and standing at ease; building tents and cleaning tents; driving vehicles and repairing vehicles; cleaning rifles, oiling machine guns and servicing artillery; guarding traffic, directing traffic, stopping traffic; loading cargo, unloading cargo; trucking, detrucking; building structures, dismantling structures; cooking, eating, cleaning up; peeling spuds, peeling more spuds and peeling even more spuds after that; eating watermelon; typing, filing and mailing; pulling teeth, giving shots, bandaging wounds; driving ambulances, riding in ambulances and giving first aid; lining up for inspection, lining up to dance; rehearsing music, playing music, enjoying music; loitering, bantering, horsing about; boxing, pitching horseshoes, playing baseball and football; feeding and playing with company mascots (among them, dogs, goats and hawks); giving medals, receiving medals; driving generals, escorting generals, saluting generals; and raising flags, folding flags and carrying flags, usually in the presence of generals. And if these activities were still not enough to whet the appetite of a young GI for action, one verb was always waiting around the corner to pounce, a verb with an infinite variety of opportunities for grief—whether through the woods, in the fields, through the mud, in the dirt, on the roads, across the bridges, under the sun, in the rain, through the snow, toward inspection, away from inspection, weapons shouldered, weapons armed, with the band, with the flag, as a company, as a brigade, as a battalion: marching, marching, always and ever marching.

Understandably, with all this effort, as well as the shadow of deployment cast permanently over the base, a major preoccupation of base officers was how to keep morale at a high. To address this need, the brass pursued a number of strategies, as summarized by one report of the 38th Division's morale officers:

139th Division Troops receive weapons instruction, undated. *United States Signal Corps, courtesy of Mississippi Armed Forces Museum.*

Troops and mascot of the Headquarters Battery, Second Battalion, 73rd Field Artillery Brigade. *United States Signal Corps, courtesy of Mississippi Armed Forces Museum.*

*Accomplishments of this section include the establishment of six full size Baseball fields and 12 Soft Ball fields, the operation of the Division Baseball league, a division boxing tournament, mass recreational athletics conducted each Wednesday afternoon, the purchase and distribution of $12,000 worth of Athletic equipment and the ground work completed for the organized winter sports of Basket-Ball, Football, as well as a Division Field Meet.*

*Entertainment is provided for all the men of the Division through the Camp Shelby Moving Picture Theater No. 2, Amateur Vaudeville and Variety shows in each Regiment, a professional vaudeville troop which visits each Regiment Recreation Hall once every 10 days and entertainments conducted every night in the 38th Division Service Club.*

*The 38th Division Service Club was one of the first of the new type opened and operated in the United States Army and is now fully equipped and has become the Mecca of the soldiers of the Division. Facilities for the amusement offered by the club are such as billiards, table tennis, card games, a library of 5,000 volumes, and in the Civic Center surrounding the Club, there are tennis courts, basket-ball courts, badminton courts, horseshoe pitching courts, a boxing arena, and a softball field. The Club also contains a soda fountain and a cafeteria.*

*The Guest House of the Division, operated as a part of the Service Club established for the accommodations for the visiting relatives of the soldiers of the Command, is so popular in the 38th Division that the demand for its facilities has caused the adding of 20 pyramidal tents. Here the visiting relatives of soldiers live under favorable surroundings for a nominal sum.*

*Among various phases of the Division Morale program, there is none more popular than the weekly convoy trips. An average of 1,000 soldiers of the Division make these trips each week-end. They visit recreational areas located at Gulfport, Biloxi, and Pascagoula, Mississippi; Mobile, Alabama, and New Orleans, Louisiana. Since the Division has been at Camp Shelby, over 20,000 individual trips have been made by the men of the Division. In addition to the trips to Recreational Areas, many other cities in the State of Mississippi have been visited.*[252]

The service clubs and rec halls were the focal points of camp social life, with one contemporary account describing them as the places where troops would gather to "drink beer, pop, and malted milks, eat cakes, cookies, and candies, and smoke cigarettes, cigars, and pipes…as they did as civilians."[253] The P-X served as a co-op, with the profits reinvested in camp life, athletic supplies and recreational concerns such as the band. Interestingly, the "library of 5,000 volumes" mentioned above was accompanied by a division bookmobile that, according to morale officers, "followed the Division from place to place, traveling some five thousand miles, and during rest periods visited each regiment in its bivouac area, providing tables, chairs, and free stationery for letter writing and distributing books, magazines, and newspapers. This service proved most popular with the men of the Division."[254]

Base officers matched these internal efforts with a dedicated program of bringing in events, performers and opportunities for socializing and recreation from outside the base, as Chad Daniels has outlined in detail.[255] But ennui could set in from time to time nonetheless, as a letter from one desk soldier from early 1942 indicates. Though unidentified in nature—the soldier signs neither his full name nor that of his recipient, lending the letter a pleasing anonymity and everydayness—the letter reveals much about the daily workings of the base and references many recognizable aspects of camp life even for modern readers. From one "Fred" of the 172nd Infantry writing at the 43rd Division post office on March 29, 1942, to one "Duane":

*Dear Duane:*

*I guess its time I got busy and answered your letter. I have been rather busy here the last few days in the office. They have keep [sic] me pretty busy pounding the typewriter ordering fodder for the boys to use on the range. They sure burned a lot of it and still have a lot of powder to burn.*

*It has been swell out here today. A real old spring day if there ever was one. There has been quite a few females floating around here today. They had about 200 girls come in yesterday to visit the boys over the week end. There will probably be quite a few silk stocking around by tomorrow morning.*

*We had an Inspection of trucks by General Hester yesterday. He said it was one of the best inspections he ever conducted. We had everything good enough so he gave the boys the rest of the day off to do as they pleased.*

*I suppose it will be rather quiet here next week end. There is going to be some of the Regiment go to New Orleans to be in a parade. They have been conducting several inspections of the Division lately and they picked us to be the ones to represent the division. We are beginning to get good enough so we get a little public notice now.*

*No, we didn't get any of the tornado. We had quite a bit of rain about that time but no high wind to do any damage. I guess they had quite a time to the north of us from what I heard.*

*They tell me they are having a very good sugar year up there. Maybe the farmers get a chance to get a little extra change.*

*No, Albert hasn't told me much about the scenery up north. I got a letter from him a couple of weeks ago. The only time I've heard from him since I got back.*

*Yes the cartridges for the 50 cal mg [machine gun] are pretty good sized. I believe they are nearly 6 inches long when loaded with lead. They are supposed to be loaded with enough push up for a slug to penetrate ¾*

*in steel at 1000 yds. I should hate to think I had a tobbacco [sic] can in my hip pocket to stop one. I'm afraid I would feel as though a mule had bunted me.*

*Yes, we have a very nice Library at the Service Club. And in our day room we have all contributed books and magazines such as* Life, Look, American, Readers Digest, *Several sport magazines, movie magazines,* Popular Mechanics *and others similar. We are a lot better equipped for reading matter here than we were in* [Camp] *Blanding* [Florida].

*I guess they don't like the outfit that moved in where we left. They seem to be quite a cheap lot from what I've heard.*

*We had a new officer come to us this week. He is a regular Army man, one day he was a private and the next day a 2nd Lt.*

*Well, the situation looks a little better tonight than it has for quite awhile. I'm afraid that things are going to shape up fast within a short time. I know to* [too] *much about the supply game.*

*I suppose the hill roads are in the best of condition now. They hadn't aught to be bothered by to* [too] *much traffic now seeing they can't buy gasoline any more Sunday. It will be rather tough on the Sat night parkers. Maybe it's a good thing they teach us to travel on our feet in the Army.*

*Well, I guess I've got about all the news for this time—so here's hoping everybody is ok up that way.*

<div align="right">

*As ever*
*Fred* [256]

</div>

Clearly, one of the highlights for any soldier at Camp Shelby was to leave Camp Shelby: preferably, toward home to see their families and their wives, or at the very least, to catch a bus or a train into town, to Hattiesburg.

## Life in Town: The Hub City During World War II

When the troops did come in, they had much to look forward to. For soldiers arriving from out of town or out of state—undoubtedly the vast majority, overwhelming the draftees and volunteers from southeast Mississippi—the WPA had published a pamphlet for getting around town, *The Serviceman's Guide to Hattiesburg and Area*. At the time, Hattiesburg was still a fraction of its current size: the city limits extended only to Twenty-eighth Avenue to the west, the Leaf River to the east, Hazel Street to the north and Sixty-

ninth Street near the Highway 49 cloverleaf to the south, so it was difficult for soldiers to get lost. Featuring accounts of local history, geography and culture, the guide listed all major downtown facilities and sites of note, including service centers, gyms and athletic fields, houses of worship, movie theaters and outdoor activities such as sporting events, hunting and fishing, with the vast majority of their institutions offering free or discounted rates to servicemembers. Of particular interest, given the deep love of boxing among the troops, was the deliberate mention of Richburg Hill, where the Sullivan-Kilrain fight had taken place fifty years earlier.[257]

Though few such guides remain in circulation today, they would have been printed by the thousands during the war, given the prominent role that the base played in town life and vice versa. For the most part, given the high level of patriotism in the area, feelings and attitudes between town and uniform were warm and respectful, with all sides acknowledging the mutual hardships and sacrifices that the war effort required. As nearly every contemporary historian writing on the subject attests, the influx of thousands of soldiers almost overnight profoundly transformed life in Hattiesburg; to give but one indication of how extensive was the transformation, Chad Daniels records that at the peak of the war, from 1943 on, soldiers outnumbered townsfolk by approximately five to one.[258] If the United States Army entertained designs of invading cities across the Atlantic and Pacific Oceans, it began with ones on its own home soil.[259]

The Hub City had experienced such an invasion before, of course, with only a single generation having passed since the last time Shelby had opened its doors to tens of thousands of troops during World War I. Again, the town rallied behind the war effort and the base, showing its support in a variety of ways. As noted above, even before America entered the war, city leaders had anticipated the need for close collaboration, with the Hattiesburg Chamber of Commerce founding the Mississippi Camp Shelby Co-operative Association in late 1940, an organization tasked with furthering the aims of the base, preparing the city and the region for the influx of troops and promoting economic development for public and private entities. Meeting regularly and declaring themselves devoted to "the doing of all things deemed advisable to cause the enlargement of Camp Shelby, and to cause Camp Shelby to be made a permanent army training post; and also to look after the betterment of life and the interests of the soldiers stationed at Camp Shelby, including the furnishing of wholesome and lawful entertainment to them, and to do any and all lawful things to make life pleasant, happy and camp-life more comfortable for the soldiers stationed at said camp," the association was

tasked with securing extra land for the base (with a $100,000 lien from the governor), finding entertainment for the troops in their idle hours and locating extra housing for the soldiers' families while they were in town.[260]

Partly as a result of the association's work, and fulfilling its nickname even further, Hattiesburg saw a resurgence of investment in its infrastructure, particularly for transport. Highway 49 was widened and extended to serve the base, the city improved and expanded its municipal airport in order to serve the movement of troops and officers across the region and, as Charles Harrington records, the railways saw an unprecedented level of use:

> *During the war, Hattiesburg was served by eight passenger trains a day on the Southern [line], and two on the Illinois Central. It was common to see soldiers lined up three abreast from the ticket office window in the Southern depot, down the platform to Market Street, and down the sidewalk almost as far as the California Sandwich Shop, waiting to buy tickets. At that time, the majority of the men in the 37th Division at Camp Shelby were natives of the New England States and naturally rode the Southern's trains in that direction. Train No. 42, the midnight train as it was affectionately called, picked up over 1000 passengers at Hattiesburg every night and filled the train to capacity.*[261]

As in so many towns across the country, rationing, scrap drives, victory gardens and parades for the Red Cross and war bonds became a part of daily life, as did the less welcome side effects of rent gouging, food and gasoline shortages and the same social and occasionally criminal ills that had befallen the city in its first inundation of men.[262] Even so, again, locals enthusiastically joined the war effort, whether indirectly by opening informal eateries and service-industry businesses for the troops, or more directly, as in local businesses such as Hercules Powder Company retooling to produce ammunition.[263] Again, as in World War I, the women of Hattiesburg banded together to provide support for the troops and their families, such as in founding the Junior Auxiliary in 1941; again, in social, religious and civic organizations such as these, the residents of the Hub City made every effort to feed, clothe and house the troops and their families where possible, hosting soldiers at home on holidays and special occasions, taking them on outings to area attractions such as Ashe Lake and Red Creek and promoting cultural and musical events to boost morale and help the troops feel as much at home as possible. In town, Holmes's Nightclub was a hotspot for nightlife,[264] and among other highlights were athletic events, such as the divisional football games held at Mississippi

38th Division Cycloners at Faulkner Field, Mississippi Southern College, 1941. *Colonel Wayne Sandefur Collection, courtesy of Mississippi Armed Forces Museum.*

Manufacturing ammunition at Komp Equipment Company. *Hattiesburg Historical Photographs Collection, McCain Library and Archives, University of Southern Mississippi. Courtesy of Kenneth G. McCarty Jr.*

Southern College—games in which Hattiesburg High School cheerleaders cheered for the troops and locals turned out en masse.

Despite the enthusiasm, it is important to note that the notion of "home" was one of the more fluid ideas in those years. Because the Second World War far exceeded the first in its duration and scale—Camp Shelby operating at full capacity for six years, compared to two, and hosting over 100,000 troops at its peak, compared to 36,000—additional pressures arrived that the town had not yet seen. Hattiesburg swelled not just from the influx of the troops but also from the arrival of their families and loved ones. The reports of the United Service Organizations in town note with regularity the experience of service club staff meeting young wives, often mothers, who had arrived looking for a place to stay, having slept the night in the train depot or bus station. In their words:

> *The rooming situation in Hattiesburg is very acute. The army has a Billeting Office in our building but the influx of army families is far beyond the supply of rooms. Many families which have moved in have remained even though their men have gone. Practically no building has been done. A population of 28,000 prior to the war, 51% of which was white, has swelled to over 60,000—and the facilities for providing for them have grown almost not at all. The Billeting Office is working under marked difficulties. Several nights have found U.S.O. cots put up and filled with wives and babies who had nowhere else to go.*[265]

While the USO prided itself on its ability to tend to these cases—at one point in a single month, the club served over one thousand requests—demand seemed forever to exceed supply, and late in the war, the *Hattiesburg American* was compelled to publish a front-page clarion call for public assistance on the matter.[266] While many townsfolk were glad to open their homes to visiting soldiers' families, others were less so, seeing themselves as unable to provide for two or more families when provision for one was difficult enough already.[267]

More than just a place for servicemen to relax while on leave in town, the USO clubs were a central point of encounter for soldiers and civilians throughout the war, and give an indication of everyday life for both groups. Of the five clubs that were originally founded, two are most worthy of note, both founded in March 1942: the main USO at 222 West Front Street, operated by the Army-Navy YMCA and the largest in town, and the East Sixth Street USO in the Mobile Street neighborhood, which served African American troops and their families.[268] With each club staffed by a fleet of

capable hostesses, including the Army Wives organization and the Girls' Service Organization (featuring such sub-groups as the Lazy Daisies and the Pinafore Prissies)—each of the women selected for their charm, hospitality and impeccable moral character—these clubs hosted a variety of events to entertain the troops and provide for their needs, enjoying widespread attendance.[269] Two accounts from the first year of operations sum up the atmosphere. In November 1942, the authors wrote that:

> *Local Hattiesburg people use the building whenever they can squeeze in a reservation for entertaining. During November, there were several garden clubs, literary clubs, music clubs, the U.D.C., the D.A.R. (no modern veterans, however!), bridge clubs, bridge luncheons, the P.T.A., church circles, sorority meetings, and teas. Besides these, the Forrest County Board of Health had two all day sessions, the County Agent had an all day session, and the Hattiesburg Community Council held its regular monthly supper meeting. They are all welcomed whenever the building is not used by soldiers or soldiers' families. Many army wives entertain in the building…Hattiesburg people call upon the U.S.O. more and more to help them. The railroad station agent was heard to comment to a forlorn soldier, "Go over to the U.S.O. They will help you work out your trip home!" A college class president and a college sorority coach each sought assistance in securing a band, two civic men's clubs came for help for their ladies' night banquets, the American Legion got help for their Armistice Day banquet, church choir directors regularly solicit music aid for their church choirs, the Junior Auxiliary requested assistance in securing a band for their Charity Ball.[270]*

A month later, in December 1942, they wrote:

> *During the day there is rarely a time when the library, the lounge, the writing tables, and the refreshment lounge are not filled with army wives. They seem so happy that they have a place where they can entertain outside of their crowded living quarters. Almost all of them can secure only one room and that, in most instances, is a small one. When the soldiers get away from camp around five-thirty or six o'clock they begin to drift in. Many couples eat at night regularly at the snack bar. Nearly always several pairs of couples can be found playing games together and many just visiting. As the crowds gather around the pianos, not only at the advertised "Tune Time" but also for their incessant sings, it seems that after a little while it shifts and the personnel changes—but the pianos do attract the crowds:*

*The hour set aside for music appreciation records on Sunday afternoon has satisfied a desire of many for that type of music. The jig-saw puzzle fad has passed, but there are always a few enthusiasts working on those while the writing desks and all available tables are in use every minute. There are several small groups of boys who pursue their hobbies—for instance, the camera fans always have the dark room in use, and a small crowd of stamp collectors devour the stamp catalogues and meet to exchange and discuss stamps. Night after night around Christmas time, wives, mothers, and sweethearts of soldiers who had come to Hattiesburg without realizing the terribly overcrowded condition of the town, were taken care of for the night in the U.S.O. Building.*[271]

Though the armed forces at the time were still segregated—a topic that Chad Daniels has explored in the Shelby context specifically—activities at the East Sixth Street USO were equally as lively as those downtown, with a comprehensive range of services offered to African American troops, including a "Writing Room, Library, Comfortable Lounges, Dark Room Equipment, Counseling Services, Showers, Shaving, Snack Bar, Music Room, Mail Service, Information Service, Distribution of Religious Literature, Home Hospitality, Room Registry, [and] Sewing Service."[272] To that list include weddings, formals and proms, as well as performances of visiting and local bands, including the aptly named Al Lundy and His Jive Bombers, of which, regrettably, no known recordings survive.[273] Understandably, dances were among the most popular events of any club's activities, with tickets to one of these events among the most coveted items a GI could own, even beyond that staple of wartime currency, cigarettes. One report from the Front Street club notes that with only 300 of 18,000 men per division allowed to attend any given dance, no fewer than 17,700 men experienced great disappointment on a biweekly basis.[274]

With such attractions waiting for them in town, it was little wonder that the troops found as many opportunities to travel to Hattiesburg as possible, and even less that they were reluctant to leave, boarding the buses back to base. Few sights were more common for townsfolk than the lines of servicemen waiting at bus stops downtown; letters to his sweetheart from one Donald Cooley stationed at Shelby during the middle years of the war describe lines so long (over a quarter of a mile) that he and other GIs had to share taxis to avoid discipline for tardiness, in one case arriving with only a minute to spare on his pass. Even despite regular increases in the number of buses, and the later leasing of a private fleet from out of state, the buses were often so

Al Lundy and His Jive Bombers. *Guide to East Sixth Street U.S.O. Club Souvenir Booklet*, circa 1943. *McCain Library and Archives, University of Southern Mississippi.*

crowded that the troops couldn't get a seat and were forced to find another way home: by taxi, by hitch or, in some cases, by foot. And find their way they did, for there were no two ways about it: the war was still on, and there was work to do.[275]

## Back on Base: The War Heats Up

If the first years of the war (1940–41) were marked by grim tidings and setbacks for the United States and its allies, with the Axis powers on the march throughout Europe, North Africa, China and the Pacific Islands, the middle years of the war (1942–43) were marked by a redoubled effort on the part of the Allies and a slow turning of the tide that would enable the major offensive pushes of the final years of the war. In 1942, Hitler had solidified his position in Western Europe and was now focusing his attention on Russia and the east, and Japan began a steady drive down the Philippines and the Dutch West Indies, conquering and fortifying one island after another— Singapore in February, Bataan in April (leading to the infamous death march), Corregidor in May—that would only be challenged when American marines landed on the island of Guadalcanal that August. For the Allies, there was no time to lose to stop these advances and, hastened by the critical naval victory at Midway in June 1942 that put an end to Japanese naval

superiority, troops training at Shelby and other bases around the country were quick to arrive and depart, shipping off to the Pacific theater (with the exception of British troops in North Africa and Soviet troops on their own soil, Allied forces had not yet established a beachhead in the European theater).

Among the first troops to deploy from Camp Shelby were those of the 37th Division, the Buckeyes, who left in early 1942 for the Fiji Islands, where they would participate in the liberation of the Solomon Islands later that year. By the time the 37th had had its first taste of combat, however, more troops had already arrived at Shelby to take their place: in February, the 43rd "Winged Victory" Division had arrived, followed shortly thereafter by the 85th "Custer" Division in May, and that September, the same month that the 43rd deployed for the Pacific to take part in the capture of the island of New Georgia, the celebrated 31st "Dixie" Division made up of troops from Mississippi, Alabama, Florida and Louisiana arrived on base. The 31st would stay for nine months of training before redeploying to other bases and ultimately shipping out to the Pacific in 1944. Two months after the 31st arrived, the 38th "Cyclone" Division departed as well, arriving in the Pacific in early 1944 to take part in some of the fiercest island-borne fighting of the war, including the Battle of Zigzag Pass and the liberation of Bataan, earning the division its other nickname of the "Avengers of Bataan." With troops arriving and departing at an increasing pace, 1942 ended on a more hopeful note than its predecessor: in late October and early November, General Bernard Montgomery defeated Field Marshal Erwin Rommel in North Africa in the Battle of El-Alamein, the Allies' first major ground victory and one that would clear the way for the invasion of Europe from the Mediterranean.[276] It would also have surprising effects back in Hattiesburg, but these would not be known until the following year.

The grueling pace of 1942 showed little signs of letting up in 1943, though with the liberation of North Africa and the halting of the German and Japanese advances in Russia and the Pacific, the tide was beginning to turn. In the winter of 1942–43, German troops, once within striking distance of Moscow, were caught off guard by the ferocity of the Russian winter and, trapped and besieged within Stalingrad, the city they had taken that summer, were forced to surrender the entire 6th Army to the Soviets. Around the same time, new faces had begun to arrive on base at Camp Shelby. Not only did the base receive news that the Women's Army Auxiliary Corps (WAAC, later shortened to WAC) were scheduled to arrive in March 1943—a new development in the armed forces and one that led

GIs to detour past the WAAC service office for a glimpse of their new fellow servicemembers, walking past in utter wonder—but those same GIs were now training alongside recruits for one of the most controversial, and later celebrated, units in the war.[277]

On January 6, 1943, the 100th Infantry Battalion had arrived to join the 85th Division for training. Composed almost entirely of Hawaiian American and Japanese American troops, the 100th Battalion—and its parent unit, the 442nd Regimental Combat Team (RCT), which was activated at Shelby at the beginning of February—had endured suspicion and hostility by many Americans who doubted the loyalty of the troops. At the outbreak of the war, Japanese American families in Hawaii and along the West Coast had been detained and relocated in internment camps in a regrettable measure of prejudice (then called "caution") against full-blooded American citizens. In the eyes of their most hostile critics, and even despite the assurances of their unit commanders, the troops of the 100th and the 442nd could not be trusted to fight for the United States.

Nothing could have been further from the truth. Not only were many of the soldiers in these units volunteers to the army, not draftees, but once at Shelby, they proved themselves to be as equal to the task of fighting as any of their fellow servicemen, conducting drills and training with speed, talent and honor that put the rumors surrounding their loyalty to shame. (Famously, these troops did suffer from the Mississippi heat and the chiggers in the forest more than the local yokels, but they suffered honorably just the same.[278]) Accepted by other soldiers and residents of Hattiesburg, who invited them into their homes and hosted dinners and events for them just as they did other units, the 100th and the 442nd became some of the most beloved units on base and in town prior to their deployment to the expanding European theater in 1943.[279] The 100th would depart sooner than the 442nd, headed first to North Africa and then to Southern Italy once the Allies had begun their campaign up the Italian boot, where they would distinguish themselves in the battle for Monte Cassino in early 1944 and earn the revered nickname of the Purple Heart Battalion for the numbers of those medals they were awarded. The division with which they had trained, the 85th, would follow behind the 100th that December, where they would suffer the worst casualties of any division that Shelby trained during the war. The 442nd—eventually becoming the most decorated unit of the entire war—would remain on base until April 1944, when they, too, would join the Italian campaign, reuniting with their fellow soldiers of the 100th Infantry Battalion outside Rome that June.

Other changes were afoot over that long spring and summer of 1943. In March, the 7th Tank Destroyer group would arrive, and in May, the 69th "Fighting" Division was activated, a division that, after its deployment in late 1944, would eventually take part in the offensive on German soil and become the first American unit to join up with Soviet troops in the European theater. June saw the departure of the 31st "Dixie" Division, and just prior to the surrender of Italy in September 1943, August saw the arrival of the 65th "Halbert" Division, a unit that, after its deployment on New Year's Eve 1944, would join Allied troops in Europe and participate in the liberation of the Maithausen concentration camp in 1945. With the exception of specialized units such as the 21st Tank Destroyer group (which remained at Shelby until the end of the war, never being deployed) and assorted smaller units, the 69th and 65th were the last major divisions to arrive on base before the end of the war—at least, the last *American* divisions.

For Camp Shelby, in late 1943, had become home to yet another set of new faces, faces that soldiers and civilians alike had barely expected to see at the outbreak of the war two years earlier: German prisoners of war. These PWs, as they were called (the designation of POW would not come into widespread use until Vietnam), were composed primarily of soldiers from the German Afrika Korps, the troops who had fought against British and American forces in the deserts of Libya, Algeria and Tunisia. Eventually numbering over three thousand men, the PWs who arrived in Mississippi were more commonly rank-and-file soldiers who had been drafted into the war, rather than hardline Nazi elements who were separated and sequestered in other bases around the country.[280] Once on base, they served mainly as labor for the camp but, in stark contrast to the condition of prisoner of war camps overseas, were treated with a level of dignity rare for enemy combatants even today. When not engaged as laborers in construction, maintenance or repair—including on Lake Shelby (later renamed Lake Geiger), which would serve as a staging ground for amphibious training for D-Day[281]—they were hired out as labor to local farmers and businesses, with the proceeds from their work reinvested into their recreational and cultural pursuits.

Which were surprisingly many. The PWs enjoyed their own chapel and chaplain (who conducted services in German), their own newspaper detailing life on base, their own amphitheater and canteen, their own soccer league (in which they routinely thrashed the American GIs) and even their own jazz band (whose instruments they had either made themselves or received as gifts from town residents concerned for their welfare). They were allowed

Women's Army Auxiliary Corps (WAACs), Camp Shelby. *United States Signal Corps, courtesy of Mississippi Armed Forces Museum.*

German prisoner of war band with instruments donated by Hattiesburg residents (undated, circa 1943–45). *Colonel T.B. Birdsong Collection, courtesy of Mississippi Armed Forces Museum.*

to drink the same beer as the American troops, even if it was nowhere near as strong as they would like, and in one remarkable act of hospitality, one group of prisoners even built a handmade piano for the daughter of a camp commander, Captain Earl Chancellor. In a final gesture of dignity, those soldiers who passed away while still prisoners received a full military burial as befit their rank. At the end of the war, they were repatriated back to Germany to work in labor camps across Europe, participating in the postwar rebuilding efforts. But according to base historians, given the taste of life in the States they had enjoyed even as prisoners, once their terms of service were completed, many PWs returned to America as soon as possible.[282]

Those movements would still be years away, however, and from their confinement on base, these PWs would first have to watch the strongholds of their homeland weaken and fall. In the first half of 1944, Soviet forces, having liberated Kiev from Nazi hands, began their westward offensive toward Berlin and the German heartland. In the same month as Western Allied forces liberated Rome, long columns of infantry and tanks rolling past the Colosseum, the combined armies of the United States, United Kingdom, France and Canada crossed the English Channel to land on the French beaches of Normandy, securing the beachhead on D-Day, June 6. Following the successful invasion of the European mainland, Allied troops rolled into Paris in August, two months before—on the other side of the world—General Douglas MacArthur fulfilled his famous pledge of "I shall return" to the citizens of the Philippines. With major Allied offensives in both theaters, it seemed that the end of the war might, for the first time, be in sight.

With that view, preparatory changes began to take shape at Camp Shelby. On November 2, 1944, the Separation Center opened on base and prepared to discharge its first soldier from active service, a number that would swell to the hundreds of thousands by the end of the war. By the end of the year, however, the last two full fighting divisions, the 69th and 65th, would depart to the European theater to refresh the troops who had fought to liberate France and Belgium and who, in December 1944, had weathered the last major German counteroffensive in the Battle of the Bulge. With the failure of this last-ditch effort, German forces from this point on waged a steady rearguard retreat: as the Allies closed in on Berlin from both sides, German generals frantically tried to halt the advance and buy the Nazi powers more time, but to no avail. The end of the war was not just in sight; it was within reach.

# *Victory and Aftermaths*

As 1945 opened, Allied forces were closing in on their goals. In Europe, the Soviets entered Poland in January and then moved on to Hungary, Slovakia and Austria over the next three months. In March, American troops crossed the Rhine River, and in the Pacific, American marines captured the key island of Iwo Jima and its airfield, enabling long-range bombers to reach Japan. In April, as Franklin Delano Roosevelt passed away and Harry S. Truman took office, former Italian dictator Benito Mussolini was executed and thrown into a peasant grave by his own countrymen; at the end of that month, Soviet forces finally entered Berlin—only to find Hitler and his intimates having taken their own lives rather than face capture, arrest and trial. With the final surrender of the German forces on May 7 and the declaration of victory in Europe (V-E Day) on May 8, all attention turned to the postwar reconstruction effort and the remaining battles to be fought against Japan. The Allies would shortly take the island of Okinawa, expecting to use it as a base for the invasion of the Japanese mainland, but that expectation would shift dramatically in August, as the use of a strange and powerful new weapon would not only accelerate the end of the war but also usher in a new era in human history.

That arrival was still months away as summer opened, however, and in the meantime, the operations of Camp Shelby continued to change. As four new national flags fluttered over Berlin—the United States, Great Britain, France and the USSR—Shelby engaged in a simultaneous process of drawdown and reorganization, with troops returning from the victorious European front arriving on base to be discharged or reassigned, depending on the needs of their unit and the orders from above. The separation center was operating at full tilt, much to the relief of servicemembers, who longed for nothing more than to come home to their wives and families, with a point system introduced to allow those with more combat experience to be discharged first. Those soldiers still on active duty faced the prospect of redeploying to the Pacific; no one, after all, outside the nuclear architects at Oak Ridge and Los Alamos expected the Japanese to surrender anytime soon. Not long before V-E Day, in March 1945 the army had established an infantry-retraining program, the Infantry Advanced Replacement Training Center (IARTC) under Brigadier General Neal C. Johnson, which aimed to retrain soldiers with expertise in other units for infantry duty in preparation for a swift deployment overseas.[283] The IARTC brought around ten to fifteen thousand additional troops to Hattiesburg at a time when all the major

divisions had left, a much-needed shot in the economic arm given the height of the wartime boom just a year or so earlier. But subsequent restrictions keeping soldiers on the base led, as one observer lamented, to "unhappy wives and empty streets in Hattiesburg."[284] The IARTC would last until the end of July, the same period that the 95th Division arrived to prepare for combat in the Pacific, and just days before a new type of light and cloud would settle over Hiroshima and Nagasaki.

From the perspective of the troops, the dawn of the atomic age landed as quietly as a newspaper on the front lawn, according to observers at the Front Street USO in downtown Hattiesburg. There, the news that would set throngs of jubilant crowds onto the streets outside took on a decidedly different shape:

> *The effect which the radio peace announcements of August 10 and 14 had on the men in the Club at the time is of interest. When the "big news" broke there were fairly large groups of servicemen and GSO girls in the Club. GSO was actively engaged in decorating the Social Hall for two big formal dances (15th and 16th) honoring the 95th's arrival. The men listened quietly to the announcements, sat pensively at writing tables, [the] snack bar, and throughout the Club. Very few even got up to leave. Practically all continued with whatever occupied their attention prior to the "flash." In the community it was observed that soldiers were unusually quiet but that it was the young folks who "painted the town red" with scrap paper, noisemakers, and hullabaloo. PEACE meant too much to battleweary soldiers to give way to boisterous demonstrations. Theirs was a blessed relief. By the end of August, the men and the wives of the 95th had about settled to a fairly normal life of USO activity.[285]*

The news carried its own shockwave through town and through the base, particularly for those troops of the 95th Division, which had arrived expecting to leave again shortly thereafter. With the surrender of the Japanese and the end of the war, the troops of the 95th and their wives appealed to their superior officers and their representatives in Congress to reconsider the need for redeployment, or at the very least the terms thereof:

> *The 95th Division came to Shelby for special training in Pacific warfare. Many wives, with babies, arrived to spend as much time with their husbands as possible before shipment to the Pacific. August events in the Pacific took an entirely [un]expected turn. It became evident that the 95th*

*was to become a Division for occupation rather than combat, and would leave for P.O.E. [Point of Embarkation] before the date anticipated. A possibility of two years' sojourn faced the men; they immediately began to resent redeployment, and protested vigorously and widely. The U.S.O. Clubs soon became centers for groups to gather in planning their organized protests to Congressmen; and for writing, wiring and phoning families to use their political influence to secure countermanded orders; they were pleading that younger men who had [no] combat experience be sent to the Pacific.*[286]

The pressure intensified and, remarkably, led not just to the reevaluation of the point system but ultimately to the deactivation of the entire division within two months: by the end of September, USO officials noted that "many men had been discharged from the Division or transferred to others and it was announced that the 95th Division would be deactivated by October 15."[287]

Separation now became the main function of the base; even despite the arrival of other units such as the 28th Division that same September now under a peacetime footing, as had happened a generation earlier, Camp Shelby's days were once again numbered. In the months following the end of the war, soldiers moved so fast through the base that beloved musical and theatrical productions staged for the troops' entertainment had to abandon any notion of a regular cast. According to the staff at the Front Street USO, in "Goin' Home," the Second Army musical show, "the leading male singer

World War II Divisional Memorial Walk, Camp Shelby (2014). *Photo by author.*

alone was changed twelve times because of transfers and discharges. The show was finally produced with three men staying over for three days *after* their *discharge*; 'the show must go on,' they said."[288]

The show would go on, until there was no one left to watch it anymore. In 1946, Camp Shelby would close its doors, having dismantled or sold off the vast majority of its buildings, even down to the water pipes underneath the ground.[289] The USO clubs would all follow that year, the Front Street club that had seen over three million people pass through its doors closing almost a year to the day since the dropping of the atomic bombs, and as this chapter in the city's history came to a close, others began to open. One of the first initiatives came as the chamber of commerce undertook an ambitious program of economic investment to attract business and industry to Hattiesburg, fully anticipating and seeking to counteract a postwar slump—a cycle that city leaders have come to expect as a matter of course.[290]

The end of the war would impact Hattiesburg in ways both small and large. A new religious denomination would put down roots in town, with the arrival of a full-time Lutheran congregation in 1947, St. John Lutheran Church. Moreover, the city's two institutions of higher education would both have new life breathed into them: after its six-year hiatus, Mississippi Women's College would reopen in 1946, having narrowly survived a vote of closure by the state Baptist Convention, and would resume its normal session the following year.[291] Mississippi Southern College, with its new name, new mascot and new degree programs, would experience a spike in enrollment from the GI Bill, even as troops arriving on campus as students encountered certain familiar sights, such as the old army field house having been relocated to Faulkner Field. The end of the decade would see the departure of some iconic presences—the Hub City sign from atop the Ross Building and the former mayor and lumberman W.S.F. Tatum in 1949—for the arrival of others: the Beverly Drive-In in 1948, the cloverleaf intersection on Highway 49 and Evelyn Gandy in 1947, the first female legislator from Forrest County and future lieutenant governor of the state.[292] Between 1940 and 1950, the city's permanent population would jump from 21,026 to 29,474, a growth rate of nearly 50 percent that the city would never again experience in a single decade.[293]

Again, given the scale of the war and the size of the base, the impacts of Camp Shelby and World War II on Hattiesburg are as difficult to overstate as they are to estimate. While the full extent of those impacts has yet to be charted, historians agree that the growth and development of Camp Shelby during the war years was one of the single most important factors in the

history of the city, not only rescuing it (as the war did for the country at large) from the depths of the Depression but also laying the groundwork for a lasting relationship between town and uniform that has served both well over the nearly one hundred years of the base's existence. At the end of the decade, Shelby's role flared up again briefly during the Korean War, when in 1950, it was reactivated as an emergency railhead facility in case of large troop movements, but those movements never came to pass. Even so, officials still recognized the value of the base and in 1956 would name it a permanent training site for the army, a status it still enjoys today.

But the victory over fascism and totalitarianism in 1945 would not spell victory on all fronts, and even as Americans geared up for a much longer, slower conflict against the ideology and forces of the Soviet Union, they were also headed into confrontation on their own shores. To the shame of the nation, African American soldiers in the South who had risked their lives to defend American democracy were still unable to fully participate in it, but over the course of the next two decades, all of that was set to change. The Cold War would largely be fought in proxy conflicts overseas, but as the 1950s opened, battles for freedom of a different sort began to break out in cities across the South—cities such as Selma, Little Rock, Birmingham and, eventually, Hattiesburg.

# A CHANGE IS GONNA COME, 1950-70

## *A New Decade*

Prior to the arrival of that movement, however, the next phase of Hattiesburg's history would see further arrivals and departures. As the war had consumed city life in the 1940s, the effects of increased population and an expanded economic base lingered well into the 1950s, a period of new growth. While this period saw a number of developments in the private and public sectors, by far the most important was the founding of a new county hospital in 1952, which would not only spur growth westward toward the university but would eventually grow to become one of the largest institutions in the city and whose later maturity would—along with its competitors—create one of Hattiesburg's major economic sectors.

The story of Forrest General Hospital had, in fact, begun in 1947, when, recognizing the need that the war had brought for more facilities for healthcare, physicians and city leaders proposed a new, comprehensive facility to relieve the strain on Methodist Hospital and the South Mississippi Infirmary, serve the citizens of Forrest County as well as its neighboring counties and offer new medical services that other institutions could not.[294] Part of the problem was that until that point, physicians largely maintained private clinics or made house calls and, unlike the medical landscape of today, were less attached to a centralized hospital that could nurture and develop their specialty and stay abreast of emerging techniques and technologies. Rather, physicians tended only to visit patients or perform

procedures *in situ*, at locations such as the infirmary on Walnut Street.[295] Part of the opportunity, advocates therefore argued, was that a new hospital would not only meet the needs of the population but also serve to attract medical talent and associated industry from around the region and further catalyze the city's postwar growth.

As a public institution, however, it would have to go to a vote. Spearheaded by a coalition of the Junior Chamber of Commerce and the Forrest County Board of Supervisors and bolstered by the prospect of a statewide appropriation for new regional hospitals, advocates undertook an ambitious campaign over the spring and fall of 1947. As historian John Guice explains, "When the [Forrest County] supervisors received the required number of signatures, they would call a special election; if a majority of the voters favored the bond issue, the county would build the hospital. The county, state, and federal governments would equally share the costs."[296] Late that year, the bond issue passed by an overwhelming margin. Construction began shortly thereafter, and on the morning of July 15, 1952, the ninety-bed hospital opened its doors to its first patient, a very pregnant Mrs. Fred K. Roberts of Purvis, who delivered a very healthy baby girl, Sandra Kaye. It was an auspicious beginning: not only would Forrest General enter a series of phases of almost unbroken growth and expansion from that point on, but it would also serve as an anchor for the development of the city at large. Guice sums up the impact:

> *The choice of a site on South 28ᵗʰ Avenue south of the college and a block east* [sic] *of US Highway 49 ultimately had a tremendous effect on the westward movement of Hattiesburg. Construction of the hospital on the western fringes of the settled part of Hattiesburg on totally undeveloped land led to the first great post-war building boom west of US Highway 49. One wonders if the selection committee understood at the time what a momentous decision they were making and if they realized as they surveyed the wooded land, that they were standing on what became the center of Hattiesburg a half-century later.*[297]

The impacts were generational. In response to this new development, the South Mississippi Infirmary would close its doors in 1956, leaving only Methodist Hospital downtown to compete with the new facility; the new neighborhood of Hillendale, adjacent to the hospital to the south, would swiftly take shape; and the university—which, following a protracted battle, would change its name from Mississippi Southern College to the University

of Southern Mississippi in 1962—would join forces with the hospital to establish its acclaimed School of Nursing in 1966.[298]

But the 1950s would see a number of other changes as well. Also in 1952, shortly before the new hospital opened its doors, Hattiesburg would be stunned by the violent double murder of two policemen, James Everett and M.W. Vinson Jr., by one Luther Carlyle Wheeler, a transient passing through town with his girlfriend. The officers gunned down in cold blood on a routine traffic stop, the murder and trial would grip the headlines for weeks with its senselessness and tragedy; according to one report, Wheeler "had never before laid eyes on the men he killed, nor was his own life in issue at the time he fired the first shot."[299] In 1953, First Baptist Church would open its main sanctuary on West Pine and Second Streets, and reading the writing on the wall of stagnant enrollment and emerging demands in higher education, Mississippi Woman's College would go coeducational, necessitating a change of name to William Carey College after "the father of modern missions" the following year.[300] The mid-1950s would see changes in both institutions. In 1954, R.C. Cook would step down as president of Mississippi Southern College, succeeded by William D. McCain in 1956, and

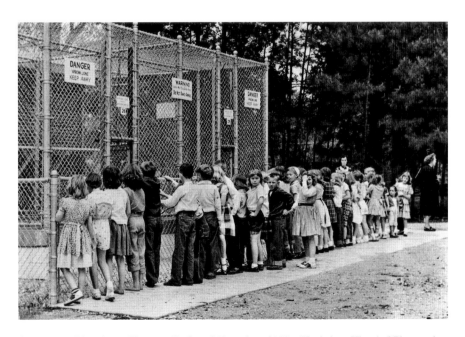

Children at Lion Cage, Kamper Park and Zoo, circa 1950s. *Hattiesburg Historical Photographs Collection, McCain Library and Archives, University of Southern Mississippi. Courtesy of Kenneth G. McCarty Jr.*

in 1956, Carey would elect Ralph Noonkester as president, who would lead the institution for the next thirty years. The city's first broadcast television station, WDAM, would sign on to the airwaves in 1956, and in 1958, an exciting new animal—an elephant from the Ringling Brothers circus named Hattie—arrived at a growing Kamper Park Zoo.[301]

Hattiesburg was on the rise. As notable as these achievements were, however, such opportunity and prosperity was still not reflective of the entire city. For in the 1950s, the South still lay under the heavy hand of Jim Crow, and despite the best of intentions of city leaders, segregation still ruled the day. The doctrine of "separate but equal" of sixty years earlier still dominated social, economic and cultural life for both races, and even when the same Supreme Court that had established that doctrine overturned it in the landmark decision of *Brown v. Board of Education of Kansas*—setting in motion a chain of events that would sweep across the country like wildfire across a plain—Hattiesburg, like most other southern cities with predominantly white governments, saw no immediate reason to change a way of life that it had harbored since its very inception.[302] As the 1950s came to a close, however, all of that was set to change.

# *The Dawn of the Era*

With the election of Dwight Eisenhower in 1953, formerly the Supreme Allied Commander in Europe and the architect of the D-Day landings, the United States had chosen a leader who would not only preside over a boom in the American economy and infrastructure during his eight years in office but also stand firm against the forces and ideology of Soviet Communism at a period when the Cold War was anything but cold. On the home front, advocates for liberal democracy saw the creeping spread of socialism everywhere, and even as Senator Joseph McCarthy conducted investigations on suspected Communists on Capitol Hill, and the House Un-American Activities Committee pursued Soviet spies and propaganda in Washington and Hollywood, there were many across the country who were willing to accuse everyone they either did not know, did not trust or simply did not agree with of being the same. This was especially true in the South when it came to matters of race.

In one sense, *Brown v. Board* in 1954, Rosa Parks's bus boycott in 1955 and the forced desegregation of Central High School in Little Rock in 1957 were

just the beginning of the civil rights era, with a full decade to pass before Lyndon B. Johnson would sign the Civil Rights Act and the Voting Rights Act in 1964 and 1965, respectively. To get there, however, the years in between would be composed of acts of courage, violence and reprisal across the region that hearkened uncontrollably back to the conflict that had engulfed the South a century beforehand, with the same set of tensions at its core. As the prospect of permanent change regarding race, education and the vote became a reality, from the perspective of conservative white southerners (who were, at this time, still voting Democratic—the South would not ally political conservatism with the Republican party until the Nixon administration), the conflict took much the same shape. Just as in the 1840s and 1850s, the idea of outside agitators coming into and disturbing their allegedly ordered—if inequitable, violent and unjust—society had resurfaced yet again, with racist whites and their white supremacist organizations across the South blaming the unrest of the time on unwanted outsiders spreading socially poisonous and destructive ideas.

This time, however, instead of labeling those who held differing views as mere abolitionists, "nigger-lovers" or scalawags, whites who opposed integration found labels that conveniently mirrored the governing styles of other regimes scattered around the world: civil rights activists (and elected leaders who shared their views) were regularly decried as communists, imperialists, dictators, totalitarians, militants, revolutionaries, internationalists, race-mixers and mongrelizers, pagans, atheists, hedonists, anarchists, nihilists and just about any other -ist that wasn't Southern Baptist (or, in a pinch, Methodist, but even those were suspect).[303] To promulgate their views, radical whites around the state and the South founded organizations to spread their ideology and sway undecided voters; in 1954, Delta planter Robert "Tut" Patterson founded the White Citizens' Councils, spreading racist propaganda and coordinating activities such as economic discrimination and intimidation of blacks and black-owned businesses. As if such activities would be confined to the private sector, in 1956, the Mississippi State Legislature founded the State Sovereignty Commission in a brazen act of resistance to federal authority.[304] This commission, a state-funded agency that ostensibly sought to "protect" the state's laws and constitution from federal encroachment or oppression, a near-certainty given the events of the day, in practice served as what Calvin Trillin has tongue-in-cheek referred to as a "cornpone Gestapo"—spying on its own citizens and monitoring activities of voter registration, civic activism and collaboration with national civil rights organizations such as the Student Nonviolent Coordinating

Committee (SNCC), the Congress on Racial Equality (CORE), the Southern Christian Leadership Conference (SCLC) and the National Association for the Advancement of Colored People (NAACP).[305] Backed by white-owned and white-leaning news outlets such as the Hederman family–controlled *Clarion-Ledger* in Jackson that regularly ran editorials approving this defiant stance and downplaying or omitting the news of the activist community, this collusion between public and private entities created a contentious, hostile and at times deadly climate in which the outside "agitators" were arriving to work.[306]

The central issue, of course, for those white Democrats who had remained in power unbroken since the late 1800s—and who had even split with the national Democratic party in 1948 to found the segregationist Dixiecrat party, in disgust at Harry Truman's progressive policies—was the loss of that power and the corresponding fear of what might happen were African Americans able to vote, and vote en masse. For radical whites, the belief that segregation did not necessarily entail discrimination remained adamant, welded to the belief that integration necessarily entailed total societal upheaval and revolution. To discourage any such ideas, lest those "uppity" blacks suddenly forget "their place" in society, white supremacist groups and individuals undertook a campaign of race-based oppression and violence that has left the soil of the state stained blood-red. Beginning in the mid-1950s, the body count in Mississippi began to rise: among the first to die was Reverend George Lee of Belzoni, murdered while driving in May 1955, followed by Lamar Smith in Brookhaven, shot to death in broad daylight at the Lincoln County Courthouse that August. A few weeks later came a case that made national headlines, when a fourteen-year-old boy from Chicago named Emmett Till was found not just dead but mutilated in Money, Mississippi—allegedly, it emerged, for having "wolf-whistled" at a white woman. To draw attention to his murder, his mother demanded an open casket at his funeral. As historian Robert Patrick Rayner explains,

> *These events* [the murders of Lee, Smith and Till] *typified Mississippi's race relations in the 1950s. Whites murdered blacks with no fear of conviction or reprisal. The white power structure demanded deference, compliance, and fear. Blacks who acted contrary to these demands often sparked massive resistance and elicited severe consequences.*[307]

Even in Hattiesburg, which had seen less open hostility than other southern cities, segregation was still the norm, and the prevailing statewide sentiment

found a home in the Hub City as much as it did anywhere else. Hattiesburg native Charles Brown recalls many different instances of discrimination from his youth, ranging from differential treatment at lunch counters (not just Kress and Woolworth's, but at local joints such as Gus's Café and Coney Island as well), refusal of service in white-owned clothing and department stores, separate water fountains in Hattiesburg City Hall, a side entrance and segregated upstairs gallery for blacks at the downtown Saenger Theater and refusal of admission to the Hattiesburg Zoo five days out of the week unless blacks were accompanying or babysitting a white child. Above all, Brown recalled, were the codes of behavior that blacks had maintained for generations under Jim Crow, codes they had developed for their own safety—codes of avoiding eye contact or physical altercations with whites, codes of yielding sidewalk or elevator space to oncoming whites, codes of addressing whites as "sir" or "ma'am" without the same ever expected in return and, above all, avoiding any contact whatsoever with the police, contact that could lead to a beating, a trip to jail (and almost assuredly a beating) or worse.[308]

Until a larger change could come, then, blacks in Hattiesburg, as in many other cities in the South, adopted these strategies of survival and nurtured instead their own communities such as the Kelly Settlement north of town, Mobile-Bouie in the center and Palmer's Crossing south of town, where they did not have to suffer being treated as second-class citizens or as second-class humans where citizenship was not even an option. Though the physical facilities of their churches, homes and schools were frequently more modest than those of whites—writer Theodore Taylor describes the Eureka School at the time as a "mostly red clay [campus] with a few straggly clumps of grass, often muddy when it rained and dusty in dry spells. It was a typical Mississippi Negro school of that day: used books brought over from the white schools; used football and basketball uniforms brought over from the white schools; used band instruments. Used everything"[309]—the members of the black community nevertheless maintained their dignity and pride in the face of such injustice and hardship, making the best of adverse circumstances. To instill the values of respect and decorum in his students, for example, Professor N.R. Burger, the principal of Eureka, studiously wore a suit every day he showed up to the school.

This is not to say that all whites in Hattiesburg at the time were racists, of course, or that all whites condoned the activities of the Ku Klux Klan, the Forrest Raiders or the Citizen's Councils—headed, in Forrest County, by one D.B. Red, who held regular meetings and distributed pamphlets outlining

the horrors of race-mixing, most assuredly the byproduct of "atheistic communism." Rather, according to contemporary interviews and print histories alike, many whites in Hattiesburg were either oblivious to the issues, seeing education and voting rights as simply not their problem, or apathetic, seeing no reason to get involved.[310] This position certainly characterized the elected officials such as the mayor and the county clerks, as well as many of the leading clergy in town, as Robert Patrick Rayner has documented. While some ministers in the white community harbored progressive sympathies, the majority preferred to maintain order in their congregations above all else. "In Hattiesburg," he writes,

> *Reverend W.J. Stanway* [of First Presbyterian Church] *never mentioned the northern ministers or civil rights protest from his pulpit. Even Newton Cox* [of Westminster Presbyterian Church], *considered the most liberal of the three* [Presbyterian] *ministers, refused to recognize on Sunday morning any social unrest in his community for fear of upsetting the peace and unity of the church.*[311]

That peace and unity so dearly prized would soon be shattered, however, by further events in Hattiesburg and around the state. If the 1950s constituted the dawn of the era, the 1960s would see the full force of its rays strike the southern soil.

The 1960s would not, unfortunately, get off to an auspicious start, if the case of one of Hattiesburg's native sons is any example. Clyde Kennard, a Korean War veteran who had returned to Hattiesburg both to care for his widowed mother and to manage their small farm, had made in 1955 the first of many attempts to enroll at Mississippi Southern College, hoping to become the first African American student at the institution. Unfortunately, though Kennard might have been ready for MSC, MSC was not yet ready for him, and personally headed by the staunch segregationist President William D. McCain (who had befriended Kennard with the ulterior motive of dissuading him from enrolling), university officers stymied and misled Kennard in his repeated applications. Undaunted, and convinced of his right to an education, Kennard applied for the final time in September 1959.[312]

This time, more than just the college officers and a denial of admission awaited him. Time after time, even under direct pressure from the highest levels of state government (including Governor J.P. Coleman, who had been apprised of the situation), Kennard had declared his intent to enroll, a resolve that threatened too much notoriety for the institution for McCain,

who was not only opposed on ideological grounds but who was also seeking to gain university accreditation for the college at the time. Alarmed by the young farmer's determination, and the impact that such a move could have across the state, the white power structure swung into action: agents from the State Sovereignty Commission, which had been following Kennard's case from early on, spied on his activities and collected details about his past life, reporting this information to the authorities and even going so far as to propose his "relocation" or murder should he persist.[313]

When no amount of pressure succeeded in persuading Kennard from withdrawing his application, two Forrest County constables followed him home from a trip to McCain's office, arresting him on false charges of reckless driving and the possession of liquor—planted evidence, as Kennard was a teetotaler—and issued him a heavy fine. Despite his being framed, given the power structure of the time, Kennard's conviction was inevitable, and the following year, even while his appeal worked its way through the courts, he was again framed for the theft of twenty-five dollars worth of chicken feed from the Forrest County Cooperative (which in the intervening months had foreclosed on his farm). After a perfunctory trial featuring a witness who claimed that Kennard had planned the crime—a witness who would only recant his testimony forty years later—Kennard was sentenced to seven years' hard labor at the Mississippi State Penitentiary, or Parchman Farm. Three years later, suffering from untreated cancer that he developed while incarcerated, he would die in Chicago at the age of thirty-six, passing away on July 4, 1963. Robert Patrick Rayner sums up the story: "The story of Clyde Kennard reveals brazen discrimination in Mississippi and in Hattiesburg. Not only did authorities deny Kennard admission to an all-white institution, in reprisal they also falsely accused him of a crime, then hastily prosecuted and sentenced Kennard to a prison system that ultimately took his life."[314] Kennard's name would not be cleared for nearly fifty years.

If justice for Kennard individually was unforthcoming, the beginning of the decade would see some progress under a new president, John F. Kennedy, and the Civil Rights Division that Eisenhower had founded in the Department of Justice in the last years of his administration to investigate and combat racial discrimination. Under federal order, attorneys for the division began locating and targeting hotspots of systemic violations around the country, and Mississippi and Forrest County rose to the top of their list. As federal attorney Gordon Martin later recalled, "The 1960 census reported that nonwhites made up 36.1 percent of the voting-age population of the state, but only 6.2 percent of them were registered to vote. Not a single

African American was registered in thirteen of the eighty-two Mississippi Counties. Forrest County had twelve."[315] Such discrepancies could not, the fed reasoned, be due to a total lack of qualified voters; some structural impediment preventing their registration must be at work.

On arrival, the attorneys found their structural impediment in the imposing figure of the 350-pound voting registrar Theron Lynd, Forrest County circuit clerk, who had served in that position since 1959. Lynd and his predecessor, Luther Cox, were well known for denying blacks the right to vote, but after the formation of the NAACP in Forrest County in 1946—another of the postwar developments by black veterans and supporters of voting rights—the county courthouse saw increasing numbers of black citizens lining up to vote. Those lines, of course, were turned away more often than not; embodying Jim Crow, Cox and Lynd were prone to ask black registrants a series of difficult, if not impenetrable, questions regarding the interpretation of state law that white registrants rarely, if ever, were required to field. And those questions were the easy ones: as part of their application, many blacks had to answer the famous question, "How many bubbles are there in a bar of soap?" When the Department of Justice sued Lynd for his violation of federal statutes in a protracted and at times even comical trial—Lynd was so obese that the court had to construct a special witness chair just for him to fit on the stand—he was finally convicted and held in contempt of court in early 1962. Remarkably, he would return to work within days, and despite federal orders to register eligible black voters (many of whom simply returned to the same courthouse to fill out the same forms they had encountered prior to the trial) and later formal censure, Lynd continued to serve in that position until his death in 1978.[316]

Nevertheless, the legal victory emboldened civil rights activists in the Hub City, and despite continued intimidation, harassment and threats, African Americans increasingly showed up to register in the months following Lynd's conviction, regardless of how many times they would be turned away. For the tide was turning, in Hattiesburg and across the South, and following events elsewhere such as the student sit-in workers in Greensboro in North Carolina in 1960, and the arrival of the buses of Freedom Riders into Mississippi in 1961 following desegregation ordered by the Interstate Commerce Commission,[317] the movement continued to gain momentum. In February 1962, just before Lynd was convicted, the major activist organizations (SNCC, CORE, SCLC and elements of the NAACP) formed the Council of Federated Organizations (COFO) to coordinate their activities, and later that year, in one of the most famous incidents of 1962, James Meredith

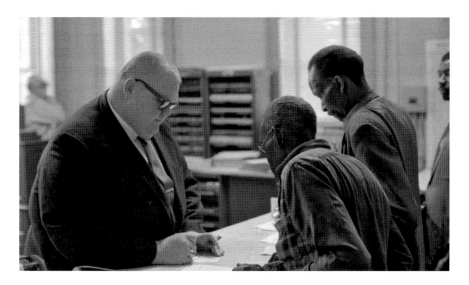

Freedom Day, January 22, 1964, Hattiesburg, Mississippi. Forrest County circuit clerk Theron C. Lynd attends to voter registration applicants in the courthouse. *Moncrief Photograph Collection, Item #13, courtesy of the Mississippi Department of Archives and History.*

sought enrollment at the University of Mississippi as the first black student. Initially barred at the doorway from the admissions office by Governor Ross Barnett, President Kennedy sent in thousands of National Guard troops to occupy the campus, with Meredith's subsequent enrollment on October 1 leading to widespread rioting and destruction, clouds of tear gas blanketing the campus like a poisonous fog, two deaths and nearly two hundred injuries. Once again, Mississippi was at the center of national attention, and in response, the president of USM reassured his students and townsfolk that no such incidents would happen in Hattiesburg if he could help it. According to one account of the time:

> *"I will fight by every means I know how to prevent integration at the University of Southern Mississippi," Dr. McCain said, "but if I get my back to the wall I want to ask you and all friends of the university to stay off the campus and trust me to handle it. There will be no rioting and bloodshed on the campus...I may be tagged by some as a moderate, but rioting on the campuses of our institutions of higher learning is no way to settle the perplexing problem of integration which faces us...*[We] *have to use every means we can to delay this unjudicial judicial degree* [of *Brown v. Board*]. *I am asking all friends and*

*former and present students of the University to leave it to my judgment in the event I get my back to the wall.*" [318]

Historian Chester Morgan tells this story in detail; a protest movement did arise on campus, one whose goals of integration would eventually be achieved.[319] Until then, 1963 would see a slew of struggles; early in the year, SCLC leader Reverend Martin Luther King Jr. would be imprisoned in Birmingham, Alabama, and write his famous letter outlining the philosophy of nonviolent resistance; in June, Governor George Wallace would attempt to block the integration of the University of Alabama just as Barnett had at Ole Miss; that same month, in one of the most grievous slayings of the era, Byron de la Beckwith would assassinate Mississippi state NAACP director Medgar Evers in Jackson (for which he would not be convicted for forty years), and in August, following Kennedy's submission of his first civil rights bill to Congress, King and other leaders would lead their largest march on Washington to date. The summer would end in tragedy, however, when Klansmen led by Robert Chambliss would bomb the Sixteenth Street Baptist Church in Birmingham in September, killing four young girls.

Amid the horror and the loss, such events did not dissuade activists in Hattiesburg from continuing to register new voters and from seeking betterment through education, economic development and civic participation for the black community. As 1963 drew to a close, the Hub City would become home to one of the state's largest rallies yet, organized by state NAACP chairman and Evers's successor, Aaron Henry, a pharmacist originally from Clarksdale. On the night of October 29, Henry held a rally and voter registration drive downtown at the Negro Masonic Temple on Mobile Street that drew over three hundred people, two hundred of whom fit inside the building, and the other one hundred overflowing onto the street, where they encouraged and responded to the clapping, speeches and music from the windows above. Despite intervention by city authorities, who sent a team of fully equipped firefighters to shut down the gathering (the only flame present being, on one account, from Henry's lit cigarette), the activists stood down the city, and the rally carried on. With the Sovereignty Commission on hand, present-day readers ironically have it to thank for detailed accounts of the event, including fiery speeches by Henry and SNCC organizer Laurence Guyot. Guyot, as recorded by state agents, proclaimed,

*We are making history in Hattiesburg tonight.* [At this time, a fire department unit passed with sirens en route to an emergency.]

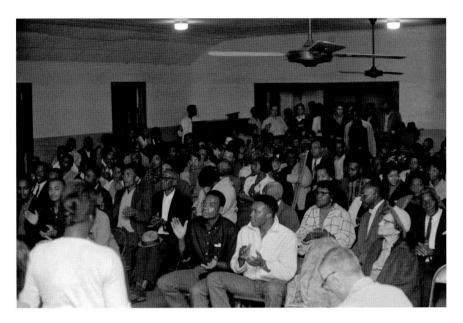

Aaron Henry for governor rally, October 29, 1963. COFO's Freedom Vote campaign event held in upper room of Negro Masonic Temple, 522 Mobile Street, Hattiesburg, Mississippi. *From the Moncrief Photograph Collection, Item #11, courtesy of the Mississippi Department of Archives and History.*

> *Do you hear that mess out there? You are going to hear a lot of that before the year is out, we are going to show them we can get what we want. We are not fighting for lunch counters, schools and churches. We are fighting for the ballot. The prime weapon a person is born with is the ballot. The ballot can change the lunch counter, the schools, the Police Chief, and the fire engines…when there is no fire.* [At this point, they all stood, screamed and clapped.] *The police here don't do anything but violate the laws they are supposed to enforce. I'll bet* [Governor] *Paul Johnson never got as much police protection in his rallies as we have here tonight.*[320]

Accompanying the program of speakers was the staging of the first Freedom Ballot in Mississippi, a mock integrated ballot that attracted nearly eighty thousand voters statewide and laid the groundwork for the emergence of the Mississippi Freedom Democratic Party the following year. According to some accounts, the Hattiesburg rally was the largest of its kind that the state had yet seen, garnering support both from members of the local community and from outside participants as well—such as four students from Yale who traveled to Hattiesburg to assist the organizers of

the vote, a trickle of outside interest that would soon become a flood.[321] Though the movement—and indeed the country—would lose one of its greatest advocates weeks later with the assassination of President Kennedy, the momentum that activists had gained up until that point would not be lost. The year was winding to a close, but the intensity of the struggle was heating up, and as 1963 gave way to 1964, the Hub City entered one of its most turbulent, violent, courageous and storied years to date.

# *1964 and Freedom Summer*

Though Hattiesburg would come to be known more for the events of the summer of 1964 than any other period that year, in truth, the seeds for what happened that summer were sown on a cold, rainy Wednesday that January. The momentum for large-scale action had been building among the leadership of the major organizations, and with Hattiesburg chosen as the site for a major demonstration for voters' rights (partly due to the outcome of the Lynd trial), that leadership descended on the Hub City to raise support and plan the attack. Mobilizing scores of volunteers who slept on floors, sofas and pallets across town, that leadership included veterans such as Fannie Lou Hamer, Robert Moses, Lawrence Guyot, Peggy Jean Connor, Victoria Gray Adams, J.C. Killingsworth, J.C. Fairley and, critically, dozens of visiting ministers from out of state who had heeded both personal and ecclesial calls to join the movement in skirmishes where moral authority was a key weapon in the war. This minister's project was composed of multiple denominations, all of which were at odds with the views of the two main southern denominations, the Baptists and the Presbyterians.[322]

Historian Taylor Branch recounts the events of Freedom Day, January 22, in detail; here it is enough to note how the antagonism and violence feared by the activists took a surprising turn when the local law enforcement assembled outside the Forrest County Courthouse that cold and rainy morning did not forcibly bar any citizens from lawful entry into the building.[323] Rather, as much as they corralled the activists, they also trained their sights on a crowd of white observers who taunted and insulted the long column of marchers, their presence ensuring that no large-scale violence would ensue. As the activists demonstrated outside the courthouse, isolated incidents did lead to the arrest and jailing of individual civil rights workers, but otherwise, the police and sheriff's office stood by as the activists sent

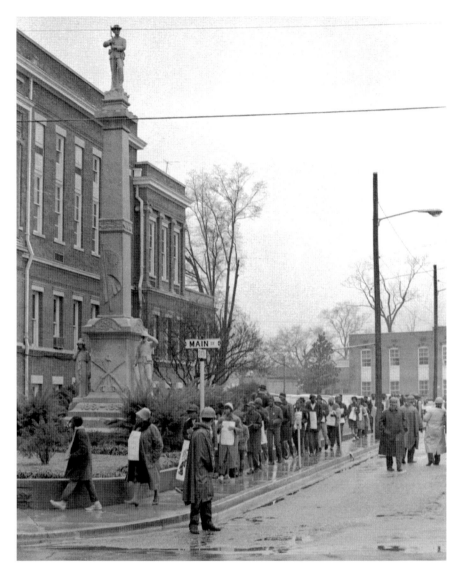

Freedom Day, January 22, 1964, Hattiesburg, Mississippi. Fannie Lou Hamer, in hat with placard, marches past Confederate monument with demonstrators outside the Forrest County Courthouse in the afternoon, watched by police. *Moncrief Photograph Collection, Item #40, courtesy of the Mississippi Department of Archives and History.*

voters into the courthouse to register, where Lynd was waiting. (This fragile peace, as Branch has argued, was partly due to city officials wishing to avoid any further negative publicity for their segregationist stance, especially after Lynd's recent conviction for contempt of court.)[324]

If city officials had expected the activists—marching, preaching and singing freedom songs—to wear out, they were as surprised as they were disappointed, for the events of Freedom Day extended well past that one morning and afternoon to form a "perpetual picket line" throughout the week, the month and, indeed, the season. As the need for an even larger effort became clear to the leadership of COFO and the other organizations, demonstrations continued to take place at the courthouse, leading to nearly 'round-the-clock action by activists and clergy even as that fragile peace began to fray. A week after the protests began, Hattiesburg police arrested nine ministers from the "northern" branch of the Presbyterian Church for disorderly conduct, after which the city tried to stifle the movement overall by obtaining a general antipicketing order from Judge Stanton Hall.[325] But despite these setbacks, as Branch and Harris both detail, the momentum would not be derailed: Freedom Day ultimately lasted well into the spring, an effort that would presage the events of the summer.[326]

"If we can crack Mississippi," the saying among civil rights workers went, "then we can crack anywhere." The summer of 1964 saw the early fruits of that hope, as a national effort led by all the major civil rights organizations resulted in thousands of activists descending upon the Magnolia State to conduct voter registration drives; teach classes in civics, literacy, mathematics and science; and stage demonstrations in heavily segregationist communities that had ignited the South since the first days of the movement. Though Freedom Summer is often referred to as the apex of the movement as a whole—even though no one season deserves that honor any more than any other—it was nevertheless the most dedicated and concerted effort by activists in the Hub City of the entire era.[327] Stirred by the passage of the federal Civil Rights Act in June (after the longest Senate debate over a bill then on record), activists poured into Mississippi and Hattiesburg eager to capitalize on this new momentum. Aware of the risks—five days after the act was passed, three civil rights workers in Philadelphia in Neshoba County would go missing—volunteers came anyway, trained in the arts of nonviolent resistance and nonconfrontation and joined the ranks of local activists who had made the African American neighborhoods of Palmer's Crossing and Mobile Street their base.

As noted in Chapter 3, for years, Mobile Street had been a vibrant community, with its extensive network of black-owned businesses, shops and restaurants, including a movie theater, grocery store, drugstore and doctor's office. As the movement took shape in the 1950s and early 1960s, the street's role as the epicenter of black life increased to the point that COFO opened

its headquarters in Lenon Woods's boardinghouse at 507 Mobile Street, a de facto point of entry for all activists. (Unfortunately, the building was later destroyed in a fire, but its location is preserved on the modern-day Freedom Summer Trail in town.) The Freedom House, as it came to be known, served as the staging point for the summer's activities, from planning voter registration drives, to coordinating Freedom Schools, to staging boycotts, to housing workers as they arrived, to hosting the Free Southern Theater and their performances of new plays, to serving as the headquarters of the Mississippi Freedom Democratic Party.[328] Along with other organizations, such as the Hattiesburg Minister's Union at the Negro Masonic Lodge (also since lost, destroyed in the 2013 tornado), the street and the neighborhood remained abuzz. The moral imperative to register black voters felt by the incoming activists and the leaders of the community led to a furor of activity as, for the first time in their lifetimes—but not, ironically, in the whole of their history, having known the privilege during Reconstruction—blacks embraced the prospect of their right to vote.

Famously, the events of Freedom Summer were kicked off by a massive Independence Day party at Vernon Dahmer's farm in the Kelly Settlement, featuring a fish fry, band and opportunity for activists and hosts to get to know one another, closely documented by visiting photographer Herbert Randall.[329] As historians of the era have noted, the majority of Freedom Summer activities were held on the grounds of the major churches of the neighborhoods, typically outside in picnic-style settings or indoors in their classroom facilities.[330] For local blacks, many of whom had little opportunity to pursue higher education or whose opportunities lay only out of town or out of state, the experience was life-changing. As one Freedom Summer participant recalled years later, "Freedom Summer was the first encounter with whites that wasn't on the 'yes ma'am/no sir' basis. White people treated us like we were somebody."[331] According to civil rights archivist and historian Bobs Tusa, "there were so many students enrolled in local Freedom Schools—an estimated 650–675—that the state Freedom School director, Dr. Staughton Lynd, professor of history at Yale University, called Hattiesburg 'the Mecca of the Freedom School world.'"[332]

Naturally, such activities drew not only the attention but also the ire of conservative whites, and black residents today vividly recall the warnings of white employers—individual and corporate alike—not to get involved in what was going on around town, for fear of losing their jobs. Many did so anyway: for black parents and children alike, the opportunity to progress past a sharecropper's education and life of menial labor such as the public

education system largely offered was too great to ignore, and the promise of a future under their own determination was worth more than any wage that whites could offer. The Freedom Schools started on July 6 and ran for two three-week sessions, with each school adopted by a church that sheltered them and provided for their needs. With volunteer educators staying in locals' homes, sometimes so many under one roof that one could not cross the floor at night for stepping on bodies, the twin feelings of risk and reward were palpable.

For that ire had been expressed on numerous occasions by whites who were determined to preserve the "southern way of life," and while it is true that Hattiesburg was not subject to the level of mass violence that other cities experienced, it is wrong to assume that the Hub City did not see its share of harassment, intimidation or reprisals against blacks and their advocates. Clara and Ernest Brooks, owners of a small bar in the Kelly Settlement, woke one night in the early 1960s to find their bar on fire and a cross burning in their front lawn,[333] and one summary of incidents that summer lists twenty-five accounts of assault, property damage, espionage and other forms of abuse in Hattiesburg alone.[334] Other events are less well known: the Reverend John E. Cameron Sr. of Petal, a Baptist pastor who undertook a ministry at Sweet Pilgrim Baptist Church in Hattiesburg during that year, recalled the night that night riders raked the front of his house with gunfire, ordered by law enforcement officials whom Cameron confronted the next day, claiming he would not hesitate to defend himself and his family against any assailants were it necessary. (The day of the attack, Cameron had felt an irresistible urge to have his family sleep in the back room of their house, contrary to their normal arrangements—an impulse that he credits to divine intervention to this day.) The attacks stopped.[335]

In the modern age, with the city's streets more free from fear, it can be difficult for Hattiesburg residents to appreciate the contingency and uncertainty of the time. "Darkness," as activist Sandra Adickes recalled, "meant danger," and Freedom Summer volunteers quickly became accustomed to retreating to their hosts' homes before nightfall, after which sightings of vehicles patrolling up and down the streets of black neighborhoods—night riders on the lookout for white faces in black homes—became commonplace, and hosts would turn the lights out early to protect themselves and those they harbored.[336] The work of Freedom Summer had to be done by daylight, but even then, activists were not safe. In one of the most shocking acts of violence in Hattiesburg that summer, on July 10, Rabbi Arthur Lelyveld from Cleveland, Ohio, and

Rabbi Arthur Lelyveld after assault, Hattiesburg, Mississippi, July 10, 1964. *Herbert Randall Freedom Summer Photographs, McCain Library and Archives, University of Southern Mississippi. Courtesy of Herbert Randall.*

Pete Seeger and Anthony Harris, Hattiesburg, Mississippi, August 1964. *Herbert Randall Freedom Summer Photographs, McCain Library and Archives, University of Southern Mississippi. Courtesy of Herbert Randall.*

his two white companions, Lawrence Spears and David Owens, were savagely beaten by a group of whites armed with a tire iron, attackers who left the three bloodied on the sidewalk in broad daylight and who then retreated to their pickup truck nearby to watch the scene as though nothing had happened. Remarkably, after the incident, Lelyveld chose to stay on as a volunteer worker in Hattiesburg and, even after his later return to Ohio, urged fellow clergy to continue to travel south to carry on the fight.[337] Ten days later, on July 20, another group of activists would be beaten as they left a downtown store, with one volunteer attacked in surprise from behind; incredibly, not only the assailant but also the victim would be charged with assault, even after he dropped to the ground in the fetal position, just as he had been trained.[338]

As the summer drew on and July melted into August, the actions of the civil rights workers received increased attention. National figures such as folk singer Pete Seeger visited Hattiesburg to show their support, holding concerts and events to boost morale and strengthen their activities. Even when the grim news arrived out of Philadelphia that the bodies of James Cheney, Andrew Goodman and Michael Schwerner had been found beneath an earthen dam, murdered by Klansmen weeks earlier, the activists continued to press on with their work. On August 11, Mrs. Dorothea Jackson staged her own boycott of Hattiesburg buses like that of Rosa Parks a decade earlier. Historian William Sturkey recalls that "when [Jackson] was removed from a bus for refusing to give up her seat on a sweltering August day, the remaining twenty black passengers stood up and also walked off that bus, spurring a boycott that would end segregated seating on city busses."[339] And on August 14, protesting the inadequate facilities at the one-room black library on East Sixth Street, Sandra Adickes and seven African Americans would attempt to integrate the Hattiesburg Public Library, walking into the whites-only facility and asking for registration cards. In Adickes's own words from her diary:

> *Jimmella Stokes, Carolyn and Diane Moncure, Gwen Merritt (all in blue SNCC shirts along with me), La Verne Reed, and Curtis Duckworth and I went to town, arrived about noon, and went to the public library. Her [the registrar's] eyes nearly bolted from their sockets. The girls told her they wanted cards. There was something (said) about "a custom that has been here since before you were born," and so on. The kids listened patiently and replied that they could not see why they should not have a library card. She said that she could not put them out, but if they stayed, she would have to call the police and close the library to everyone. Jimmella said, "If*

*we can't use the library, then nobody else should." We sat down and she telephoned. We read magazines, and after twenty minutes the police chief came and asked if I were the leader. I said, "I'm not the leader; I'm a friend of these girls." He said, "All right, get out; we're closing the library." We left and everybody left. The cop got out and said, "You're under arrest." I asked for the charge. He said, "Vagrancy." I asked on what basis he was arresting me for vagrancy. He said, "I have orders to pick you up. Don't resist." I went to a cell. In about ten minutes a man came. I was asked more questions, fingerprinted, photographed, and returned to my cell. Chief Herring said that COFO had called and asked the amount of my bond. After about an hour, the Guild lawyers came and I was bailed out.*[340]

The library would remain closed (ostensibly "to conduct an inventory") until August 17, when Adickes and more civil rights workers would return. Astounded by their move, city officials closed the library, this time indefinitely, and arrested four of the activists on charges of vagrancy once more. Incredibly, the library would remain closed for a further three weeks, until pressure from local whites who were unable to use the facility forced it to reopen, this time with a new policy. Only in 1972 would the Sixth Street branch of the library close, ending segregated libraries in town.

If eyes in the Hub City were on its civil rights workers that summer, eyes statewide were on a new political party that had emerged over the previous year, the Mississippi Freedom Democratic Party (MFDP). Led by Fannie Lou Hamer, Aaron Henry and Hattiesburg natives Peggy Jean Connor and Victoria Gray Adams, the MFDP shot to prominence that long, hot summer as organizers planned their next move. Though the party had only been formally organized that spring, by early summer, it was meeting in the COFO headquarters on Mobile Street, and in August, it held a convention in Jackson to plan its assault on the Democratic National Convention in Atlantic City at the end of that month. Decrying the all-white party registration by the mainstream Democrats, the MFDP challenged the Democrats' legitimacy on the floor of the convention in an extraordinary show of resolve against the reigning tendencies of the party in power and their incumbent nominee for president, Lyndon B. Johnson. The MFDP sought to replace the Mississippi Democrats with an integrated slate of delegates; in one of the most memorable incidents of the convention, Hamer, a Sunflower County native and former sharecropper, testified on live television about her experiences being jailed and beaten for registering to vote, famously claiming, "I am

sick and tired of being sick and tired" and demanding of the stunned public, "Is this America?" As Freedom Summer drew to a close, that question would ring throughout the halls of the country, and while the MFDP would not receive what it sought at the convention—offered a compromise of two at-large (non-voting) seats, the delegates refused to accept Johnson's offer, claiming that they had not traveled all the way to New Jersey to return empty-handed—its efforts nonetheless emboldened the movement further. Mississippi had not yet been cracked, nor had Hattiesburg (with the majority of the white elected power structure still in office), but chips were flaking off the ice, and those in pursuit of the waters of freedom could hear them rushing deep underneath.

In retrospect, looking back on Freedom Summer on its fiftieth anniversary, it is remarkable to consider both the extent of the challenges that lay before the activists in Hattiesburg and the extent of the progress that they made. Armed with conviction, belief and skills intended to defuse conflict before it could explode, they entered a volatile situation whose outcome in other areas of the state had been marked by the last names of those who had been beaten, maimed or killed. While it is true that Forrest County was nowhere near the hotbed of violence that other places experienced—McComb had been nicknamed the bombing capital of the state, and Jackson, Philadelphia and Brookhaven had already sampled their portion of grief—the atmosphere of fear, suspicion and hostility was nevertheless as present in the county named for a leader of the Klan as it was in any other. Even the *Hattiesburg American*, owned by the segregationist Hederman brothers and edited by the like-minded Leonard Lowrey, made its position known both in overt editorials and in covert omissions of events.[341] But it is important to remember that for every act of derision, intimidation or hate that characterized reactionary white attitudes of the time, there were just as many (if not more) actions of love, respect, kindness and courage that defined the era as well. If Freedom Summer has left a legacy for contemporary readers and citizens of Hattiesburg, it is of resilience and strength in the face of adversity, even as the physical monuments to the struggle have given way to historical markers in the neighborhoods where the crowds once gathered, the teachers once taught and the singers once sang their songs.

# *The Later Years, 1965–69*

The period following Freedom Summer would be defined by another set of triumphs and defeats, as 1964 turned the corner into 1965. Over the winter, FBI officials would pursue the murderers of the Philadelphia Three but meet regular resistance from the courts in the process, with the first two waves of arrests dismissed by the local judge. In February, Malcolm X would be assassinated in New York, and in March, six hundred activists would march over the Edmund Pettus Bridge in Selma into a solid wall of tear gas, police dogs and nightsticks. This "Bloody Sunday," as it came to be known, would bring Martin Luther King to Selma to conduct another march and, from there, walk all the way to Montgomery with over twenty-five thousand people alongside him. That summer, Congress would pass the Voting Rights Act, which Lyndon Johnson would sign into law in August.

Back in Hattiesburg, Rabbi David Ben-Ami of the city's only Jewish temple, who had outspokenly supported civil rights activists and promoted charitable works among the community's poor, would be asked to leave Temple B'Nai Israel for fear of inviting reprisals from radical whites.[342]

October 28, 1965 Ku Klux Klan rally in a Hattiesburg, Mississippi field. Robert M. Shelton, imperial wizard of the United Klans of America, signs autographs. *Moncrief Photograph Collection, Item 317, courtesy of the Mississippi Department of Archives and History.*

Both USM and William Carey College would give in to pressure and finally admit black students for the first time. With President William D. McCain reading the writing on the wall, USM would admit Raylawni Branch and Elaine Armstrong as undergraduates,[343] and President Ralph Noonkester of Carey would present a stark choice to the institution's board. As Noonkester later recalled, "Carey College was the only Baptist school in Mississippi or Alabama that would even think about integrating. I sold it to our trustees simply as a survival requirement. I told the board I'm not going to preach any sermons about the moral background of this but you will either do this or you will close the school. I was doing this as an economic factor."[344] In 1966, Rowan High School graduates Vermester Jackson and Linda Williams would become the first African American students at Carey; for his decision, Noonkester, too, would have a cross burned in front of his house.

If the events of 1964 had been a high point for Hattiesburg, then those of 1966 brought the city to one of the lowest in its history. Early in the morning on Monday, January 10, a gang of Klansmen headed by local imperial wizard Sam Bowers—who had also conspired in the murders of the civil rights workers in Philadelphia—attacked the home of Forrest County NAACP leader Vernon Dahmer in the Kelly Settlement. In a harrowing assault that took the Dahmers completely by surprise, Bowers and his night riders firebombed the house, shooting pistols and rifles and throwing explosives through the windows. Dahmer held off the attack, firing back at the intruders, while his family escaped out the back window—his sons, who were in military service out of state or overseas, were away from home at the time—but as a result of his efforts to defend his family, who would suffer primarily burn and smoke damage from the attack, Dahmer would die from his injuries the following day. The official cause of his death was searing of the lungs.[345]

Known for his passionate conviction that "if you don't vote, you don't count," Dahmer was not unaware of the risks of his activities: he knew that he had been targeted both by the state Sovereignty Commission and the Forrest County Citizen's Council for investigation and possible reprisal.[346] But his murder, the most horrific act of violence in Hattiesburg up to that point, shocked the entire city nevertheless. In a massive protest march that same week (led, among others, by Medgar Evers's brother Charles), activists called for a full investigation to bring Dahmer's killers to justice, along with a host of fifteen requests to city authorities to bring about racial equality in the legal, education, police and health systems in order to honor and avenge their leader's death.[347] A biracial coalition would rally behind the Dahmers, blacks and whites alike helping to rebuild their

Charred remains of Vernon Dahmer's car the morning his house and store in the Kelly Settlement were firebombed on January 10, 1966. *Moncrief Photograph Collection, Item #513, courtesy of the Mississippi Department of Archives and History.*

destroyed home and farm through financial contributions and donated labor. Sixteen men would eventually be charged with the crime, but as fit the statewide trend of white assailants of the era escaping prosecution or conviction for their crimes, Bowers himself would go free on a mistrial and would not be convicted for over thirty years. The attack, Robert Patrick Rayner has noted, struck directly at the heart of the Hub City, which, until that point, had not considered itself capable of such violence, and its horror convinced even whites who had staunchly defended the ideology and practice of segregation of the need for reconciliation. Even segregationist elites such as business owners, ministers and the leadership of the *Hattiesburg American* (no friend to the movement, as noted above) called for justice, and faced with the alternative, attitudes finally—if slowly—began to change.[348]

"Slowly" would be the key word; entrenched attitudes built up over generations would not be dislodged overnight, and in the later years of the movement, activists had to fight just as hard for justice. In 1967, the case against the murderers of the Philadelphia Three would finally go to trial—leading to seven convictions, eight acquittals and three mistrials, including that of the architect of the murders, Edgar Ray Killen. In Hattiesburg, the local NAACP chapter would lead another wave of boycotts on white businesses. Sandra

Army sergeant George W. Dahmer, USAF staff sergeant Martinez A. Dahmer, USAF master sergeant Vernon F. Dahmer Jr. and army specialist fourth class Alvin H. Dahmer at the ruins of their father's house, Hattiesburg, Mississippi, January 1966. *Courtesy of the Dahmer family.*

Adickes would later recall that "Mrs. [Daisy Harris] Wade helped organize a boycott of Hattiesburg's bus company and downtown businesses for failing to hire black workers. An important [factor] in the speedy success of the boycott was a group of thirteen young men known as 'the Spirit,' that J.C. Fairley recruited. As Dr. Harris explained, a person in the black community who did not support the boycott would be visited by the Spirit and afterward know 'that he or she should fear the Spirit more than anything else.'"[349] In March 1968, on a statewide tour of Mississippi, Martin Luther King would visit Hattiesburg, speaking to a packed assembly at Mount Zion Baptist Church two weeks before being assassinated in Memphis. According to a later account,

> *"My husband met him at the plane," said Jeanette Smith, whose husband, Dr. C.E. Smith, was president of the Forrest County Chapter of the NAACP from 1967–1972. "We waited all night. The church was packed. Everybody*

Demonstration on morning of Vernon Dahmer's funeral, January 15, 1966, Hattiesburg, Mississippi. *Moncrief Photograph Collection, Item #366, Mississippi Department of Archives and History.*

*waited until he came. He probably spoke about 20 minutes."…King spoke about a nationwide poor people's campaign and a proposed mass march on Washington, which he said would happen at the end of April. The purpose of the march, King said, was to expose the plight of the poor, including blacks, whites, Mexican-Americans and Puerto Ricans to the Congress and the President…Dr. King apologized for being so late, Mrs. Smith said, and spoke about his "dream." But it was the look on his face that she remembers best. "It looked like he was looking beyond the crowd," she said. "I guess it was a look of death. He would be looking at you but he looked far away."* [350]

That summer, tragedy would strike again when Attorney General Robert F. Kennedy would be assassinated in Los Angeles. With American troops now fully embroiled in the conflict in Vietnam, one of the most tumultuous decades in the nation's history was drawing to a close. In 1969, the Dahmer trial would end in a mistrial, due to suspected juror intimidation by the local Klan, but attorney James Finch would still net four convictions in the case. Building on its previous decisions over the past two decades, the United States Supreme Court would declare in *Alexander v. Holmes County Board of*

April 8, 1968, Hattiesburg, Mississippi march in memory of Dr. Martin Luther King Jr., four days after his death. *Moncrief Photograph Collection, Item #682, Mississippi Department of Archives and History.*

*Education* that "freedom of choice" of public schools for white and black students did not, in fact, lead to desegregated schools, mandating that school districts across the country integrate their classrooms immediately. While some teachers and students would cross the color line into white and black schools in the years following the decision, progress would be slow and fitful. Concerned about the state of what they saw as failing public facilities, white families throughout the Deep South would begin to move their children to private schools and academies (in some cases, founding them in order to do so), leading to de facto segregation once more; unfortunately, Hattiesburg would experience a degree of the same fate.[351]

## *The Fruits of the Movement: Loss and Gain*

In one of the most moving documents from the era, Clyde Kennard outlined his view of racial equality in a letter to the *Hattiesburg American* on September 25, 1959, shortly after his first arrest on false charges and a year before his

imprisonment at Parchman Farm. Speaking for blacks who saw an education as a means to a better life and who saw enfranchisement as a form of dignity they had once possessed but that had been unjustly taken away, Kennard testified to the common humanity that he shared with members of all races:

> *It is an easy matter, I suppose, for White people to misunderstand the aspirations of Negroes; this is understandable. But we have no desire for revenge in our hearts. What we want is to be respected as men and women, given an opportunity to compete with you in the great and interesting race of life. We want your friends to be our friends; we want your enemies to be our enemies; we want your hopes and ambitions to be our hopes and ambitions, and your joys and sorrows to be our joys and sorrows. The big question seems to be, can we achieve this togetherness in our time? If the segregationists have their way we shall not. For instead of preaching brotherly love and cooperation they are declaring the superiority of one race and the inferiority of the other. Instead of trying to show people how much they are alike, they are busy showing them how much they differ. Instead of appointing a commission to study the problem to determine whether integration or segregation is the best policy for Mississippi at this time, they appointed a commission to try to maintain segregation at all cost whether it is the best policy or not the best policy. In this matter I like to quote from the great Indian leader, Mahatma Gandhi, in his discourse on the existence of God. He says: "In the midst of death, life persists; in the midst of untruth, truth persists; in the midst of darkness light persists." So, let it be, in our case.[352]*

Sadly, like Martin Luther King, Kennard would not live to see his dream realized, but that decade, composed so equally of tragedy and victory, would without a doubt have brought him closer to his goal. In 1969, the same year that John F. Kennedy's challenge for mankind to visit the moon would be met, the first African American doctoral candidate, Walter Washington, would graduate from USM. The achievements of these two men would be honored by USM officials in 1993, with the dedication of Kennard-Washington Hall. The same decade that saw so much violence and suffering would also yield a legacy of generational change in civic representation, sowing the seeds for political and economic development within the black community that would flower in the years to come. Vernon Dahmer's name would come to grace the national Civil Rights Memorial in Montgomery, Alabama,[353] and the 1970s and 1980s would see the emergence of the first black political class in Hattiesburg, which would not only elect its first leaders but also successfully

lobby for reforms in city and county governance in moves that would change the face and shape of Hattiesburg permanently.

The end of the civil rights era, as noted, would coincide with the rise of the conflict in Vietnam, and while flower power would never take hold of the Hub City the way it would Berkeley or Greenwich Village, the escalation of the war would still reach Hattiesburg in other ways. Local residents would serve in that conflict, and Camp Shelby would train the 199th Light Infantry Brigade, for which local resident and Korean War veteran Ott Brockman, along with camp brass, would organize a thunderous, patriotic send-off in the newly opened Reed Green Coliseum at USM on the eve of their deployment in 1967. Brockman's tribute, intended to make the soldiers feel appreciated in the wake of so many protests across the country, featured a packed-out arena replete with bands, beauty queens and celebrity guests such as baseball legend Dizzy Dean, sending the troops off in style.[354] During this same time, subterranean echoes of the Cold War abroad would make their appearance at home in Mississippi, with the federal government conducting the first of several underground nuclear tests in neighboring Lamar County under the code name Project Dribble in 1964, blasts that caused the *Hattiesburg American* building downtown to sway for nearly three minutes.[355] According to the Mississippi Department of Archives and History,

> *News reports indicate that the countdown began at 9:44 a.m., as it had done on two previous occasions, but this time the crowd of over 50 "newsmen, politicians and observers mounted on the crest of the hill to watch the shot" were not disappointed as the blast exploded precisely at 10:00 a.m. Reporters at the scene described how the "earth rolled and bumped three or four times shaking a communications trailer and other structures and bobbing 50 cars and trucks on their springs." Project employee Billy Ray Anderson recalled how the observation trailer rocked and rolled and "[t]hose politicians came running out of the trailer, grabbing their handkerchiefs and wiping sweat off their foreheads."*[356]

Outside of the civil rights movement—which, as one of the great epochs in the nation's history, often obscures many other views of the period—Hattiesburg would see other significant changes to its fabric as well. Due to a toxic combination of neglect and disinterest, the city would lose much of its historic architecture from its founding era, including the McClanahan House (demolished in 1960), the Hotel Hattiesburg (1961), the McInnis House (1961) and the majestic Tatum House (1964), emblems of

the city's golden age as a lumber capital.[357] The railroad and transportation industry would also see the end of an era as the Lindsey Wagon Company would manufacture the last eight-wheeled wagon in 1964, and the Interstate Commerce Commission would authorize the sale and dissolution of the Mississippi Central Railroad in 1967 to the Illinois Central Railroad, the Bonhomie and Hattiesburg Southern line following in 1973. Perhaps most devastating would be the arrival of Hurricane Camille in 1969, a storm that would impact cities across the Gulf Coast and cause hundreds of millions of dollars' worth of damage.[358]

But for all the loss, the Hub City would see a great deal of gain in the 1960s, chief among it the strengthening of its medical sector both in Forrest General Hospital under longtime CEO Lowery Woodall and in Hattiesburg Clinic, which had opened its doors in 1963.[359] Keeping pace with this emergence, both USM and William Carey—which had enjoyed significant eras of expansion and growth in those years—would swiftly open schools of nursing to supply the needs of the medical establishment; USM would open its school in 1966, and Carey would merge with the Mather School of Nursing in New Orleans two years later.[360] Accompanying this growth in the educational and medical sectors would be investment in the economic infrastructure of the city, with the construction of Interstate 59 in 1962–63, linking Hattiesburg, New Orleans and Meridian even more closely (and following the original route of Hardy's first railroad); the creation of Southern National Bank in 1965 (the city's first new bank since 1905); and the arrival of longtime Hattiesburg employer Marshall Durbin and the expansion of the Pine Belt Regional Airport, both in 1968.[361] The city would gain the first black-owned radio station in Mississippi, WORV-AM, in 1969, and to showcase the grit and ambition of local residents, a group of twenty-one high school students would set a record in the *Guinness Book of World Records* for the longest continual game of Monopoly ever played—755 hours over thirty-two days concluded on the morning of August 27, 1968.[362] Their prowess in fiscal matters, even if fictional, would set a fitting tone for the next phase of the city's growth as, after so much tumult in its historic core, the Hub City began increasingly to look outward, a direction from which it would never look back.

## 6

# OUTWARD GROWTH, 1970-2000

## *Introduction*

In the immediate aftermath of the civil rights era, the challenges that the movement had overcome would not disappear overnight. In truth, even though the legal battles for racial equality had been won at the national level, activists found a number of practical tasks left to accomplish as the dust settled from their fight, such as actually achieving enough votes to elect minority representatives to power in southern cities like Hattiesburg. Voter registration and efforts to integrate local schools and facilities would continue, as would their obstructions—one Hattiesburg resident recalled visiting a water park in the 1970s whose owners, rather than submit to integration, closed its doors and filled its pools with alligators[363]—but those battles would require a slower, steadier pressure to win, as opposed to the violent confrontations of years past.

At the beginning of the 1970s, the nation remained focused on overseas events, primarily the conflict in southeast Asia and Vietnam. The horrors of that conflict and protest at home were enough to fill the mind of any citizen, and for many in Hattiesburg in those years, it was difficult to focus on much else from a political perspective. The 1970s in Hattiesburg would in many ways be politically quieter than years past, but that decade would still see pronounced change on a variety of fronts, from the demographic to the economic to the environmental. As the 1980s dawned, renewed political engagement would transform the city's governance in profound ways, and

the 1990s would end the century (and the millennium) with a breathtaking rate of growth that recalled that of a century prior. Taken together, each of the developments in these three decades would set the stage for the Hattiesburg most residents know today.

# The 1970s: Changing Natures

Part of the reason for the slower pace of events of the 1970s, at least in terms of political reform following the civil rights era, can be attributed to changes in the makeup of the state of Mississippi, changes that included Forrest County. Ever since their institution in ancient times, censuses have been activities of enormous interest and significance—the demographic equivalent of an artist's self-portrait. The 1970 census was no exception: it revealed in hard data what many during the previous decade had felt, namely that Mississippi, like the South, was undergoing profound transformation. Among the trends revealed that year were historic reversals in the state's racial and economic character: where in 1900 nonwhites (predominantly blacks) had outnumbered whites by a 60 to 40 ratio of 910,070 souls to 641,200, by 1970, that ratio was nearly the exact opposite, with whites outnumbering blacks 1,393,283 to 823,629. While the state's overall population had grown for the first time since the 1940s, moreover, the decade from 1960 to 1970 had exacerbated a trend of nonwhite (black) outmigration, with Mississippi experiencing the highest rate of any state in the South at 10.5 percent. During these years of the movement, blacks had either fled local and regional unrest or left in search of economic opportunity elsewhere, in a continuation of the Great Migration to cities such as Chicago, Washington or Los Angeles.[364]

Other shifts were taking place as well, as the state's predominantly rural population saw a dramatic tilt toward urbanism. Where in 1900 only 120,035 Mississippians lived in cities compared to the state's 1,431,235 rural dwellers, by 1970, the number of city dwellers had risen to 986,642 compared to 1,230,270 country folk—a shift in proportion from 7.7 percent to 44.5 percent urban, and rising. The Mississippi Delta suffered the most from these changes, with the central and coastal counties seeing the highest rates of growth over that time—as one demographer at the time suggested, "Urban growth in Mississippi seems to be moving in the direction of many dispersed centers of growth—a pattern which many students of population

distribution see as a preferred substitute to the proliferation of supercities."[365] Forrest County was consistent with those trends, growing from a total population of 52,722 in 1960 to 58,849 in 1970, with the majority of that increase in the white population: a gain of 5,554 souls against a decline of 427 blacks. Overall, the state of Mississippi was growing, but growing unevenly from north to south, rural to urban, white to black. As described below, in Hattiesburg, such discrepancies would dilute the efficacy of the new civil rights laws until the 1980s, when a new wave of legal challenges would arrive to ensure their implementation in full.

In the meantime, however, urbanism in Hattiesburg would receive a curious boost when, in 1970, the Hub City would receive the first of several such distinctions: a sibling city. Under Mayor Paul Grady's administration, Hattiesburg was named a sister city with Santa Maria de Los Ángeles, Chile, a city on that country's central coast. In July of that year, a delegation visited Hattiesburg on a mission of economic and diplomatic development, which the Chilean national newspaper heralded as follows:

> *Los Ángeles. The Mayor Waldemar Agurto and a delegation of officials from this city, will travel to Hattiesburg, Mississippi to formalize the agreement of twinning that has been reached by the two cities. The Mayor of Los Ángeles has proposed to his American colleague two possible dates for this trip, from 21 to 27 June or from 5 to 11 July of the present year. This trip will not entail a cost for the municipal finances, as members of the delegation would not pay their tickets but use the LAN* [Latin American Airlines] *CHILE credit system instead. The stay in Hattiesburg will be covered by the municipality of that city.*[366]

While it is not immediately apparent what long-term effects this relationship has had on Hattiesburg—economic, political or cultural—it would nevertheless serve as an excellent opportunity to boost awareness of and interest in other cultures and showcase the Hub City's offerings to the wider world. Interestingly, in recent years, the trend has continued: in addition to Santa Maria de Los Ángeles, Hattiesburg now boasts three more sister cities in St. Cloud, Minnesota; San Jose, California (both of which rendered assistance during Hurricane Katrina, discussed in the next chapter); and, most recently, Linyi, China, with which it shares partnerships in trade and higher education.[367]

Further bolstering Hattiesburg's self-image in those years was the selection of a new mascot at USM: in 1972, the golden eagle was selected to replace

Santa Maria de Los Ángeles, Chile, became Hattiesburg's sister city on July 21, 1970. Second from left, Mayor Waldemar Agurto. Far right, Mayor of Hattiesburg Paul Grady. *Hattiesburg Historical Photographs Collection, McCain Library and Archives, University of Southern Mississippi. Courtesy of Kenneth G. McCarty Jr.*

the southern "General Nat" and its Old South-era overtones, with the university's first live animal mascot, Nugget, arriving on campus eight years later.[368] In 1975, another iconic presence would arrive on campus with the election of Dr. Aubrey K. Lucas as president of the university; among Lucas's accomplishments over the next twenty years, writer Mark Olderr notes, were "the formation of the Teaching and Learning Resource Center; creation of the Faculty Senate; establishment of the Center for International Education; replacement of the quarter system with the semester system; and creation of the Polymer Science Institute; reorganization of the university's 10 schools into six colleges, formation of the Institute for Learning in Retirement; and affiliation with the new athletic conference, Conference USA."[369]

If this era was marked by a shift in Hattiesburg's internal and external image, that shift was further occasioned by economic transformations as well. As discussed in Chapter 3, by the 1930s, the old-growth timber had long been cut, with secondary industries arriving to fill the gap; by the 1970s, with the partial regrowth of timberlands in the area, a third wave of industries in paper and pulpwood processing had arrived as well. That growth had been slower in Mississippi than in other neighboring states, but by the time it had arrived, the presence of these manufacturers rivaled those of other southern states. As historian Warren Flick observes,

> *The growth of a modern pulp and paper industry in the South may be viewed as a symbol of the profound change that occurred in the woods industries over the last hundred years. At the turn of the century, lumber was the principal product of the forest. The lumber industry was notoriously migratory, moving from one area of virgin timber to another, and finally to the West Coast to exploit its vast Douglas fir forests. The southern paper industry was insignificant. By 1980, pulp and paper had become the dominant wood industry in the South, more than double the size of the lumber industry in many southern states. The same period witnessed the development of forestry as a profession and the realization on the part of individual wood users that, in addition to being harvested, wood could be profitably grown in the South. The wood industry, especially the paper industry, became a permanent resident interested in the long-term future of the region.[370]*

While nothing would replace the virgin pine, these moves locally in Hattiesburg with the arrival of Georgia Pacific in 1978 nevertheless shored up the resilience of economic diversification, resilience further illustrated

Aerial view of downtown Hattiesburg, circa 1970s. *Hattiesburg Historical Photographs Collection, McCain Library and Archives, University of Southern Mississippi. Courtesy of Kenneth G. McCarty Jr.*

by the creation of the Hattiesburg industrial park and the establishment of other large employers at the time such as Mississippi Tank Company, Pine Burr Packing Company, Big Yank Manufacturing, Price Brothers Concrete Pipe Company and Funsten Pecans, to name a but a few.[371]

Another illustration of the changes of those years is seen through the expansion of the communities surrounding Hattiesburg; the early 1970s saw the long-awaited incorporation of Petal in 1974, which, after a court battle the previous year, finally received its writ from Forrest County. Unusual for its size at the time—incorporated with a population of 8,200, it was by some accounts the largest unincorporated city in the world—Hattiesburg's neighbor across the Leaf River also enjoyed the distinction shared by the Hub City itself of being the only city in the world to bear its name.[372] Following municipal elections and a ceremony featuring the county and state officials, the city swore in its first mayor, Ulmer Byrd, in May 1974. While the full flowering of this growth would not arrive for another two decades,

the period also saw growth out west past Interstate 59 in the neighborhood of Oak Grove in Lamar County, which soon established its footprint, including businesses, churches, schools, newspapers and the seeds of a long-running dispute about incorporation versus annexation by Hattiesburg that continues even today. Accompanying the development of this neighborhood was the continued growth of Lake Serene and Lake Forgetful, as the magnet drawing Hattiesburg westward gained strength.[373]

That magnetism would affect the city in other ways in the 1970s, however, as the city's economic center of gravity was set to shift from its long-standing home downtown to the southern edge of town. In 1974, after years of petitions and designs, Cloverleaf Mall opened in the crook of its eponymous intersection at Highway 49 and Broadway Drive and proceeded to bring with it the interest and attention of shoppers, business owners and retailers from across town. For a city whose primary economic infrastructure had been small- to medium-sized businesses, often family owned, Hattiesburg's first shopping mall not only rerouted economic growth and provided a "one-stop shop" for consumers but also served as an anchor for major national retailers whose impact the Hub City

Waldoff's Department Store, Cloverleaf Mall, Hattiesburg, Mississippi. *Courtesy of Milton Waldoff Jr.*

1974 Leaf River flood memorial, Chain Park, Hattiesburg, Mississippi. *Photo by author.*

had yet to fully feel. (National chains such as J.C. Penney and Woolworth's had maintained a presence in Hattiesburg for decades but had largely been confined to the architectural strictures of downtown—by comparison, the new mall offered thousands of square feet for their wares.)

# OUTWARD GROWTH, 1970-2000

The first local retailer to expand into the new facility was Milton Waldoff Jr., owner of Waldoff's Department Store, which his father had first opened downtown on Batson Street in 1924. Of the move to Cloverleaf, Waldoff recalled:

> *I wanted to be in a shopping center because I was seeing what was happening in downtowns nationally when shopping centers were built. As a young man, I wanted to grow my business—it had grown a lot since my father founded it. I really wanted to get out to the mall, because I felt it was the future, based on what I was seeing. At first I elected to keep my downtown store but reduce the inventory, and use that facility for other purposes. But the customer base left downtown when the mall opened, and I knew there was no way I could support both downtown* [and my other stores]...*I did feel misgivings, leaving downtown—my father had gotten his start down there. But nearly everyone understood that it was what it was, and times were changing. People liked the idea of coming to the mall and not paying for a parking meter, and having all the stores in one place. It was strictly a business decision.*[374]

Waldoff's would not be alone, as other merchants such as Smart Shoe Store, owned by Maury Gurwitch, would also make the move, leaving downtown to languish until the early 1980s and a new mayoral administration, discussed in the following section. Further altering the city's center of gravity in 1974 was a more traumatic event, one still vividly remembered by local residents. On Easter week that April, prolonged and heavy rains upriver caused the Leaf to rise until it broke its banks, flooding much of eastern Hattiesburg in a grim echo of a similarly destructive flood that had struck the community thirteen years earlier in 1961. The disaster was one of the worst the city had ever seen:

> *Sixteen inches of rain fell in a three day period resulting in the Easter flood of 1974...More than 8000 people fled their homes and the total estimate of the destruction reached an astounding 60 million dollars. On April 14 authorities predicted the impending high waters. The Leaf River was expected to crest at thirty feet and approximately 2000 residents were encouraged to evacuate. The magnitude of the flood remained unknown. By April 16 the Leaf River had crested at 34 feet and one person was discovered dead. Camp Shelby provided shelter for 2000 refugees, many with nothing left. By April 18 the proportions of the disaster became more*

*apparent. The United States Geological Survey reported that flood levels of the Leaf and Pearl River were the highest that could be expected in an average 100 year period. President Richard M. Nixon visited south Mississippi and promptly declared the area a national disaster.*[375]

Local organizations immediately responded, with the Red Cross feeding and sheltering refugees and the basement of St. James United Methodist Church, used as a Freedom School just ten years earlier, used as a relief station for victims.[376] With little time to prepare, however, many residents affected lost everything in the flood. As with the earlier flood in 1961, the impact caused more than just property damage and loss of life; it reshaped the neighborhood, redrawing the maps of settlement across east Hattiesburg. As one resident, Roscoe Pickett, later recalled, "[The flood] caught the people off guard again and it covered a greater area…Ebenezer Baptist Church (on East Eighth Street) was covered to the top. That was too much for many of the people."[377] Poorer, predominantly African American families unable to rebuild or absorb their losses relocated to neighborhoods south and west of the affected area, and by many accounts, the slow decline of the Mobile Street neighborhood that had been in effect since the end of the civil rights era was hastened dramatically. Fearing for their livelihoods, business owners chose to reopen in areas outside the floodplain, fragmenting the area's historic core and leading to a period of stagnation and abandonment in Mobile-Bouie that only recently, in the 2000s, has begun to reverse.

Nixon's relief after the disaster would be welcome in Forrest County, even if, shortly to resign due to the Watergate scandal later that year, relief for Nixon himself would be slow in forthcoming. As if to bookend the decade with further insult to injury, the final blow in those years came in the form of Hurricane Frederic on September 12, 1979, a storm sweeping through Alabama and Mississippi so large that Camp Shelby again had to be used as a refugee center, and President Jimmy Carter—only two months before the Iranian hostage crisis would grip the country and the world—would visit the area and again offer federal relief. Though nowhere near as destructive to Hattiesburg as it was to cities along the state line and in the Mobile Bay area, Frederic nonetheless displaced families across the region, leveled standing timber crops and reminded residents whose images of Camille in 1969 were still all too fresh in mind of the fragility of life along the Gulf Coast.[378] The lesson would not be the last.

# The 1980s: A Century of Government, A Change in Government

The crises facing the country under the Carter administration—economic stagnation, high oil prices and national malaise—persisted in Hattiesburg well into the early 1980s, with a declining downtown and a degree of uncertainty about the city's direction for growth. Even the oil crisis found its way into the Hub City, with residents encouraged to turn down their thermostats and wear sweaters around the house and municipal paving trucks prone to leave local streets half paved each month until the city's coffers could refill and supply them with gasoline to finish the job.[379] Meeting those challenges was one of the city's most dynamic mayors; historians and politicians alike concur that the arrival of Mayor Bobby Chain at city hall in 1980 (following the resignation of Mayor Bud Gerrard and a special election) brought in a wave of growth and development that rivals any in the city's history. Other accounts detail Chain's accomplishments in depth,[380] but it is sufficient here to note his efforts in revitalizing a downtown that had lain in sore neglect for years. Street beautification, an improved traffic plan, the renovation of historic buildings such as city hall and the Saenger Theater and the reopening of the Front Street USO Service Club as a community center led to renewed senses of identity and pride in the Hub City, a renewal greatly welcomed as the city approached the centennial of its founding in 1982.

This centennial, marking the date that William Hardy had founded the town (his first visit to the area was in 1880, but incorporation would not follow until 1884), offered Hattiesburg residents an opportunity to remind themselves of where they had come from and to consider where they were going. Kicked off with a ceremony at the Saenger that February, the birthday party lasted all year, with commemorative events and celebrations and the *Hattiesburg American* publishing a special monthly series in its pages detailing the city's history and progress throughout its first century. The mood would ride high into Chain's tenure even as he personally enlisted local business leaders to assist him in his revitalization plans, with civic pride finding another opportunity for expression two years later when, in 1984, the World's Fair would be held in New Orleans. As part of the Mississippi Pavilion, city officials organized a "Salute to Hattiesburg Week" in July to showcase the city's history, culture and contributions to the state and region. According to contemporary accounts, the exhibit drew hundreds of visitors from around the world, sparking interest in the Hub City from a global

Manuscript for City of Hattiesburg centennial 1984 theme song, by Althea Jerome. *Courtesy of Raoul and Althea Jerome.*

audience.[381] Whether any visitors arrived from Santa Maria de Los Ángeles in Chile, unfortunately, is not recorded.

But not all was worthy of celebration. At the end of that year, the Hub City would see a loss that brought sorrow to the entire community. On New Year's Eve 1984, Officer Jacqueline (Jackie) Dole Sherrill of the Hattiesburg

Police Department would be killed in the line of duty after an altercation with a felon on Eastside Avenue. Sherrill, thirty-three, had achieved considerable distinction in her years of service, including being the first female graduate from the School of Criminal Justice at USM, the first female police officer for the HPD and its first female detective as well.[382] As with the deaths of Officers Everett and Vinson in 1952 and the murder of Vernon Dahmer in 1966, news of her death coursed through the city, still a small town despite its size. Resolved to let neither her accomplishments nor her sacrifice go unheeded—her funeral at Main Street Baptist Church drew approximately one thousand mourners—the city chose to rename its community center in her honor.

The final change that Hattiesburg saw in the Chain years was, ironically, the change that spelled the end of the Chain years, and that had its roots in the previous era of the city's history. As had happened a generation earlier, threads of local, state and national influence came together to usher in a structural reform in city governance, again turning on the problems caused by racial discrimination. Formally beginning in 1982, the change was one instance of a political shift sweeping southern cities and would leave Hattiesburg permanently transformed in its wake.

The issue this time was not registration but representation. Since 1910, Hattiesburg had maintained a mayor-commission form of government, wherein a mayor and two at-large commissioners served as the chief elected leaders for the city. (Forrest County had its own form of government, the board of supervisors, which had been founded shortly after the creation of the county, but this board was distinct from the city's government.) From 1910 onward, given both the demographic makeup of the city (predominately white) and the fact of discrimination against African Americans, the political system had been wholly controlled by whites—a common scenario in southern cities both during Jim Crow and after. After the Voting Rights Act of 1965, however, African American communities across the South began to look for equal representation in local government, taking cases of discrimination to court and, in some cases, all the way to the highest court in the land.

The problem was clear-cut: due to the legacies of racial discrimination (including voter intimidation, poll taxes and literacy tests), blacks were still unable to elect candidates to city government. Blacks were not just at a disadvantage historically and politically; they were at a disadvantage numerically. In many southern cities, including Hattiesburg, there were simply fewer blacks than whites, and thus fewer on the rolls: due to these

imbalances, to elect a black candidate, a majority greater than half of black voters might be required to equal and best a simple majority of white votes. Against these constraints, leaders in black communities began to seek alternative means of achieving representation. Frequently, this meant petitioning or suing for wards to be drawn up, ensuring equal representation of all communities, given that geographic segregation commonly lingered after educational and civic desegregation, a sad reality still well known today. In Mississippi, a string of towns including Jackson had begun to experience such cases, which frequently ended up in higher state and federal courts.

In Hattiesburg, where no African American had been elected to high city office since its founding under the alderman system (to 1910) or the mayor-commission system (from 1910 on), a group of local black leaders filed a suit claiming that the black community was being discriminated against in precisely this fashion. The suit, *Boykins v. City of Hattiesburg* (1980) sought that the city change to a system that would allow representation in accordance with the demographic makeup of the city as determined in the 1980 census, in which blacks constituted 34 percent of the population. (A 1979 citywide referendum to change the electoral system had failed overwhelmingly, largely along racial lines; James Boykins had been the second African American on the voter registration list of Forrest County in 1951.) The way for this to happen, black leaders argued, was to carve out areas where black majorities already existed, such as the Mobile-Bouie neighborhood. In response, Chain's administration defended itself by arguing that the law did not need to be changed, given that the original charter for the at-large system had not been written with discrimination as its intent. As Wayne Easterling, city attorney for Chain, later characterized the issue:

> *Until the suit was filed the law was this: even though as a matter of fact blacks couldn't get elected, the law unquestionably was that it really didn't matter unless it was the intention of the creators of that system to prevent black participation in government. To have the law changed, you had to prove that in 1910 the law was constructed with the intent to discriminate against blacks. For the city, it was easy to argue that because blacks in the early part of the century were politically impotent anyway. It was a moot point: discrimination had already happened. But de facto discrimination was not enough to change the law.*[383]

The case went before Judge John Roper of the United States District Court. In the meantime, however, higher powers in the land were at work.

After hearing the case of *Mobile v. Bolden* (1980), the United States Supreme Court established the purposeful intent requirement to warrant changes to electoral laws. Two years later, the United States Congress extended Section 2 of the Voting Rights Act (1964) to establish a new standard for discrimination: no longer was intent required to prove discrimination, but rather results—that is, whether a municipality's electoral districting led to racial discrimination regardless of whether it was designed to do so. Given that federal law was being determined even as *Boykins v. City of Hattiesburg* sat on his docket, Judge Roper waited for those decisions to settle before rendering his own.

On March 21, 1984, Roper returned his opinion, deciding in favor of Boykins based on expert testimony, political analysis, witness accounts and demographic data. Even though he found that the 1910 law did not necessarily discriminate in its original intent, the at-large system did nevertheless result in de facto discrimination, with blacks historically denied participation in the electoral process in myriad ways beyond issues met at the voting booths themselves. "In the instant case," he wrote, "the evidence is overwhelming that Hattiesburg Blacks, as a result of massive historical discrimination, are at a serious socio-economic disadvantage. In the context of the at-large electoral system maintained in Hattiesburg, this has resulted in almost total preclusion of Blacks from effective participation in Hattiesburg's political process."[384] Understanding that this decision would not be popular among the more entrenched dimensions of the white power base, Roper offered this rationale:

> The Court would hope…that the majority of the citizens of this City look upon this decision as an opportunity to finally and forever eradicate both past and present vestiges of racial discrimination and seek a new beginning in race relations. In weighing the merits of this decision a citizen should attempt to place himself in the shoes of the minority voter, comprising 34% of the population of this City, who has not had a member of the Black race to represent him in City government during the 73 years the Mayor-Commission form has been in effect. Aside from the legal requirements of § 2 of the Voting Rights Act, a dissatisfied citizen should ask himself whether this [result] is fair to one-third of the citizens of this City. If the situation were reversed and the now majority White population of the City comprised only one-third of the electorate, would not the White community be seeking in this Court the same type relief now requested by the Black community?[385]

Hattiesburg City Council, 1987. *From left*: Kathryn Cummings, Eddie Holloway, Mayor G.D. Williamson, Ed Morgan and Charles Lawrence Jr. (Councilman John Buckley not pictured.) *Courtesy of Eddie Holloway.*

Roper therefore held that Hattiesburg was required to change its system, ordered wards to be drawn up and set out legal guidelines for the process. On the city's losing its suit, Mayor Chain recalled years later that even though the cases were often tied up for years, the writing was quickly appearing on the walls of city hall. As Chain said, "I didn't think we had a choice. The federal court system was ordering these little cities to do it—while you could delay it, you couldn't stop it, and I thought it was better to go along with it. The best thing to do was to take advantage of it, and make it work right."[386]

Inevitable as it might have been, the decision cost Chain his position. Despite his track record in economic development, downtown revitalization and his initiatives in city planning, white voters who opposed the change rallied behind G.D. Williamson, one of the two at-large commissioners, and swiftly elected him in the 1985 contest. Williamson was the first mayor to serve with the newly formed city council, which was created out of five wards—two predominately white, two predominately black and one with a largely tossup demographic—a system that is still in place today. The first council members included John Buckley, Kathryn Cummings, Eddie Holloway, Ed Morgan and Charles Lawrence. Of those first years on the revamped city council, Holloway, an African American who represented Ward 2 (the tossup) and served on the city council from 1985 to 2002, recalled the transition between systems:

> *I think the successes of our form of government have to be attributed to Mayor Chain. Even though I was never able to work directly with him, he*

*set in motion orientations for the other two incoming city councilmembers. We examined budgets, we looked at the bond indebtedness of the city, we looked at every department that he had set up during his administration, each of whose directors met with us. We toured city facilities, we had very little work to do in terms of inquiry—he had it all laid out. It was my first time to work with a team of professionals. Each of us ably worked on behalf of our ward, but it was really Mission Hattiesburg. We had a seamless transition from the Chain campaign to the Williamson administration. Overall, the public was accepting of this new form of government. We got accolades from across the state almost monthly—we had representatives from other parts of the state visit Hattiesburg to see what we were doing and how we were doing it.*[387]

These reforms, sweeping as they were, were not the only changes that Hattiesburg saw as the 1980s drew to a close. In the continued wake of debates about the implementation of desegregation in local communities and a sign that the injustices of the previous eras would require more than a few years to heal, the city adopted a federally ordered desegregation plan for its public schools in 1987 mandated by the Fifth Circuit Court of Appeals. Based on assessments that revealed that elementary schools still suffered from racial imbalances in their population, the decision divided the city into northern and southern attendance zones, with all area high school students now attending Hattiesburg High School on Hutchinson Avenue. The historic Eureka School closed its doors for the first time since opening them in 1921 and would later reopen as a community center; henceforth under the plan, white and black students would be grouped together in one of a handful of different elementary and junior high schools scattered throughout town. While this division would not be the last overhaul of the public education system in Hattiesburg—more reform would follow in the late 1990s, reverting to a neighborhood-based school system—it would set the tone for a fairer distribution of resources and demographics at a time when echoes of segregation continued to linger.[388]

The other major reform to end the era focused on land. Due to zoning decisions of the 1950s, certain neighborhoods in town faced inequitable development and inconsistent patterns of use. As writer Nikki Davis Maute observed,

*The major contributor to the decline of neighborhoods in east Hattiesburg was the decision by city officials in the 1950s to zone the entire area*

*industrial. The industrial zoning at that time meant landowners could build almost anything they wanted—and many did. So the area ended up with family homes next door to junkyards and with honky tonk bars in residential neighborhoods…Although no one will say so publicly, most city officials, both black and white, believe the then-white government leaders were not interested in preserving predominantly black neighborhoods. The city fathers decided to take those neighborhoods and make them industrial because they were near the Leaf River. But the river floods, and if any thought was given to the problem of flooding, it was not made public then.*[389]

Reflecting on his tenure as council member in those days, Eddie Holloway has echoed the point:

*Hattiesburg's government* [of the late 1980s] *was not reflective of the Black residents of the city. It appeared that the African American communities were not included in the framework of city planning. It seemed like street paving was performed from a "oh by the way" notion, rather than from an intentional system of governance. The same speaks for recreational services: many of the recreational areas were not documented on the city maps and improvements were paid for with funds that were left over from official city recreational projects…The vast majority of the African American communities were zoned Heavy Industrial, which allow any type of business operation that was allowed in the City. So for the most part, all of the city ordinances, codes, systems and plans had to be amended to include the historically African American neighborhoods. The other challenges were to educate and inform the residents of the city, particularly the African Americans. It was quite difficult because they were not included in the system of governance until the change of the form of government.*[390]

In order to bring equity to these neighborhoods, Hattiesburg's new mayor, Ed Morgan—who had just defeated Williamson—signed a Land Development Code into law in 1989 that not only cut down on such irregularities in land use, eliminating the "open zoning" or "pyramid zoning" that had plagued these areas, but also streamlined the process for enforcing violations and remediating or demolishing blighted and abandoned properties. While not every property would receive immediate treatment under the new code, it nevertheless served as a platform by which longer-term strategies for growth and development would reach the affected neighborhoods, old and new alike. As the city began to turn its attention

westward more than ever, such measures would become increasingly necessary. For as the timber forests of the south had once beckoned the barons of the previous century, so, too, the untrodden stretches of land west of Interstate 59 now called the developers and retailers of the modern age.

## *The 1990s: Westward Explosion*

Longtime residents of Hattiesburg well remember the days in which the only entities west of I-59 could be counted on one hand: the Coca-Cola Bottling Plant, moved from its previous facilities in 1978 (its original location downtown had been founded in 1906[391]); Methodist Hospital, which had followed suit in 1980 in order to better compete with Forrest General; Lake Serene; Canebrake; and, ultimately, the town of Columbia. Certainly for the 1970s and for much of the 1980s, the part of Hattiesburg that lay in Lamar County was sparse, untended and altogether ripe for the picking. The geographic pressures on the town had been long established: with industrial development to the north, Petal to the east and large private landholdings and Camp Shelby to the south, barring the unlikely construction of any skyscrapers downtown, the only way to go was west.[392] That Lamar County residents did not uniformly receive such an influx with open arms was beside the point; the trickle of interest in the previous two decades would, by the early 1990s, become a full-fledged torrent.

With Methodist and the Coke plant as anchors, joined by other larger corporations such as K-Mart, Toys "R" Us and Books-A-Million over time, the area between the hospital and the interstate was the first to fill in, forming a relatively contained zone of retailers, small chains and locally owned and corporate restaurants. Even the major churches of the city began to recognize the attractions of the area: in 1990, First Presbyterian Church moved from its home downtown to its present location out west, with the congregation of True Light Missionary Baptist Church, a former Freedom School church, moving into the historic brick building on North Main. Other congregations would follow: in what for a time resembled a game of ecclesiastical musical chairs, Main Street Baptist Church would also leave its home on North Main to move to Hardy Street and then a location out west across from Methodist (all the while retaining its name, now a misnomer), with Mount Carmel Baptist Church occupying its palatial former home. First Baptist Church would move from its historic location on the corner of

West Pine and Second Avenue to a new facility (and much later, a new name of Venture Church) on the Lincoln Road extension, with Sacred Heart Catholic School moving into its old home in 2010. Temple Baptist Church would leave downtown to construct an expansive new campus almost in Oak Grove, with Hardy Street Baptist Church later moving into its mid-century building back downtown. Such shifts opened a new chapter in the city's second century, as its founding congregations—many of which dated back to Hattiesburg's earliest years—repositioned themselves on the edge of the city's growth.

As the decade opened, the majority of those moves were still in the works; in 1994, however, the opening of Turtle Creek Mall poured accelerant on an already healthy flame. Turtle Creek, the city's first new shopping mall since Cloverleaf Mall exactly twenty years earlier, both echoed and magnified the city's push in that direction, adding tens of thousands of square feet for retail, dining and film and spurring the development of infrastructure in the acreage surrounding the complex. The economic impact on the area was immediate—creating 250 jobs during construction and 1,800 jobs after completion—and served, just as Cloverleaf had, to attract even more interest from national chains, which saw West Hattiesburg as a lucrative and untapped new market.[393] The period would not only see the acquisition of Methodist Hospital and its renaming to Wesley Medical Center in 1997, but it would also see the decline of Cloverleaf's retailers and a general downturn in the once-bustling intersection surrounding Highway 49 and Broadway Drive, with that area's fortunes primarily stabilized by traffic to the Gulf Coast, the student population of William Carey and the city's automotive row on West Pine. Hattiesburg's center of gravity had shifted once more; this author, a teenager at the time, clearly remembers locals young and old, black and white alike visiting Turtle Creek simply to visit, not even necessarily to

Turtle Creek Mall, aerial view from north, looking southeast (Wesley Medical Center in upper-left corner; US Highway 98 runs left to right). *Courtesy of CBL & Associates Properties, Inc.*

shop, its caché was so high. Ironically, like the Front Street of the 1890s, the Main Street of the 1920s or the Mobile Street of the 1950s, the half-mile corridor between the department stores at the north and south end of the mall was the new place to see and be seen.

Part of this development stems from a move away from urbanism that Hattiesburg had been undergoing for years, with the city's growth measured by the wheel of the automobile, rather than the horse's hoof or the human foot. In contrast to the dense urban fabric of its origins, latter-day Hattiesburg had by then cemented its dependency on cars, making little gesture toward return until its next efforts at downtown revitalization, discussed in the next chapter. In the consumer age, the experience of living in proximity to local suppliers was diminishing, and Turtle Creek hastened that change irrevocably. With rare exception, such as the family-owned Leatha's Bar-B-Que Inn, this growth would see little of the small-town character that had defined the Hub City since its founding. With a second wave of major chains, big-box retailers and fast-food restaurants lining the highway from the mid-1990s on and the arrival of swiftly assembled shopping centers, whose elegant architectural elements could not disguise their essentially corporate origins, the days of neighboring merchants engaging in price wars over candy were now largely over. Granted, such was true across the South, but residents of the Hub City are prone even today to shake their heads in disbelief at how fundamentally transformed was their sense of the city in less than a single generation. While locals largely applaud the growth in jobs and infrastructure that the westward movement brought—along with the main drag of Hardy Street and Highway 98, the expansion included two east–west corridors, West Fourth Street (north of Hardy) and Lincoln Road (south of Hardy), both now major thoroughfares—the question of whether that growth could have arisen in a more managed, sensible way still lingers in the minds of many.

Despite this focus on growth out west, it is important to recognize that other areas of Hattiesburg also experienced the same. The move out west was less a total exodus than the latest shift in the city's center of gravity, and city officials at the time were well aware that a balanced approach would be necessary to preserve the city's economic future and prevent a large-scale flight of the tax base from Forrest County to Lamar.[394] To that end, to accompany the opening of Turtle Creek, the city sponsored the construction of a new civic and economic infrastructure alongside its physical improvements to reinforce Hattiesburg's presence as a regional draw for events, conferences and business: chief among them was the Area Development Partnership,

formed in 1992 out of the former chamber of commerce. Of the ADP, writer Mark Olderr notes,

> *When* [Mayor Ed] *Morgan took office, economic development was in the hands of elected officials. The* [ADP] *was created as the organization to carry on a more cohesive economic development plan, as well as to take on the responsibilities of a traditional chamber of commerce. That allowed economic development to be transferred from the political sector to the professionals. The public dollars going into the ADP allowed initiatives to be driven by business leaders of the community in concert with elected officials.*[395]

Other institutions soon took shape, including a new consolidated public library for Hattiesburg, Petal and Forrest County, which opened in 1996 and featured a stirring mural by noted artist William Baggett detailing the city's history. During those same years, the city broke ground on a new convention center on Highway 49 North, opened in 1998, and the Forrest County Multi-Purpose Center on Highway 49 South, which opened in 1999. Bracketing the city's westward pull with facilities on its other borders and yielding millions of dollars in economic impact annually, these two facilities would help to stabilize and direct the city's growth in tangible and intangible ways.[396]

Even so, it is difficult to overstate the extent to which westward expansion defined the decade, and any history of Hattiesburg of the era must look in no small wonder at how little time was required for such extensive development. Future historians will no doubt quantify this growth in ways that set it in context with the national economic boom of the 1990s, with other eras of the city's history and with other cities of comparable size and makeup such as Meridian, Tuscaloosa or Knoxville. For the time being, however, the shadow of the future may best be illuminated by a voice from the past, namely, that of Hattiesburg's founder, whose name graces the street along which the city grew. When asked by critics why he built his house so far outside of town—at the time, in 1895, a distance of about a mile—William Hardy is said to have replied that "he was not concerned because the town would come to him."[397] One wonders what he would have said had he lived to see just how true his words would become.

# *The End of the Century*

Of course, economic growth was not the only story of Hattiesburg in the 1990s, and these years saw a number of other significant developments that thrust the Hub City into the national spotlight. In 1992, the mascot of USM, Nugget, was found dead in his cage, a death that the local rumor mill quickly labeled murder, a charge that would have constituted a federal crime under the Endangered Species Act. After an investigation, federal and university officials determined that the golden eagle had instead died of starvation due to improper feeding habits, but despite these assurances, the rumor mill would churn for years.[398] Tongues would wag about another of the Hub City's residents for much happier reasons when, in 1995, Osceola McCarty, a local African American woman who had worked as a laundress all her life, offered her life savings to USM in a donation of over $150,000. Having quietly deposited her wages for decades, beginning with individual dimes, McCarty's gift would go toward establishing scholarships for students in need—but her own generosity would garner international attention, given her humble origins, receiving honors ranging from the Presidential Citizens Medal from President Bill Clinton to an honorary doctorate from Harvard University. Finally, justice would be served for the murder of Vernon Dahmer when, in 1998, Sam Bowers would be convicted after four previous trials had ended in deadlock. Though it was comfort long belated for the Dahmer family and those in Hattiesburg who had condemned the crime, Bowers would journey to Mississippi State Penitentiary, defiant until the end. His own end would arrive eight years later, with only an out-of-state relative to claim his body.

As Hattiesburg began to close the decade, however, such notes of sorrow and loss would nevertheless fade into the overarching melody of a city once more ascendant, a melody that would be heightened by the string of awards and accolades that it had received during those exuberant years. Not only had Hattiesburg been named America's Most Livable Small City by the United States Conference of Mayors in 1992, but in 1990, it had been ranked the Number One Small City in the South and, in both 1990 and 1994, the top small city nationwide for healthcare by G. Scott Thomas. In 1997, the city received the first Tree City USA Award from the National Arbor Day Foundation, and in 1998, the Commission on Accreditation for Law Enforcement Agencies would award the Hattiesburg Police Department national accreditation, the first law enforcement agency in Mississippi to receive it. That same year, *Money* magazine would rank Hattiesburg as the

seventeenth most livable small city in America; with its surging economy, its diversified industries and its strengths across economic, civic and educational sectors, the Hub City was turning heads both inside and outside the state.[399] Remarking on the city's years of economic development, reform in governance and modernization of its planning and codes in the late 1980s and 1990s, council member Holloway later recalled:

> *It was an amazing time. It was transitional—an effort at betterment. It was a tough time, because it was a period of change, and change is not always easy or welcome. But it was pivotal. We could gladly call those years a renaissance of Hattiesburg—but for growth to be sustained, there has to be a continual assessment and repair, and to my mind, that growth has meant the exodus of its population. That said, it was a fantastic period of governmental performance whereby we continued the four-year plans of Mayor Chain and Mayor Morgan, and we put systems in place to take us forward. I really hope I did elevate a tremendous segment of people to a greater level and a brighter day.*[400]

Interestingly, the demographic trends noted at the outset of this era survived intact in some ways but diverged in others. By the end of the 1990s, population gains and increasing urbanization had both contributed to a rising tide across Mississippi that had lifted many of its boats. According to the 1990 and 2000 censuses, the effects of those trends were greatly magnified in Hattiesburg, with Lamar County occupying third place in population growth statewide (behind Madison and Hancock Counties) in 1990 at 27.7 percent, including the state's highest growth rate for African Americans overall. As proof of this process, the West Hattiesburg area was categorized as a Census Designated Place in recognition of the weight it now carried. Just missing the designation in 1990, Hattiesburg would be declared a Metropolitan Statistical Area in 1994, opening the door for further federal funds and opportunities for continued growth.[401]

Contrary to the growth patterns of the 1960s and 1970s described at the beginning of this chapter, however, Mississippi was now experiencing a major influx of residents, including, surprisingly, minority populations. As demographer Barbara Logue observed, remarking on the growth of the 1990s and its expected continuation after the turn of the millennium,

> *Part of this anticipated growth is due to natural increase—the excess of births over deaths. The second factor underlying Mississippi's anticipated*

*population growth is net immigration. Since for most of this century, net migration has been negative for the state (that is, more people have moved out than have moved in), the reversal from net outmigration to net immigration combines with natural increase to raise the growth rate substantially over earlier decades.*[402]

Included in these trends were the results that black and white populations in Hattiesburg had nearly equalized, a factor that would shortly have historic implications for the Hub City. In the year that corks popped across the world to ring in the new millennium, however, Hattiesburg threw another birthday party to mark its centennial since Governor A.J. McLaurin had declared its official status as a city. Featuring a public parade throughout the downtown, marching bands, a centennial time capsule buried by the mayor and, of course, birthday cake, the Hub City looked back with pride on its accomplishments.[403] But with one door closing and another opening, the new millennium would usher in a new era in more ways than one.

# HATTIESBURG TODAY AND TOMORROW, 2000-PRESENT

## *The New Millennium*

With the confetti swept up, the balloons taken down and the dreaded Y2K bug thankfully avoided, Hattiesburg looked to the new millennium with high aspiration as it rode the twin local and national economic waves. At the turn of the millennium, the dot-com bubble was at its peak, with stock indices swelling with profits from Internet companies—and many investors in Mississippi in particular rising on the spectacular tide of the company MCI WorldCom, famously first founded as Long Distance Discount Services at a Days Inn in Hattiesburg in 1983 before growing to become one of the largest telecommunications providers in the country. To the horror and loss of its shareholders, however, MCI was later found to have engaged in duplicitous accounting practices to hide losses and exaggerate earnings and became a major casualty when that bubble began to burst.

The year after one historic election—historic for being settled by the Supreme Court—put Texas governor George W. Bush in office, another historic election put Hattiesburg's first African American mayor in office, former realtor and Forrest County supervisor Johnny Dupree. Campaigning on a platform of growth in business and education, the hopes and dreams of those who had fought in the civil rights movement finally came true when Dupree defeated incumbent Ed Morgan in 2001, a position Dupree would occupy for three more terms. With growth steady,

enrollment strong, profits high and a hope fulfilled, the future of the Hub City seemed bright—until one morning in September of that year, when the ash of two burning buildings in New York darkened the sky.

Despite the strength of Hattiesburg's position at the turn of the millennium, it is safe to say that its fortunes in this era were determined more by events outside its control than by those directly within it. Following the events of September 11 and the sudden resumption of a wartime footing, Hattiesburg once again had to prepare for the reality of armed conflict overseas—in Afghanistan in 2001, followed shortly thereafter by the invasion of Iraq in 2003. Camp Shelby, which had served in those intervening years primarily as a joint-forces and National Guard training post, quickly retooled as one of the largest mobilization centers nationwide for troops scheduled to deploy overseas beginning in the summer of 2004. Again, as in World War II, the sight of soldiers in town became commonplace as units from all over the country arrived for billeting and maneuvers, the breathtaking summer temperatures deemed ideal for soldiers training to fight in desert conditions. (Shelby had seen similar action during the First Gulf War in 1991–92, but not to the same extent.) And again, as in years past, locals overwhelmingly supported the troops, opening their homes, businesses and churches to the service members passing through or, in many cases, bidding farewell to family members and friends who had been called up for duty. In the period between 2004 and 2014, approximately 280,000 American and Canadian troops would pass through the base on the way to the Middle East; had anyone asked historian W.T. Schmidt's question of whether, after 1945, Hattiesburg would welcome a large-scale military remobilization at Shelby, the response to these conflicts would lay the matter conclusively to rest.[404]

With the effects of these two wars felt in ways both small and large—Hattiesburg would mourn the loss of its first soldier, army specialist Joshua Bunch, in August 2004[405]—the city would endure a second major trial in late 2005 when Hurricane Katrina, a Category 3 storm that had already left a trail of devastation in New Orleans and the Mississippi Gulf Coast, arrived in the Hub City on August 29, sending shockwaves of damage and loss throughout the region. While Hattiesburg did not suffer total inundation and evacuation as did the Crescent City, or obliteration and erasure as did many of the towns and cities along the region, it did nevertheless suffer extraordinary impacts of its own: severe damage to municipal infrastructure and utilities, with power and other services suspended for days and weeks; a flood of thousands of refugees from across the coast that, on some accounts, doubled the city's population overnight; strains and shortages on

basic supplies such as gasoline, food and water; a leveling of much of the city's standing timber to the point that once-familiar neighborhoods were rendered unrecognizable (this author remembers disorientation finding his own house, so badly rent was the city's visual fabric); and the loss of life, property and livelihood that left a traumatic scar on the city's psyche. Few structures escaped the storm's fury; the more notably damaged buildings included the old Hattiesburg High School building, already in disrepair, and the Gulf Coast campuses of the two universities, catastrophic losses each.[406] As writer Frederick Barthelme observed in the aftermath,

*Without power and water, Hattiesburg becomes a sweat palace, a 100,000-person sauna, and everyone who can be in his or her car is in his or her car, where the air, thank God, is still conditioned. At least as long as the gas holds out, which, from the look of things, isn't going to be all that long. By Thursday afternoon the lines at the pumps are beyond silly, past ludicrous, all the way to ridiculous. Yesterday you waited three hours if you were lucky. Today it's six hours, and a line of 200 cars circling up an off-ramp from Highway 59. And the word is that the government—federal, state, city, who knows?—is taking over the gas allocation tomorrow. But if they have the gas, the people are out touring the devastation—four, five sometimes six to a car. Most beautiful among the sights are the great downed trees, bringing a stately majesty to our streets, something like what the sculptor Mark di Suvero might have done in his heyday, which I don't quite remember now. He is the guy who made art out of giant tree trunks and he would be happy here today. The avenues are littered with exquisitely poised trees—tilted, angled, jilted, twisted, spun, splintered, bent over, transformed by the storm into great barricades, graceful arches, lovely bridges over roads. It's as if God got tired and tossed a God-sized handful of these 80-foot pine trees, pick-up-sticks fashion, on our town.*[407]

The story was not all despair, however. Not only did local residents showcase their resilience, resourcefulness and strength by immediately joining recovery efforts—without waiting for permission, residents armed with chainsaws and pickup trucks swung into action clearing the streets of downed trees and tarping damaged roofs—but in one example, the Forrest County Multipurpose Center was converted into a housing and medical shelter both for evacuees coordinated by the local chapter of the American Red Cross and for lost animals cared for by the Humane Society. Residents whose homes escaped damage gave of their time, compassion and resources

Destroyed house after Hurricane Katrina, Hillendale neighborhood, September 2005. *Photo by author.*

Cars abandoned in Midtown shopping center after Hurricane Katrina, September 2005. *Photo by author.*

to care for refugees seeking shelter and care, refugees who had in many cases lost everything they owned. As Barthelme noted, "back in Hattiesburg, the heat is grotesque and there are people doing wonderful things for each other.

People getting food out to the needy, people giving free ice to people who need ice, the manager at the Wendy's sending out free burgers to the police officers directing traffic. The post-hurricane quotidian is so far the opposite of New Orleans: the ridiculous conditions are bringing out the best, not the worst, in the natives."[408] Such a collective spirit typified the local reaction, with residents frequently referring to themselves as "third-hardest hit" after New Orleans and the coast, even as they rolled up their sleeves, kicked off their heels and set to work.

The effects of the storm would far outlast the initial weeks of cleanup and recovery, and even as power, water and utilities returned to the darkened city blocks and the time spent queuing for gasoline decreased from hours to minutes, Hattiesburg experienced a profound change in its character. As writer Mark Olderr has observed,

> Hattiesburg's recovery, although difficult, was relatively swift. As such, Hattiesburg served as a staging point for many of the workers who had to go work down on the Gulf Coast or New Orleans. In addition to the workers, there were hundreds, maybe thousands of people from the coast and New Orleans who had made temporary homes here. Many people decided to stay in Hattiesburg after the storm, and the city's population and tax revenues showed a corresponding jump. Although Katrina was terrible, Hattiesburg actually grew as a result of the storm.[409]

Nor would the city escape further turmoil and change in the years after Katrina, which would arguably become the defining event of that decade. The two universities, USM and William Carey (which had become William Carey University in 2006), would see profound changes in their leadership in the years after Katrina, with the death of Carey president Larry Kennedy that same year and a rapid, controversial series of appointments and departures at USM.[410] In 2007, the old Hattiesburg High School building, which had been undergoing renovation at the time, would be the subject of a devastating arson attack by local youth, seriously jeopardizing its future and leaving the historic building a hollow, burned-out shell.[411] In 2009, the Hercules chemical plant would close its doors after nearly ninety years of business in a move that further signaled Hattiesburg's turn to a retail- and service-based economy, and in 2010, the historic Beverly Drive-In Theater, a local landmark even after its closure a few years earlier, would burn to the ground as well.[412] Once-familiar faces and names around town began to be mentioned only in the past tense, as the city had to bid farewell to some of its oldest friends.

If, in 2010, locals had thought they were in for a quieter decade than the preceding one, they could scarcely have been more wrong. The beginning of that decade would prove surprisingly eventful: though yet another president of USM would arrive in early 2013 to fill Dr. Martha Saunders's recently vacated position, no one could predict that this new leader—Dr. Rodney Bennett, the first African American president of the institution—would do so within days of another major natural disaster. On the evening of February 10, a thunderstorm system moving northeast across the region spawned a massive EF4 tornado that touched down in west Hattiesburg and proceeded to track east-northeast, damaging Oak Grove High School before following almost the exact layout of Hardy Street toward the center of town with winds of up to 170 miles per hour. Crossing Hardy from south to north almost directly in front of the USM administration building, it continued on the same track eastward, devastating buildings such as the historic Westminster Presbyterian Church, portions of Hattiesburg High School and hundreds of homes in the Mobile Street, North Hattiesburg and Petal areas.

As with Katrina eight years earlier, the response was swift—after first-response crews moved to stabilize the ruptured infrastructure, city, state and university officials mobilized to repair the damage. Miraculously, no lives were lost; a result aided partly by the fact that, it being Mardi Gras weekend, the student body at USM was largely off campus on the Gulf Coast or in New Orleans celebrating the holiday. Damage to the campus, however, was extensive: not only were the beloved live oak trees lining Hardy Street uprooted, leaving the southeast corner of campus as stark and barren as when the university was first founded, but numerous buildings—including the music department and the historic Ogletree House (once the president's home)—suffered extensive structural damage, in some cases total. School spirit remained high, however, as a determined consortium of students, faculty and staff set about restoring the beauty of the campus.

Several months later, Hattiesburg residents geared up for a different sort of challenge, one faced in the world of ideas and issues rather than bricks and mortar. Up for reelection for his fourth term, Mayor Johnny Dupree won the Democratic primary in May, leading to a contest against four independent candidates: Dave Ware, Clyde Stewart, Nathan Jordan and Shawn O'Hara. The race proceeded largely as normal until election day on June 4, when it took an unexpected turn that would captivate local, state and national audiences for the next four months. When the ballots were counted, a razor-thin margin of thirty-seven votes of Dupree over Ware—a former city council member—combined with

The American Red Cross Hattiesburg Office, destroyed during the February 10, 2013 tornado, with no injury or loss of life. *Photo by Steven Coleman, American Red Cross.*

irregularities in the absentee and affidavit ballots, led Ware's campaign to formally challenge the results.

The trial began in June, during which both Ware's and Dupree's attorneys presented arguments for the validity and invalidity of certain ballots, depending on where they were collected, by whom and how they were handled in the process. Testimony of election officials, city staff and law enforcement personnel was both controversial and emotional, spilling over onto social media websites such as Facebook and Twitter, where it seemed the election was being played out only a step away from the courtroom. Even as speculation about corruption, mishandling and malfeasance ran rampant, the trial reached a climax on July 30, when presiding judge William Coleman received a decision from the twelve jurors. (Ware's attorneys argued that numerically, Ware won on all the unequivocally legal ballots, no matter how many of the disputed were retained; Dupree's attorneys argued for the original result to be upheld and the closure of this potentially divisive process.)

In a live broadcast, the jury returned a verdict of nine to three in favor of Ware, a verdict that initially appeared to bring an end to the trial as well as the beginning of a new era in city politics. But as the candidates and the city looked on in amazement, when polled individually for their votes by the judge moments later, the tally changed from nine to three to

eight to four (the result necessary for a Dupree victory), suggesting that one of the jurors had changed his vote on the spot. Immediately, the trial descended into disarray, and after an appeal by Ware's campaign, Coleman agreed to review this unforeseen change of events. Days later, after further arguments and testimony from both campaigns, Coleman issued a ruling on the integrity of the case. He declared that though under the law jurors had the right to change their minds even at such late contexts, validating the eight-to-four result, he also ruled that Dupree's campaign had failed to adequately respond to the main arguments of the Ware campaign regarding irregularities in the ballots. Declaring a mistrial, he ordered a new special election to be held at a later date.

While at the time it seemed like a cautious victory for both sides—Dupree would remain mayor in the interim, and while Ware had not won outright, he was given another chance to run, hopefully in an election where increased voter turnout would settle the matter conclusively—the city was given only a brief respite during which to catch its breath. The two candidates returned immediately to campaigning (the others had withdrawn from the ballot), and on September 24, voters returned to the polls, this time overseen by poll workers trained by state officials. Turnout on the day exceeded expectations, with lines appearing out the door of polling stations before they even opened. For most of the day, Ware's campaign maintained a comfortable lead, but as the final precincts returned their ballots that night, more questions began to emerge even as that margin began to shrink. The result was again deferred, as the absentee and affidavit ballots again presented irregularities that the electoral commission had to settle over a painstaking subsequent week. As days drew on, Dupree began to take the lead, and late on that Saturday evening, Ware conceded the mayor's victory, 7,507 to 7,305.

While the drama alone made the election worth watching, most concerning was the health of the electoral process itself, with irregularities in balloting and counting as well as confirmed accounts of voter fraud leading many on both sides to wonder about the integrity of the election. Citizens and observers from local, state and national sources expressed dismay that an election could suffer so many failures in its process, leading to a widespread feeling that for whatever reason, the city had not fully outgrown the ploys of vote-fixing and mismanagement of years past. Such a viewpoint unfortunately fed perceptions of Hattiesburg (and south Mississippi generally) as a backwoods place where locals still could not accomplish a mechanism as basic to democracy as a smooth election and

led to widespread calls for electoral reform at all levels. For no matter who received their ballot, one thing all Hattiesburg residents could agree on following those tense, emotional days was that they were glad it was finally over, and they hoped it would never happen again.

## Renewals and Retrospectives

That said, events are events and, granting their significance, are nevertheless as individual notes in a symphony whose music continues to flow. Within the music that has played since the turn of the millennium, other slower, steadier themes have arisen as well. Among the major themes is the revitalization of Hattiesburg's downtown, its physical environment and its cultural identity, culminating in a sense of civic pride that has lent new optimism and confidence to the growth that has characterized the city. Even as the city's growth out west has shown little signs of slowing, recent years have still seen a return to the historic core of the town, evidenced in preservation and renewal, the reclamation of individual buildings alongside the restoration of larger districts and a strengthened sense of responsibility for Hattiesburg's unique history.

First, in an echo of the revitalization efforts undertaken by city government in the 1980s and 1990s, the 2000s have seen a push to restore the physical character of downtown in an effort to lure residents and businesses back to the area. While for decades the city had sought and received National Register of Historic Places status for many of its neighborhoods, including downtown (1986), the Oaks (1993) and Newman-Buschman (1999), the jewel in its crown was still to come. Shortly before Mayor Ed Morgan left office, his administration negotiated the purchase and restoration of the historic Southern Railway Company train depot, which until that point had foundered in disrepair. Following a seven-year, $10 million renovation that concluded in 2007, the depot would not only continue to serve the daily passenger trains as it had since 1910, but it would also expand its services to include bus, taxi and event facilities. Not long after this restoration was concluded, Hattiesburg's two skyscrapers, the Ross (now America) and Carter Buildings, entered into extensive renovation to reopen as mixed-use facilities, complementing the many small businesses—restaurants, shops and music venues—that populated their ground-level corridors. These small enterprises that girdle the blocks along Main, Front and Pine Streets have

The Carter Building, downtown Hattiesburg, showing restoration and local businesses. *Photo by Matt Bush.*

Hattiesburg Depot after restoration, 2014. *Photo by author.*

contributed greatly to the return of foot traffic in the area and have served to counterbalance the growth seen elsewhere.

Furthermore, to increase local use of the area and to stoke the coals of civic pride, the city and its partners such as the Hattiesburg Arts Council and the Historic Hattiesburg Downtown Association began to sponsor regular events to showcase downtown's heritage and offerings, from open-air art walks to holiday events to music and cultural festivals that celebrate other nearby historic neighborhoods as well, such as the Mobile Street Renaissance Festival, now approaching its ninth year. Spearheaded by music venues such as the Thirsty Hippo for a younger clientele, fine dining at restaurants such as 206 Front for more upscale patrons and musical and stage events at the restored Saenger Theater for audiences of all ages, the sight of pedestrians in the area has in recent years evoked the downtown Hattiesburg of the early and mid-century. Of this increased focus on downtown, Adam Myrick, the proprietor of Click Boutique on Front Street—a Hattiesburg native who had left the city only to return years later as an entrepreneur—remarked that when he and his business partner opened their store,

> We saw opportunity, we saw new investors from when I had left. The Prices [Charles and Anita Price] were in the middle of renovating the Oddfellows Building, and we saw major infrastructural development moving in. We also saw the America and Carter Buildings moving back in, and we knew that with these residences on top of us, we'd do well. We wanted to create a little slice of New York downtown here—it became a part of our motto, to have a part of the Big City in the Hub City, something different from the traditional experience here in the South. We were not first on the scene; we were the middle on the scene—we were fortunate to come into a place where a groundwork had been laid. With every merchant that comes to downtown, there's a little pop of glitter that catches people's eyes and reminds them of the opportunity we have.[413]

Noting particularly the interwoven aspect of the downtown fabric, Myrick added,

> The difference between downtown and a strip mall is that in a strip mall, you don't have neighbors to support you and to work with. We've pursued partnerships with Southbound Bagels, with Benny's Boom Boom Room, with A Gallery; everyone here has become tied in to one another. The question is how do we keep this audience, bring people in, and engage the city. It has

*been amazing to go from being an individual who wants that for downtown, to a store that wants that for downtown, to an organization* [the Historic Hattiesburg Downtown Association] *that also believes in the same vision—it has a ripple effect. I am absolutely grateful for every experience I've had, and for every person who spends a single moment downtown.*[414]

Lest this renewed attention to the city's urban environment overshadow its rural origins, these years also saw a renewed interest in preserving and promoting the city's natural environment. Hattiesburg's parks, gardens and outdoor spaces expanded after the turn of the millennium, with the most prominent addition being the creation of the Longleaf Trace walking and cycling trail along the former Illinois Central rail line. Conceived in 1993 and opened in late 2000, the Trace has grown from just a few miles of converted railroad track to a corridor that extends from USM in Hattiesburg to Prentiss in Jefferson Davis County, a present-day distance of forty-one miles, and with further expansions to the downtown Hattiesburg area scheduled under the city's 2008 master plan.[415] Accompanying the development of this corridor have been further renovations and expansions of Kamper Park and Zoo, the construction of a large-scale sports complex and athletic field at Tatum Park in south Hattiesburg, the beautification of the historic Gordon's Creek waterway and the opening of Chain Park in east Hattiesburg along the banks of the Leaf River on land deeded to the city by the former mayor. Even despite increases in private development and the terrible haircut administered by Hurricane Katrina, Hattiesburg has remained a remarkably green city, with few vistas around town devoid of its beloved pine trees, agricultural vehicles and implements such as logging trucks still a common sight on city and county roads.

Of course, not every environmental issue has met with such success—as of this writing, the city's efforts to find a solution to a wastewater treatment issue on the Leaf River have met with little progress and much frustration, and it is unclear how and when such a solution will be reached. Even so, if the city's founding fathers had predicted that diversification would be necessary for the city to survive past the timber boom, it is safe to say that they never could have anticipated its full extent. Not only have retail- and service-based industries achieved a permanent place at the city's economic table, but since the 1990s, Hattiesburg has seen the emergence of other sectors as well. Now known as a burgeoning culinary destination where restaurateurs such as Robert St. John, Chris Ortego and Tom White combine the roots of southern cuisine with diverse new influences, Hattiesburg has also profited

from a change in state brewing laws to welcome beer brewer Southern Prohibition to the downtown area. Hattiesburg has furthermore emerged as a destination for the visual and performing arts through its initiatives such as the Festival of Swans (a citywide project placing painted swans in front of locally iconic sites[416]) and FestivalSouth, a month-long arts and music festival held in downtown venues.[417]

Recognizing the value that creative economies play in the modern age, initiatives such as these have simultaneously increased the cultural offerings available to current residents and brought new demographics and constituents to town. For the past two decades, Hattiesburg has grown to become a national destination for retirees, in part due to its high quality of life and its emergence likewise as a medical destination. Far from its humble origins in Drs. Gillis and Dearman's Doctor Shop, the friendly rivalry between the two major hospitals has led to a major regional presence for primary and specialist care throughout southeast Mississippi and the Gulf Coast, with the hospitals themselves now accompanied by a wide variety of associated clinics, research laboratories, support units and educational facilities—including in 2009 the creation of the College of Osteopathic Medicine at William Carey University, the first of its kind in the region. Now widely known as a medical epicenter, Hattiesburg's growth in medical and paramedical activity is a central component of its economic and civic footprint.

Finally, with growth across so many sectors—physical, economic, natural and cultural—the period since the turn of the millennium has been marked by a reassertion of Hattiesburg's civic pride. For a town whose early identity (indeed, its very nickname) was to some extent dependent on others—a hub is held in place by its spokes, even as all the elements together form a wheel—part of the story of the Hub City in its later years has included the articulation of that identity and the creation of an iconography independent of those other entities. Rather than emphasizing what Hattiesburg has given to and received from Jackson, New Orleans or Mobile, the question has become what the city has created, developed and owned for itself. The tradition of town mascots begun by Hattie the elephant in 1958 and continued by the first Nugget in 1980 was revived with the arrival of the city's third golden eagle of the same name in 2013, now in residence at Kamper Park. To date, Hattiesburg has produced such iconic local products as Rice's Potato Chips, Ward's Root Beer and Shipley's Donuts; even as the city has found a home in area stomachs, it has also found a place between area book covers, with writers such as James Whorton Jr. and David Walker portraying the city in the pages of

*Burgopoly* sculpture by Erik Eaves. *Photo by author.*

their fiction.[418] Such literary notoriety raises a provocative question: with the presence of the Center for Writers at USM and new generations of wordsmiths undertaking their training for years at a time, it is not inconceivable that further versions of the city may emerge. Were local and regional recognition not enough, Hattiesburg has received even more national attention in recent years, with its surprise inclusion in an episode of the television show *Space Ghost: Coast to Coast* in 2001.[419]

Such aspects of civic pride are perhaps best expressed in a contemporary sculpture celebrating the city's cultural heritage, currently on view at the Hattiesburg Visitor's Center. Entitled *Burgopoly* by sculptor Erik Eaves and modeled after the popular board game Monopoly, the cast-iron piece identifies elements unique to Hattiesburg such as historic streets, railroad infrastructure, the swans and the Hub City sign. While tongue-in-cheek, such an artwork only reaffirms the city's mature articulation of its identity. To the extent that it remains a hub bearing many spokes, there is no doubt that Hattiesburg has grown to be able to stand alone.

# Hattiesburg Tomorrow: The Futures of the Hub City

Undoubtedly, the road to that maturity has by no means been smooth, as Hattiesburg has rarely—if ever—been exempt from the challenges that have consumed the state and the nation. Over its 130 years, the city has experienced moments that define the life of an individual body just as much as they do the body politic: it has seen eras of astounding growth (in the lumber boom) and quiet progress (in the 1970s), has seen windows of great initiative (in securing Camp Shelby) and of lost opportunity (being passed over for a state Presbyterian seminary). It has seen vivid competition (in healthcare) and admirable cooperation (in disaster relief), and it has seen moments of great pride (during World War II) accompanied by periods of deep shame and sorrow (throughout the civil rights movement). To its credit, the city has seen its share of firsts: within the state of Mississippi, Hattiesburg is the home of the first Parent-Teacher Association, established at the Walthall School in 1907; the first black-owned and operated radio station, WORV-AM; the first high school football game (Hattiesburg High against Laurel in 1907); and the first nationally accredited municipal police department. Home both to the largest railway platform (924 feet during World War I) and the youngest college president (Ralph Noonkester at William Carey) in America in their times, Hattiesburg is home as well to the country's first African American naval aviator, Jesse Leroy Brown, who served and died for his country even while unable to vote in its elections.[420]

These are high honors indeed. For peopling the history of the Hub City are a host of driven individuals who have devoted their lives to their city and community, irrespective of the costs and regardless of the risks. Though it is impossible to single out all those who, over the course of its history, have made and shaped Hattiesburg into the place as we know it today, it is equally unthinkable to omit the contributions of those leaders from all walks of life who embody the timeless virtues of courage, loyalty, persistence and vision. Individuals such as William Hardy and W.S.F. Tatum, who shepherded the town through its earliest stages. Or Alma Hickman and N.R. Burger, whose passion for education directly touched the lives of generations of students, or W.W. Crawford and T.E. Ross, who devoted their lives to improving public sanitation and health. Individuals such as Clyde Kennard and Vernon Dahmer, Raylawni Branch and Peggy Jean Connor, whose struggles and sacrifices lent the city its moral center and whose legacies continue to serve as a touchstone for the political challenges of today. Individuals such as Ralph Noonkester, Aubrey Lucas and Lowery Woodall, who led the

largest institutions in the city not for self-gain but for the betterment of the thousands they served.

Indeed, taking the long view, these institutions offer a useful barometer for how much the city has grown. From its original roster of 17 faculty and 227 students at the Mississippi Normal College, the University of Southern Mississippi now boasts 925 faculty and over 12,000 undergraduate students. William Carey University, née the Mississippi Women's College, has grown from 167 students in its second session to now over 2,000, not to mention both universities' graduate programs, national accreditations, championship-winning athletic teams and interdisciplinary centers and programs that now define the landscape of higher education. From its first unit of horse-drawn ambulances in 1917, Camp Shelby is now host to approximately 100,000 soldiers, police units and other support staff annually, and from its first patient (and her newborn daughter) Forrest General Hospital now admits over 30,000 patients per year.[421] Nor can these snapshots account for the hundreds of churches that populate the landscape, up from an original eight, or the untold numbers of small and family-owned businesses in the Hub City, some of which—like Ben Shemper and Sons and the Dews Foundry—are nearly as old as the city itself. Indeed, from its founding population of around 250 in 1884 to 45,989 in 2010, a full reckoning of the city's growth may never be possible.

That said, consideration of Hattiesburg past invites consideration of Hattiesburg future, and historians in years to come will have ample opportunity to tell this story anew, examining these years for their own telltale symptoms of larger change. Camp Shelby may be one useful indicator in that regard: subject to national pressures and demands as it is, its fortunes directly impact those of its host community, and the changing landscape of combat forces in the Middle East (as of this writing in 2014) and the consequent reevaluation of the American military presence there may well reach the streets and shops of the Hub City. If previous conflicts such as the first two world wars are any precedent, the base may well see a drawdown in the near future—a welcome conclusion in the interests of peace but a challenging reality for those who rely on the presence of the troops for their livelihoods. The hope is that, regardless of the outcome, base and city leaders will act with the same wisdom and skill that ensured their mutually beneficial relationship for nearly a century.

In the absence of any functioning crystal balls, however, such considerations must remain in the realm of speculation. What is certain is that over the course of its 130 summers, Hattiesburg has seen certain

years that have been key to its growth and development. As this account has shown, the years 1880, 1893, 1910, 1917, 1943, 1964, 1985, 2005 and even 2013 have all, each for their own reasons and each in their own ways, altered the flow of the city's history. One may wonder what the next such pivotal year will be and what driving forces will lead to the kind of generational change that the Hub City has become accustomed to seeing; with the return to its historic center yoked with its outward growth, the opportunities for further consolidation as a city of the New South (to take Gaines Dobbins's phrase) are many. New corridors radiating outward in every direction—along Lincoln Road, West Fourth Street and Highways 42 and 11—suggest areas for expansion in years to come, but whether a major new institutional presence will emerge as well, only time will tell.

Certainly, city officials consider these questions closely, and the comprehensive plan adopted in 2008 will provide a guide for economic and urban growth over the next two decades. Having identified forty-five specific goals in areas ranging from character and identity, urban and natural sustainability, infrastructure, education and housing, city planners are bound by state law to incorporate these guides into their work.[422] As Linda McMurtrey, former city planner and co-architect of the plan, recently said,

> *The core of the 1989 plan was to protect neighborhoods, institute code enforcement and to let downtown develop. As the standard lifespan for city plans is twenty years, we knew when the time would be for a new plan. We had started the process in 2000—for all neighborhoods, not just historic ones. We wanted to see what they wanted and how they wanted the city to function in the future. Among other priorities, we are focusing on corridors: on the midtown corridor, the Hardy Street corridor, on Mobile Street and on Broadway Drive. The national trend is to come back into the core [of a city], but Hattiesburg is twenty years behind the times. We are now catching up on that trend—to increase the ad valorem and the assets the city has, to prevent the city from seeing everything go to the outskirts, to focus on engaging young entrepreneurs to come into these areas and make them areas of prominence.[423]*

Future assessments will judge the success of these efforts to curtail this urban "doughnut hole"; until then, with these considerations in mind, a glance at Hardy Street today reveals just how far the city has come. From its foot at the base of Pine Street downtown to Oak Grove Road to the edge of the major retail and service developments out west, crossing one state

highway (49) and a federal interstate (59) to become another federal highway (98), and with hundreds of businesses lining its freshly paved lanes, more wealth likely exists along this single seven-mile stretch in the modern age than existed in the entire first decade of the city's founding—a remarkable testament to the architect of that founding and the prescience of his vision.

Critical to recall is the fact that none of this growth has been guaranteed, and at any one of those moments in the city's history, its fortunes could have gone the other way. Indeed, the history of close votes affecting Hattiesburg runs surprisingly deep: the state was nearly named Washington instead of Mississippi, the Normal School nearly ended up elsewhere in the state as well as elsewhere in town and Mississippi Women's College nearly closed in 1946, all on votes with uncomfortably close margins. Similarly, Dr. W.W. Crawford's efforts to woo General Leonard Wood could have failed, without which there would have been no Camp Shelby. Though its modern landscape can at times feel inevitable, the Hub City was never entitled to the prosperity and opportunity it enjoys today, and a few minor alterations to the city's historic fabric would have resulted in a fundamentally different tapestry. But acknowledging these counterfactuals, what is remarkable is that even Hattiesburg's first historian recognized something of the essential driving spirit that had animated the town since its beginnings. Writing in 1898, Otis Robertson observed,

> *Hattiesburg has every advantage that a town could ask. It bids fair to be the largest town in Mississippi. Its water is good. Its climate is as good as might be expected in the South. Its surrounding country is fertile. Its people are progressive, but not aggressive. There is hardly another community that has as little "neighborhood quarrels" as does Hattiesburg, and especially do we note the harmony that exists among the professional men. The town is strictly a Christian town, five-eighths of the people being members of one or the other of the eight churches that are to be found in its limits. But not withstanding all this Hattiesburg is not a "Garden of Eden," as some have pictured it. Money does not grow on trees. But there are hundreds of opportunities for good honest men to make good honest livings.[424]*

Forgivably out of date on some of his counts—Hattiesburg is now home to communities of many different faiths, for instance, and a growing number of different traditions and houses of worship—the portrait Robertson drew a century ago of the opportunities for honest individuals to make honest livings still bears more than a passing resemblance to the city today.

For those concerned about the future of the city, it is worth spending an afternoon on the banks of its rivers, in the company of the Bouie or the Leaf. There, one still finds a certain peace far from the rush of traffic on the highways or the shrill blast of the whistle on the tracks, a peace as ready and welcome as it was the day Hardy first stopped there to lunch. Nor is it hard to imagine floating down one of these streams over a century ago, looking for a site on which to make a settlement, find food and shelter and/or raise a family. Call home. Small fish still flit beneath their streams, bream and mullet in search of their own midday meal, and their waters still flow lazily on a summer's day, swirling and eddying around each of their bends and curves. Today, instead of floating lumber downstream to the mills, the city's two rivers are primarily used for floating canoes—tourists and naturalists more interested in a weekend away than a workday ahead. Above them on the bluffs, small firepits built by transients scatter ash in the winds, and nowadays the old portages are strewn with the archaeology of the modern age: aluminum cans, plastic bottles and acrylic graffiti that mark the passage of those whose names might never be known to history.

As, in some way, it should be. There is a comfort in such regularity, in such a continuation of use over years both shallow and deep. Though the mysteries of the past may be more brightly illuminated by the knowledge of the present, it is safe to say that locals of all eras will always hold dear the simple pleasure of pulling up a fish from its depths, and taking the long view of time, such concerns swiftly float away on the current. Where water flows, people follow, and every city, like every river, has at least two stories inside it: the story of where it has come from and the story of where it is going. If the point of reflection offers appreciation toward the former and opportunity toward the latter, then only one question remains. Now that Hattiesburg has reached its full maturity, where does it want to go?

# NOTES

## *Chapter 1*

1. Reams, "Red Flag Predictive Model," 46–47.
2. Jackson, Higgins and Reams, "Woodland Cultural and Chronological Trends," 230.
3. Jackson, *Evaluation of Remote Sensing Effectiveness*, 18.
4. Ibid., 26.
5. Reams, interview.
6. Freeman, "Cultural Complexity," 20.
7. Jackson, Higgins and Reams, "Woodland Cultural and Chronological Trends."
8. Cf. Reams, "Red Flag Predictive Model"; Jackson, Higgins and Reams, "Woodland Cultural and Chronological Trends"; Jackson, *Evaluation of Remote Sensing Effectiveness*.
9. Reams, "Red Flag Predictive Model," 11.
10. Cf. Jackson, Scott and Anderson, *Archaeological Investigations*; Barnett, *Mississippi's American Indians*, 26.
11. Jackson, *Evaluation of Remote Sensing Effectiveness*; Reams, interview.
12. Dunn, "Analysis of Lithic Artifacts"; Jackson, Higgins and Reams, "Woodland Cultural and Chronological Trends"; Freeman, "Cultural Complexity"; Reams, interview.
13. Dunn, "Analysis of Lithic Artifacts," 46.
14. Jackson, *Evaluation of Remote Sensing Effectiveness*.
15. Brown, *Archaeology in Mississippi*, 244ff.
16. Reams, interview.
17. Reams, "Red Flag Predictive Model," 58.
18. Jackson, *Evaluation of Remote Sensing Effectiveness*, 30.
19. Barnett, *Mississippi's American Indians*.
20. Blitz and Mann, *Archaeological Investigations*, 67.

21. Baca, *Native American Place Names*; cf. Smith, "Study of Place Names."

22. Quoted in Bond, *Mississippi*, 15.

23. Powell, *Accidental City*, 129ff.

24. English, *All Off*, 4ff notes that these treaties gave rise to the boundary marker of St. Stephen's Line—a line that had to be surveyed by federal agents, and that led to the famous "Three Chopped Way" as a route between Natchez and the interior of the Piney Woods; Cf. Napier, "Piney Woods Past," and Brandon, "The Search for St. Stephens Road."

25. Barnett, *Mississippi's American Indians*, 180–81.

26. Ibid., 207.

27. McCraw, "David Holmes," records that at the constitutional convention that summer, "Washington came within seven votes of being the name given to the state, but Mississippi was selected." Had that narrow margin been reversed, one wonders what the Pacific Northwest state of Washington would have been called today.

28. Olderr, *City of Hattiesburg*, 19.

29. English, *All Off*, 7–8.

30. Ibid., 5–6; WPA County Histories (Forrest County).

31. Lowry and McCardle, *History of Mississippi*, 555.

32. Ibid., 555–56.

33. McWhiney, "Antebellum Piney Woods," 44; See also Bynum, *Free State of Jones*, 69ff.

34. Clark, "Piney Woods"; cf. also English, "Early Life."

35. Wertz, "165 Years"; Cf. also McWhiney's discussion of early Perry County, "Antebellum Piney Woods," 48ff.

36. L.A. Besancon, quoted in Hickman, *Mississippi Harvest*, 7–8, and Fickle, *Mississippi Forests*, 57.

37. Claiborne, "Trip," 514–15.

38. Pitts, *Life and Confession*, xxii.

39. Ibid., 142. This author's uncle, John Alan Morris of Hattiesburg, has claimed that the skeleton was displayed in the back room of a drugstore on Front Street for the price of a nickel a view but declined to say—or, perhaps more conveniently, had forgotten—which one.

40. Hickman, *Mississippi Harvest*, 8.

41. Fickle, *Mississippi Forests*, 58.

42. Morgan, personal conversation; Smith, *Mississippi in the Civil War*.

43. Bynum, *Free State of Jones*, 47ff.

44. This account is adapted from several sources; interested readers are urged to consult Andrew English's excellent history of the early Hattiesburg area, *All Off for Gordon's Station*.

45. McSwain, *Blue and the Grey*, 67.

46. English, *All Off*, 16–19

47. Cf. Bynum, *Free State of Jones*; Leverett, *Legend of the Free State*; Jenkins and Stauffer, *State of Jones*; Varnado, *Free State of Jones*. News of Knight's exploits reached far and wide; Kelly, "Newton Knight," records that even Captain Hardy, during his

campaign with the Army of the Tennessee, wrote to wartime governor Charles Clark imploring him to deal with the insurrection.

48. Roberson, "History of the *Hattiesburg American*," 21.

49. Bond, *Mississippi*, 125ff.

50. Grivno, interview.

51. Hickman, *Mississippi Harvest*, 93.

52. Bond, *Mississippi*, 146.

## *Chapter 2*

53. Fickle, *Mississippi Forests*, 43; Hickman, *Mississippi Harvest*, 68ff.

54. Among this correspondence is a letter that, for the first time in Hattiesburg historiography, reveals Hardy's status as a slave owner. This letter, which avoided transcription by prior editors and historians working with the collection, survives only in partial form and lacks an exact date but was mostly likely written in mid-September 1862 while Hardy was stationed near Fredrick City, Maryland. Written to Sallie Ann in Raleigh, Hardy issues orders regarding a slave on their property. It seems that one of the Hardys' slaves named Judy had harbored a fugitive, and merited punishment for her actions. The first page of the letter is lost (a letter from Hardy's sister, Margaret Elizabeth Hardy Evans, comprises the reverse side), but the second page begins: "…know anything about it—I hope you may be able to get along until I return when I will bring her to a proper sense of her duty. In any event I want her severely whipped for her conduct in harboring that negroe and I want you to prohibit Judy from visiting or receiving visitors and to that end inform Mr Spencer to ask the [illegible] to whip her whenever they catch her out from home. She is a spoilt negroe and I fear will give you trouble, if so ask father to hire you another and hire her out, but don't let her take [Gail?] with him…" The intent of publishing this information here is not to prosecute a man of his era for holding views that might well be expected of him—Hardy was a famously virulent critic of Reconstruction—but rather to contribute to the historical record of one of Mississippi's most distinguished individuals, especially given that letter's omission in previous research. The letter is housed in the McCain Library and Archives, Reference# M380 Box 2 (Civil War Letters).

55. Fike, "William H. Hardy."

56. Hardy, *No Compromise*, 128. The introduction of Hattie's memorial volume, likely written by her husband, further describes her "of robust physique, light hair and light blue eyes, with complexion as fair as a lily." (Hardy and Hardy, *Memorial*, 2.)

57. Hardy (William H. and Hattie L.) Papers, 1873–1929. McCain Library and Archives, Special Collections, Reference #M182.

58. Robertson, *Facts about Hattiesburg*, 5; English, *All Off*.

59. Hardy, *No Compromise*, 218–19.

60. Ibid., 219.

61. Sturkey, "Heritage of Hub City," 83–84.

62. Hardy, *No Compromise*, 238.

63. Hardy and Hardy, *Memorial*, 44.

64. Ibid., 93.

65. Frost, "Four Centuries."

66. Brockway et al., *Restoration of Longleaf Pine*, 8–9.

67. Beyond this general overview, cf. Hickman, *Mississippi Harvest*; Napier, *Lower Pearl River's Piney Woods*; Hoffman, *Dummy Lines*; Fickle, *Mississippi Forests*.

68. Lee, interview.

69. Hickman, *Mississippi Harvest*, 106ff.

70. Ibid., 121ff.

71. Sturkey, "Heritage of Hub City," 74.

72. Hoffman, *Dummy Lines*.

73. Hickman, *Mississippi Harvest*, 177, 157–58.

74. Clayton, "Wild Women," 12.

75. Barksdale, *Hattiesburg Fire Department*.

76. Dearman, "Letter to Jack Gay."

77. Fickle, *Mississippi Forests*, 118.

78. Napier, "Piney Woods Past," 19.

79. Means, "Wiregrass Restoration."

80. *St. Louis Lumberman*, April 15, 1905; quoted in Hickman, *Mississippi Harvest*, 177.

81. Goodspeed Publishing Company, *Biographical and Historical Memoirs*, 239. There is a slight discrepancy in numbers in Goodspeed's history, probably given that its chronicler visited Hattiesburg (errantly called Hattiesburgh in the narrative text) prior to 1890 when its population was 650. By the time of the book's publication in 1891, it had likely risen to 1,172.

82. Roberson, "History of the *Hattiesburg American*," notes debate over which newspaper was truly the first—the *Herald*, published by A.J. Russell; the *American Citizen* (founded circa 1893); or the *Democrat*—noting the different kinds of content in each publication. The matter is complicated by the arrival in 1885 of the *Hattiesburg Progress*, which published twice a week, according to the *Hattiesburg American* article "Through the Years." Settling that debate is less important here than in showcasing the swift rise of publishing outlets in the nascent town.

83. Roberson, "History of the *Hattiesburg American*," 54.

84. *Hattiesburg American*, "Early Hattiesburg Settlers."

85. Cf. Robertson, *Facts about Hattiesburg*; English, *All Off*.

86. The 1899 *Typographical Journal*, p. 522, lists one J.M. Williamson, an applicant to the journal's society and Hattiesburg's sixth mayor, as "proprietor of *Hattiesburg Democrat*, Hattiesburg, Miss., since 1885." Given Oliphant's editorship, the discrepancy is unclear.

87. *Democrat*, 8, Column 1.

88. *Democrat*, 3, Column 5.

89. *Democrat*, 6, Column 2.

90. Robertson was both an early historian and an early census-taker. In 1898, the same year of publication of his history, he conducted a census for Mayor T.J. Mixon and the board of aldermen: a handwritten document at USM reads "I, Otis Robertson, duly appointed by the board of said town to take a census of the town of Hattiesburg, showing the occupation, age, race, sex, and time of residence of each inhabitant

hereby submit the roll of said inhabitants, which total number amounts to 3600. Otis Robertson, Nov[ember] 12, 1898." (McCain Library and Archives, Special Collections, Reference #M208, Box 1, Folder 9) Unfortunately, no record of his methods or materials survives; all that remains is his final estimate, a number in keeping with the earlier 1890 estimate of 1,172 and the later 1900 estimate of 4,175.

91. Robertson, *Facts about Hattiesburg*, 57–59.

92. *Democrat* 1894, 8, Column 5.

93. This layout would draw thinly varnished criticism almost a century later by a New York–based planning firm, Alexander & Moskowitz, Inc., hired in 1969 as part of a downtown revitalization project. "The street pattern in downtown Hattiesburg," the architects wrote, "is clearly representative of an age before the modern automobile and truck revolutionized transportation. Most of the streets in downtown form irrational patterns characterized by narrow lanes, odd angles, bad offsets and jogs, lack of continuity and similar flaws. The only relatively straight and continuous streets are Main and Pine. But, even they do not make smooth, efficient connections to outer areas." Not only do they criticize downtown as having no architecturally significant buildings, but in a further jab, they bemoan its unsuitability for automobiles: "The traffic and on-street parking, also man-made features, allow largely unrestricted turning movements, excessive on-street parking and cause frequent lane changing. All of these factors contribute to conflict, congestion, and slowly moving traffic."

94. Cf. McCarty, *Hattiesburg*, 100–01; an undated early photograph of the hotel and spa at Rawls Springs, housed at the McCain Library and Archives (Special Collections, Reference #M246-234), shows another such contraption.

95. Saltsman, *Climatological Summary.*

96. Hattiesburg Municipal Archives, McCain Library and Archives, Special Collections, Reference #M208, Box 1, Folder 3.

97. Robertson, *Facts about Hattiesburg*, 27.

98. Ibid., 69–73.

99. Cf. Lucas, *Grace Transforms*. The houses of worship mentioned here are simply those within the city limits of Hattiesburg. Other congregations formed in outlying communities surrounding the new town in its early days, such as Rocky Branch Missionary Baptist Church in Sumrall, founded in 1882; and Central Baptist Church (now Rawls Springs Baptist Church) and First Baptist Church of Glendale, both founded in 1883 (*Hattiesburg American*, "Rocky Branch Missionary Baptist Established in 1882," "Rawls Spring Baptist Blessed Church," "First Baptist of Glendale Enjoys Colorful, Prosperous History"). As noted in Chapter 1, the oldest of all is Providence Baptist Church, founded in Eatonville in 1818.

100. Temple B'nai Israel, n.d.

101. Robertson, *Facts about Hattiesburg*, 1.

102. City of Hattiesburg, *Hattiesburg, Mississippi*; English, *All Off.*

103. English, *Ringside at Richburg*, among others has chronicled this story in depth.

104. The following records are found in the Hattiesburg Municipal Records collection, McCain Library and Archives, Special Collections, Reference #M208, Box 1.

105. McWhiney, "Antebellum Piney Woods." Lucas, *Grace Transforms*, 10, details a case of ecclesiastical punishment for the sale of alcohol, drunkenness and gambling.

106. Hattiesburg Municipal Records collection, McCain Library and Archives, Special Collections, Reference #M208, Box 1, Folder 12. Records from the period include a volley of letters from workmen to the mayor and aldermen, complaining that E.E. Collins, the builder, had not paid their daily wage, and seeking relief from the authorities (which, based on extant receipts, seems to have been granted).

107. Hartfield, Opinions by City Attorney.

108. Robertson, *Facts about Hattiesburg*; Ross, "History of Medicine."

109. Hattiesburg Municipal Archives, McCain Library and Archives, Special Collections, Reference #M208, Box 1, Folders 10 and 12.

110. Hattiesburg Municipal Archives, McCain Library and Archives, Special Collections, Reference #M208, Box 1, Folder 17.

111. Hattiesburg Municipal Archives, McCain Library and Archives, Special Collections, Reference #M208, Box 1, Folders 14 and 15.

112. Mayor Evans Hall: Mayor's Report to Aldermen (December 4, 1899). Hattiesburg Municipal Archives, McCain Library and Archives, Special Collections, Reference #M208, Box 1, Folder 18.

113. Elsewhere, Hattiesburg Public Schools, *Education*, notes that "mixed in with the early recorded history of Hattiesburg are accounts of a 'little log house' located between Gordon's Creek and Main Street that was used as a schoolhouse in 1885. Students of that early school remembered Main Street as a muddy road running in front of the building. Cool drinks of water were sipped from drinking gourds at a nearby well...The school received its official accreditation in 1897 and graduated its first class of three students in 1898."

114. Robertson, *Facts about Hattiesburg*, 15–17. Whether Robertson knew of the lynching in 1890, or whether he chose not to include it, is not known.

115. *Hattiesburg American*, "35 Years Ago Oil Lamps Supplied Lights for City."

116. Hattiesburg High School, "Fifty Years."

117. McCarty, *Hattiesburg*, vii.

118. Claiborne, "Trip," 523–24. The emphases, remarkably, are his.

119. Hickman, *Mississippi Harvest*, 66; Skates, "Hattiesburg." A forthcoming volume by Reagan Grimsley promises to address this story in detail.

120. Cf. Hardy, *No Compromise*, and English, *All Off*.

121. The importance of the Gulf and Ship Island rail line cannot be overstated. As WPA historians (WPA, *Source Material for Mississippi History*, 4) later noted, "Though it had taken twenty years in the building...Mr. Hardy's railroad more than fulfilled its promise. It gave the State a deep-water harbor, more than doubled population in the towns along its route, built the city of Gulfport, and stamped Hattiesburg once and for all as a railroad center."

122. Ross, "History of Medicine."

123. Holton, "Fines Cheaper"; English, *All Off*.

124. Whether the fire department was founded in response to the two fires at the South Mississippi Infirmary, or was already in place before them, is uncertain, but the proximity between the two events is notable.

125. Fickle, *Mississippi Forests*, 75.

126. McCarty, *Hattiesburg*, 39.

127. *Saturday Evening Eye*, 1904.

128. Shemper Family Papers, McCain Library and Archives, Special Collections, Reference #AM98-73.

129. McMillen, *Dark Journey*.

130. The image appears in McCarty, *Hattiesburg*, 30.

131. Robertson, *Facts about Hattiesburg*, 53.

132. Cruthirds and Cruthirds, *Hattiesburg*, 67; Wicht, interview.

133. McGhee, *Mississippi Black Newspapers*.

134. *Hattiesburg News*, "8000 Visitors Attend the Prosperity Celebration."

135. Sturkey, "Heritage of Hub City," 99–102; Taylor, *Flight of Jesse Leroy Brown*, 24, notes that between 1890 and 1936, there were a total of nine lynchings but offers no sources for this claim.

136. Quoted in Roberson, "History of the *Hattiesburg American*," 77.

137. Shady Grove Baptist Church, "History."

138. Cruthirds and Cruthirds, *Hattiesburg*, 94; see also English, *All Off*.

139. Saltsman, *Climatological Summary*; *Lewiston Evening Journal*, 1906; *Youngstown Vindicator*, 1906; WPA, *Source Material for Mississippi History*. According to the *Vindicator*, "During the latter part of the blow there was such a quantity of wreckage in the streets that few persons attempted to walk about. The fire department was called out in the vicinity of Gordon's Creek to rescue women and children imprisoned in their homes by an overflow of the creek. Five buildings were blown down, one of them being a large warehouse. The First National Bank was unroofed."

140. Photographs of the Leaf River flood appear in McCarty, *Hattiesburg*.

141. Lamar County Historical Society, *Purvis Tornado*, 2. WPA historians add another dimension to the story: "According to the preachers of the State, Purvis was wicked and was surely headed for a downfall. The downfall came at 4 o'clock one afternoon in the early 1900's. A cyclone hit the town, stopping the clock, killing several people and injuring many more. Feeling that the prophecy of doom had been fulfilled, Purvis people left the courthouse clock at 4 pm as a reminder." (WPA, *Source Material for Mississippi History*, 31)

142. Lamar County Historical Society, *Purvis Tornado*, 10–12.

143. *Hattiesburg American*, "A History of Hattiesburg." According to the article, the citation comes from "the last paragraph of an article that appeared in the May 8, 1900 edition of the *Hattiesburg Daily Progress*."

144. *Saturday Evening Eye*, 1904.

145. Quoted in Roberson, "History of the *Hattiesburg American*," 35–36. Dobbins's figures seem elevated; federal census records suggest that the population of Hattiesburg would reach 13,270 people only in 1920. The 1910 data records 11,733 residents.

146. Thomas, "Hattiesburg, Mississippi."

147. O'Neal, "Petal History"; Lee, "Ceremony to Mark Emergence."

148. *Hattiesburg American*, "U.D.C. Formed 30 Years Ago." The UDC seems to have had trouble maintaining the land, likely given its size, so it deeded it as a partnership to the city.

149. Dearman, "Letter to Principal."
150. Not all was roses in the city ascendant: as soaring as its fortunes were, so, too, were the flames that rose from the city's buildings on a regular basis. According to Barksdale, *Hattiesburg Fire Department*, 11, "1910 seemed to have had more fires than any of the previous years. On May 18, 1910, the Fabracher Hotel suffered a serious fire. On June 2, the Pitts Building on West Pine Street was seriously damaged and a Mexican was burned to death. On November 1 of the same year, Swift & Company, located in the Old Compress Building at Mobile and Second Street, was a total loss. On December 14, the Pullen and Batson Products Company on East Pine Street was totally destroyed." The year 1925 would also be a conflagratory one, with the Phoenix Laundry, the Woodmen of the World building and the Fine Bros. Department Store also suffering major losses.
151. Hickman, *Mississippi Harvest*, 177ff., 198.
152. Both *Price's Industrial Magazine* and *Hattiesburg News*, "8000 Visitors Attend the Prosperity Celebration," note the old nickname, whose origins are unclear and which has long been forgotten to history.
153. WPA, *Source Material for Mississippi History*, 4. Hickman, *Mississippi Harvest*, and Steen, "Piney Woods," note that lumber companies in the Piney Woods came under federal investigation for price-fixing, which led to widespread changes in the industry in the 1910s and 1920s.
154. Hardy, *No Compromise*, 248. According to English, *All Off*; the WPA History of Forrest County; and Moore and Slade, *History of Morriston*, one Francis (Frank) Marion Morris of Morriston, who served as the chair of the board of supervisors for Perry County, was responsible for the suggestion of naming the county after Forrest due to his admiration for the officer; that Frank Morris is this author's great-great-grandfather on his father's side. This author takes no responsibility for the decision.
155. Roberson, "History of the *Hattiesburg American*."
156. HAHS, *History of Hattiesburg Coloring Book*, 3.

## *Chapter 3*

157. Kyriakoudes, interview.
158. Ibid. The YMCA building was replaced by the current Federal Building.
159. City of Hattiesburg Department of Planning & Community Development (DPCD), *Historic Hattiesburg*, 3:1.
160. Braswell, "New Designation."
161. National Register of Historic Places, "Historic Hattiesburg."
162. DPCD, *Historic Hattiesburg*, 5:1.
163. National Register of Historic Places, "Oaks District."
164. Ibid.
165. Thornton, "Heart of Hattiesburg," 53ff.
166. *Advertiser News*, "Old High School."

167. National Register of Historic Places, "North Main Street."

168. DPCD, *Historic Hattiesburg*, 6:2.

169. Brown, interview; see also Taylor, *Flight of Jesse Leroy Brown*.

170. McRaney, "American Way."

171. Wheeler, *William Carey College*, 21; Morgan, *Dearly Bought*, 18.

172. *Hattiesburg American*, "Bygone Days: March 14, 1922" and "Veteran Founded Hattiesburg." According to these accounts, the first street to be covered with asphalt was Hardy Street, which comes as no surprise; what is more surprising is a later request by the newspaper to close downtown streets to traffic in 1922 to flash statewide election returns on its buildings. *Hattiesburg American*, "Bygone Days: August 15, 1922," notes that "traffic, it was believed, would 'endanger life and limb.'" How fast drivers of the day were speeding is unfortunately not recorded.

173. Barksdale, *Hattiesburg Fire Department*, 15; the Hattiesburg Area Historical Society Museum has artifacts from the tragedy, including the steering wheel of the truck. Barksdale notes (p. 13) that motorization was the main issue in question in 1915 and that the department's new American LaFrance pumper was "the first piece of motor apparatus ever to be used in Hattiesburg," requiring its own engineer to operate. Later (p. 51), he describes the fate of the four-legged engineers who had served up to that point: "On the arrival of the new fire truck in March, 1915, it was really a regrettable sight when 'Pete' and 'Button' the two horses at No. 1 Station, said to be two of the most sensible pieces of horse flesh owned by any southern department, were crowded out of their home that they had occupied for years and out of the jobs that they had held so proudly and so well, driven into the street to do the most menial labor…They were forced to be street cleaners whereas in the past they had been engineers. In other times they were pointed to with pride as they dashed down Main Street in front of a clanging bell, or pranced around West Pine Street while receiving their daily exercise. [Now] they were seen drawing dirt filled wagons or a load of stone from one point to another, or standing around in the sun waiting orders from a negro driver. No one had told them what their future might be as none of the fire daddies had the heart to do so."

174. William Carey University (2014). South Mississippi College seems not to have been the first institution for professional training at large. Advertisements in the *Saturday Evening Eye* of 1904 solicit applications for the McLendon Business College, operated by one O.H. McLendon, president, and Reverend J.L. Red, vice-president, which trumpeted its success at placing its students in nearly every major lumber company in the region, and other companies besides. Unfortunately, few other details of this institution survive, and it does not appear to have lasted for very long.

175. Wheeler, *William Carey College*, 11. See also Thomas, "Hattiesburg, Mississippi."

176. Ibid., 12.

177. Ibid., 14.

178. Ibid., 16.

179. Wheeler, "Praising God," 7; Wheeler, *William Carey College*, notes that among the losses were all of the records and catalogues of South Mississippi College, leaving an unfortunate gap in our understanding of the city's history.

180. Wheeler, *William Carey College*, 20.

181. Wertz, "Dorothy Ware."

182. Ibid.

183. Wheeler, "Praising God," 9. No account of an ecclesial women's college would be complete, however, without mentioning the realities and frustrations of campus life that the young women faced. Wheeler, *William Carey College*, 24, notes that the girls always managed to circumvent the strict rules of decorum regarding the opposite sex, including smuggling letters out through a deliveryman confederate. Other oral histories (e.g. Wertz, "The Charmer," and Wertz, "Dorothy Ware Remembers…") describe how students dealt with the system of demerits that the administration enforced—but unlike their male predecessors, none mention either an axe or a stump.

184. Hickman, *Mississippi Harvest*.

185. Morgan, *Dearly Bought*, 3–4.

186. Ibid., 5–6. According to Wansley, "History of USM," following its initial donation, the Ross group then sold another 80-acre parcel to the school at a heavily inflated premium of $100 per acre, whose proceeds they immediately donated back to the school. The Newman Lumber Company donated a further 640 acres for a total land acquisition of 840 acres, ensuring the institution would have room to grow.

187. Morgan, *Dearly Bought*, 15.

188. Ibid., 13.

189. Saetre, *Pride*.

190. Morgan, *Dearly Bought*, 28.

191. Sutley, "Southern Miss 'Demons.'"

192. Wertz, "Member of First Class." Morgan, interview, notes that the length of the certificate was five years, not ten.

193. The benefactor for Faulkner Field was local concrete tycoon L.E. Faulkner, whose name also adorns the Faulkner Building downtown—not the Mississippi author William Faulkner (born Falkner, in any case). As *Hattiesburg American*, "Dedication of New S.T.C. Stadium," notes, the dedication for the field was held in 1932.

194. The figure comes from Walthall, "State Teachers College," likely citing internal sources.

195. Hickman, *Mississippi Harvest*, 195; Schmidt, "Middle Years," 69.

196. Morgan, *Dearly Bought*, 17; *Hattiesburg News* (1915). The account continues: "'I weighed the fish,' Mr. Hall, who is a veteran fisherman, said, 'on some old-fashioned cotton scales, which means that the weight was absolutely exact. It is the biggest cat-fish I have ever seen in this part of the country, and the biggest I have ever landed from any stream.' In spite of the enormous size of the fish, he had but little trouble landing it, Mr. Hall said. 'I used a hook one size larger than the regular trout hook, and once it had been swallowed by the fish, it was an easy matter to pull it through the water to the side of the boat, and then to lift it in.' The fish was brought to Hattiesburg and displayed for some time. It attracted no little attention."

197. Schmidt, "Middle Years," 69. Forrest's original quote was his strategy for victory in battle, which was famously to "get there fustest with the mostest men."

198. Olderr, *City of Hattiesburg*; Schmidt, "Middle Years," 70.

199. Cruthirds and Cruthirds, *Hattiesburg*, 87. Because most of the soldiers in the 38th Division were native Kentuckians, they chose to name the camp in Shelby's honor rather than for Dr. Crawford, as had at one point been proposed.

200. *Camp Shelby Mississippi*, 1. These figures recur in numerous publications about the history of the camp. Cf. *Souvenir Castle* for firsthand details of life in the camp by an individual unit.

201. Barry, *Great Influenza*, 149. He notes that when the epidemic did arrive in 1918, in two waves in April and then again in October (killing more American soldiers than did German guns), early exposure among the recruits already at the base protected them against the second, more virulent strain. According to Morgan, *Dearly Bought*, thanks to the efforts of campus physician Dr. May F. Jones, not a single life was lost at the Normal College.

202. Wansley, "Entertaining Camp Shelby."

203. Mac Jones, "21 Literary Clubs."

204. Barksdale, *Hattiesburg Fire Department*, 13. He notes other instances of mutual aid during the time as well.

205. Wansley, "Entertaining Camp Shelby."

206. Morgan, *Dearly Bought*, 32.

207. Ibid.

208. As Cruthirds and Cruthirds, *Hattiesburg*, and Daniels, "Military Pastimes," both note, one of the facilities at the camp was an early airfield, over which aviatrix Ruth Law dazzled audiences.

209. Rowland, *Official and Statistical Register*, 649.

210. Bootlegging in Mississippi deserves its own history, and Hattiesburg is no exception. Wertz, "Ben Earles," and interviews with Easterling, 2014, and Branch, 2014, recall local instances of known suppliers of hooch; despite public propriety, everyone knew where to go should the thirst arise. Branch recalled that in Palmer's Crossing, local law enforcement would even occasionally act as the supplier, passing out bottles in brown bags and being paid for their services in turn.

211. Mac Jones, "21 Literary Clubs."

212. Ibid.

213. *Advertiser News*, "Mystic Krewe."

214. Gonzales, "Hattiesburg," 129; Wansley, "Entertaining Camp Shelby"; Wicht, interview.

215. *Hattiesburg American*, "Dorothy Won Fame."

216. National Register of Historic Places, "Parkhaven Historic District."

217. English, *All Off*, 88–95; Watson, *Historic Hattiesburg*, 11.

218. Wansley, "Entertaining Camp Shelby."

219. English, *All Off*, 92.

220. Chain and Pittman, *Bobby Lee Chain*, 30; Taylor, *Flight of Jesse Leroy Brown*.

221. Morgan, *Dearly Bought*, 29.

222. Schmidt, "Middle Years," 78.

223. McCarty, *Hattiesburg*, 107–13.

224. Bond, *Mississippi*, 209.

225. Schmidt, "Middle Years," 72.

226. McRaney, "American Way." See also HAHS, "How Time Flies!" for more on the airport, and Wertz, "Ben Earles."

227. Barksdale, *Hattiesburg Fire Department*, 21.

228. *Living New Deal*, "Hattiesburg"; Morgan, *Dearly Bought*, 52.

229. Wheeler, *William Carey College*, 42.

230. Masters, "Ashe Nursery."

231. Lee, interview; Fickle, *Mississippi Forests*; Steen, "Piney Woods."

232. Masters, "Ashe Nursery."

233. *Hattiesburg American*, "Hercules Plant."

234. Hickman, *Mississippi Harvest*, 121–38; Schmidt, "Middle Years," 70ff.

235. *Hattiesburg American*, "Death of Last Local Confederate Veteran." For more on the entrance of Willmut Gas, founded by W.S.F. Tatum in a brazen takeover of other area energy interests, see Hughes, *Oil in the Deep South*, 93–96.

236. Wertz, "Frank Tatum."

237. Bond, *Mississippi*, 221–26.

238. Hickman, *Mississippi Harvest*, 240.

239. WPA, *Mississippi*, 417.

## Chapter 4

240. United States Army, *Pictorial History, Thirty-Seventh Division*, 38.

241. Camp Shelby Historical Collection, McCain Library and Archives, Special Collections, Reference #AM91-49.

242. Morgan, *Dearly Bought*, 68.

243. Schmidt, "Middle Years," 74. See also Chain and Pittman, *Bobby Lee Chain*, 37ff.

244. Harrington, "Railroad Rebuilt." To give one idea of how critical the railroads were for the rapidly swelling base, and for troop movements throughout the region, Harrington notes, "The movement of a division required the dispatching of a 17-car train (15 sleeping cars and two kitchen cars in each train) every four hours for almost three days, night and day."

245. Ibid.; Grimsley, *Hattiesburg in Vintage Postcards*, 98–99.

246. Daniels, interview; Mississippi Armed Forces Museum (2014). Portions of the following account derive from interviews with base historians, archival materials and public documentation held at Camp Shelby and materials in the Camp Shelby Historical Collection, McCain Library and Archives, References #AM10-97 and AM91-49.

247. Camp Shelby Historical Collection, McCain Library and Archives, Reference #AM10-97.

248. Chaney, "Camp Shelby."

249. Daniels, "Military Pastimes," 146. Interestingly, some of the older regiments—like the 152nd Infantry of Indiana, 76th Brigade, 38th Division—had served in nearly every American conflict dating back to the founding of the country and had even served opposite the South during the Civil War. This time, however, these units were fighting to preserve the Union from without, not from within.

250. Daniels, interview. In comparison to the other and smaller bases in Mississippi—Camp Van Dorn in Natchez and Camp McCain in Grenada—Camp Shelby was uniquely equipped to process piecemeal units and reallocate them to other brigades or divisions where they were needed most.

251. United States Army, *Pictorial Review, Seventy-Third Field Artillery Brigade*; United States Army, *Pictorial History, Thirty-Seventh Division*; and United States Army, *Pictorial History, Thirty-Eighth Division*.

252. United States Army, *Pictorial History, Thirty-Eighth Division*, 22, 402.

253. Camp Shelby Historical Collection, Special Collections, McCain Library and Archives, Reference #AM10-97. Daniels, "Military Pastimes," notes that alcohol was allowed on base in defiance of statewide prohibition and details the "invasion" of Pearl River County by beer trucks arriving from Louisiana to serve the troops.

254. United States Army, *Pictorial History, Thirty-Eighth Division*, 25.

255. Daniels, "Military Pastimes."

256. Correspondence: "Fred to Duane," (1942). Fred's liberties with spelling and grammar have been left uncorrected.

257. WPA, *Serviceman's Guide*.

258. Daniels, "Military Pastimes," 147. See also Chain and Pittman, *Bobby Lee Chain*, for an extensive discussion of Hattiesburg during the war years.

259. Interestingly, the army did invade American towns—just those without any people in them. Training exercises were conducted at a ghost town constructed near New Augusta in Perry County, for troops anticipating urban warfare situations. Accounts of these exercises are still on display at the Mississippi Armed Forces Museum.

260. Mississippi Camp Shelby Co-operative Association files, Hattiesburg Area Chamber of Commerce Records, McCain Library and Archives, Reference #M216, Box 11, Folder 2. The quote comes from the Charter.

261. Schmidt, "Middle Years," 74; Harrington, "Railroad Rebuilt." Notes on the infrastructure development are in the Mississippi Camp Shelby Cooperative Association files, cited above.

262. Schmidt, "Middle Years," 78; Daniels, "Military Pastimes," 147. Chain and Pittman, *Bobby Lee Chain*, offer a vivid depiction of town life during the time and note (p. 41) that at that time, rationing extended to "certain groceries, sugar, staple goods, or even shoes or clothing."

263. Mississippi Armed Forces Museum, 2014; Hattiesburg Front Street U.S.O. Service Club Records, October 1942. The report notes that "factory girls from a near-by defense plant have discovered that a good lunch at a reasonable price may be obtained at our snack bar, and they are giving us a noon-day rush." Which downtown defense plant employed these Rosie the Riveters is unfortunately not named, but the report does hint at the extent of the wartime industry in the area—the 1942 WPA *Serviceman's Guide* (p. 14) notes similarly that "Hattiesburg industrial plants, like plants elsewhere, are devoting their facilities to war work, turning out their regular products or converting their machinery to new uses."

264. Both Chain and Pittman, *Bobby Lee Chain*, and Taylor, *The Flight of Jesse Leroy Brown*, offer differing portrayals of Holmes's establishment, but both are united in

their assessment that it was the center of town nightlife for many during the war. Taylor (p. 69) recalls that the club, "with a rowdy reputation for beer-drinking, was a haunt for GIs for Camp Shelby and Mike Lowry, its owner, was said to be involved in bootlegging."

265. Hattiesburg Front Street U.S.O. Service Club Records, July 1943. It is unclear where the author of this report obtained his or her demographic figures, as they do not match census records from 1940 and so should be taken with a grain of salt.

266. Hattiesburg Front Street U.S.O. Service Club Records, June 1942 and October 1944.

267. Toxey Morris, interview.

268. The remaining three included clubs operated by the National Catholic Community Services (on Pine and Hemphill Street), the YWCA and the National Jewish Welfare Board.

269. Though it is not widely known today, Hattiesburg did have an area of town where GIs who were interested in less wholesome forms of entertainment would frequent. Chaney, "Camp Shelby," recalls that "with 60,000 troops to choose from (many of whom were in their late teens and early twenties), the local girls were choosy and drove a hard bargain. However, there were always such places as the houses on Southern Avenue, where the girls and women (mostly the latter) would entertain the troops for the usual three dollar fee. But for the GI's to go off the beaten path to patronize these houses, they had to adopt the sailor's attitude of 'Any Old Port During A Storm.'"

270. Hattiesburg Front Street USO Service Club Records, November 1942.

271. Ibid., December 1942.

272. Daniels, "Military Pastimes"; *Guide to the East Sixth Street U.S.O. Club Souvenir Booklet*.

273. Dedicated on March 22, 1942, the East Sixth Street USO is a welcome example of racial cooperation in the days of segregation, with the prominent white businessman Frank Tatum chairing the committee to establish it. Today, the club serves as the African American Military History Museum, honoring the service of local black servicemen in the armed forces, and is the last surviving example of this particular architectural pattern of USO club in the country: of the five original designs from the war, no others have survived (Brown, interview).

274. Hattiesburg Front Street USO Service Club Records, June 1942. Daniels, "Military Pastimes," notes that soldiers outnumbered the available girls by around twenty to one, and hardship was not limited to the men in any case: the USO report from March 1942 notes that "real patriotism is displayed by the girls who come up smiling by the over-anxious soldier who steps on fair lady's dainty slipper."

275. Cooley, "Letter"; Chain and Pittman, *Bobby Lee Chain*; *Hattiesburg American*, "Great Shelby Activity."

276. *Hattiesburg American* "Great Shelby Activity"; Chain and Pittman, *Bobby Lee Chain*, 52. During this same time, in late September 1942, President Franklin Delano Roosevelt would also visit Hattiesburg and Camp Shelby under the utmost secrecy.

277. *Hattiesburg American*, "Great Shelby Activity."

278. Easterling, interview; Chain and Pittman, *Bobby Lee Chain*, 49.

279. Daniels, "Military Pastimes"; Chain and Pittman, *Bobby Lee Chain*. Both these accounts single out one Earl Finch for his hospitality toward the soldiers and the lifelong relationships that developed between Finch and the members of the units. In the Hattiesburg Front Street USO Service Club Records, the report from July 1943 notes that locals held a birthday shrimp supper for Japanese American troops in Hutment #6 of an unidentified Field Artillery battalion, and even more interestingly, the April 1945 report notes that, since March 1944, one local resident, A.T. Whitton, had run a USO service club exclusively for Japanese American troops (in addition to the five already established). Once the soldiers had deployed, Whitton donated all the material from the club to the Front Street USO, material that currently remains unknown to present-day historians. Were it to be found, an even fuller portrait of the lives of these soldiers could be painted.

280. Daniels, interview.

281. Chain and Pittman, *Bobby Lee Chain*, 50.

282. Daniels, interview. Relations were not idyllic, of course; Hattiesburg historian Bill Wicht recalled that PWs would occasionally attempt to escape into the dense woods of the Pine Belt, and their commander, Colonel T.B. Birdsong, would drive after them in his Jeep, honking his horn to let them know he was on the trail. When finally they would crawl out of the woods, hungry, lost and tired, not to mention wearing a fresh suit of ticks and chiggers, Colonel Birdsong would round them up and bring them back to base. (Wicht, interview 2013).

283. *Hattiesburg American*, "Great Shelby Activity"; Hattiesburg Front Street USO Service Club Records, February 1945.

284. Hattiesburg Front Street USO Service Club Records, May 1945.

285. Ibid., August 1945. It did not take long for jokes about the atomic age to enter into the lexicon; the USO report from October 1945 notes that "the juke-box, on loan from a local dealer, suffered atomic damage from the hands of seasoned veterans in the combat for music."

286. Ibid. Whether due to haste, typing errors or no opportunity for revision, the spelling and grammar in these reports is not always consistent; where necessary, I have amended the authors' errors.

287. Hattiesburg Front Street USO Service Club Records, September 1945.

288. Ibid., October 1945.

289. *Hattiesburg American*, "Camp Shelby."

290. Hattiesburg Front Street USO Service Club Records, September 1945.

291. Wheeler, "Praising God."

292. Other departures and arrivals were more somber. Barksdale, *Hattiesburg Fire Department*, 35, records that on December 17, 1950, Hattiesburg mayor D.W. Holmes was killed in an auto accident near Collins, Mississippi; his wife would take his place as mayor for three months until a special election the following March, when E.J. Currie became mayor. As of this writing, Mrs. Holmes remains the only woman to have served as the mayor of Hattiesburg.

293. Roberson, "History of the *Hattiesburg American*."

## Chapter 5

294. Guice, *Forrest County General*.

295. Toxey Morris, interview (2013).

296. Guice, *Forrest County General*, 11.

297. Ibid., 24.

298. Gonzales, "Hattiesburg," 130–31; Morgan, *Dearly Bought*; Guice, *Forrest County General*, 66.

299. Holton, "Two Officers Murdered."

300. Wheeler, *William Carey College*; she notes that college administration recognized the fastest way to boost male enrollment was to start an athletic program, which they did with total haste.

301. *Hattiesburg American*, "Elephant Arrives Friday"; City of Hattiesburg, *Hattiesburg, Mississippi*, has a photo of Hattie on its back cover.

302. For a discussion of this attitude statewide, see Bond, *Mississippi*, 229ff.

303. Theological disputes over race were common in the civil rights era, with theology frequently used as a weapon (or a shield) in one's arsenal of opinions. As for political disputes, progressives and activists under Ike received their fair share of accusations, but claims of dictatorship and communist totalitarianism hit a zenith under JFK, whom conservative southerners frequently accused of colluding with the Soviets—even as he stood his ground during the nuclear arms race and the Cuban Missile Crisis. The practice of labeling a president with whom one does not agree a socialist or communist has changed little over the last fifty years.

304. Carter, *South Strikes Back*; Katagiri, *Mississippi State Sovereignty Commission*.

305. Trillin, "State."

306. Thompson, *Black Press*. Martin, *Count Them One by One*, 8, writes of the Hederman brothers that "Bill Minor, the legendary Mississippi bureau chief of the *New Orleans Times-Picayune*, termed the sons 'Bible-quotin', Bible-totin' racists.' A classic Hederman story I recall seeing was captioned 'McComb Negro Hits Train.'"

307. Rayner, "On Theological Grounds," 26.

308. Brown, interview. Harris, *Ain't Gonna Let Nobody*, elaborates in detail.

309. Taylor, *Flight of Jesse Leroy Brown*, 65.

310. Toxey Morris, interview, February 2014.

311. Rayner, "On Theological Grounds," 55.

312. Dittmer, *Local People*; Minchin and Salmond, "Saddest Story"; Branch, *Pillar of Fire*, 51ff.

313. Minchin and Salmond, "Saddest Story."

314. Rayner, "On Theological Grounds," 29.

315. Martin, *Count Them*, 8.

316. Ibid. For those interested to see Lynd in the flesh, a CBS video showing him is reproduced in part within a presentation Martin gave after the publication of his volume, available at http://vimeo.com/21753432.

317. *Freedom Riders*, 2010.

318. *Hattiesburg American*, "McCain Thinks Southern Can Escape."

319. Morgan, *Dearly Bought*.

320. The full text of Guyot's and Henry's speeches can be viewed online at http:// mdah.state.ms.us/arrec/digital_archives/sovcom/result.php?image=images/ png/cd01/001092.png&otherstuff=1|16|1|70|3|1|1|1073|#.

321. Gustafson, "In October 1963."

322. Cf. Hay, *Hattiesburg Diary*, for a firsthand account.

323. Branch, *Pillar of Fire*, 214ff; Watson, *Freedom Summer*. See also the account at http://www.crmvet.org/tim/timhis64.htm#1964hburg.

324. Branch, *Pillar of Fire*.

325. Chaze, "Anti-picketing Injunction Issued"; Rayner, "On Theological Grounds." Cf. Hay, *Hattiesburg Diary*.

326. Branch, *Pillar of Fire*, 270; Harris, *Ain't Gonna Let Nobody*, 40–42.

327. Primary sources for the civil rights era in Hattiesburg are far more extensive than can be incorporated in this one synthesis. Outside of private holdings, the McCain Library and Archives at USM holds the personal papers and correspondence of nearly every local leader here named. Interested readers should consult the Civil Rights in Mississippi Digital Archive and the list of finding aids for the Special Collections libraries at http://www.lib.usm.edu/ spcol/collections/manuscripts/lists-of-collections/subjects/subj-cr.html.

328. Zinn, *SNCC*.

329. Randall and Tusa, *Faces of Freedom Summer*, is a definitive account of the summer's events.

330. The seven historically African-American churches most directly involved with Freedom Summer activities were Mount Zion Baptist Church, Priest Creek Missionary Baptist Church, Morning Star Baptist Church, True Light Baptist Church, Bentley Chapel United Methodist Church, St. John's United Methodist Church and St. Paul United Methodist Church.

331. Public remarks made by Mrs. Irene Jones at the Freedom Summer Fiftieth Anniversary Conference at the University of Southern Mississippi in Hattiesburg, Mississippi, June 19–21, 2014.

332. Tusa, "Brief History."

333. Mees, "Kelly Settlement."

334. Civil Rights in Mississippi Digital Archive, "Freedom Summer."

335. Cameron and Williams, *Oral History*; public remarks made by Cameron at the Freedom Summer Fiftieth Anniversary Conference at the University of Southern Mississippi in Hattiesburg, June 19–21, 2014. Harris, *Ain't Gonna Let Nobody Turn Me 'Round*, famously details his arrest as a young boy during the Freedom Day demonstrations, with an officer brandishing a blackjack at him, saying, "This is what we use to beat niggers' asses with." To be black in those days, Harris observes, meant little protection from abuse save submission or humiliation, especially in a system where the law, the courts and city officials were largely of one mind.

336. Bond, *Mississippi*, 261.

337. Randall and Tusa, *Faces of Freedom Summer*; see also the Lelyveld Collection at USM: http://www.lib.usm.edu/legacy/archives/lelyveld.htm.

338. Martínez, *Letters from Mississippi*, 151ff.

339. Sturkey, "Heritage of Hub City," 8. That boycott would return in force in 1967 under the leadership of Daisy Harris Wade, secretary of the Forrest County NAACP and mother of historian Anthony Harris, cited elsewhere in this account.

340. Adickes (Sandra E.) Papers, McCain Library and Archives, Reference #M322. The number of SNCC workers joining her is unclear; her diary lists only six workers by name, but the news article of the *Hattiesburg American* reporting on the closure lists "seven Negroes" in the incident.

341. Rayner, "On Theological Grounds," addresses Lowrey's position in detail. Cf. Braswell, "Newspaper Largely Silent," who writes that the newspaper "published little about what was happening during Freedom Summer. Many articles were small or were deep inside the newspaper."

342. Ben-Ami (David Z.) Papers, McCain Library and Archives, Reference #M365. For more on the experience of the Hattiesburg Jewish community during Freedom Summer, cf. Fisher, "When Freedom Summer Came to Town."

343. Morgan, *Dearly Bought*, 128–29.

344. Quoted in *Hattiesburg American*, "Noonkester Pushed"; Wheeler, *William Carey College*.

345. Buzard, "Worth Dying For."

346. Mitchell, "Spy Records Sought."

347. Chaze, "15 Requests."

348. Rayner, "On Theological Grounds," argues that Dahmer's murder was the catalyst for the shift in attitude, in that with blood now on locals' hands (despite convictions not arriving for years), whites could wash their own of the struggle no longer.

349. Adickes Papers, McCain Library and Archives. See also the Fairley (J.C.) Papers, McCain Library and Archives, Reference #M340.

350. Jackson, "Locals Recall." The Smiths' home, too, would be shot at in February, as photographer Winfred Moncrief documented (cf. the Moncrief Photograph Collection, Item #596).

351. Pickett, "School for Negroes"; Harris, *Ain't Gonna Let Nobody*.

352. Kennard, "Letter to Editor."

353. Maute, "Civil Rights Martyrs."

354. Kaffer, "Unit Sent to Vietnam."

355. Cresswell, "Nuclear Blasts."

356. MDAH, "Contextual Notes."

357. HAHS, *Lost Hattiesburg*; HAHS, *More Lost Hattiesburg*.

358. Hearn, *Hurricane Camille*.

359. Guice, *Forrest County General*; Hattiesburg Clinic, "From Humble Beginnings."

360. Morgan, *Dearly Bought*, 107ff; Guice, *Forrest County General*, 66ff; Wheeler, *William Carey College*.

361. Chain and Pittman, *Bobby Lee Chain*.

362. *South Mississippi Weekly*, "Man for the People"; *Spartanburg Herald*, "Monopoly of Interests." An undated *Hattiesburg American* clipping from the day of the event is in the LHPFC Hattiesburg Vertical File: *Hattiesburg: Facts and Trivia*.

## *Chapter 6*

363. Shepherd, interview.

364. Bryant, "Population Growth"; Rungeling and Hollman, "Profile of Mississippi."

365. Bryant, "Population Growth," 1.

366. *La Nación*, "Los Ángeles, Ciudad Hermana de Hattiesburg, Mississippi." Translation by Dacia Viejo-Rose.

367. Olderr, *City of Hattiesburg*, 44; McDaniel, "Hattiesburg."

368. Morgan, *Dearly Bought*, 134–35.

369. Olderr, *City of Hattiesburg*, 29; Morgan, *Dearly Bought*, 138ff.

370. Flick, "Wood Dealer System."

371. See Olderr, *City of Hattiesburg*, and Lee, "City's Top Priority," for more on the growth and development of the industrial park. While not all of these corporations survive today, aerial photographs from the time are housed in Special Collections, McCain Library and Archives, Reference #M246, Box 2, Folder 17.

372. City of Petal, *A History of Petal*, 54. The name Petal is attributed to Petal Polk, a two-year-old girl who died of diphtheria in the winter of 1904. At a loss as to what to name their fledgling trading post, local residents named the town in her honor. Cf. also Lee, "Ceremony to Mark Emergence of Petal as a New City," and O'Neal, "Petal History Dates Back to Early 1900's."

373. Cf. Olderr, *City of Hattiesburg*, on the development of Lake Serene.

374. Waldoff, interview.

375. Morgan, *Hattiesburg Flood*.

376. Fielder, interview.

377. Quoted in Carson, "History Pushes Town West."

378. Boone, *Hurricane Frederic*.

379. Interview with Virginia Morris, 2014.

380. Cf. Olderr, *City of Hattiesburg*. Chain's autobiography (Chain and Pittman, *Bobby Lee Chain*), though biased, is useful for a firsthand perspective on the era.

381. Williams, "Fair Salutes Hattiesburg" and "Hattiesburg."

382. Cf. the City of Hattiesburg Police Memorial page, http://www.hattiesburgms.com/city-departments/police/police-memorial (accessed July 9, 2014).

383. Easterling, interview.

384. Roper, "Opinion," 25.

385. Ibid., 40.

386. Chain, interview.

387. Holloway, interview.

388. Conner, "School Plan"; Eureka School Museum, "Eureka School."

389. Maute, "Zoning Woes"; Holloway, interview.

390. Holloway, interview.

391. Coca-Cola United, "Hattiesburg"; Guice, *Forrest County General*.

392. Shelby would contribute to those pressures in other ways; from 1989 to 1994, the base waged and won a controversial court battle against environmental conservation organizations to expand its training areas into the De Soto National

Forest. More details about this fight are available in the LHPFC Hattiesburg Vertical File: *Camp Shelby*.

393. Area Development Partnership, "Economic Climate."
394. Holloway, interview.
395. Olderr, *City of Hattiesburg*, 40.
396. Ibid.
397. DPCD, *Historic Hattiesburg*, 8:2.
398. Caviness, "Lucas."
399. *Advertiser News*, "Hattiesburg Tidbits"; Area Development Partnership, "Economic Climate in Hattiesburg, Mississippi."
400. Holloway, interview.
401. Maute, "Hub City Ranks"; Brannon, "Pine Belt Population."
402. Logue, "Mississippi."
403. City of Hattiesburg, "City Celebrates."

## *Chapter 7*

404. Schmidt, "Middle Years," 75.
405. Iraq Coalition Casualty Count; *Clarion-Ledger*, "List of Mississippi's Fallen," offers a fuller account of his death.
406. Morgan, *Treasured Past*; Wheeler, *William Carey College*, 103. Chain and Pittman, *Bobby Lee Chain*, 201ff offers a brief account of Katrina's impacts on the area hospitals and the emergency response.
407. Barthelme, "Mississippi's Morning After."
408. Ibid.
409. Olderr, *City of Hattiesburg*, 42.
410. Morgan, *Treasured Past*.
411. Poet Gary MacGregor, *All My Rabbits*, immortalized the attack in his poem "Sacrilege."
412. Kemp, "Beverly Drive-In."
413. Myrick, interview.
414. Ibid.
415. Mozingo, *Longleaf Trace Companion*; Longleaf Trace, "Call for Projects"; McMurtrey, interview.
416. Area Development Partnership, *Festival of Swans*.
417. To date, Hattiesburg has unfortunately not seen a resurgence in its cinematic heritage; it remains to be seen whether the golden age of cinema in the 1910s and 1920s will return to the downtown area.
418. Whorton, "Hattiesburg, Mississippi"; Walker, *Alexander's Ring*. One of the most celebrated novels portraying the Hub City (though disguised by another name) is former *Hattiesburg American* reporter Elliot Chaze's *Tiger in the Honeysuckle*, written and set during the civil rights era. Cf. also *Gordon's Creek Anthologies*, Volumes I and II.
419. The episode, entitled "Knifin' Around," aired on the Cartoon Network on September 2, 2001, and featured guest stars Björk and Thom Yorke. Footage of the episode is readily available from Internet sources.

420. Walker, "Your Schools"; Hinton, "Hattiesburg Played." Rayner, "On Theological Grounds," notes the city's loss of the seminary; where not previously cited, the other information comes from the Hattiesburg Area Historical Society Museum.

421. Morgan, *Dearly Bought*, 15; USM, "Southern Miss Overview"; Wheeler, *William Carey College*, 18; Kemp, "Fall Numbers Down"; Daniels, interview; Forrest Health, *Annual Report 2012*. Not included in this history, given their distance from the city, are Pearl River Community College and Jones County Junior College, institutions that have long served Hattiesburg-area residents since their foundings in 1909 and 1927, respectively. More recently, Antonelli College, originally founded in 1990 as Moore Career College, serves the needs of the area's business students and maintains a campus on Highway 49 North.

422. City of Hattiesburg, *Hattiesburg Comprehensive Plan*.

423. McMurtrey, interview.

424. Robertson, *Facts about Hattiesburg*, 1.

# BIBLIOGRAPHY

<span style="font-variant: small-caps;">P</span>age numbers for newspaper articles have been given where available. Likewise, newspaper articles without a byline are cited as the news organization and the date. On locations for sources: the Library of Hattiesburg, Petal and Forrest County (LHPFC) maintains a vertical file of resources on Hattiesburg history, recently opened to the public and from which many of these sources were drawn. Where not otherwise available, individual sources are listed as LHPFC Hattiesburg Vertical File: *name of folder*. As this file enjoys active cataloguing and use, future researchers are encouraged to check with the library to see whether additional materials have been added or specific files consolidated since the time of this writing.

As well as published sources, this history draws on sources that have not previously appeared in Hattiesburg historiography. Among these are early sources that, due to their age, are found only in incomplete form, including *Price's Industrial Magazine* (1905) and the October 26, 1932 edition of the *Hattiesburg American*, celebrating the city's golden jubilee discussed in Chapter 3. Other sources, such as the *Saturday Evening Eye* "Industrial Edition" of 1905 and T.O. Watkins's "Industrial Edition" of 1908, have been identified as extant but not located. While fragments of these sources survive in places such as the Hattiesburg Vertical File, it has not been possible to locate and assemble every one of these in full. Future accounts would benefit enormously from that effort, as well as from locating each installment of the *Hattiesburg American*'s centennial series "The Hattiesburg Story," published monthly in 1982, of which many (but not all) copies are available in the LHPFC Hattiesburg Vertical File. Finally, future historians will benefit from certain works forthcoming in the next few years: a biography of William Hardy by Reagan Grimsley, a centennial history of Camp Shelby by Chad Daniels and two studies of the civil rights era by William Sturkey and Jerry Mitchell.

# BIBLIOGRAPHY

Adickes, Sandra. "History Lessons in Hattiesburg." Civil Rights Movement Veterans. Jackson, MS: Tougaloo College, 2000. http://www.crmvet.org/info/hburg.htm (accessed 1 June 2014).

*Advertiser News*. "Hattiesburg: Tidbits." March 17, 1999.

———. "Mystic Krewe of Zeus." February 17, 2000, C1.

———. "Old High School Honored with Historic Marker." July 8, 1998, A1.

Alexander and Moskowitz, Inc. *Downtown Hattiesburg, Mississippi: Revitalization Plan and Program*. Report prepared for the Downtown Redevelopment Committee, City of Hattiesburg, Mississippi, 1969. Located in LHPFC Hattiesburg Vertical File: *Hattiesburg–Downtown*.

Area Development Partnership. "Economic Climate in Hattiesburg, Mississippi. Executive Summary." Hattiesburg, MS, April 1996. Article found in LHPFC Hattiesburg Vertical File: *Economic Development*.

———. *Festival of Swans*. Brandon, MS: Quail Ridge Press, 2007.

Baca, Keith A. *Native American Place Names in Mississippi*. Jackson: University Press of Mississippi, 2007.

Barksdale, E.J. *Hattiesburg Fire Department, 50th Anniversary 1904–1954*. Hattiesburg, MS: Hattiesburg Fire Department, 1954. Printed by Geiger Printing Company.

Barnett, James F. *Mississippi's American Indians*. Jackson: University Press of Mississippi, 2012.

Barry, John. *The Great Influenza: The Story of the Deadliest Pandemic in History*. Revised edition, New York: Penguin, 2005.

Barthelme, Frederick. "Mississippi's Morning After." *New York Times*. September 2, 2005.

Blitz, John H., and C. Baxter Mann Jr. *Archaeological Investigations in Coastal Jackson County, Mississippi*. Mississippi Gulf Coast Archaeological Project Interim Report No. 1. Bay St. Louis, Mississippi, 1993.

Bond, Bradley G. *Mississippi: A Documentary History*. Jackson: University Press of Mississippi, 2003.

Boone, C.F. *Hurricane Frederic: The Frederic Story in Pictures and Words*. Lubbock, TX: C.F. Boone, 1979. Located in LHPFC Hattiesburg Vertical File: *Hurricane Frederic*.

Branch, Taylor. *Pillar of Fire: America in the King Years 1963–1965*. New York: Simon and Schuster, 1999.

Brandon, Lea Anne. "The Search for St. Stephens Road." *Mississippi Magazine* 5 (May–June 1985): 39–40.

Brannon, Keith. "Pine Belt Population Mushrooms." *Hattiesburg American*, October 11, 1998, 1A.

Braswell, Janet. "New Designation to Revive Railroad Area: Conservation Commission to Supervise Historic District." *Hattiesburg American*, December 14, 1999.

———. "Newspaper Largely Silent About Summer Struggle." *Hattiesburg American*, July 4, 2004, 3A.

Brockway, Dale G., Kenneth W. Outcalt, Donald J. Tomczak and Everett E. Johnson. *Restoration of Longleaf Pine Ecosystems*. United States Department of Agriculture, Forest Service, Southern Research Station, 2005 (rev. 2006). General Technical Report SRS-83.

# BIBLIOGRAPHY

Brown, Calvin S. *Archaeology in Mississippi*. Introduced by Janet Ford. Jackson: University Press of Mississippi, 2009 [1926].

Bryant, Ellen S. "Population Growth and Redistribution in Mississippi, 1900–1970." Mississippi State University Agricultural and Forestry Experiment Station, Bulletin 79 (December 1971).

Buzard, Patricia Michelle. "Worth Dying For: The Trials of Vernon Dahmer." Master's thesis, Department of History, University of Southern Mississippi, 2002.

Bynum, Victoria. *The Free State of Jones: Mississippi's Longest Civil War*. Chapel Hill: University of North Carolina Press, 2001.

Cameron, John E., and Donald Williams. "An Oral History with Reverend John E. Cameron, Sr." Civil Rights Documentation Project, 1999. http://www.usm. edu/crdp/html/transcripts/cameron_revered-john-e-sr.shtml.

Carson, Kelly. "History Pushes Town West." *Hattiesburg American*. February 25, 1996. 5.

Carter, Hodding III. *The South Strikes Back*. Garden City, NY: Doubleday and Co., 1959.

Caviness, Brandi. "Lucas: Nugget Starved." *Student Printz* (University of Southern Mississippi), July 28, 1993, 1.

Chain, Bobby, and Bob Pittman. *Bobby Lee Chain: The Life and Journals of a Mississippi Entrepreneur*. Jackson, MS: Franklin Publishing, 2010.

Chaney, William M. "Camp Shelby: Where Boys Became Men, Pronto!" in *History of 147ᵗʰ Inf. 37ᵗʰ Inf. Div. By S/Sgt William M. Chaney 147ᵗʰ Inf RCT. 37ᵗʰ Inf. Div.* Hattiesburg, MS: Archives of Camp Shelby, 1986.

Chaze, Elliot. "Anti-picketing Injunction Issued After Nine Ministers Arrested." *Hattiesburg American*, January 29, 1964, 1.

———. "15 Requests to be Made by CR Leaders." *Hattiesburg American*, January 12, 1966, 1.

———. "Hattiesburg Comprehensive Plan 2008–2028 and Land Development Code." http://government.hattiesburgms.com/city-departments/urban-development/ hattiesburg-comprehensive-plan-2008-2028-and-land-development-code (accessed August 1, 2014).

———. *Hattiesburg, Mississippi 1884–1964: 80 Years of Progress!* Hattiesburg, MS: Mayor and Commissioners of Hattiesburg, 1964.

———. *Tiger in the Honeysuckle*. New York: Bantam Books, 1966.

City of Hattiesburg. "City Celebrates Centennial of Proclamation." *Advertiser News*, March 17, 1999, 10A.

City of Hattiesburg Department of Planning and Community Development. *Historic Hattiesburg: History and Architecture of Hattiesburg's First Neighborhoods*. Hattiesburg, MS: Neighborhood Development Division, City of Hattiesburg, 1989.

City of Petal. *A History of Petal, Mississippi*. Petal, MS: Printed by the Kopy Shop, 1976.

Civil Rights in Mississippi Digital Archive. "Freedom Summer Incident Summary by City or County." Hattiesburg, MS: University of Southern Mississippi Libraries. http://digilib.usm.edu/crmda_incident2.php#H (accessed June 15, 2014).

Claiborne, J.F.H. "A Trip Through the Piney Woods." *Publications of the Mississippi Historical Society* IX (1906): 487–539.

*Clarion-Ledger* (Jackson, MS). "List of Mississippi's Fallen Soldiers." February 23, 2010. http://archive.clarionledger.com/article/99999999/NEWS/61105008/List-Mississippi-s-Fallen-Soldiers (accessed July 30, 2014).

Clark, Thomas D. "The Piney Woods and the Cutting Edge of the Lingering Southern Frontier." in *Mississippi's Piney Woods: A Human Perspective*, edited by Noel Polk. Jackson: University Press of Mississippi, 1982. 59–78.

Clayton, Alec. "Wild Women and Wild Horses: A Narrative History of Hattiesburg." *Persons Magazine* (January 1982): 12–36.

Coca-Cola United. "Hattiesburg: Coca-Cola Bottling Company United, Inc." 2014. http://cocacolaunited.com/locations/hattiesburg/ (accessed July 1, 2014).

Conner, J. Syd. "School Plan Questions Linger." *Hattiesburg American*, April 30, 1987, 1A.

Cooley, Donald. Letter to Eleanor McKinley, dated June 15, 1942. Donald Cooley Collection, Box 572, Folder 1, Call# 2010.058.013. Hattiesburg, MS: Camp Shelby Archives.

Cresswell, Stephen. "Nuclear Blasts in Mississippi." Mississippi History Now, 2008. http://mshistorynow.mdah.state.ms.us/articles/293/nuclear-blasts-in-mississippi.

Cruthirds, Brooke, and Colter Cruthirds. *Hattiesburg.* Mount Pleasant, SC: Arcadia Publishing, 2013.

Daniels, Chad. "Military Pastimes: Entertaining the Troops at Camp Shelby, 1917–1945." *Southern Quarterly* 50.1 (Fall 2012): 131–51.

Dearman, Thomas E. Letter to Jack Gay, Mayor of Petal, dated April 8, 1990. Hattiesburg, MS: Dearman Collection of Hattiesburg History, 1900–1910, Special Collections, McCain Library and Archives, University of Southern Mississippi. Reference AM90-14, AM90-28.

———. Letter to Principal of Hardy Street School, Hattiesburg, MS, dated January 18, 1990. Hattiesburg, MS: Dearman Collection of Hattiesburg History, 1900–1910, Special Collections, McCain Library and Archives, University of Southern Mississippi. Reference AM90-14, AM90-28.

*Democrat.* January 4, 1894, vol. 9, no. 1. Hattiesburg, MS: Newspaper Collection, McCain Library and Archives, University of Southern Mississippi. Reference# M174.

Dittmer, John. *Local People: The Struggle for Civil Rights in Mississippi.* Champaign: University of Illinois Press, 1995.

Dunn, Michael Christopher. "An Analysis of Lithic Artifacts from the Swamp Child Site (22FO666): An Investigation into Site Function and Adaptive Strategies." Master's thesis, Department of Anthropology, University of Southern Mississippi, 1999.

Dunston, C.E. *Preliminary Examination of the Forest Conditions in Mississippi.* Bulletin No. 7. Jackson: Mississippi State Geological Society, 1913.

English, Andrew R. *All Off for Gordon's Station: A History of the Early Hattiesburg, Mississippi Area.* Baltimore: Gateway Press, 2000.

———. "Early Life Along the Leaf." *Advertiser News,* June 19, 1996.

———. *Ringside at Richburg: America's Last Heavyweight Bare-Knuckle Championship.* Baltimore: Gateway Press, 2008.

Eureka School Museum. "Eureka School: Restoration and Renewal." 2014. http://www.hattiesburgeureka.com/ (accessed July 1, 2014).

Fickle, James E. *Mississippi Forests and Forestry*. Jackson: University Press of Mississippi, 2001.

Fike, Claude F. "William H. Hardy: An Extraordinary Life." *Hattiesburg American*, January 31, 1982, 3F.

Fisher, Marc. "When Freedom Summer Came to Town." *Moment Magazine*, July/August 2014. http://www.momentmag.com/freedom-summer-came-town/ (accessed July 12, 2014).

Flick, Warren A. "The Wood Dealer System." in *Mississippi's Piney Woods: A Human Perspective*, edited by Noel Polk. Jackson: University Press of Mississippi, 1982. 144–54.

ForrestHealth. *Annual Report 2012*. Hattiesburg, MS: Forrest General Hospital. http://www.forrestgeneral.com/workfiles/PDF%20Forms/2012_Annual_Report.pdf (accessed August 10, 2014).

"Fred to Duane," March 29, 1942. Hattiesburg, MS: Camp Shelby Historical Collection, Special Collections, McCain Library and Archives, University of Southern Mississippi. Reference AM05-18.

*Freedom Riders*. Documentary film. Stanley Nelson, dir. 113 minutes. PBS: The American Experience, 2010. http://www.pbs.org/wgbh/americanexperience/freedomriders/.

Freeman, Matthew Ronald. "Cultural Complexity at Deathly Silent (22FO826): A Middle Woodland Mound in the Mississippi Pine Hills." Master's thesis, Department of Anthropology, University of Southern Mississippi, 2008.

Frost, C.C. "Four Centuries of Changing Landscape Patterns in the Longleaf Pine Ecosystem." in Herman, S.M., ed. *Proceedings of the 18th Tall Timbers Fire Ecology Conference*. Tallahassee, FL: Tall Timbers Research Station, 1993. 17–43.

Gonzales, John E. "Hattiesburg Since World War II." in *Hattiesburg: A Pictorial History*, edited by Kenneth G. McCarty Jr. Jackson: University Press of Mississippi, 1982. 129–32.

Goodspeed Publishing Company. *Biographical and Historical Memoirs of Mississippi*. Chicago: Goodspeed Publishing Company, 1891. 2 vol., illustrated.

*Gordon's Creek Anthologies: A Compilation of Short Stories, Poetry, and Photos*. Hattiesburg, MS: Gordon's Creek Press, 2012.

*Gordon's Creek Anthologies* Vol. 2. Hattiesburg, MS: Gordon's Creek Press, 2013.

Grimsley, Reagan. *Hattiesburg in Vintage Postcards*. Charleston, SC: Arcadia Publishing, 2004.

Guice, John D.W. *Forrest County General Hospital (1952–2002). The Evolution of a Regional Referral Center: A Prophecy Fulfilled*. Jackson, MS: Hederman Brothers, 2002.

*Guide to the East Sixth Street USO Club Souvenir Booklet*. circa 1945. Hattiesburg, MS: Special Collections, McCain Library and Archives, University of Southern Mississippi, Reference #M432.

Gustafson, David. "In October 1963, America Turned Her Watchful Eyes Towards Hattiesburg." *Hattiesburg Post*, October 31, 2013, 1A–15A.

Hardy, Toney A. *No Compromise with Principle: Autobiography and Biography of William Harris Hardy in Dialogue*. New York: Stratford Press, 1946.

Hardy (William H. and Hattie L.) Papers, 1873–1929. Hattiesburg, MS: Special Collections, McCain Library and Archives, University of Southern Mississippi. Reference #M182.

# BIBLIOGRAPHY

Hardy, William Harris (compiler), and Lamar Hardy (editor). *Memorial of Mrs. Hattie L. Hardy*. Meridian, MS: privately published, 1898. Hattiesburg, MS: Special Collections, McCain Library and Archives, University of Southern Mississippi. Reference #M182.

Hardy (William H. and Sallie J.) Papers, 1860–1972. Hattiesburg, MS: Special Collections, McCain Library and Archives, University of Southern Mississippi. Reference #M380.

Harrington, Charles P. "Railroad Rebuilt in 3 Weeks." *Hattiesburg American*, April 25, 1982, 16E.

Harris, Anthony J. *Ain't Gonna Let Nobody Turn Me 'Round: A Coming-of-Age Story and Personal Account of the Civil Rights Movement in Hattiesburg, Mississippi*. North Charleston, SC: CreateSpace Independent Publishing, 2013.

Hartfield, George T. Opinions by City Attorney, files of Mayor J.M. Williamson, 1891–2. Hattiesburg, MS: Special Collections, McCain Library and Archives, University of Southern Mississippi. Reference #M208, Box 1, Folder 2.

*Hattiesburg American*. "Bygone Days: August 15, 1922. (60 Years Ago)." August 15, 1982, 4D.

———. "Bygone Days: March 14, 1922 (60 Years Ago)." March 14, 1982, 3D.

———. "Camp Shelby." in "Welcome Home to South Mississippi" supplement, August 1, 1993, 23E.

———. "Death of Last Local Confederate Veteran." March 28, 1982, 19E.

———. "Dedication of New S.T.C. Stadium and Grid Battle Climax of Golden Jubilee." October 26, 1932. Article found in LHPFC Vertical File: *University of Southern Mississippi*.

———. "Dorothy Won Fame In $2.98 Bathing Suit." June 8, 1934. Article found in LHPFC Hattiesburg Vertical File: *Goff, Dorothy Dell*.

———. "Early Hattiesburg Settlers Were Sturdy, Friendly Folks." June 24, 1967.

———. "Elephant Arrives Friday; March of the Tusk Tonight." May 1, 1958, 1.

———. "First Baptist of Glendale Enjoys Colorful, Prosperous History." August 15, 1982. Article found in LHPFC Hattiesburg Vertical File: *Churches*.

———. "Great Shelby Activity Shown in Headlines." December 28, 1945.

———. "Hercules Plant is in 50ᵗʰ Year Here." May 19, 1972, 17.

———. "A History of Hattiesburg." March 12, 1971, 13.

———. "McCain Thinks Southern Can Escape Rioting, Bloodshed." October 1962 (exact date undetermined).

———. "McComb 'Passes' Test of NAACP." November 19, 1964, 1.

———. "Noonkester Pushed for Integration of Carey." July 4, 2004, 3A.

———. "Rawls Springs Baptist Blessed Church." August 15, 1982. Article found in LHPFC Hattiesburg Vertical File: *Churches*.

———. "Rocky Branch Missionary Baptist Established in 1882." April 30, 1981. Article found in LHPFC Hattiesburg Vertical File: *Churches*.

———. "35 Years Ago Oil Lamps Supplied Lights for City." October 26, 1932.

———. "Through the Years: City of Hattiesburg (Last 120 years)." December 31, 1999, 10A.

———. "U.D.C. Formed 30 Years Ago." October 26, 1932. Article found in LHPFC Hattiesburg Vertical File: *Clubs and Organizations*.

# BIBLIOGRAPHY

———. "Veteran Founded Hattiesburg." July 28, 1996, 5.

Hattiesburg Area Historical Society (HAHS). *Hattiesburg Past and Present.* (wall calendar). Volume XII. Hattiesburg, MS: Hattiesburg Area Historical Society, 1986.

———. *The History of Forrest County, Mississippi.* Hattiesburg, MS: Hattiesburg Area Historical Society, 2000.

———. *History of Hattiesburg Coloring Book.* Hattiesburg, MS: Hattiesburg Area Historical Society, 1976.

———. "How Time Flies!" *Hattiesburg Area Historical Society* newsletter 17, no. 1 (Spring 2014).

———. *Lost Hattiesburg* (wall calendar). Volume VIII. Hattiesburg, MS: Hattiesburg Area Historical Society, 1980.

———. *More Lost Hattiesburg* (wall calendar). Volume IX. Hattiesburg, MS: Hattiesburg Area Historical Society, 1981.

———. *1984.* (wall calendar). Volume XI. Hattiesburg, MS: Hattiesburg Area Historical Society, 1984.

*Hattiesburg City Directory 1905: A Complete Residence Directory of the City of Hattiesburg, Miscellaneous Directory of Streets, Public Institutions, Churches, Schools, Societies, Etc.* Compiled by Charles B. Rogers. Hattiesburg, MS: The Daily Progress.

Hattiesburg Clinic. "From Humble Beginnings to a Multispecialty Success." 2013. http://www.hattiesburgclinic.com/50th-anniversary-our-story (accessed July 2, 2014).

Hattiesburg Front Street U.S.O. Service Club Records, 1942–1946. Hattiesburg, MS: Special Collections, McCain Library and Archives, University of Southern Mississippi. Reference #M211.

Hattiesburg High School. "Fifty Years at Hattiesburg High School, 1898–1947." *The Fiftieth Annual Commencement,* 1947. Booklet located in LHPFC: *Schools, Public.*

*Hattiesburg News.* "8000 Visitors Attend the Prosperity Celebration; Confederate Veterans Reunion Adjourned at Noon." October 13, 1910. Hattiesburg, MS: Newspaper Collection, McCain Library and Archives, University of Southern Mississippi. Reference# M174.

———. "86-pound Cat Fish Is Landed in Leaf River by Dan Hall." May 27, 1915.

Hattiesburg Public Schools. *Education: Today's Investment, Tomorrow's Dividend.* Hattiesburg, MS: Hattiesburg Municipal Separate School District, n.d. (early 1980s). Booklet located in LHPFC Hattiesburg Vertical File: *Schools, Public.*

Hay, Dean. *A Hattiesburg Diary, February 1964.* Hattiesburg, MS: Zeman (Zoya) Freedom Summer Collection, McCain Library and Archives, University of Southern Mississippi, Reference #M320.

Hearn, Philip. *Hurricane Camille: Monster Storm of the Gulf Coast.* Jackson: University Press of Mississippi, 2004.

Hickman, Alma. *Southern as I Saw It: Personal Remembrances of an Era, 1912–1954.* Hattiesburg: University of Southern Mississippi, 1966.

Hickman, Nollie. *Mississippi Harvest: Lumbering in the Longleaf Pine Belt 1840–1915.* Jackson: University of Mississippi Press, 1962.

Hinton, Alan. "Hattiesburg Played in First Football Game." *Hattiesburg American,* October 31, 1982, 7E.

# BIBLIOGRAPHY

Historic Hattiesburg. *History and Architecture of Hattiesburg's First Neighborhoods.* Hattiesburg, MS: Department of Planning and Community Development. Neighborhood Development Division. n.d. (early 1990s).

Hoffman, Gilbert H. *Dummy Lines Through the Longleaf: A History of the Sawmills and Logging Railroads of Southwest Mississippi.* 2nd ed. Brookhaven, MS: Quentin Press, 1999.

Holton, Dorothy. "Fines Cheaper in the Old Days." *Hattiesburg American*, May 22, 1964. Article located in LHPFC Hattiesburg Vertical File: *Hattiesburg Police Department.*

———. "Two Officers Murdered in 1952." *Hattiesburg American.* n.d. Article located in LHPFC Vertical File: *Hattiesburg Police Department.*

Hughes, Dudley J. *Oil in the Deep South: A History of the Oil Business in Mississippi, Alabama, and Florida, 1859–1945.* Jackson: University Press of Mississippi, 1993.

Iraq Coalition Casualty Count. "US Fatalities by State." 2009. http://icasualties. org/Iraq/ByState.aspx (accessed July 30, 2014).

Jackson, H. Edwin. *An Evaluation of Remote Sensing Effectiveness in the Pine Hills of Southeast Mississippi: Ground-truthing Excavations at 22FO1294 and 22FO1301.* Report submitted to the Mississippi Military Department, Shelby Joint Forces Training Center, Camp Shelby, Mississippi, 2008. MOA: 07-MOA-ARE-10, 08-MOAP-06.

Jackson, H. Edwin, Melissa L. Higgins, and Robert E. Reams. "Woodland Cultural and Chronological Trends on the Southern Gulf Coastal Plain: Recent Research in the Pine Hills of Southeastern Mississippi." in *The Woodland Southeast*, edited by David G. Anderson and Robert C. Mainfort Jr. Tuscaloosa: University of Alabama Press, 2002.

Jackson, H. Edwin, Susan L. Scott and Selina Anderson. *Archaeological Investigations at the Burkett's Creek Site (22FO748), Hattiesburg, Mississippi.* Report submitted to the Mississippi Department of Archives and History. Hattiesburg, MS: Susan Scott and Associates, 1995.

Jackson, Robyn. "Locals Recall King's Visit, Influence Here." *Hattiesburg American*, January 19, 1986, 1F.

Jenkins, Sally, and John Stouffer. *The State of Jones: The Small Southern County That Seceded from the Confederacy.* New York: Anchor Books, 2010.

Kaffer, Nancy. "Unit Sent to Vietnam Made Grand Exit." *Hattiesburg American*, July 15, 2007 (special supplement on Camp Shelby ninetieth anniversary), 12.

Katagiri, Yasuhiro. *The Mississippi State Sovereignty Commission: Civil Rights and States' Rights.* Jackson: University Press of Mississippi, 2001.

Kelly, James R., Jr. "Newton Knight and the Legend of the Free State of Jones." Mississippi History Now, 2009. http://mshistorynow.mdah.state.ms.us/ articles/309/newton-knight-and-the-legend-of-the-free-state-of-jones (accessed March 13, 2014).

Kemp, Ed. "Beverly Drive-In Burns to Ground." *Hattiesburg American*, October 30, 2010.

———. "Fall Numbers Down at USM, JCJC, PRCC: William Carey Breaks 4000 Enrollment." *Hattiesburg American*, September 21, 2012.

Kennard, Clyde. "Letter to Editor: The Race Question." *Hattiesburg American*, September 25, 1959. http://zinnedproject.org/materials/kennard-clyde/letter-to-the-editor-1959/.

Lamar County Historical Society. *The Purvis Tornado, April 24 1908*. Hattiesburg: Impact Printing, 2004.

*La Nación* (Santiago, Chile). "Los Ángeles, Ciudad Hermana de Hattiesburg, Mississippi." March 24, 1970, 8.

Lee, Ben. "Ceremony to Mark Emergence of Petal as a New City." *Hattiesburg American*, May 2, 1974.

———. "City's Top Priority Is Industrial Development." *Hattiesburg American*, July 2, 1978. 6C, Progress Edition.

Leverett, Rudy H. *Legend of the Free State of Jones*. Jackson: University Press of Mississippi, 2009.

*Lewiston Evening Journal*. "Reliable News Is Lacking: For 36 Hours New Orleans Has Had No Word from Nearby Towns." September 28, 1906, 11.

Living New Deal. "Hattiesburg Homesteads." February 9, 2014. https://livingnewdeal.berkeley.edu/projects/hattiesburg-homesteads-hattiesburg-ms/ (accessed April 7, 2014).

Logue, Barbara J. "Mississippi: Population Growth to 2010: What Recent Projections Show." *Mississippi Economic Review and Outlook* (September 1997). Mississippi Institutions of Higher Learning: Center for Policy Research and Planning, 1997.

Longleaf Trace. "Call for Projects: NTEC, Communities Benefit." n.d. http://www.longleaftrace.org/Awards/Combenefit/communitiesbenefit.htm (accessed August 1, 2014).

Lowry, Robert, and William H. McCardle. *A History of Mississippi: From the Discovery of the Great River by Hernando De Soto, Including the Earliest Settlement Made by the French under Iberville, to the Death of Jefferson Davis (1541–1889)*. Jackson, MS: R.H. Henry and Co, 1891.

Lucas, Sean Michael. *Grace Transforms: A History of the First Presbyterian Church, Hattiesburg, Mississippi*. Hattiesburg, MS: Tishomingo Tree Press, 2013.

MacGregor, Gary. *All My Rabbits*. Hattiesburg, MS: privately printed, 2013.

Mac Jones, Andrew (Mrs.). "21 Literary Clubs of Hub Promote Progress of City." *Hattiesburg American*, October 26, 1932, B5–B6.

Martínez, Elizabeth, ed. *Letters from Mississippi: Reports from Civil Rights Volunteers and Freedom School Poetry of the 1964 Freedom Summer*. Brookline, MS: Zephyr Press, 2007.

Martin, Gordon A. *Count Them One by One: Black Mississippians Fighting for the Right to Vote*. Jackson: University Press of Mississippi, 2010.

Masters, Carolyn Nau. "Ashe Nursery Observing Six Decades of Reforestation in South Mississippi." *Advertiser News*, November 20, 1996.

Maute, Nikki Davis. "Civil Rights Martyrs Honored." *Hattiesburg American*, November 6, 1989, 1A.

———. "Hub City Ranks Among Leaders in Cities Gaining New Residents." *Hattiesburg American*, March 10, 1991, 6A.

———. "Zoning Woes Date Back to '50s." *Hattiesburg American*, April 18, 1990.

McCarty, Kenneth G., Jr., ed. *Hattiesburg: A Pictorial History*. Jackson: University Press of Mississippi, 1982.

McCraw, Edythe W. "David Holmes: Mississippi's First Governor." *Mississippi News and Views*. (December 1967): 14–17.

McDaniel, Mike. "Hattiesburg Mayor Presents City to China." WDAM News. March 24, 2010. http://www.wdam.com/story/12198774/hattiesburg-mayor-presents-city-to-china (accessed May 12, 2014).

McGhee, Flora Ann Caldwell. "Mississippi Black Newspapers: Their History, Content, and Future." PhD dissertation, Department of History, University of Southern Mississippi, 1985.

McLemore, Richard Aubrey, ed. *A History of Mississippi* 2 vols. Jackson: University and College Press of Mississippi, 1973.

McMillen, Neil. *Dark Journey: Black Mississippians in the Age of Jim Crow*. Champaign: University of Illinois Press, 1990.

McRaney, David. "The American Way." *Hattiesburg American*, October 16, 2007.

McSwain, Robert J., Jr. *The Blue and the Grey: Perry County, Mississippi's Civil War Soldiers*. Carrolton, MS: Pioneer Publishing Company, 2006.

McWhiney, Grady. "Antebellum Piney Woods Culture: Continuity Over Time and Place." in *Mississippi's Piney Woods: A Human Perspective*, edited by Noel Polk. Jackson: University Press of Mississippi, 1982. 40–58.

Means, D. Bruce. "Wiregrass Restoration: Probable Shading Effects in a Slash Pine Plantation." *Restoration and Management Notes* 15.1 (Summer 1997): 52–55.

Mees, Reuben. "Kelly Settlement Endured Violence, Tragedy." *Hattiesburg American*, February 6, 2006.

Minchin, Timothy J., and John A. Salmond. "'The Saddest Story of the Whole Movement': The Clyde Kennard Case and the Search for Racial Reconciliation in Mississippi, 1955–2007." *Journal of Mississippi History* 71 (Fall 2009): 191–234.

Mississippi Army National Guard. *Camp Shelby Mississippi*. Pamphlet (undated, circa 1980s). Hattiesburg, MS: Special Collections, McCain Library and Archives, University of Southern Mississippi. Box AM91-49, Folder AM09-70.

Mississippi Department of Archives and History (MDAH). "Contextual Notes, Tatum Salt Dome Blast: Item #180-269, Moncrief Photograph Collection." n.d. http://mdah.state.ms.us/arrec/digital_archives/moncrief/image.php?display=context&item=234#sdfootnote6sym (accessed August 7, 2014).

Mitchell, Jack. "Community Leadership Spurs City Development." *Hattiesburg American*, February 23, 1997.

Mitchell, Jerry. "Spy Records Sought in Dahmer's Death." *Clarion-Ledger*, March 25, 1998, B1.

Moore, Arlice, and Leonard L. Slade Jr. *History of Morriston, Mississippi: From It's Beginnings in 1862 before the Civil War to 1988*. Baltimore: Gateway Press, 1988.

Morgan, Chester. *Dearly Bought, Deeply Treasured: The University of Southern Mississippi, 1912–1987*. Jackson: University Press of Mississippi, 1987.

———, interviewer. *Hattiesburg Flood of 1974: Collection of Interviews*, April 16, 1974. Mississippi Oral History Program. Hattiesburg: University of Southern Mississippi.

———. *Treasured Past, Golden Future: The Centennial History of the University of Southern Mississippi*. Jackson: University Press of Mississippi/University of Southern Mississippi, 2012.

Mozingo, Anthony A. *The Longleaf Trace Companion*. Purvis, MS: Toot Toot Publishing Company, 2009.

Napier, John H., III. *Lower Pearl River's Piney Woods: Its Land and People*. Oxford: University of Mississippi Center for the Study of Southern Culture, 1985.

———. "Piney Woods Past: A Pastoral Elegy." in *Mississippi's Piney Woods: A Human Perspective*, edited by Noel Polk. Jackson: University Press of Mississippi, 1982, 12–24.

National Register of Historic Places—Inventory Nomination Form. "Historic Hattiesburg Neighborhood District." United States Department of the Interior, Heritage Conservation and Recreation Service. n.d. Located in LHPFC Vertical File: *Neighborhoods, Historic (Historic Hattiesburg Neighborhood District)*.

———. "Hub City Historic District." United States Department of the Interior, Heritage Conservation and Recreation Service. April 30, 1980, prepared by Jody Cook. Located in LHPFC Vertical File: *Neighborhoods, Historic (Hub City Historic District)*.

National Register of Historic Places—Registration Form. "North Main Street Historic District." United States Department of the Interior, National Park Service. n.d. Located in LHPFC Vertical File: *Neighborhoods, Historic (North Main Street Historic District)*.

———. "The Oaks District." United States Department of the Interior, National Park Service. n.d. Located in LHPFC Vertical File: *Neighborhoods, Historic (Oaks District)*.

———. "Parkhaven Historic District." United States Department of the Interior, National Park Service. Prepared by Gene A. Ford and Linda B. Ford, June 30, 2001. Located in LHPFC Vertical File: *Neighborhoods, Historic (Parkhaven Historic District)*.

Olderr, Mark. *The City of Hattiesburg 1884–2009: Challenges and Growth, Historic Past and Brilliant Future*. Hattiesburg, MS: M&M Publishing, 2009.

O'Neal, Mary. "Petal History Dates Back to Early 1900's." *Hattiesburg American*, May 15, 1975, 26.

Pickett, Rhoda. "The School for Negroes in the Palmer's Crossing Community." *Mississippi Junior Historian* (Mississippi Junior Historical Society/Mississippi Historical Society) 17 (1978): 40–64.

Pitts, J.R.S. *Life and Confession of the Noted Outlaw James Copeland*. Introduction to facsimile edition by John D.W. Guice. Jackson: University Press of Mississippi, 1980 [orig. 1909].

Powell, Lawrence N. *The Accidental City: Improvising New Orleans*. Cambridge, MA: Harvard University Press, 2012.

*Price's Industrial Magazine*. "City of Hattiesburg, Mississippi." Approx. 81pp. Partial copy found in LHPFC: *Hattiesburg History*.

Randall, Herbert, and Bobs M. Tusa. *Faces of Freedom Summer*. Tuscaloosa: University of Alabama Press, 2001.

Rayner, Robert Patrick. "On Theological Grounds: Hattiesburg Presbyterians and the Civil Rights Movement." Master's thesis, Department of History, University of Southern Mississippi, 2009.

Reams, Robert E. "A Red Flag Predictive Model for the Black Creek and Biloxi Ranger Districts, De Soto National Forest." Master's thesis, Department of Anthropology, Wake Forest University, 1995.

Roberson, Patt Foster. "A History of the *Hattiesburg American*." PhD dissertation, Department of History, University of Southern Mississippi, 1985.

Robertson, Otis. *Facts about Hattiesburg*. Third edition, Hattiesburg, MS: Progress Book and Job Print. Reprinted by Hattiesburg Area Historical Society, 1966 [1898].

Roper, John. Opinion: *James Boykins, et al., v. City of Hattiesburg, et al.* March 21, 1984. United States District Court, Southern District of Mississippi, Hattiesburg Division. Civil Action H77-0062(C).

Ross, Barbara Ann Conner. "History of Medicine in Hattiesburg." *Hattiesburg Area Historical Society Newsletter* 16, no. 1 (Spring 2013): 1–3. http://www.hahsmuseum.org/pdf_newsletters/HAHS%20Vol_16%20No_1.pdf (accessed December 5, 2013).

Rowland, Dunbar. *The Official and Statistical Register of the State of Mississippi, 1920–1924*. Jackson, MS: Hederman Brothers, 1923.

Rungeling, Brian S., and Kenneth W. Hollman. "A Profile of Mississippi's Changing Population." *Mississippi's Business: Bureau of Business and Economic Research* 30, no. 2 (October 1971). Oxford, MS: University of Mississippi School of Business Administration.

Saetre, Gilbert T. *The Pride: 1920–1970*. Hattiesburg, MS: University of Southern Mississippi, 1969.

Saltsman, E.J. "Climatological Summary of Hattiesburg, Mississippi." *Climatography of the United States* No. 20–22, circa 1962. Found in LHPFC Hattiesburg Vertical File: *Climatology*.

*Saturday Evening Eye* (Hattiesburg, MS). edited by Gaines S. Dobbins and H.S. Evans. September 24, 1904.

———. "Industrial Edition." December 1905. Special edition to the newspaper.

Schmidt, William T. "The Middle Years." in *Hattiesburg: A Pictorial History*, edited by Kenneth G. McCarty Jr. Jackson: University Press of Mississippi, 1982, 69–79.

Shady Grove Baptist Church. "History." 2014. http://shadygrovebaptistchurch.publishpath.com/about (accessed June 10, 2014).

Skates, John Ray. "Hattiesburg: The Early Years." in *Hattiesburg: A Pictorial History*, edited by Kenneth G. McCarty Jr. Jackson: University Press of Mississippi, 1982, 5–11.

Smith, Jack Alan. "A Study of Place Names in Forrest County, Mississippi." PhD dissertation, University of Auburn.

Smith, Timothy B. *Mississippi in the Civil War: The Home Front*. Jackson: University Press of Mississippi, 2010.

*South Mississippi Weekly* (Hattiesburg, MS). "A Man for the People Dream Comes True." September 9, 1982, 1.

*Souvenir Castle. 113th Engineers, Camp Shelby, Miss*. Hattiesburg, MS: Dever Printing Company, August 1918. Hattiesburg, MS: Grimsley (Reagan L.) Research Collection, McCain Library and Archives, University of Southern Mississippi, Reference #AM 05-18.

*Spartanburg Herald* (Spartanburg, SC). "Monopoly of Interests." August 28, 1968, 1.

Steen, Harold K. "The Piney Woods: A National Perspective." in *Mississippi's Piney Woods: A Human Perspective*, edited by Noel Polk. Jackson: University Press of Mississippi, 1982, 3–11.

Sturkey, William M. "The Heritage of Hub City: The Struggle for Opportunity in the New South, 1865–1964." PhD dissertation, Department of History, Ohio State University, 2010.

Sutley, Bill. "Southern Miss 'Demons' Returning to Old Haunt May 30." *Advertiser News*, May 27, 1998, 3A.

Taylor, Theodore. *The Flight of Jesse Leroy Brown*. New York: Avon Books, 1998.

Temple B'nai Israel. "History." http://hattiesburgsynagogue.org/wordpress/history/. n.d. (accessed November 26, 2013).

Thomas, W.O. "Hattiesburg, Mississippi." *Taylor-Trotwood Magazine* 6, no. 1 (1908): 115–22.

Thompson, Julius E. *The Black Press in Mississippi, 1865–1985*. Gainesville: University of Florida Press, 1993.

Thornton, Carolyn. "The Heart of Hattiesburg." *Mississippi Magazine*. n.d. 48–85.

Trillin, Calvin. "State Secrets." *New Yorker* 71, no. 14. May 29, 1995, 54–64.

Tusa, Bobs. "A Brief History of the Civil Rights Movement." 2003. http://www.lib.usm.edu/legacy/archives/crsitdoc.htm (accessed June 2, 2014).

*Typographical Journal* 15, no. 12. (December 15, 1899). Indianapolis, IN.

United States Army. *Pictorial History, Thirty-Eighth Division, Army of the United States, Camp Shelby 1941*. Atlanta, GA: Army-Navy Publishers, Inc, 1941.

———. *Pictorial History, Thirty-Seventh Division, Army of the United States, Camp Shelby, Mississippi, 1940–1941*. World War Regimental Histories, Book 182, 1941.

———. *Pictorial Review, Seventy-Third Field Artillery Brigade, Army of the United States, Camp Shelby, Mississippi*. World War Regimental Histories, Book 87, 1941.

University of Southern Mississippi. "Southern Miss Overview and Facts." 2014. http://www.usm.edu/about/southern-miss-overview-facts (accessed August 5, 2014).

Varnado, Scott, director. *The Free State of Jones*. Digital film, hosted at http://vimeo.com/26634334. 11 minutes. 2010.

Walker, David. *Alexander's Ring*. Amazon Digital Services: Winpublish, Inc, 2013.

Walker, Gordon. "Your Schools: A Heritage of Leadership." *Transitions: Public Education in Hattiesburg* 20, no. 2 (March 1999). Hattiesburg, MS.

Walthall, Frances. "State Teachers College: Expansion of Services Depends on Legislature." *Hattiesburg American*, January 13, 1940.

Wansley, Clarice. "Entertaining Camp Shelby Soldiers in War I." *Hattiesburg American*, March 28, 1982, 9E–11E.

———. "A History of USM—The Early Years." *Hattiesburg American*, July 25, 1982, 2E–3E.

Watkins, T.O. "Hattiesburg, Miss. Industrial Edition." Martin Printing Co., under the direction of the Commercial Club, May 1908. Cited in *Hattiesburg American*, "Hattiesburg's Assets 31 Years Ago," January 13, 1940. Article found in LHPFC: *Economic Development*.

Watson, Bruce. *Freedom Summer: The Savage Season of 1964 That Made Mississippi Burn and Made America a Democracy*. New York: Viking, 2010.

Watson, George R., Sr. *Historical Hattiesburg*. Hattiesburg, MS: privately printed, 1974.

Wertz, Sharon. "Ben Earles Recalls Growing up in the 1920s." *Hattiesburg American*, March 28, 1982. 4E.

———. "'The Charmer' of 1930 Recalls Woman's College Glory Days." *Hattiesburg American*, June 27, 1982 (Supplement: The Hattiesburg Story, Chapter 6: The Carey College Story.) 5E.

———. "Dorothy Ware Remembers…" *Hattiesburg American*, June 27, 1982 (Supplement: The Hattiesburg Story, Chapter 6: The Carey College Story.) 11E.

———. "Frank Tatum Sr. Recalls Sawmill and Railroad History." *Hattiesburg American*, February 28, 1982, 3E.

———. "Member of First Class Recalls Her Normal College Days." *Hattiesburg American*, July 25, 1982 (Supplement: The Hattiesburg Story, Chapter 7: The USM Story.) 17E.

———. "165 Years of Providential Care." *Hattiesburg American*, September 25, 1983, 1D.

Wheeler, Donna Duck. *William Carey College: The First 100 Years*. Charleston, SC: Arcadia Publishing, 2006.

Wheeler, Milton. "Praising God for His Blessings." *Profile* 18 (Spring 1981): 7–12. Hattiesburg, MS: William Carey College.

Whorton, James, Jr. "Hattiesburg, Mississippi." in *A Cast of Characters and Other Stories: Stories from the Blue Moon Café*. Edited by Sonny Brewer. San Francisco: MacAdam/Cage, 2006.

William Carey University. "History of William Carey University." n.d. https://www.wmcarey.edu/history-william-carey-university (accessed March 18, 2014).

Williams, M.E. "Fair Salutes Hattiesburg." *Hattiesburg American*, July 8, 1984, 1A.

———. "Hattiesburg Debuts at Fair." *Hattiesburg American*, July 9, 1984, 1A.

Works Progress Administration. *Mississippi: The WPA Guide to the Magnolia State*. Introduction by Robert S. McElvaine. Jackson: University Press of Mississippi, 2009 [1938].

———. *A Serviceman's Guide to Hattiesburg and Area*. Jackson, MS: Works Progress Administration Service Division, 1942.

———. Source Material for Mississippi History: Preliminary Manuscript [by counties]. Compiled by State-wide Historical Research Project, Susie V. Powell, Supervisor. Forrest County, 1935–1942. Hattiesburg, MS: University of Southern Mississippi, Cook Library, Microform Reel A752.

*Youngstown (OH) Vindicator*. "Death and Destruction by the Storm." September 28, 1906. Vol. XVIII, No. 28. p. 1.

Zinn, Howard. *SNCC: The New Abolitionists*. Boston: Beacon Press, 1964.

# Interviews
# (all conducted in Hattiesburg unless noted otherwise)

Mr. John Appleyard (Pensacola, Florida), August 5, 2013.
Mrs. Raylawni Branch, June 21, 2014.
Mr. Charles Brown, February 17, 2014.
Mayor Bobby Chain, August 22, 2013.
Mr. Keith Coursey, November 19, 2013.
Mr. Chad Daniels, April 15 and 22, 2014.
Mr. Wayne Easterling, September 9, 2013, and August 5, 2014.
Mr. Carey Fielder, June 21, 2014.
Professor Max Grivno, September 13, 2013.
Dr. Eddie Holloway, August 8, 2014.
Professor Louis Kyriakoudes, September 24, 2013.

Mr. Mike Lee, November 11, 2013.

Mrs. Linda McMurtrey, August 12, 2014.

Dr. Toxey M. Morris, September 16, 2013; February 17, 2014; and April 21, 2014.

Mrs. Virginia Morris, July 8, 2014.

Mr. Adam Myrick, August 6, 2014.

Mr. Robert Reams (Brooklyn, Mississippi), December 23, 2013.

Mr. Ken Sewell, October 7, 2013.

Mrs. Diane Shepherd, July 7, 2014.

Mr. Milton Waldoff Jr., July 15, 2014.

Mr. Bill Wicht, September 16, 2013.

# INDEX

# INDEX

# ABOUT THE AUTHOR

A native of Hattiesburg, Benjamin Morris is a researcher at the Open University and a member of the Mississippi Artist Roster. The author of *Coronary* (Fitzgerald Letterpress, 2011), his work has received such honors as a Pushcart nomination; the Academy of American Poets Prize from Duke University; the Chancellor's Medal for Poetry from the University of Cambridge; fellowships from the Mississippi Arts Commission and Tulane University; and a residency from A Studio in the Woods in New Orleans, where he lives. Visit his website at http://benjaminalanmorris.com.

*Photo by David G. Spielman.*